150 Best Cottage and Cabin Ideas

150 Best Cottage and Cabin Ideas

Francesc Zamora Mola

HARPER
DESIGN

An Imprint of HarperCollinsPublishers

150 BEST COTTAGE AND CABIN IDEAS
Copyright © 2016 by LOFT Publications

HarperCollins books may be purchased for educational, business, or sales promotional use.
For information, please e-mail the Special Markets Department, at SPsales@harpercollins.com.

First published in 2016 by:
Harper Design
An Imprint of HarperCollins*Publishers*
195 Broadway
New York, NY 10007
Tel.: (212) 207-7000
Fax: (855) 746-6023
harperdesign@harpercollins.com
www.hc.com

Distributed throughout the world by:
HarperCollins*Publishers*
195 Broadway
New York, NY 10007

Editorial coordinator: Claudia Martínez Alonso
Art director: Mireia Casanovas Soley
Editor and texts: Francesc Zamora Mola
Layout: Sara Abril

ISBN 978-0-06-239520-7

Library of Congress Control Number: 2015940684

Printed in China
17 SCP 2

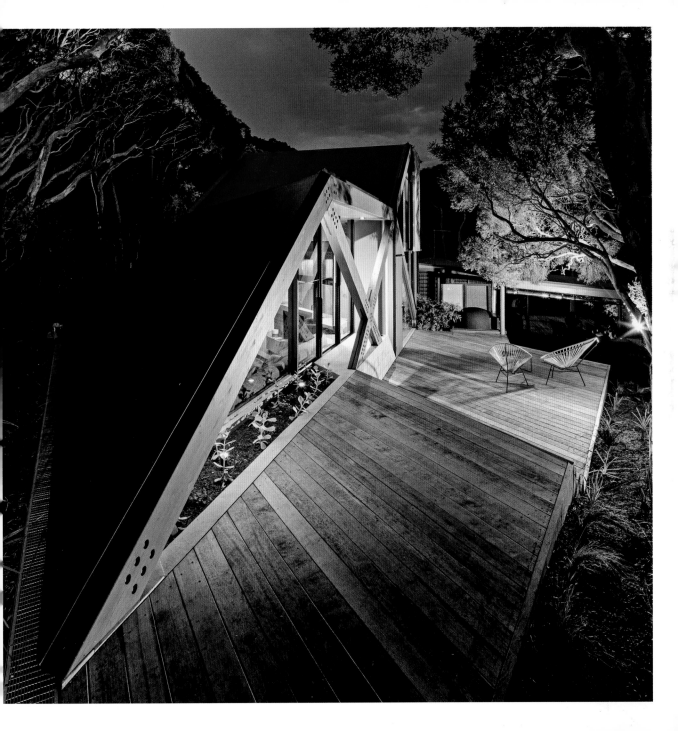

CONTENTS

INTRODUCTION

Notions of nature, remoteness, simplicity, and comfort come to mind when trying to describe the timeless allure of cabins and cottages. This suggests that, perhaps, the idea behind these constructions has to do with lifestyle as much as with architecture. Who hasn't dreamed of a small cabin in the woods or a cottage by a lake? We have all grown up with images of the rustic homes of pioneers and settlers of the American West. Their adventurous and rugged lifestyles appealed to all of us, in part because of their rustic log cabins and idyllic landscapes.

Truth is that those cabins and cottages originally fulfilled a need for protection from the elements and wild animals. Their compact scale and sturdy construction satisfied this necessity. With time, the old mountain architecture quickly got romanticized and cabins became stylish. The once simple and basic structures evolved to become fancy, spacious accommodations, opening the interior to the great outdoors.

What hasn't changed is the idea of a cabin or a cottage as a getaway. A getaway offers the chance to disconnect from daily stress, with only nature and the sky above as witnesses to our quiet time with just our thoughts and our most treasured essentials.

Almost everyone has fantasized of having a refuge near a lake or a stream, in the mountains or in a meadow, and far from anyone else. Quite a pleasant thought, and actually quite attainable. Remoteness seems to be a key ingredient of the getaway experience. But what draws people to spend time in remote locations? It's as if the farther we go from a metropolitan lifestyle, the freer and, consequently, the better we feel. Humans seem to have an innate tendency to seek a connection with nature as an antidote to the pressures of urban life.

The cottages and cabins featured in this volume honor the sites on which they are located and respect the ecological value of their environments. We can see in these projects how their design has been guided by a consideration of views—both immediate and distant—as well as by topography, sun angles, and wind currents and by their natural settings in general. The remoteness of some locations requires the use of basic sustainable strategies such as passive solar heating, shading, and off-grid power systems. Difficult access to the sites limits the choice of materials to locally available timber and

stone, or premanufactured building parts. In this respect, modular construction can facilitate the building process and makes potential future expansions simple.

150 Best Cottage and Cabin Ideas pledges allegiance to a modest architectural archetype that recalls pioneers and settlers eking out a simple existence, with few to no commodities, using only the locally available natural resources, and felling trees that were then stacked and notched together to create simple shelters. These constructions are symbols of retreat, refuge, and a more or less rugged, independent lifestyle. The enduring style of the cabin or cottage is that of a sturdy, solid shelter from the elements. Their simplicity seems to prevail in modern constructions and so do their predominant features: exposed-beam ceilings, built-in furnishings, and large, open floor plans.

Many of these building designs take after the gable and shed roof traditional construction. Others take a modern twist on the established building typologies. The importance of the roof as a basic architectural feature has served to organize the contents of this book under three categories: Gabled, Hipped, and Pyramid Roofs; Shed and Saltbox Roofs; and Flat and Custom Roofs. Roofs speak to us of shelter. Their basic forms have come down to us unchanged through ages. Their silhouettes are still unmistakable in today's modern home. From the outside, a roof defines the look of a home; from the inside, it gives form to the spaces that it shelters.

Today's cottages and cabins are often spacious and comfortable, and they often have more than one floor, with enough room to accommodate visitors. The interior is open and flexible combining various functions. They are also likely to include fully equipped kitchens, whirlpool tubs, saunas, and other luxuries. Large windows and doors blur the distinction between interior and exterior. They face the surrounding landscape, making nature appear as part of the interior and allowing interior activities to spill out onto surrounding terraces.

Perhaps it's not so much about vacationing, but about escaping to a place with a minimum of interference, a refuge from daily stresses. In a cabin away from the urban environment, we can return to living at least a part of our time in a more natural way.

Gabled, Hipped, and Pyramid Roofs

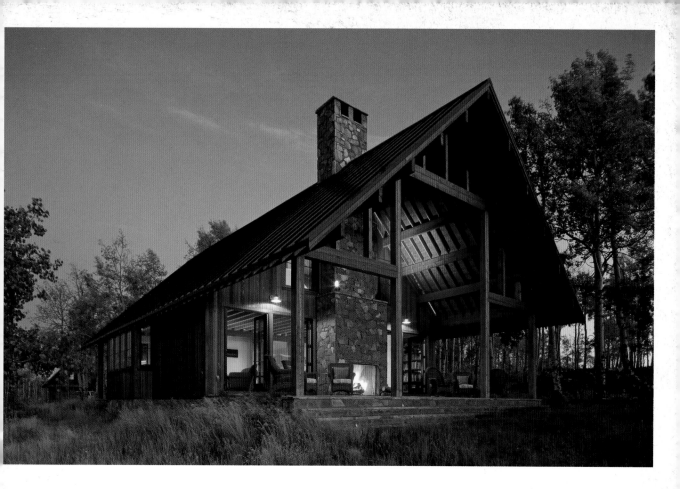

The natural setting was clearly in mind when the architects designed this ranch-style house, using wood and stone to blend in with the beauty of the landscape. The selection of materials pairs with the archetypal house shape to give the building a homey appeal and a strong sense of place. All aspects of the architecture seen from the outside—such as shapes and proportions, as well as materials and finishes that are used to articulate the surfaces—give the interior definition.

Country House in Colorado
2,766 sq ft

Turnbull Griffin
Haesloop Architects

Walden, Colorado, United States
© David Wakely Photography

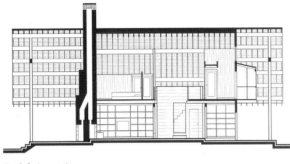

North-facing section

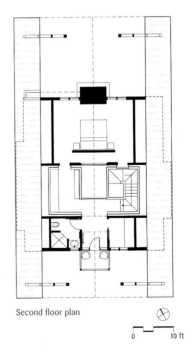

East-facing section

Ground floor plan

Second floor plan

0 10 ft

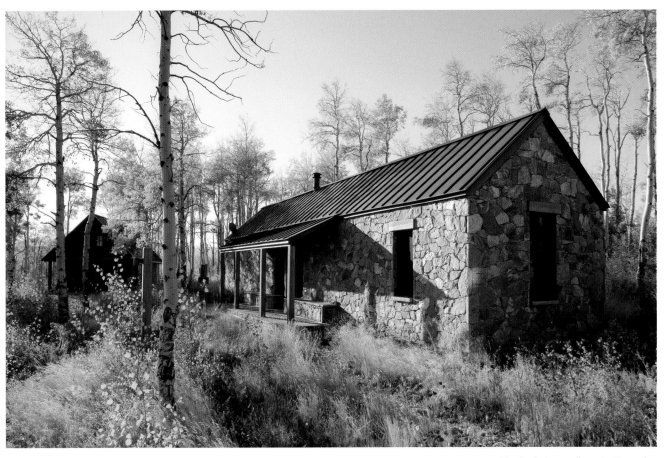

The simple stone wall construction and gable roof put the cabin in harmony with its surroundings, which in turn complement the construction to make it a dream mountain retreat.

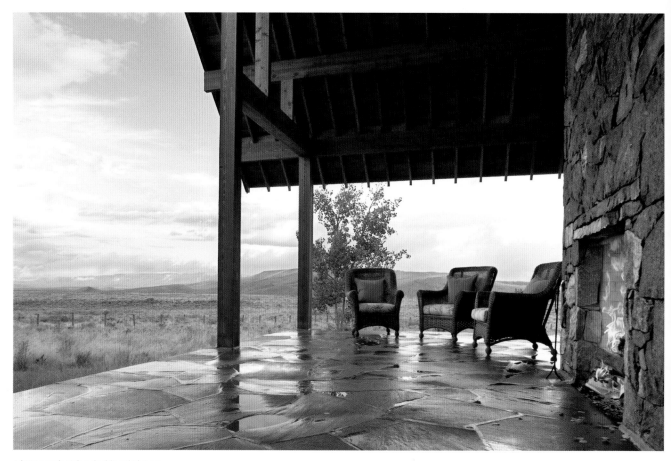

A large porch with a double-sided stone
fireplace and exposed roof rafters
provides ample room for a daytime
gathering during good weather or for
a quiet time at dusk.

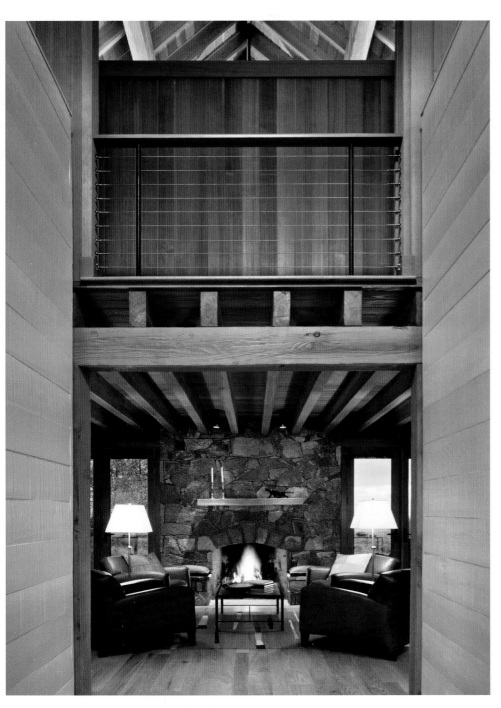

The interior is compact, yet addresses the expansive scale of the landscape with large windows flanking the double-sided fireplace.

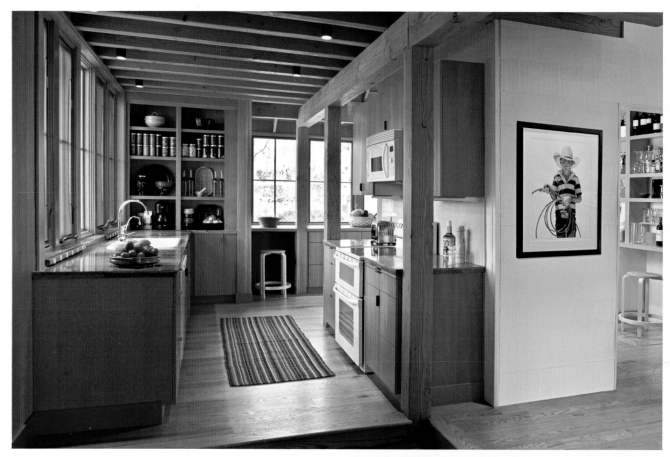

001

One way of integrating built-in furniture into the overall design of a room is to borrow architectural features of the space, for instance, matching shapes and proportions, repeating trim details, and using similar materials.

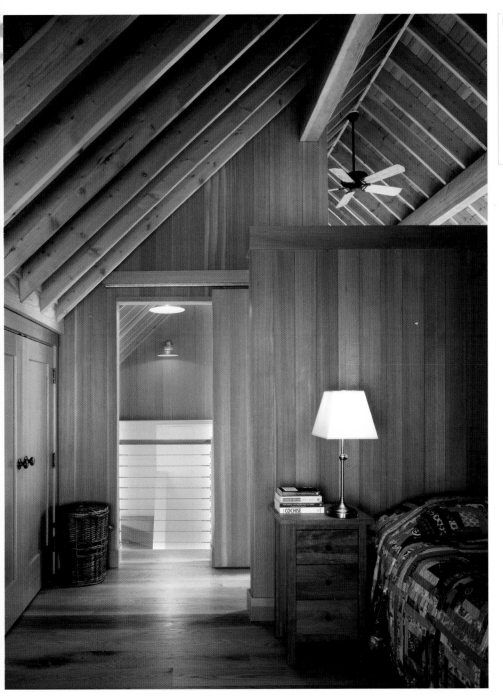

002

Enhance the unique architectural character of a building by focusing on its shape. This is achieved by using a limited selection of materials and sparse furnishings.

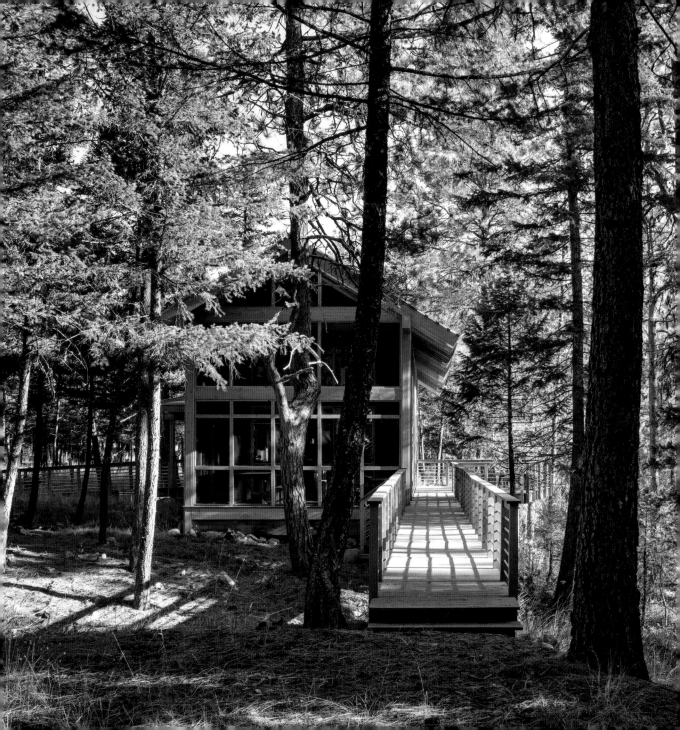

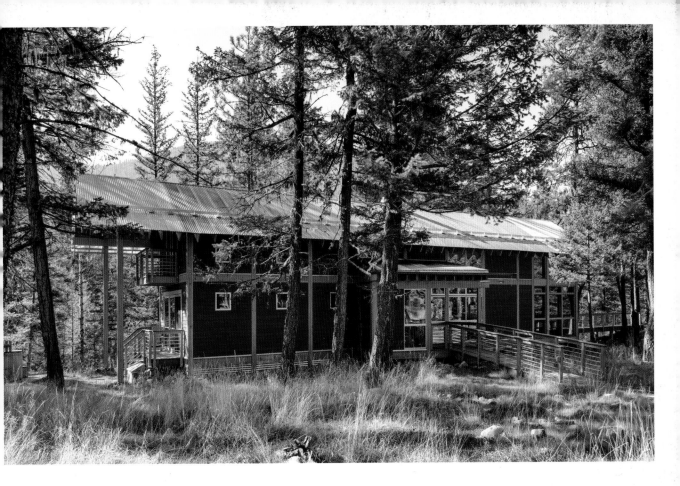

The area where this cabin is located was enjoyed as a campground by a family for many years, before it became the site for their year-round getaway. The cabin stands on concrete piers and is approached via an elevated walkway through towering trees, minimizing environmental impact. Its timber-frame design is expressed in the exterior and the interior, achieving a barn-like feel with contemporary details.

Foster Loop Cabin
1,650 sq ft

Balance Associates Architects

Methow Valley, Washington, United States

© Steve Keating

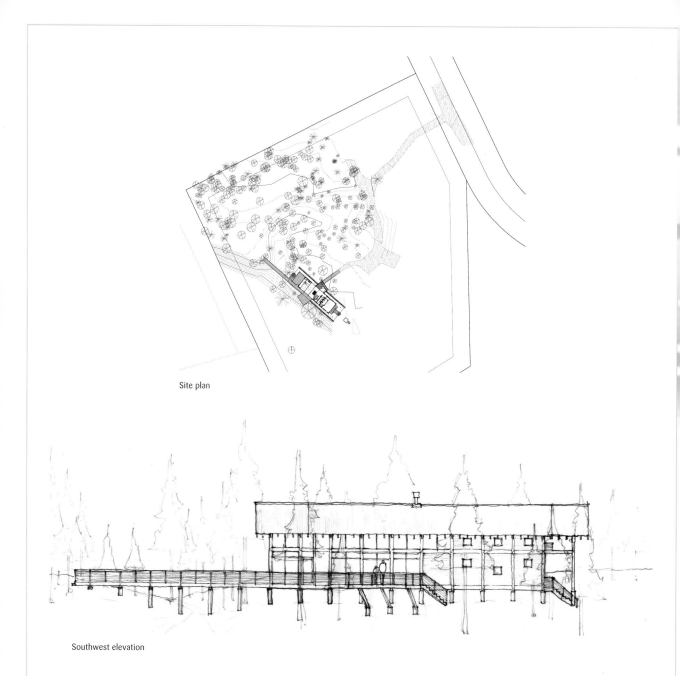

Site plan

Southwest elevation

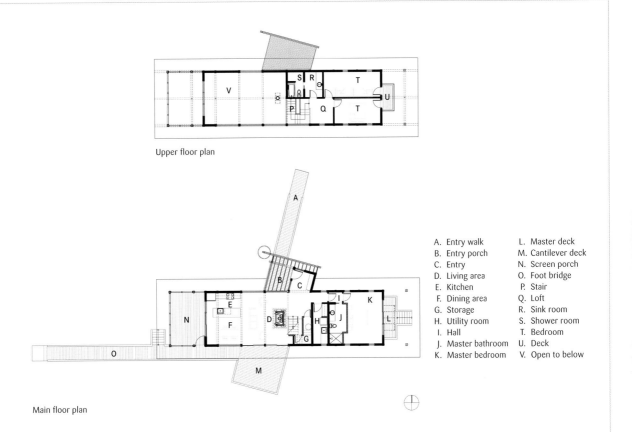

Upper floor plan

Main floor plan

A. Entry walk
B. Entry porch
C. Entry
D. Living area
E. Kitchen
F. Dining area
G. Storage
H. Utility room
I. Hall
J. Master bathroom
K. Master bedroom
L. Master deck
M. Cantilever deck
N. Screen porch
O. Foot bridge
P. Stair
Q. Loft
R. Sink room
S. Shower room
T. Bedroom
U. Deck
V. Open to below

The entry opens-up to a one-and-a-half-story living space and kitchen organized around a centrally located fireplace and staircase. This staircase leads to "tent-like" bedrooms with low walls on the second floor.

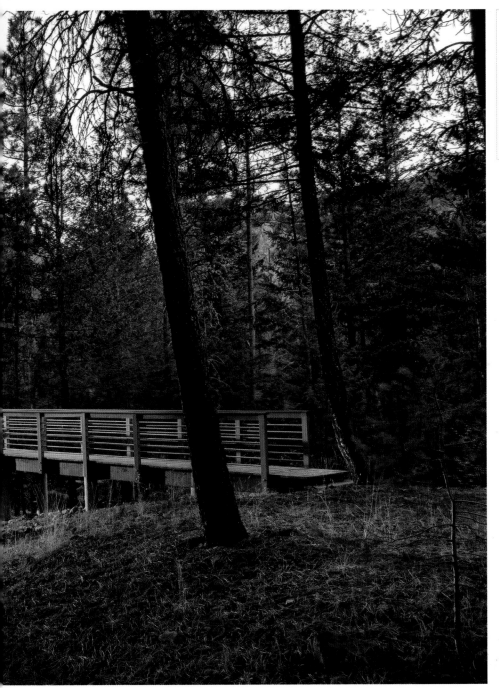

Raising a structure on posts or piers can minimize ground disturbance and protect against storm-water flooding.

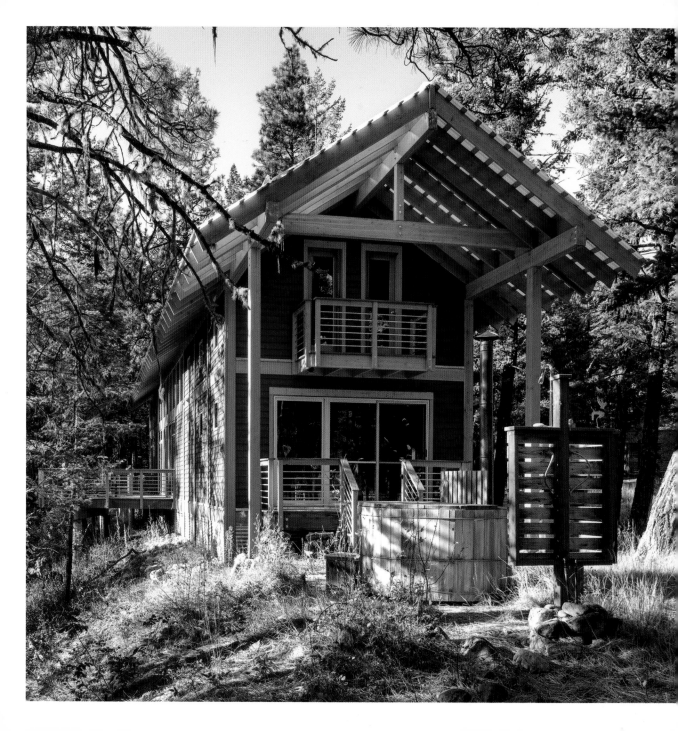

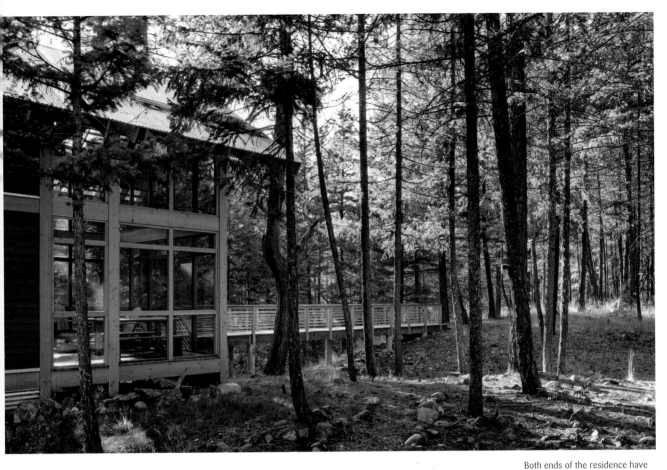

Both ends of the residence have indoor-outdoor spaces. All work together to provide natural transitions from the wooded setting to a welcoming interior.

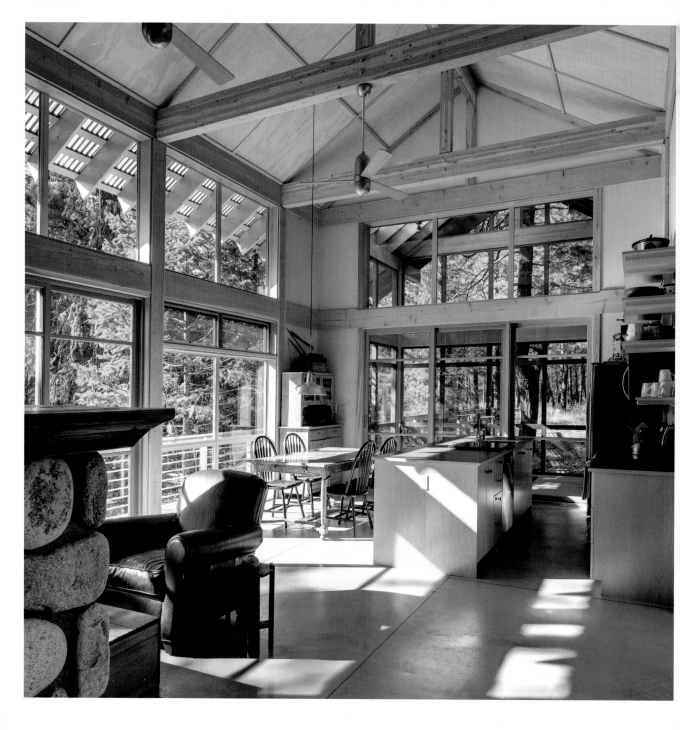

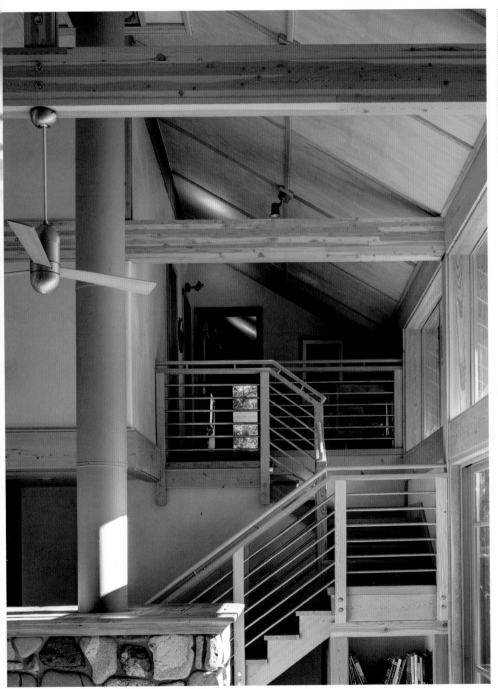

An exposed glulam roof frame blends construction technology and rustic barn-style charm. Glulam construction can support large spans, has a superior fire performance, and delivers a good strength-to-weight ratio.

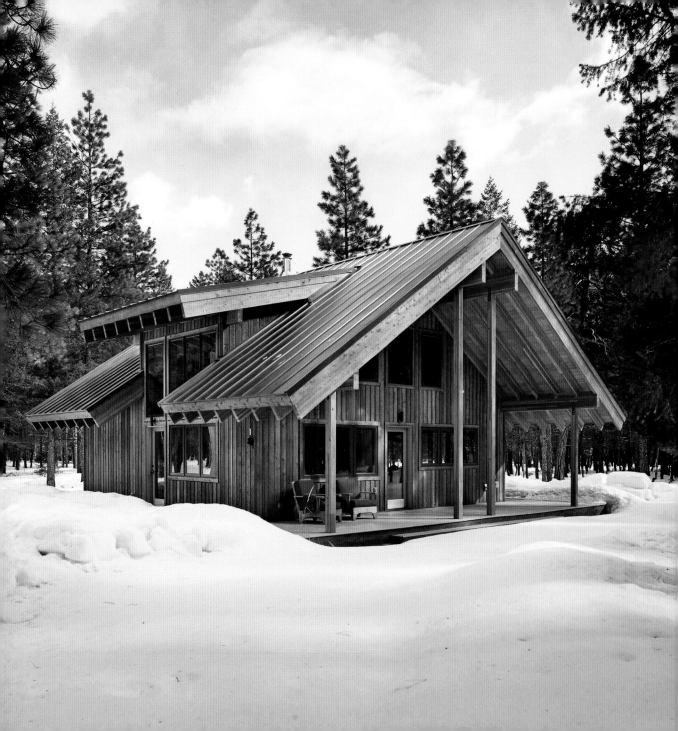

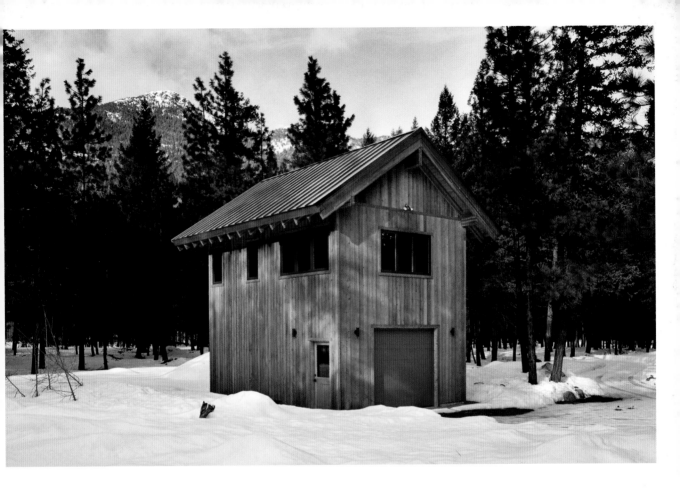

This small cabin with a large porch combines tradition with key contemporary accents. Its prominent gable roof and deep overhangs are a powerful representation of the idea of a shelter, one that humans have sought through history to satisfy a need for protection. Built in a clearing, the cabin is backed by a forest, which acts as a shield against the wind. The overall design, which translates into a graceful harmonization of form and material with the natural setting, is simple proof that our love affair with the archetypal pitched roof cabin endures.

Goat Peak Cabin

1,160 sq ft

Lawrence Architecture

Cascade Mountains, Washington, United States

© Benjamin Schneider

Site plan

Common
property

Methow River

South elevation

North elevation

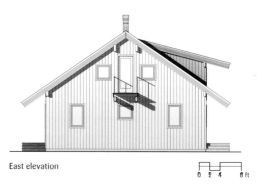

West elevation

East elevation

0 2 4 8 ft

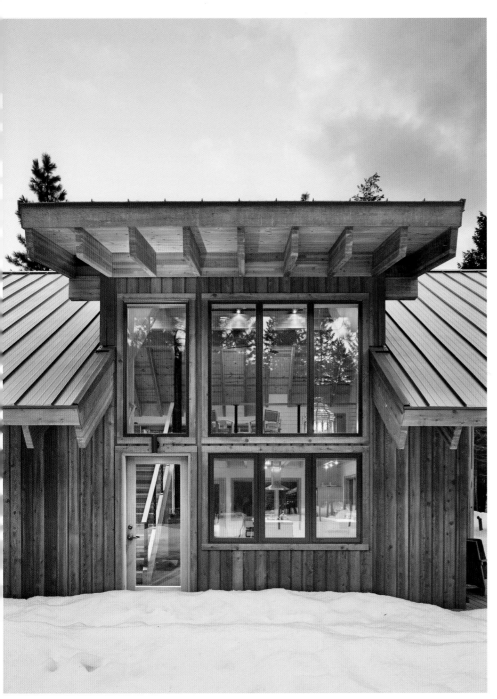

The gable roof is framed with glulam and has large overhangs to shelter the building from the hot summers and cold, snowy winters. The main space features a shed dormer, which offers scenic views.

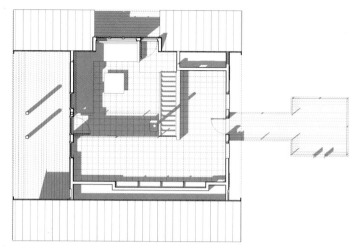

Second floor plan

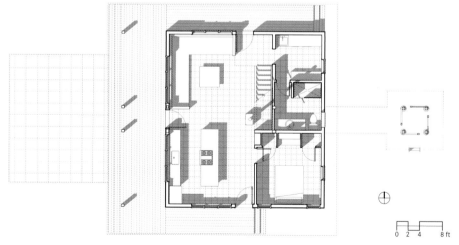

Ground floor plan

0 2 4 8 ft

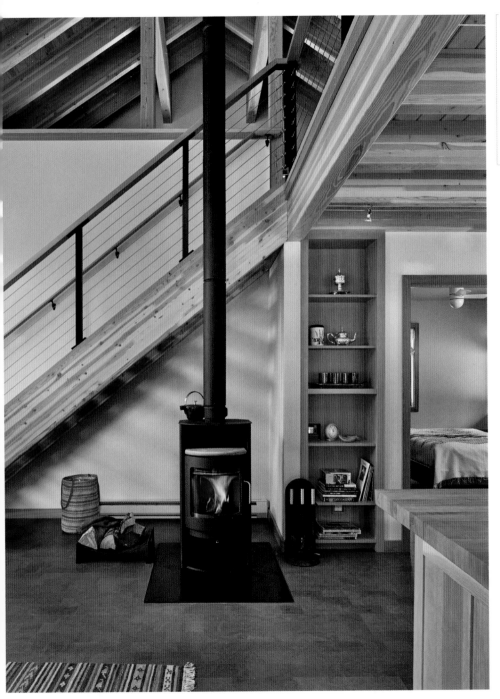

The popular pot bellied metal stove can stand anywhere as long as the flue can run up and out. Not only does such a stove capture attention, it's also efficient, releasing more heat than masonry hearths.

006

Mezzanines are best tucked under soaring ceilings. This extra level helps solve space issues while extending visual reach.

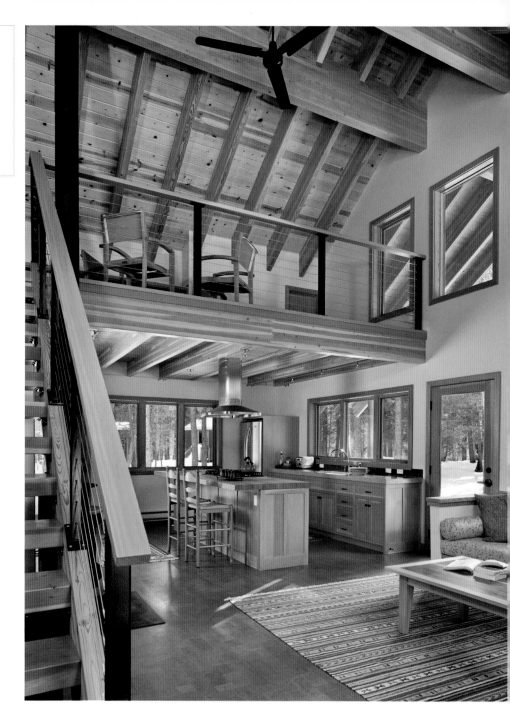

The vertically open living room gains a focal point through the solid, wooden banquette. Wood-framed windows at various heights and roof beams extend the woody palette to all points in the room. The result: design unity and balance.

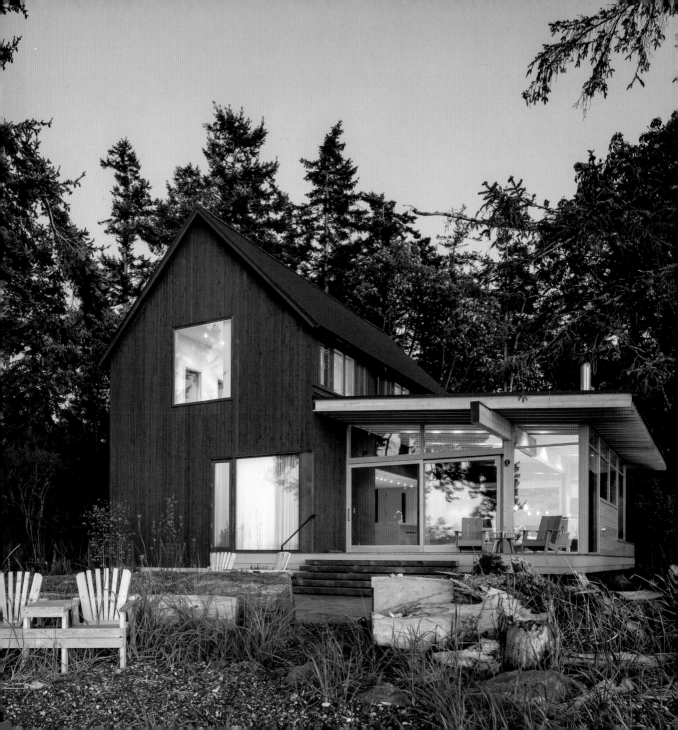

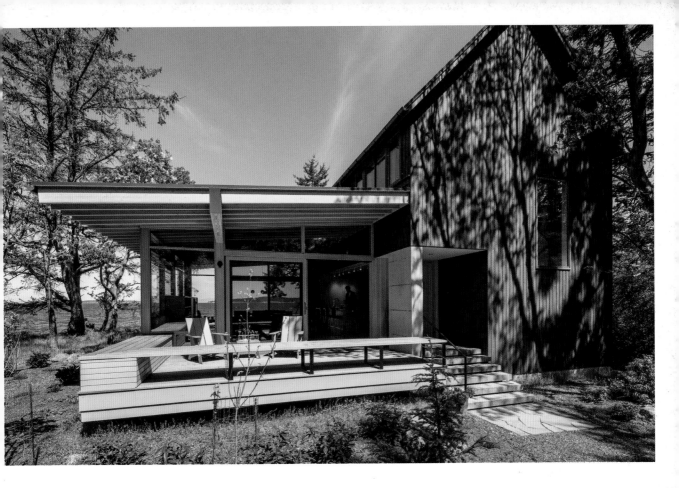

The design of this cabin responds to the desire of the occupants to explore a Northwest island vernacular style for their retreat by a lake—a look and feel that would fit comfortably and timelessly on an island the owners have visited regularly for many years. The design integrates a gable roof construction that evokes a typical island farmhouse. It opens up into a contemporary single-story, open-plan living area with decks, allowing for outdoor leisure.

Bunny Lane

284 sq ft

Heliotrope Architects

San Juan Islands, Washington, United States

© Sean Airhart

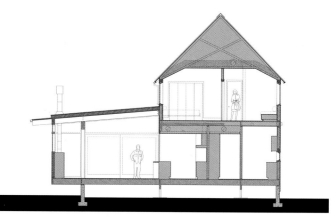

Second floor plan

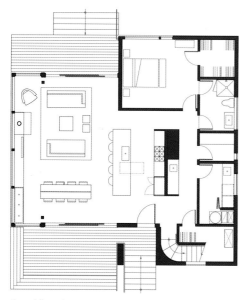

Ground floor plan

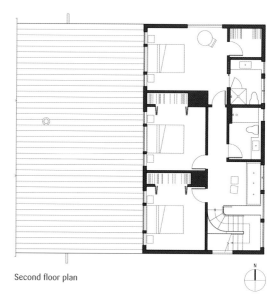

Second floor plan

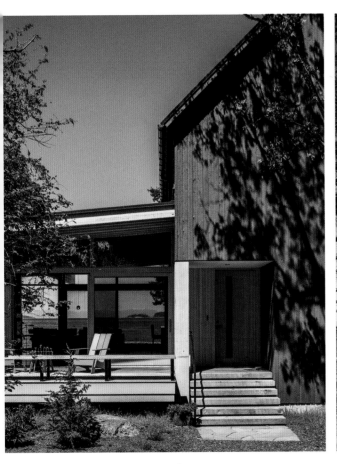
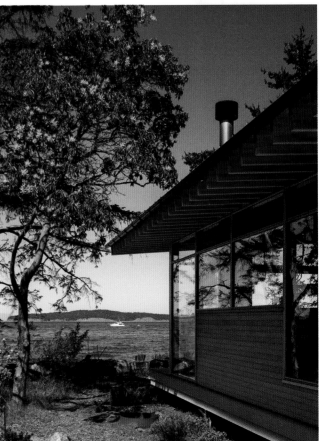

The shed-like structure houses the living area, while the gable roof construction contains bedrooms, bathrooms, and utility spaces. The step-back form allows all upstairs bedrooms a water view.

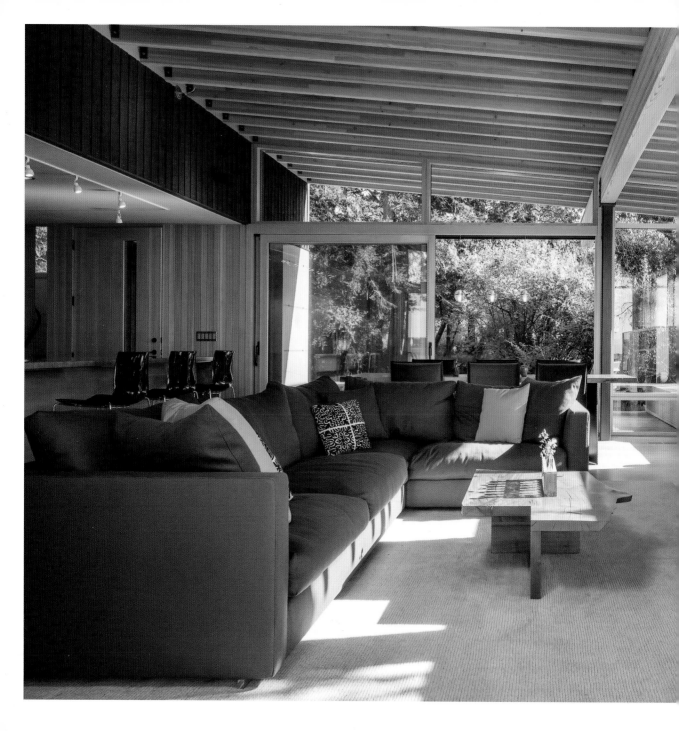

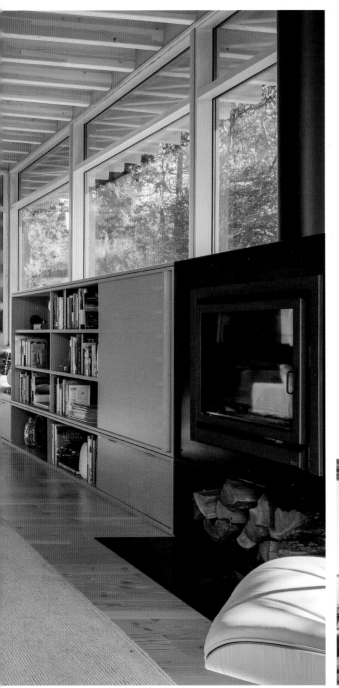

007

Large furniture can define different areas without altering the proportions of a room and maintaining the feeling of spaciousness. Choose low furniture to enhance an open feeling.

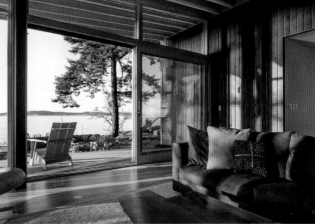

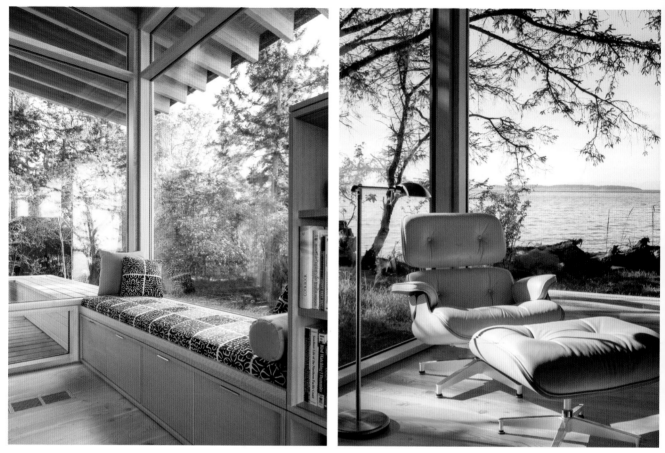

008

Enjoy the views all year round
with seating arrangements
along a wall with big windows.
To prevent sunlight damage
to furniture and fabrics,
use low-E glass to limit the
amount of UV rays passing
through the windows.

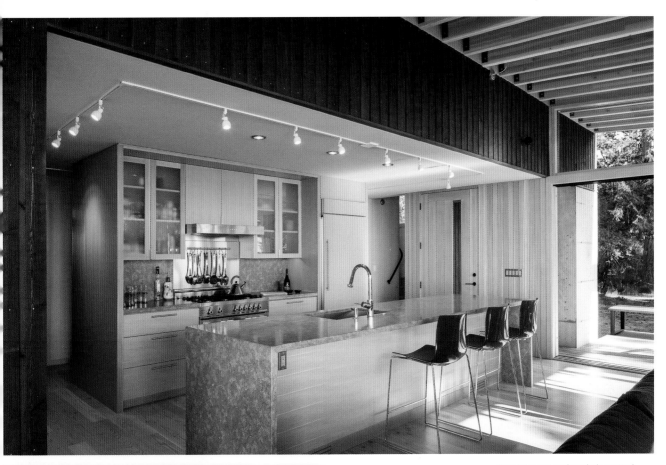

Dominant materials include vertical cedar siding; Douglas fir-framing details, including doors and windows; locally milled Douglas fir floors; vertical grain-fir veneer cabinetry; and limestone countertops.

The brightly lit staircase connects two different atmospheres: the woodsy, cozy single-story open living area and the cool, comfortable sleeping quarters on the second level of the gable-roof construction.

A seating area at the second-floor landing serves as a quiet nook for reading or gazing out the window. This small but convenient space off the bedrooms uses the guardrail as an opportunity for shelving and adds storage space under the banquette.

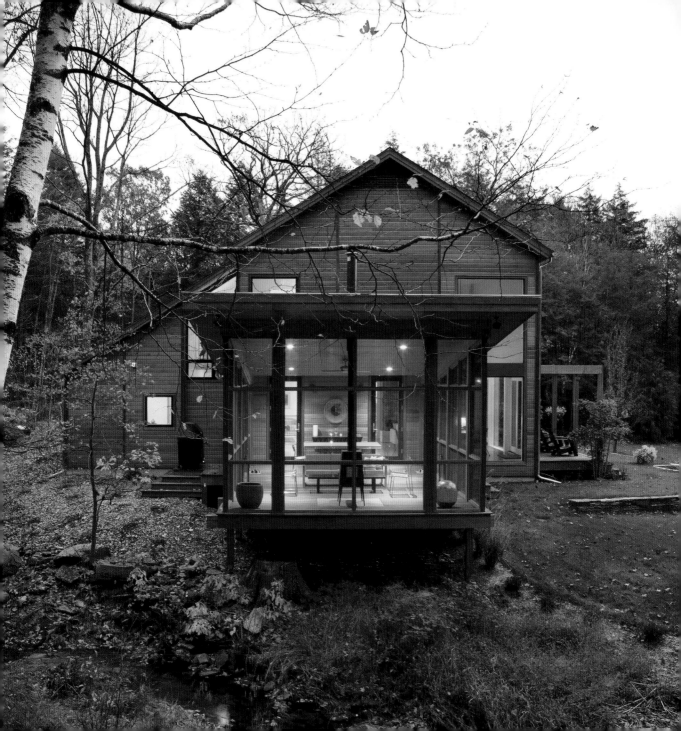

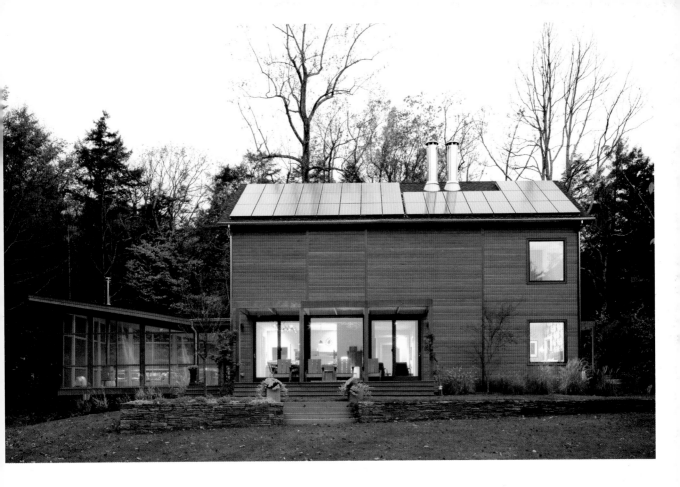

Situated in a wooded 6.8-acre parcel next to a stream, this modern farmhouse is the result of an extensive remodel and extension of an existing 400-square-foot cottage. The redesign strengthens the connection between interior and exterior by means of windows of different sizes and proportions that draw one's attention to natural wetlands and rock outcroppings across the nearby stream.

Bug Acres of Woodstock

2,700 sq ft

CWB Architects

Woodstock, New York,
United States

© Rachael L. Stollar

Preliminary site plan sketch

Preliminary west (entry) elevation

Preliminary building section looking east

Preliminary south elevation

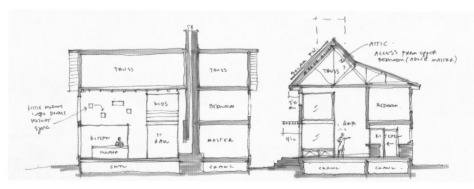

Preliminary building section looking north

Preliminary building section looking west

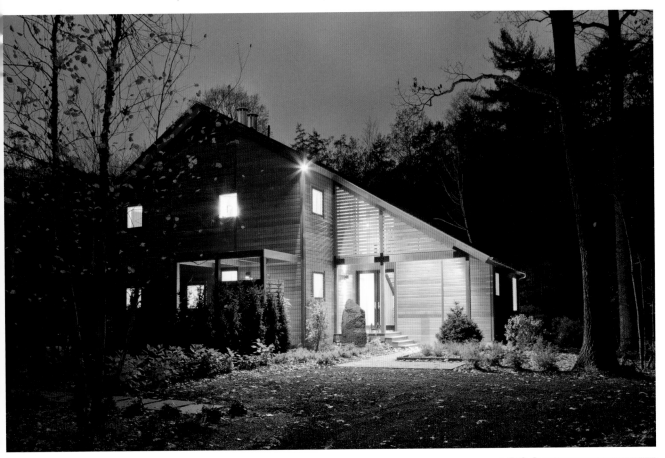

Outdoor lighting is an important decorative and functional element. It can be used to illuminate paths, create focal points in the landscape around the home, and provide a sense of security.

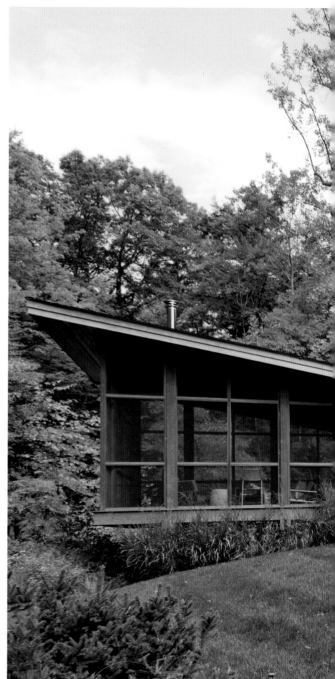

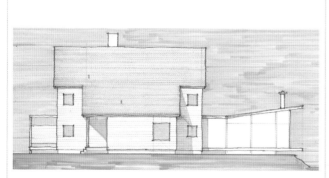

Preliminary design sketch

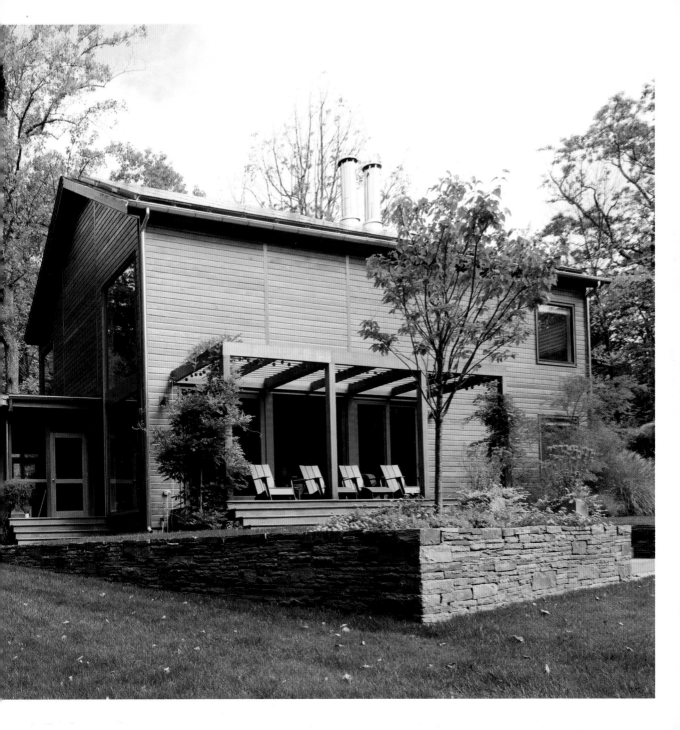

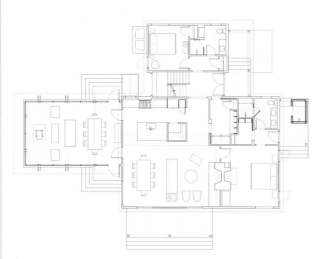

Ground floor plan

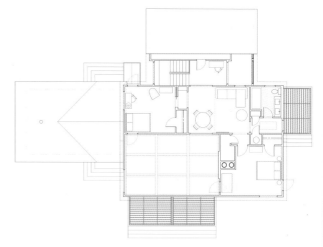

Second floor plan

The remodel and extension
transformed the modest
two-bedroom, one-bathroom
cottage into a stunning
four-bedroom home.

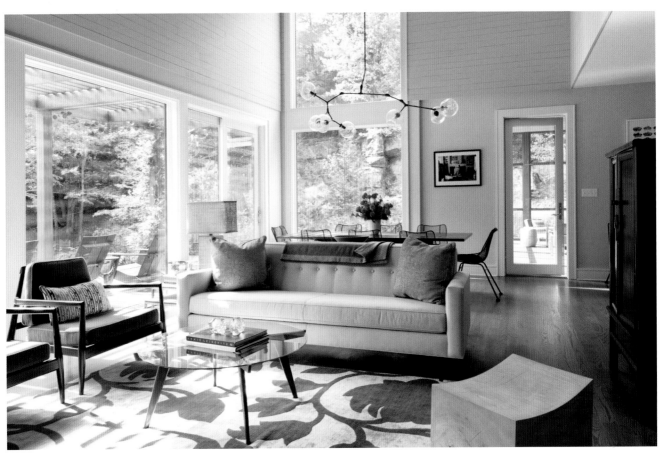

010

You can strengthen the connection between an interior space and the outdoors by using colors and patterns inspired by the natural world, natural materials such as stone and wood, and outdoor furniture.

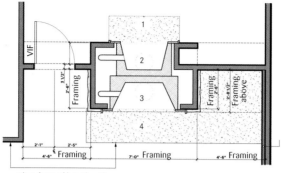

VIF

Framing 3 1/2"
2'-6"

Framing 2'-6"
2'-8 1/2"
Framing above

5

2'-1" 2'-5"
4'-6" Framing 7'-0" Framing 4'-6" Framing

Align front of hearth with
finished gypsum wallboard 12

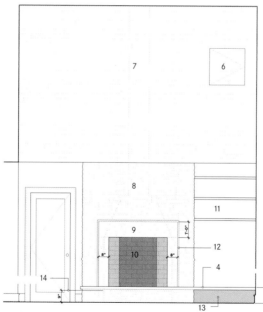

Family room fireplace. Plan and elevation

1. Flush hearth: ¾" thick bluestone
 slab, flamed finish
2. 36" Isokern Standard fireplace
3. 48" Isokern Magnum fireplace
4. Raised hearth: 2" thick bluestone
 slab, flamed finish
5. Finished face of the wall furred
 in 2" + ½" plywood to conceal
 structural steel posts
6. Hatch to bedroom hidden within
 plank wall
7. Rough-sawn 1 x 4 paint grade pine
 planking at upper sections of wall
8. Dry stack thin veneer bluestone
9. Bluestone slab surround
 flamed finish
10. Firebox for 48" Isokern Magnum
 modular masonry fireplace
11. Open painted wood shelves
12. 1" x 3½" bluestone back band
 around perimeter of slab surround
13. Open below for wood storage:
 back and side lined with
 bluestone slab
14. Top of foundation for living room
 fireplace unit

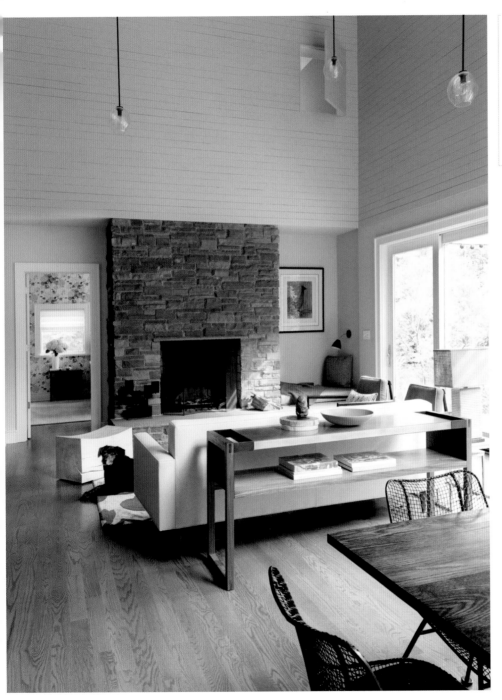

The mountain cabin represents an archetypal form and a symbol of refuge and shelter from the elements. This concept is strongly anchored by a fireplace, generally made of stone, which also ties the construction to its setting.

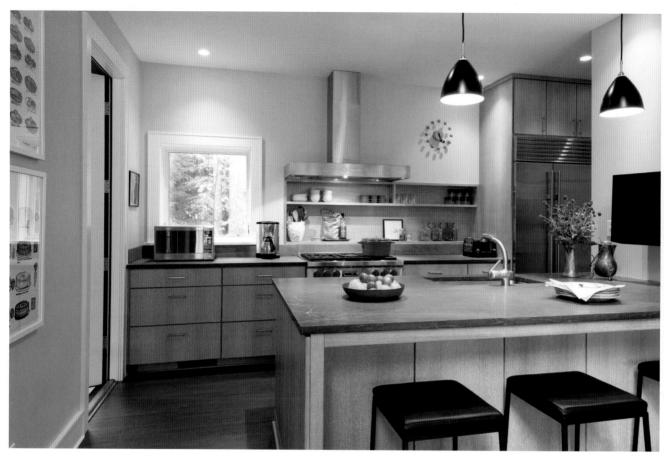

012

One-wall kitchens with islands are similar to galley kitchens, when it comes to traffic and work. They allow for an efficient workflow between the sink, fridge, and stove.

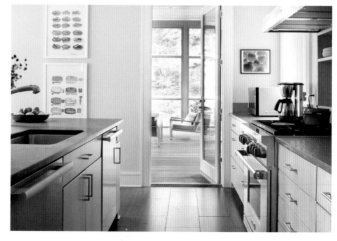

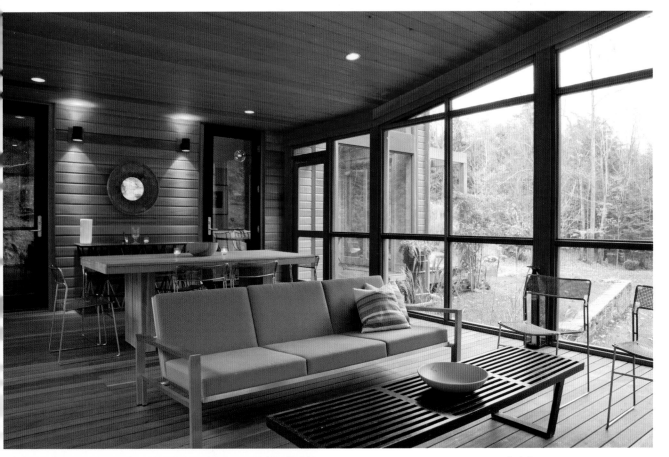

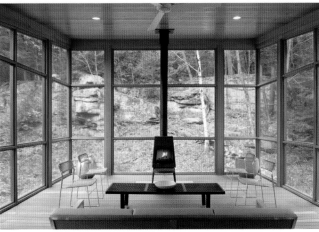

013

Wood-burning stoves are not exclusive to rustic cabins. They have found their way into many modern homes. New advances in technology make these stoves burn more efficiently and cleaner.

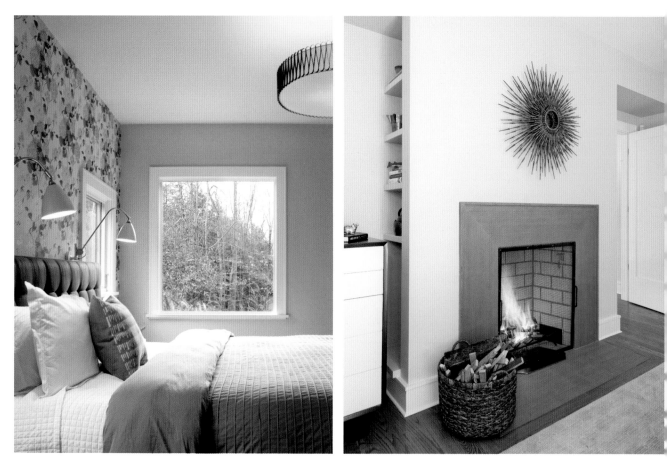

014

Colors, patterns, and textures come together to create a well-balanced and harmonious space. Patterns and prints should be selected according to the size and proportions of the room they are intended for.

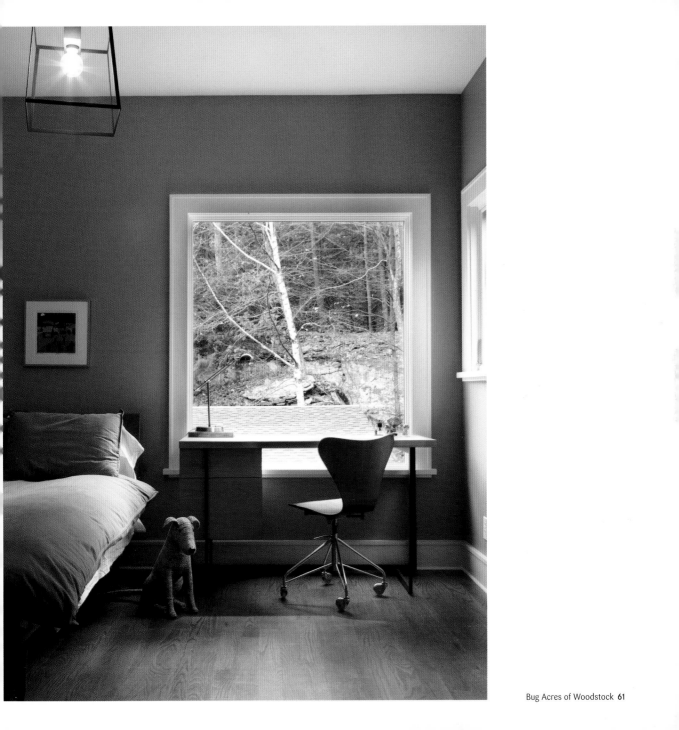

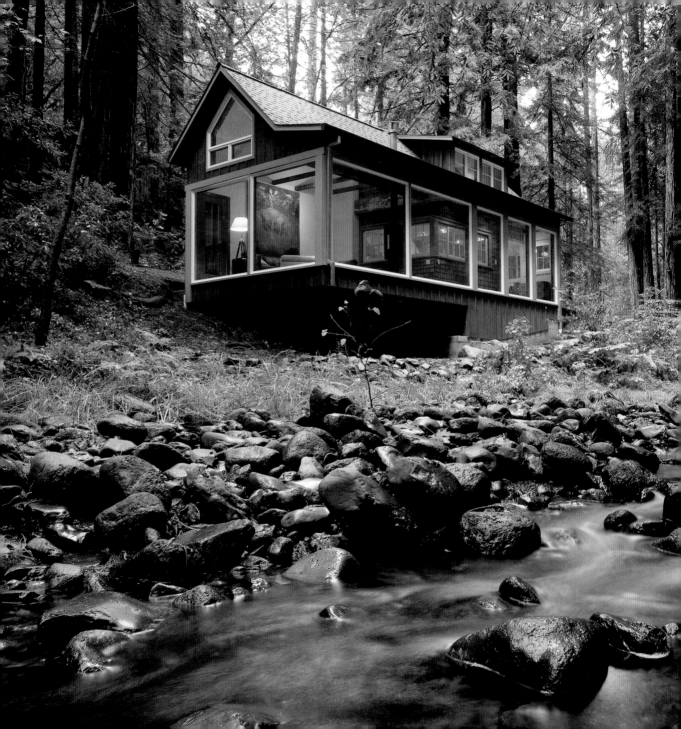

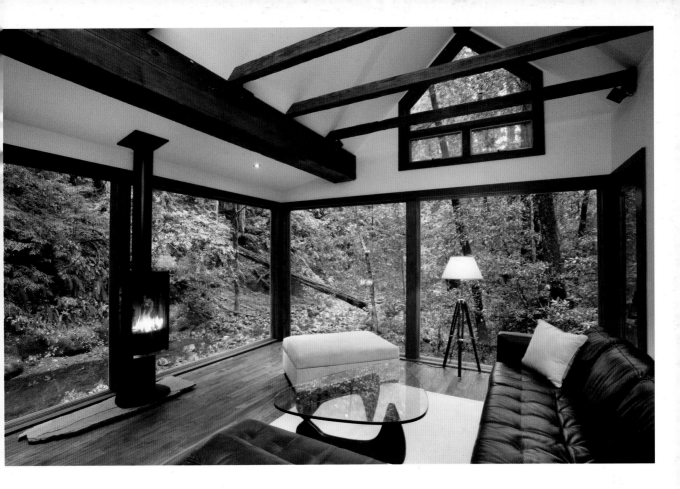

This 1920s shingle-style cabin is beautifully situated among shady firs and redwoods. Its original layout, however, precluded views to a nearby boulder-strewn creek. Stringent regulations limited new construction to only thirty-three percent more than the original structure's footprint. Replacing an underutilized deck presented the opportunity to create a new double-height living room to wrap the original exterior. The room's glass walls showcase views of the swirling waters below.

Creekside Cabin

1,275 sq ft

Amy A. Alper, Architect

Calistoga, California, United States

© Eric Rorer

The original cabin exterior is preserved and featured as a backdrop to the new spaces. The living room is set under an extension of the existing roofline, while the hallway is defined by a shallower roof pitch that gestures toward the creek.

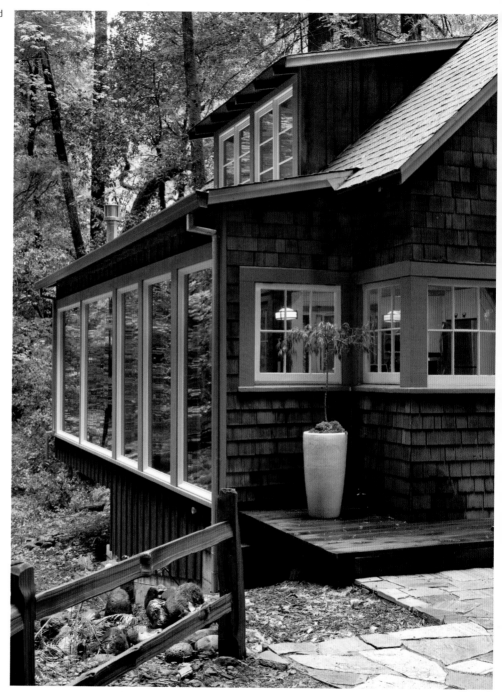

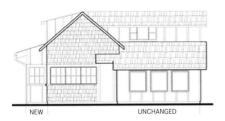

East elevation

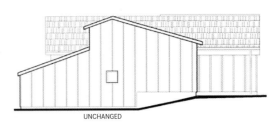

North elevation

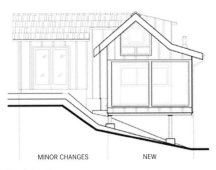

West elevation

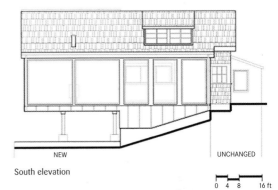

South elevation

0 4 8 16 ft

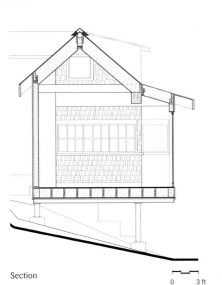

Section

0 3 ft

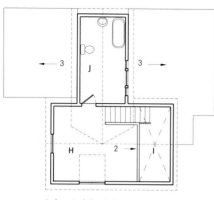

Before: Loft level plan

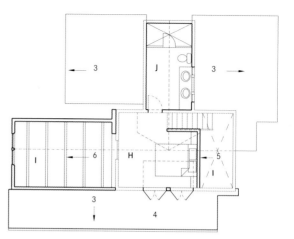

After: Loft level plan

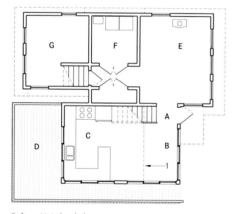

Before: Main level plan

A. Entry	F. Laundry room	1. Line of
B. Dining area	G. Guest room	loft above
C. Kitchen	H. Bedroom loft	2. Parapet wall
D. Deck	I. Open to below	3. Roof below
E. Living area	J. Bathroom	

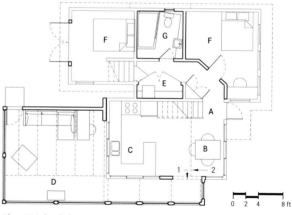

After: Main level plan

0 2 4 8 ft

A. Entry	G. Guest bathroom	1. New opening
B. Dining area	H. Master bedroom	2. Line of loft above
C. Kitchen	I. Open to below	3. Roof below
D. Living room	J. Master bathroom	4. New dormer
E. Laundry		5. Full height wall
F. Guest room		6. Beams below

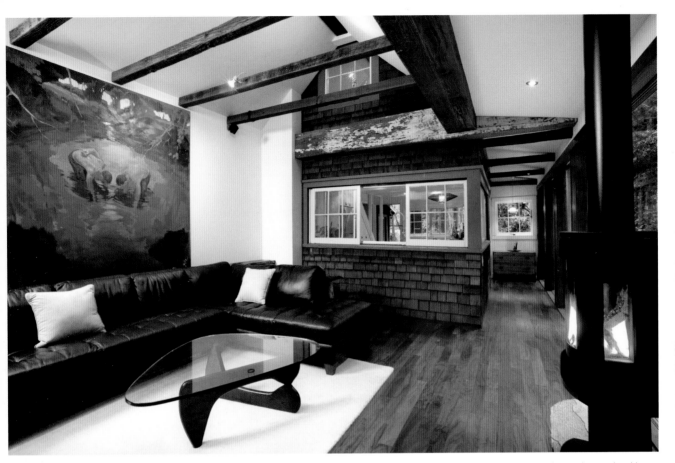

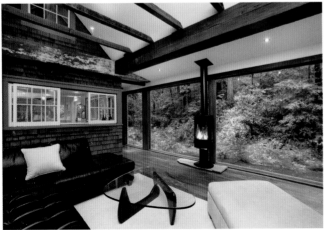

New materials complement the old, with reclaimed beams mediating between the existing structure and the addition, while visually echoing the surrounding woods beyond.

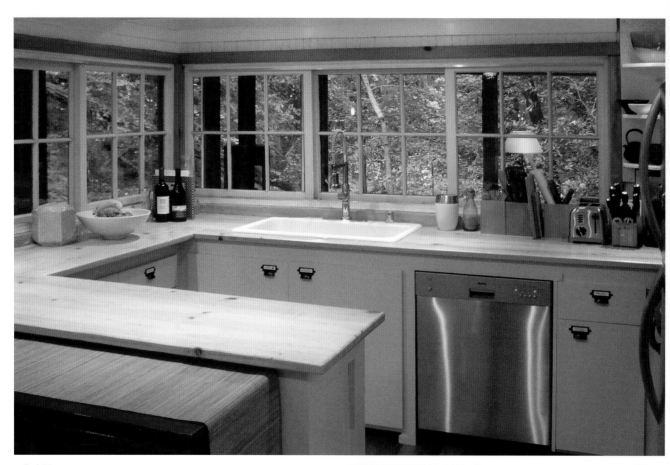

015

A peninsula kitchen works like a kitchen with an island, except that the island is connected to the kitchen. Its compact layout makes it a good space-saver, since it requires less clearances than kitchens with islands.

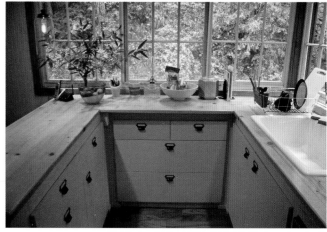

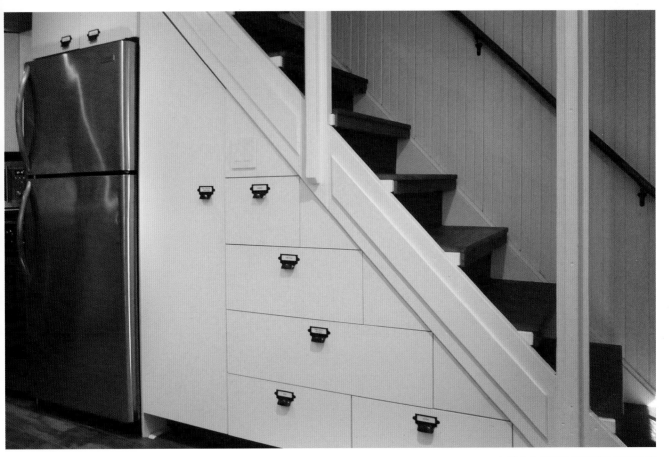

016

Put the awkward space under a staircase to good use. It may seem the hardest space to deal with, but it lends itself to smart storage solutions, including open shelving and pullout drawers.

The addition was designed to wrap around the original exterior, fulfilling the client's request that the existing structure remain unchanged. The windows and doors that once were in contact with the elements now playfully connect the living room with the kitchen.

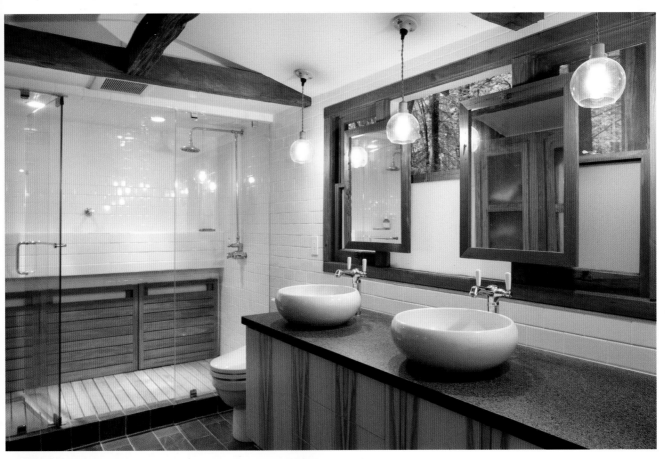

017

The use of different wood textures creates a rich juxtaposition enlivened by adjacent contrasting surfaces.

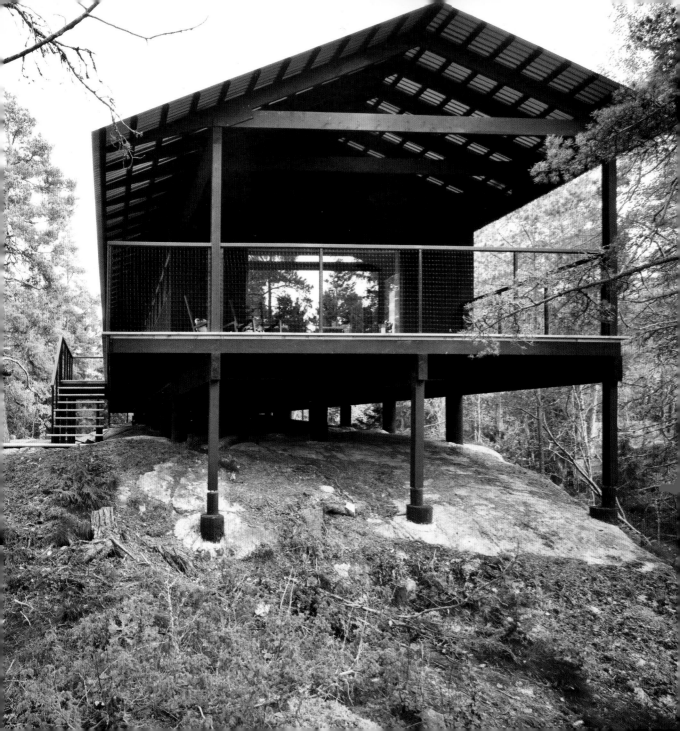

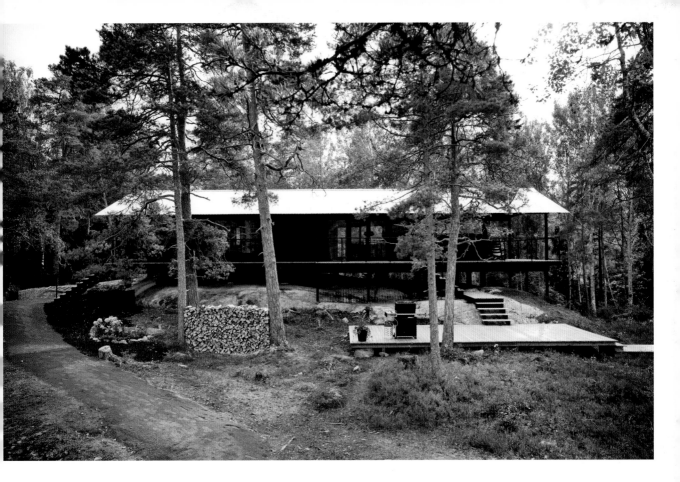

At first glance, the site appears as a fairly typical archipelago plot with granite outcrops, pine trees, and blueberry bushes, but soon an unusual, dramatic topography reveals itself. This site was an apt choice for an equally bespoke retreat, one that takes full advantage of the uniqueness of the natural surroundings. It stands on a ridge bordering a thirty-foot drop into a gorge where pine trees and some hardwoods grow. The orientation of the ridge dictates the building's form and the spatial subdivisions.

Holiday House Vindö
1,157 sq ft

Max Holst Arkitektkontor
Vindö, Stockholm, Sweden
© Hannes Söderlund

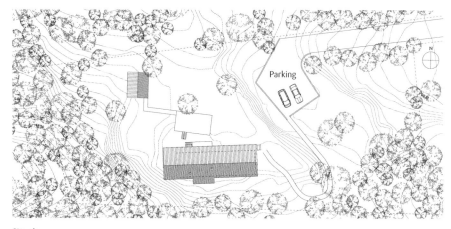

Site plan

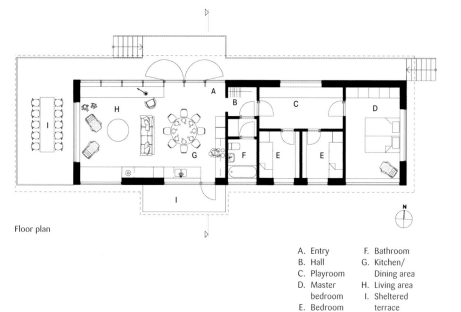

Floor plan

Section

A. Entry
B. Hall
C. Playroom
D. Master bedroom
E. Bedroom
F. Bathroom
G. Kitchen/ Dining area
H. Living area
I. Sheltered terrace

North elevation

East elevation

South elevation

West elevation

The cabin is a case study on how to create a living space in connection with the sky, the surroundings, and the distant landscape.

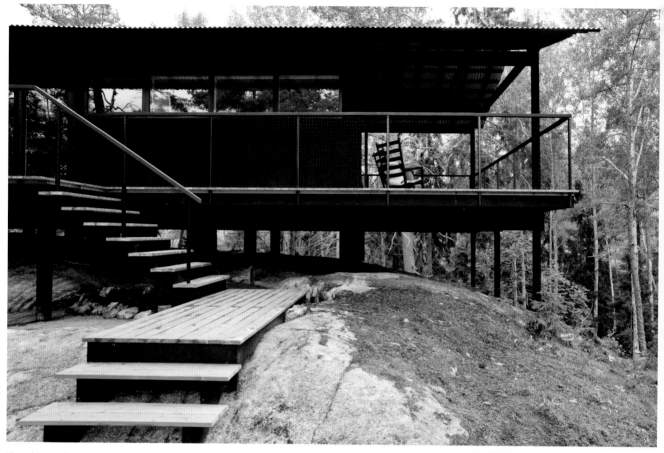

The cabin stands on concrete piers painted black and has exposed timber rafters. The material palette is simple and essentially rooted in local building traditions.

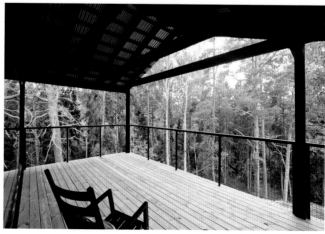

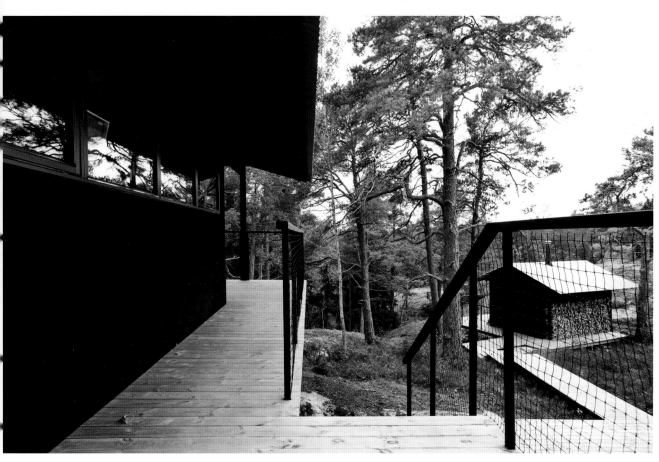

018

Keep guardrails as low-impact as possible so views don't become obstructed. Wire mesh is a building material that can fulfill the primary function of a guardrail, while being practically invisible.

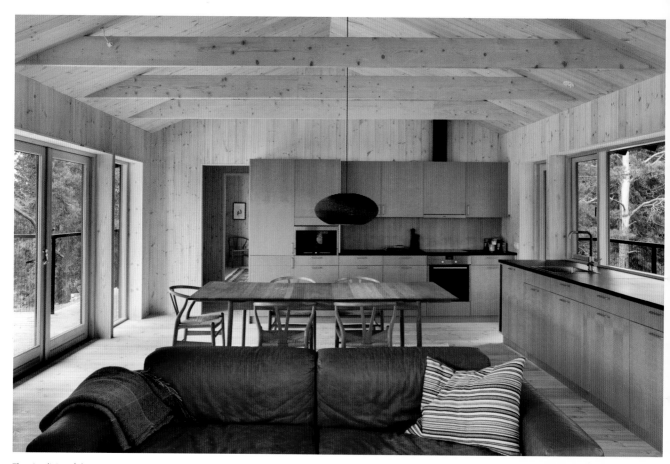

The simplicity of the exterior is mirrored in the interior. Emphasis was put on the unique character of wood as a versatile building material that allows an honest expression of the building.

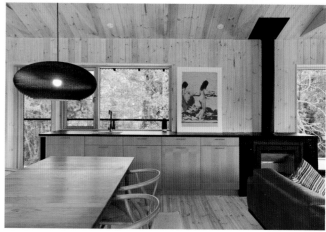

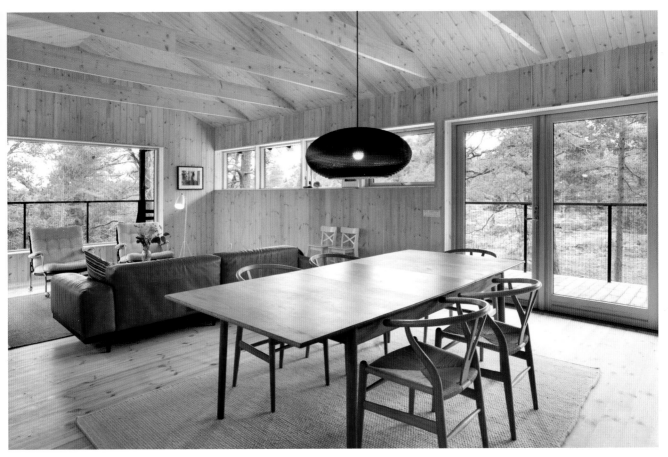

019

A limited material and color selection promotes a unified design, and the use of large openings that visually and physically connect interior and exterior contribute to the integration of the building with the landscape.

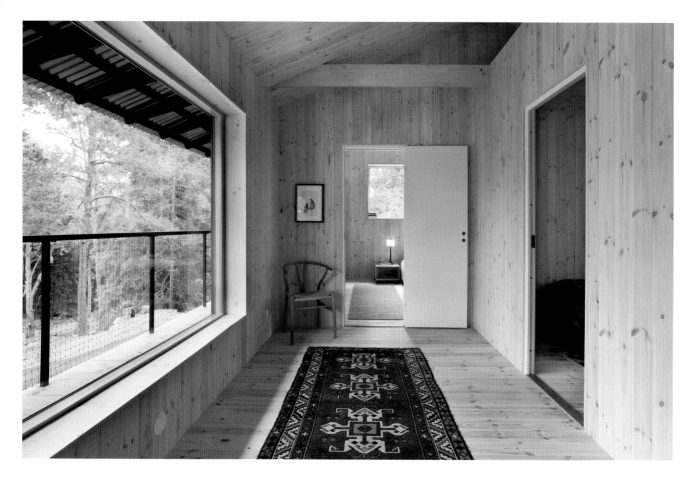

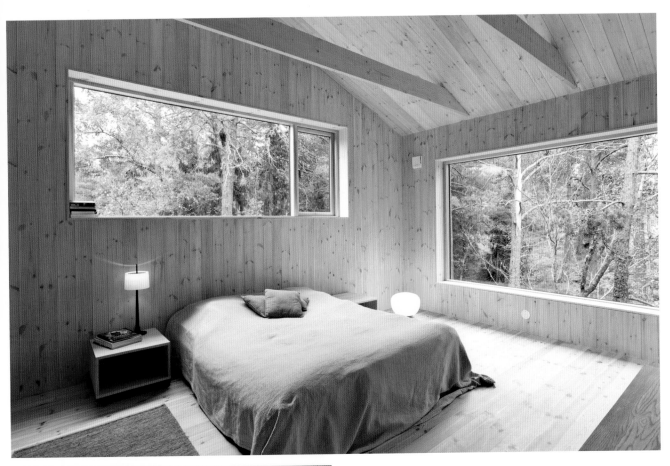

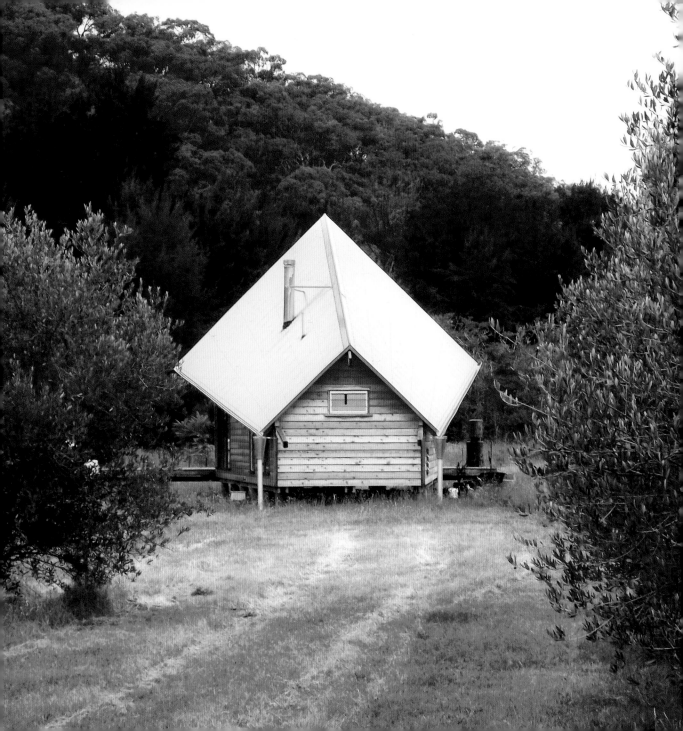

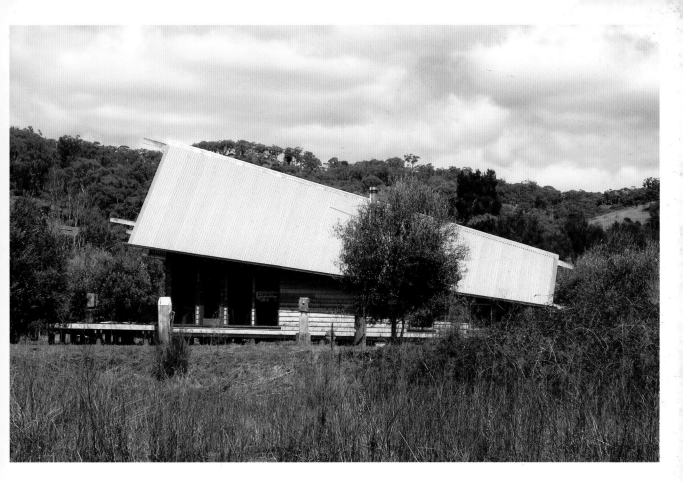

Turon House is a structure that combines traditional barn construction and modern industrial architecture. The structure was built to provide shelter in any weather. Its simple, yet eye-catching design focuses on the geometry of the roof, efficiently fulfilling its function as a protective element. The sloping metal gable roof sits on top of wood walls, an arrangement that provides more ceiling height to the space usually used during the daytime while tightly hugging the sleeping area.

Turon House
646 sq ft

Greg Hill

Turon Valley, New South Wales, Australia

© Greg Hill

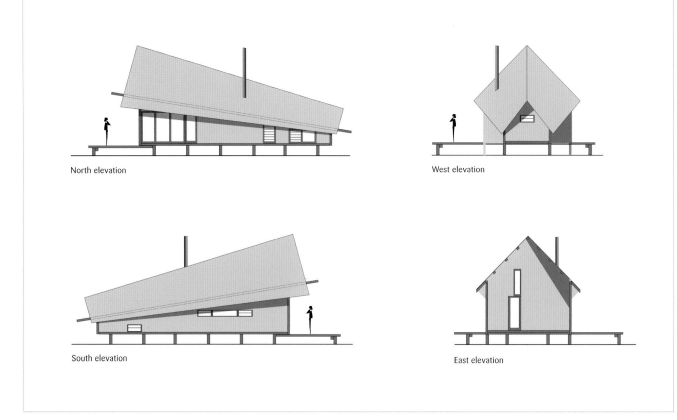

North elevation

West elevation

South elevation

East elevation

A deep overhang protects the front of
the house from the elements and at the
same time provides a sheltered space
for outdoor activities.

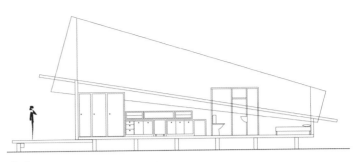

Section

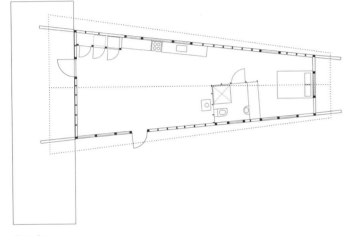

Floor plan

020

Getting proportions and scale right is critical for the creation of a harmonious living space. The tapered shape of the floor plan echoes the profile of the building. The ceiling is tall where the room is wide, and it's low where the space is narrow.

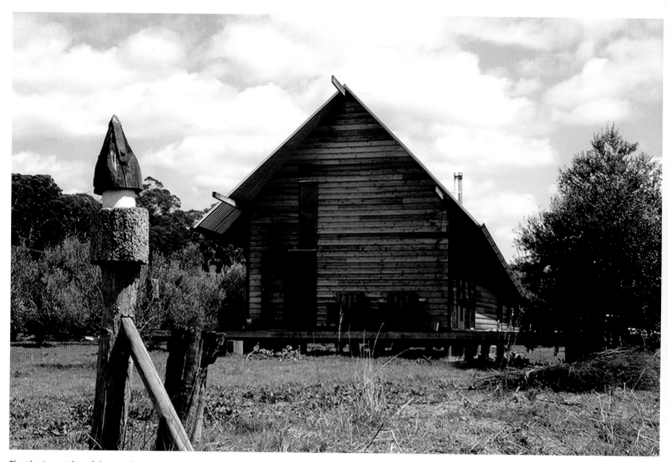

The sloping quality of the metal
roof and its tapered shape make for
a more dynamic and contemporary
interpretation of the archetypal
gable roof.

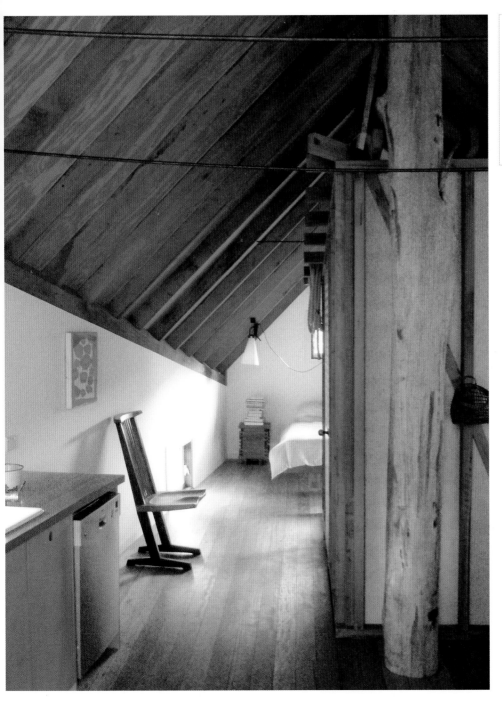

Achieve a rustic aesthetic
through combining hardwood
floors and rough-sawn rafters.
The tree-trunk column use
in this cabin reinforces
the connection with the
natural world.

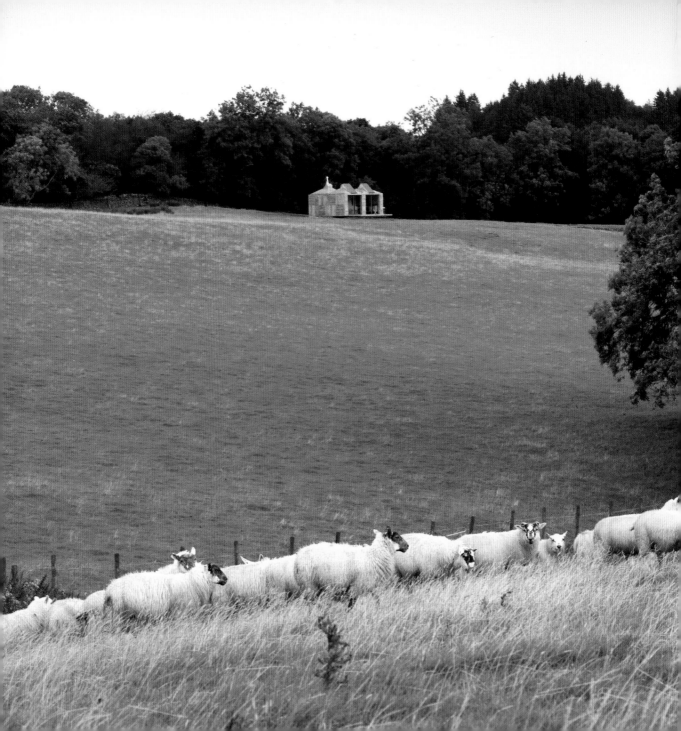

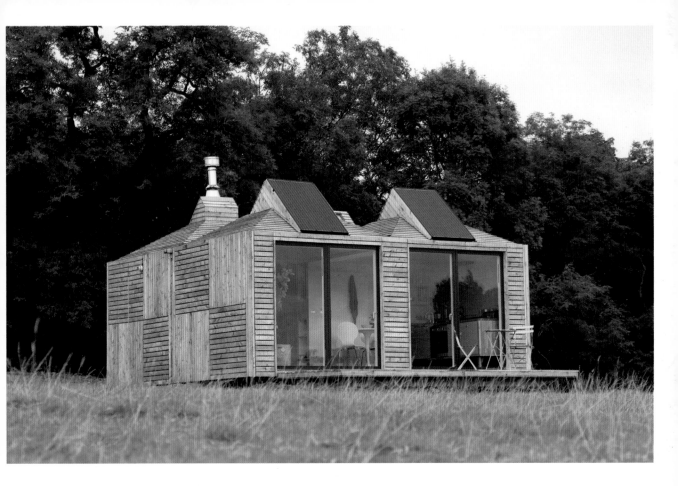

Brockloch Bothy quietly stands on a one-hundred-and-ninety-acre property of rolling hills and woodland, far from any neighboring buildings and operating independently of all public utility services. The intimacy of the location makes Brockloch Bothy a unique retreat to escape from city life. It is a modular building that combines contemporary design with the use of sustainable materials. The configuration comprises four ninety-seven-square-feet modules—each with a distinctive pyramid roof—grouped to create a comfortable living space.

Brockloch Bothy

387 sq ft

echoLIVING

Dumfries and Galloway, Scotland, United Kingdom

© echoLIVING

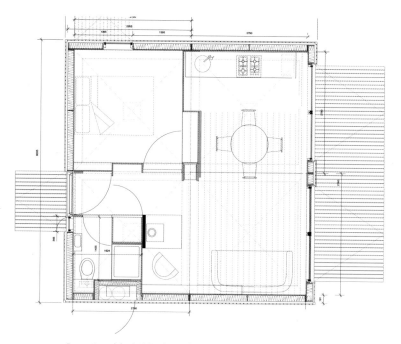

Four-unit modular building layout for Brockloch Farm

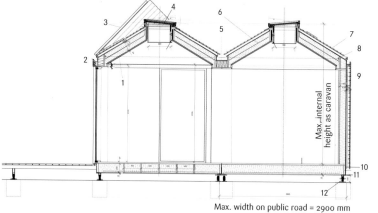

Max. internal height as caravan

Max. width on public road = 2900 mm

Section

1. 27 mm cross laminated board
2. VM zinc gutter
3. Solar PV
4. Roof light and glazing manually operated
5. Lacomet valley gutter
6. 200 mm sheep's wool insulation
7. Roof cladding to suit onto 45 x 45 treated SW battens; cladding to be made as pyramid off-site to drop over skylight
8. Solitex Plus breather paper to roof
9. 140 mm sheep's wool insulation
10. 200 x 35 Kerto ring beam
11. 100 x 150 x 6 galvanized steel angle ring beam
12. 150 mm adjustment on jack legs 5 degrees

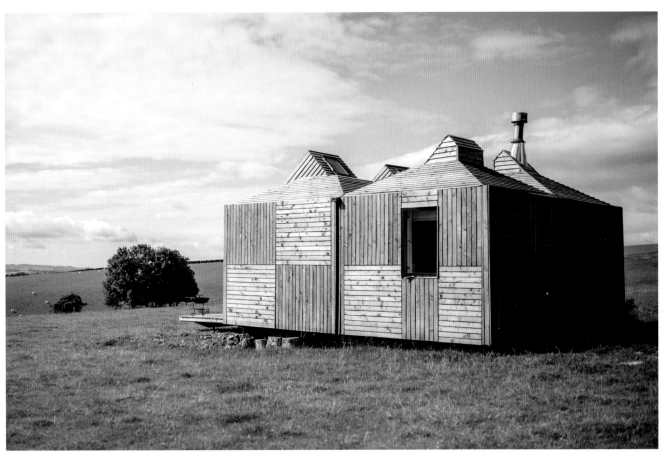

The modular system used for the construction of Brockloch Bothy is suitable for home offices, garden sheds, and holiday homes. A single module of ninety-seven square feet can be expanded according to different needs.

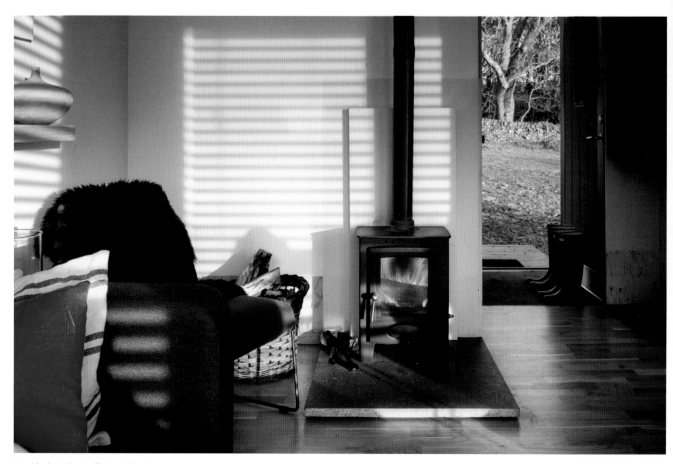

Brockloch Bothy is off the grid, with power generated by solar panels and heat provided by a wood-burning stove. No TV or Wi-Fi is on offer, but beautiful scenery abounds to engage guests.

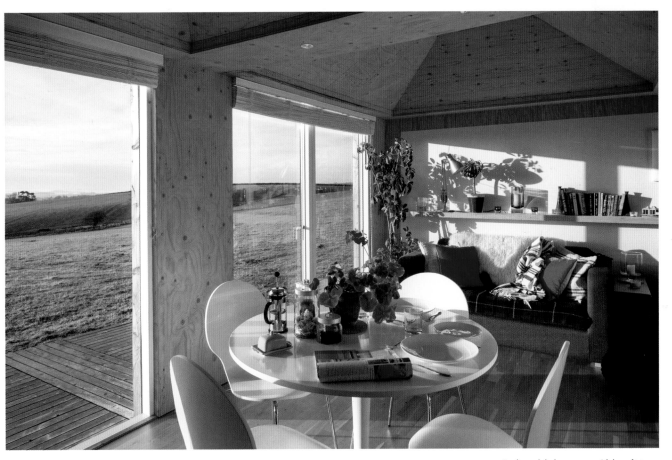

Each module has a pyramidal roof
with a skylight, contributing to passive
solar heating. Sheep's wool insulation
helps maintain thermal comfort.
These features are some of the green
specifications that make Brockloch
Bothy so unique.

023

A compact kitchenette is a smart feature in any small living space and particularly in seasonal homes. The choices in this arrangement cover the basic needs and maximize the kitchen space's efficiency.

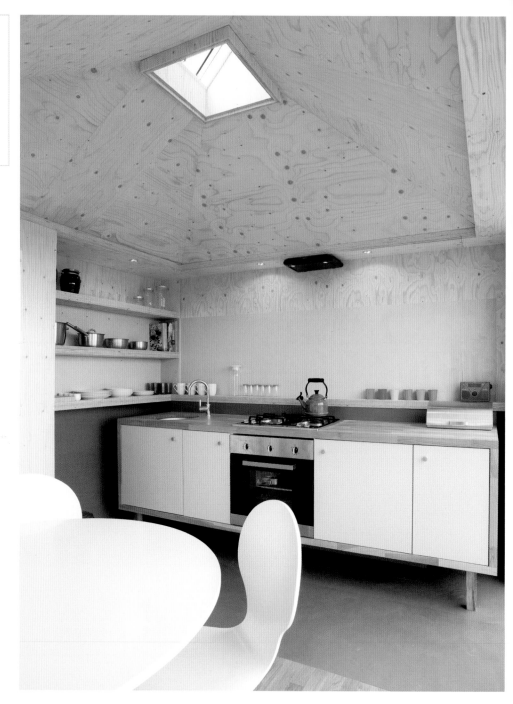

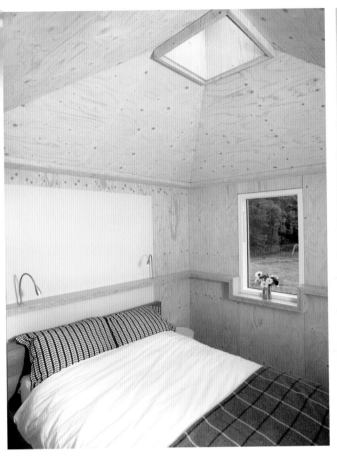

024

Off-grid homes require special design considerations, including gray water systems, black water systems, and specialty components to maintain a supply of running water off the grid and manage waste without a sewer hookup.

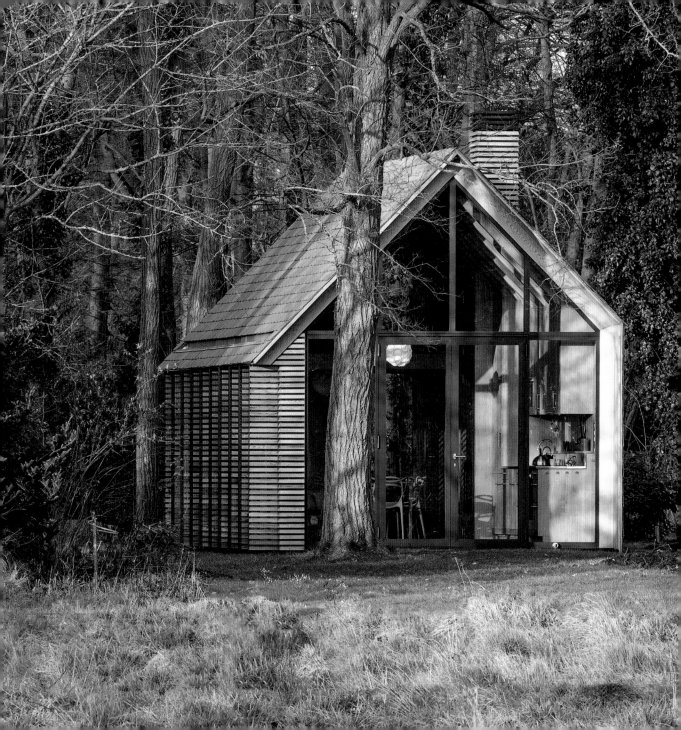

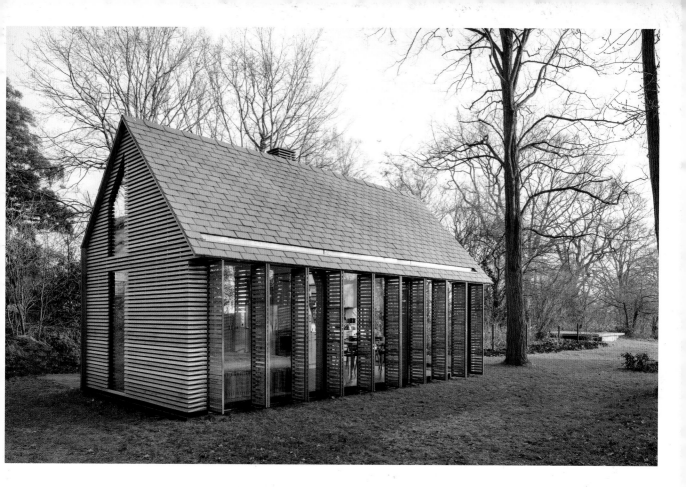

The recreational house replaces an existing garden shed in a rural area outside Utrecht. The foundation of the existing structure was reused and dictated the perimeter of the new construction, which incorporates the archetypal gable roofline. The use of natural materials contributes to the house blending in with the surrounding landscape. The indoor-outdoor connection varies according to the construction method, making walls completely opaque, or translucent, letting in filtered light and providing enough privacy without obstructing views of the outside.

Recreational House
323 sq ft

Zecc Architecten, Roel van Norel (Interior Designer)

Utrecht, the Netherlands

© Roel van Norel, Stijn Poelstra

025

An ordinary, typical construction can be made special with unique, well-thought-through architectural details. A creative use of materials can make all the difference.

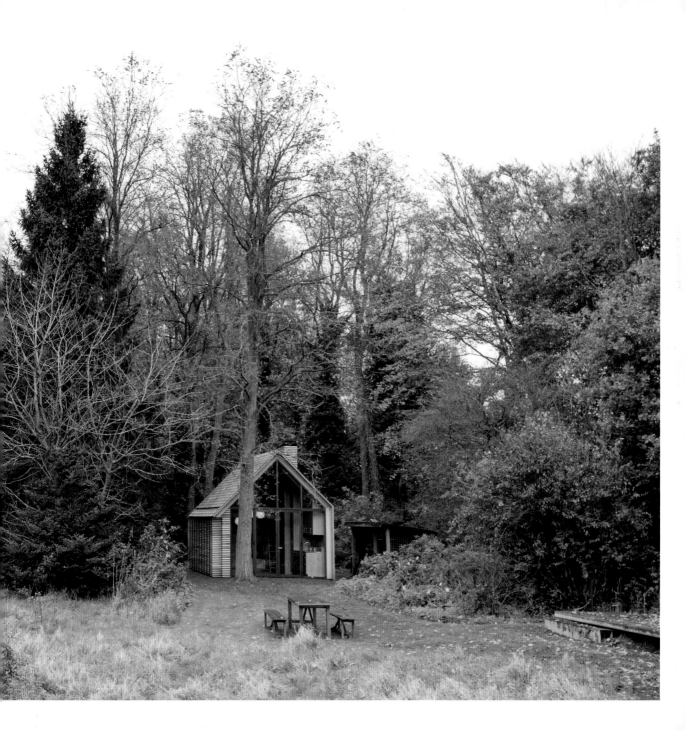

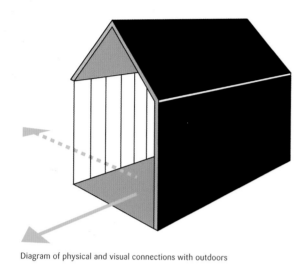

Diagram of physical and visual connections with outdoors

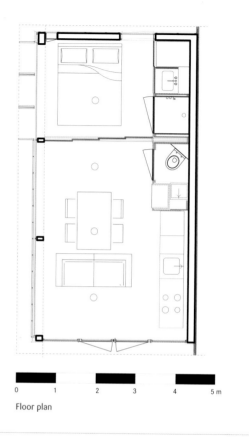

| 0 | 1 | 2 | 3 | 4 | 5 m |

Floor plan

The exterior treatment of the building provides different levels of privacy: one of the long walls facing neighboring houses is shingled and has no openings, while the front is entirely made of glass. The two other sides are a combination of glass and wood slats, providing privacy, but also letting in light.

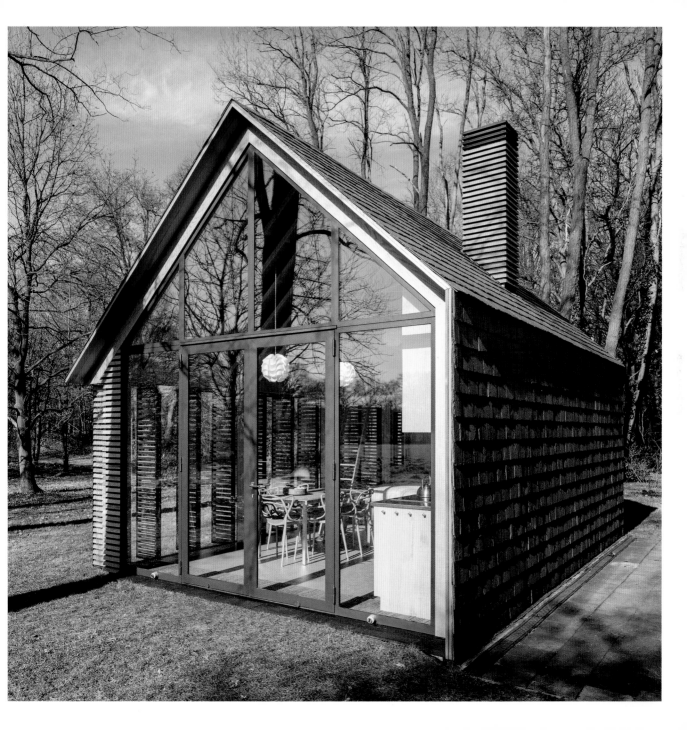

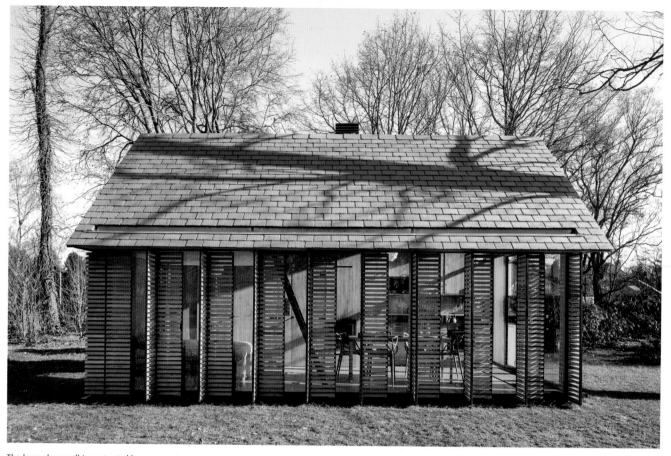

The long glass wall is protected by folding shutters that help control the amount of light reaching the interior. They also provide privacy when desired.

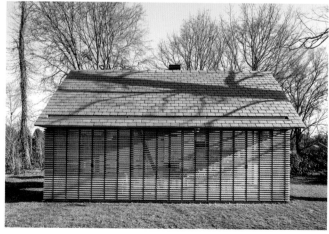

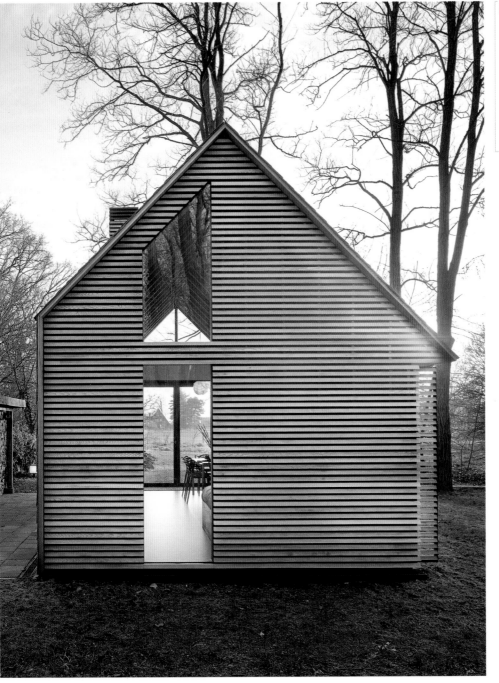

Wood-slatted shutters are an efficient light-control design feature. They also provide privacy without compromising the airy feel of an interior. These functional aspects are enhanced by the design appeal they give to a building.

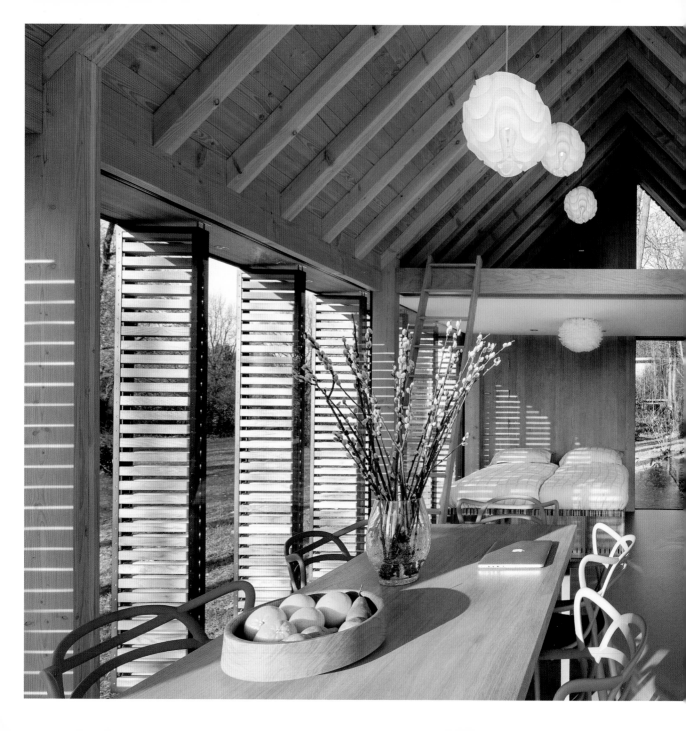

Optimize wall space by installing full-height cabinets and appliances. By putting wall space to work, you'll keep clutter away from the more airy, open parts of a home and gain space in compact living quarters.

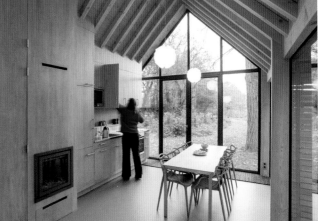

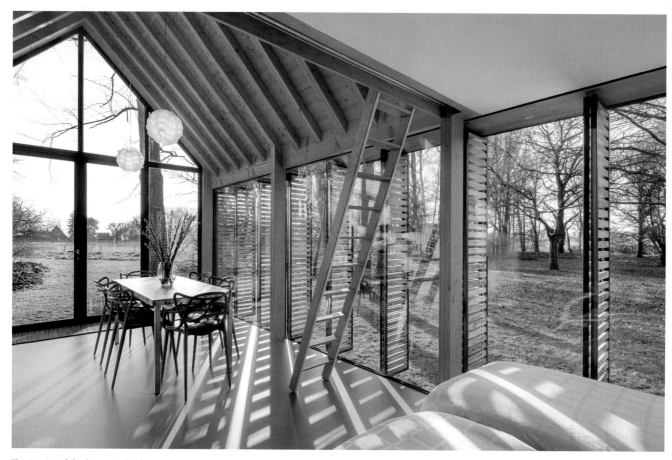

The interior of this house is clad in light cedar to complement the exterior finish. It focuses on comfort, making the most of the setting, views, and natural light, as well as an optimal use of the available interior space with the bare minimum furnishings.

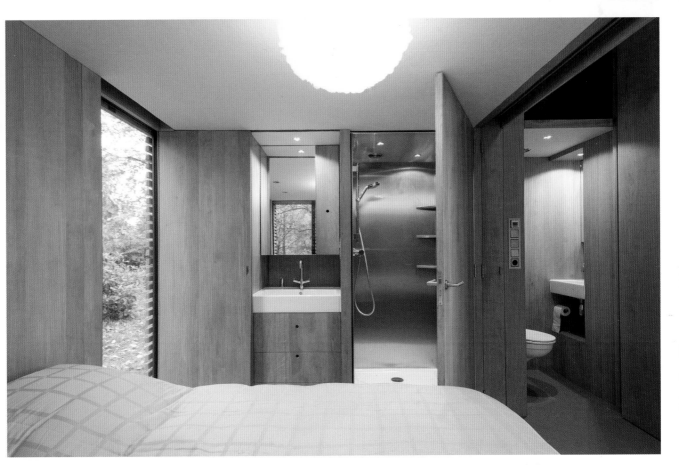

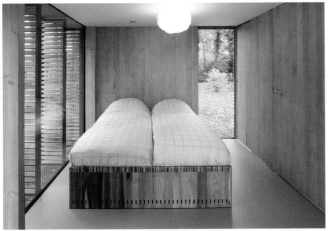

028

In compact spaces, enclosing each bathroom fixture in a separate compartment along one wall can clear some valuable space and allow their simultaneous use.

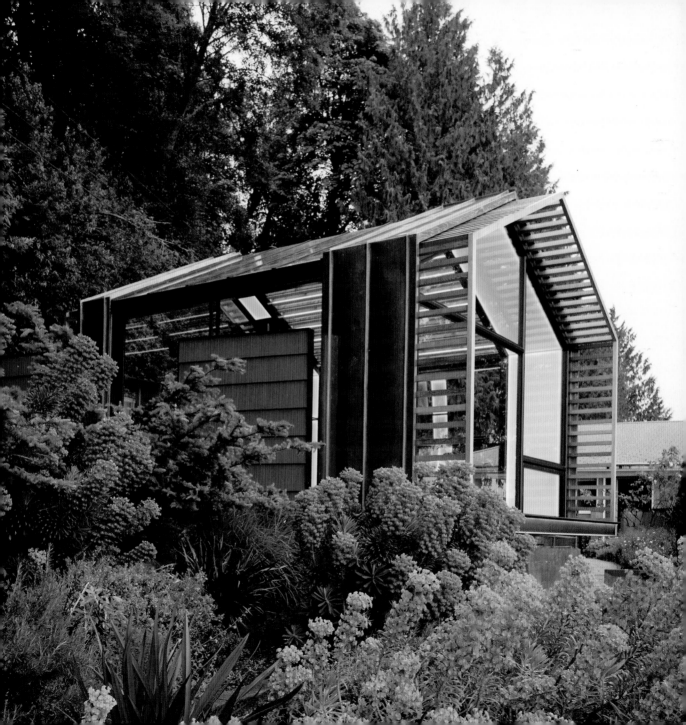

This project involved the restoration of a post-World War II structure. Despite being in serious disrepair, it was rich with stories. Work started with taking apart the structure. Then the materials were reclaimed and incorporated into the renovation. Reclaimed pine, a discarded basin, and a century-old stove evoked thoughts about those who had lived in the building before. This project was about the reuse of ordinary, old items to create an extraordinary space and an inspiring environment for new creations.

Garage
1,147 sq ft

Graypants

Vashon Island, Washington, United States

© Amos Morgan Photography

Copper cladding

Interactive LED panels

Poetic passage

Recessed bed + lounge

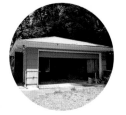

Original garage

Original fir construction

Conceptual design features

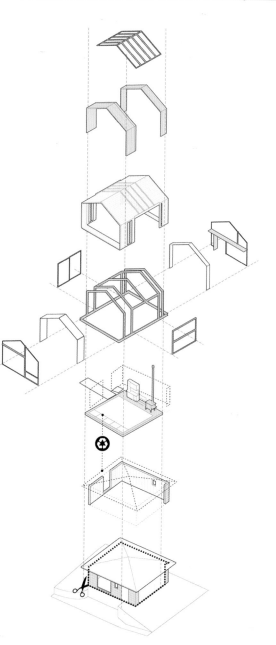

Exploded axonometric

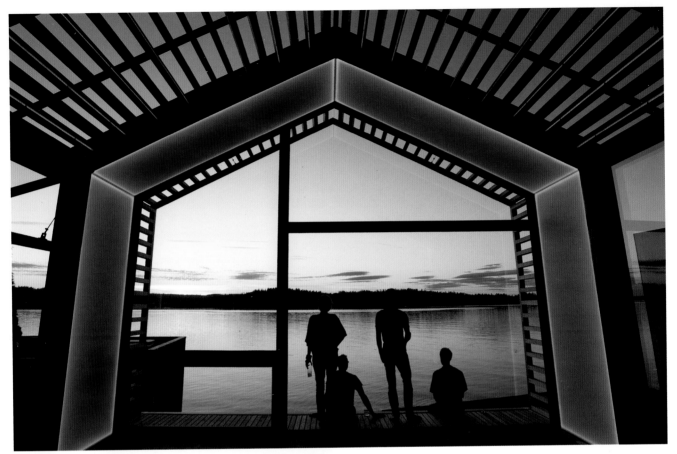

029

Consider a layout that provides enough flexibility to adapt to the different seasons and number of people to be accommodated. Sliding or retractable walls can achieve this goal, expanding usable space when the weather allows it.

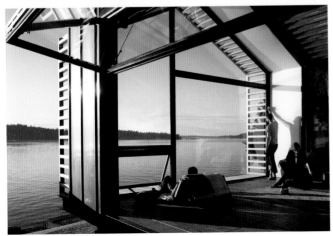

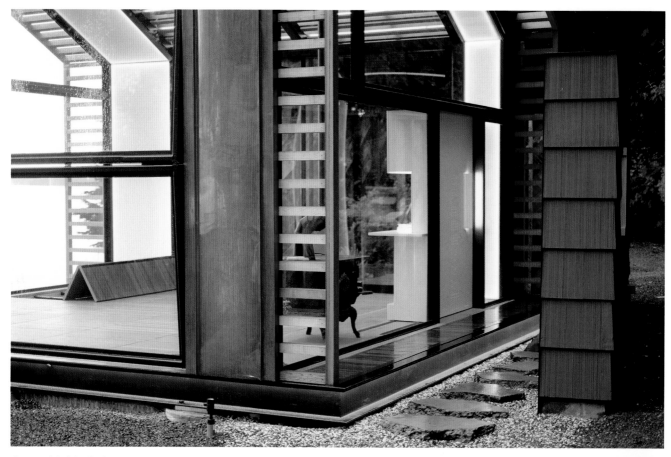

The remodel of the derelict garage explores the design possibilities of an old structure through a coherent dialog between existing and new materials. The garage has a second life with the implementation of passive sustainability and modern technology.

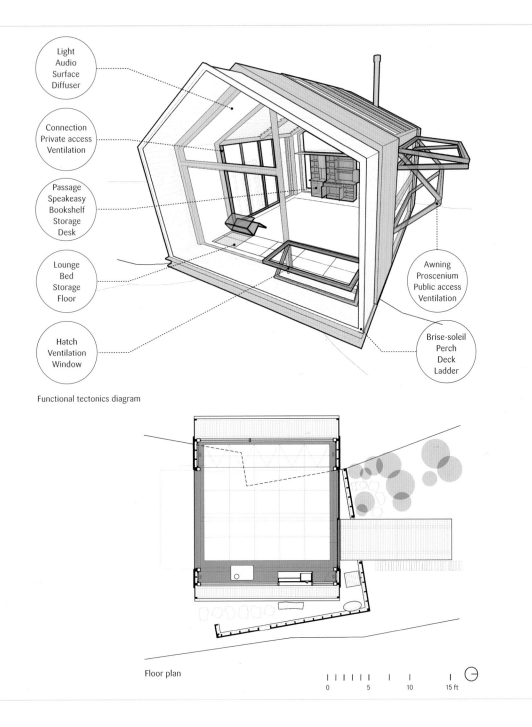

Light
Audio
Surface
Diffuser

Connection
Private access
Ventilation

Passage
Speakeasy
Bookshelf
Storage
Desk

Lounge
Bed
Storage
Floor

Hatch
Ventilation
Window

Awning
Proscenium
Public access
Ventilation

Brise-soleil
Perch
Deck
Ladder

Functional tectonics diagram

Floor plan

0 5 10 15 ft

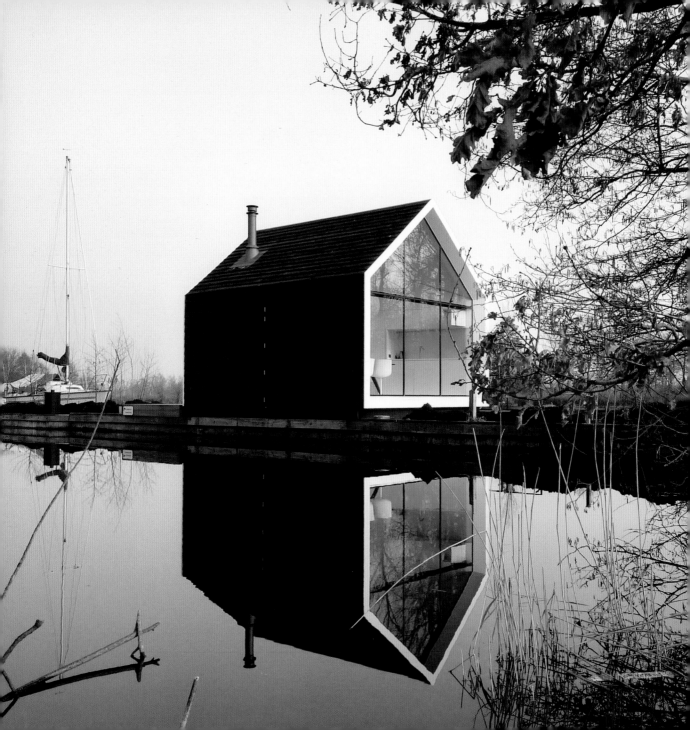

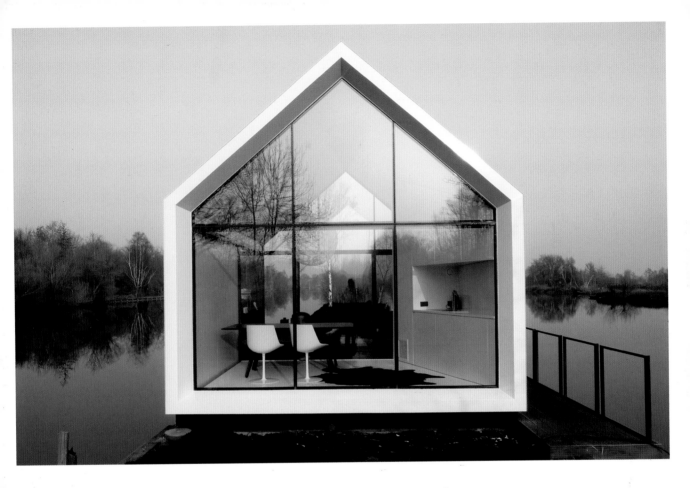

Located on an island of 16 x 330 feet in a lake area, the house is a frame that captures the views of the immediate and distant landscape. One of the glass façades can be completely opened so that the interior spills out onto the terrace, and one of the solid sides can fold open, offering a panoramic view of the surroundings and maximizing the sense of openness.

Recreational Island House
226 sq ft

2by4-architects

Breukelen, the Netherlands

© 2by4-architects

030

Exterior spaces compensate for the lack of ample interior spaces. Make the most of your patios, terraces, and balconies to open up your home—especially on warm, sunny days.

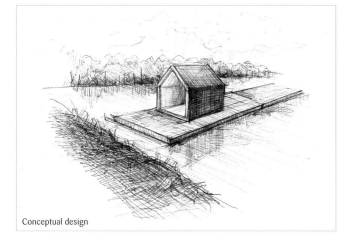

Conceptual design

Longitudinal section

The cabin experience starts well before being inside the pitched-roof structure. Access to the cabin is via an elevated jetty that leads to a terrace, which acts as the building's entry point.

Living spaces with a strong indoor-outdoor connection not only integrate better with the site, they also make the most of natural light and offer the possibility to enjoy additional living space.

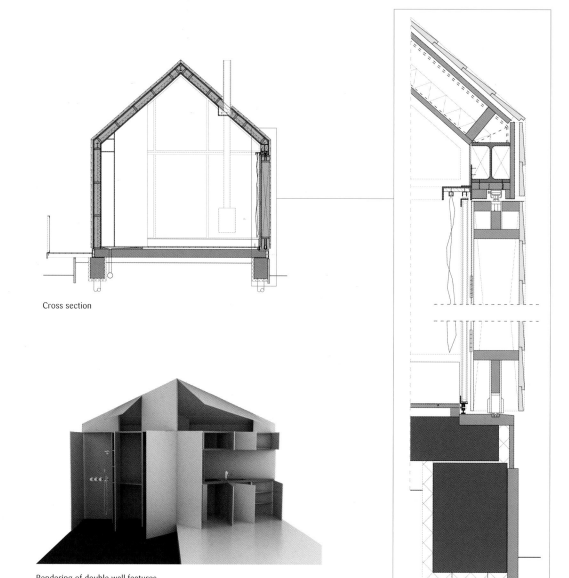

Cross section

Rendering of double wall features

Wall section detail

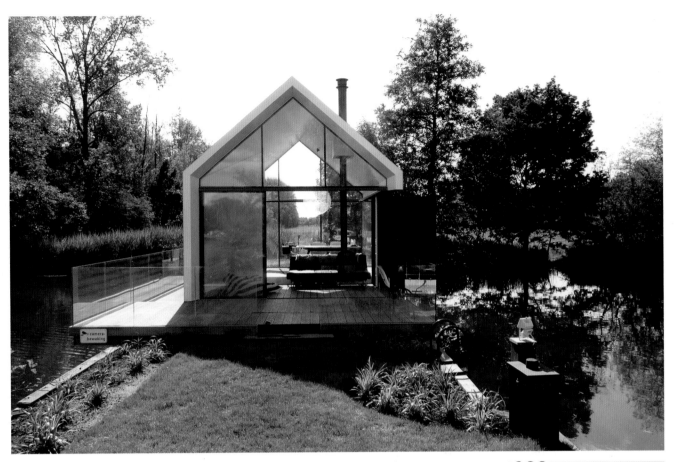

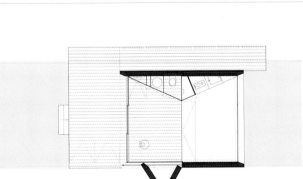

Floor plan

032

One inherent problem with building small is creating a space that has all the necessary amenities. The design of this floating cabin incorporates a compact double-wall feature that encloses a kitchen and a bathroom.

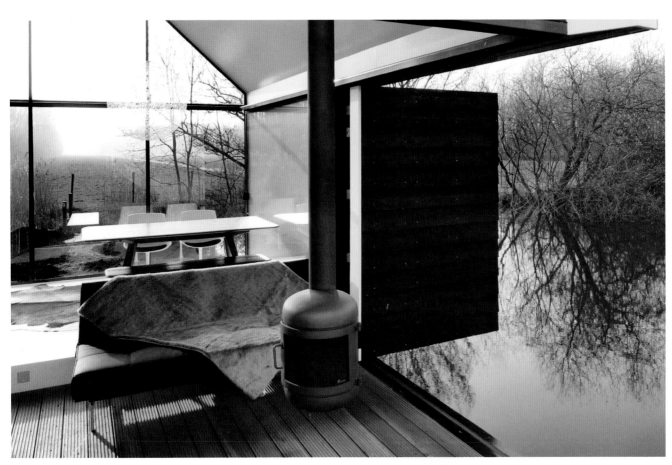

033

Hanging stoves don't take up valuable floor area in small spaces and add a stylish touch to contemporary interiors.

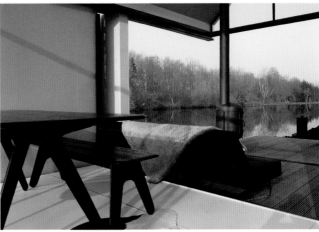

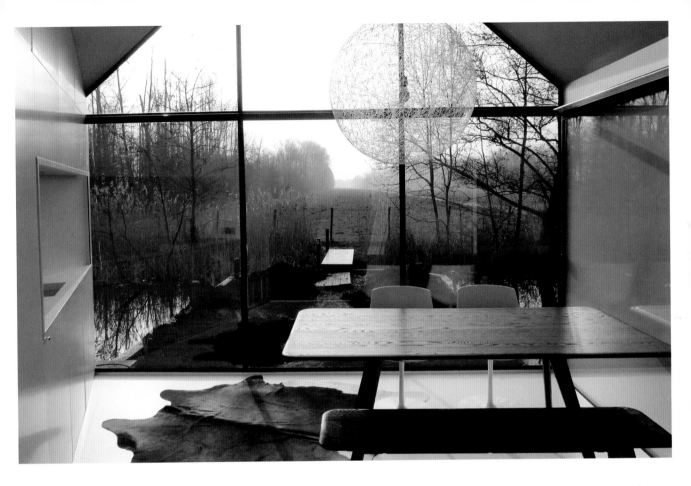

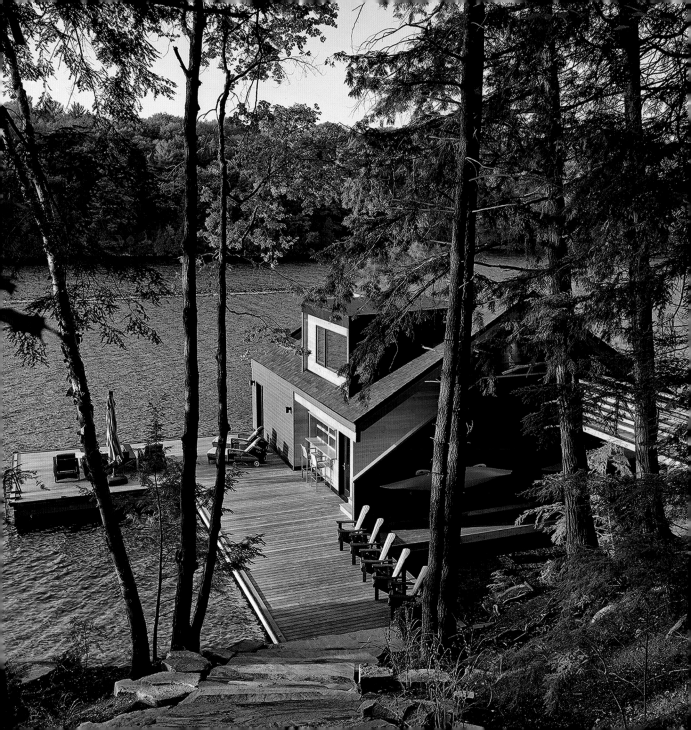

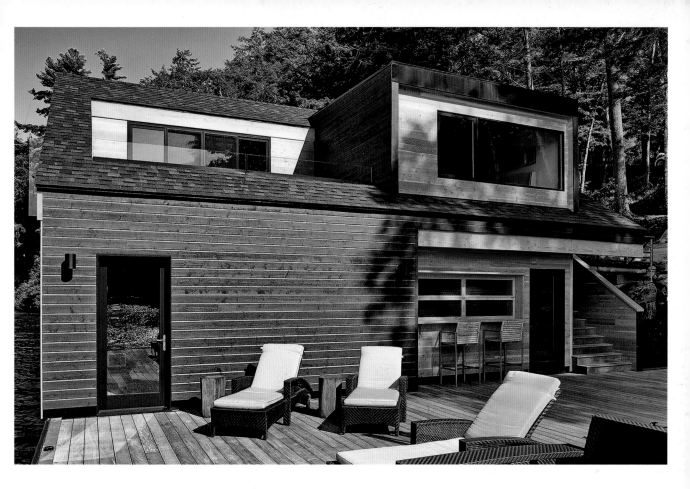

In a site-specific approach, this remarkable seasonal boathouse on the shore of Lake Joseph benefits from dynamic spatial qualities responding to the site conditions and to the occupants' desires. The zoning by-laws guided a complex design process involving building orientation, openings, sunlight, and materials. By the end of this process, two important programmatic requirements were met: views were directed toward desired locations along the lake and headroom was added by means of a dormer to create usable space below the roof.

Lake Joseph Boathouse
600 sq ft

Altius Architecture

Lake Joseph, Ontario, Canada

© Altius Architecture

DORMER ROOF SLOPED

DORMER ROOF SLOPED
DECK SMALLER

WALL PUSHED BACK TO LESSEN VISUAL IMPACT

MORE ROOF HERE TO EMPHASIZE EAVES AT FIRST STOREY

BOTH DORMERS LESS THAN 50% OF THE ROOF AREA

MAX 1M OVERHANG - NO COVERED DECK

Preliminary design sketch

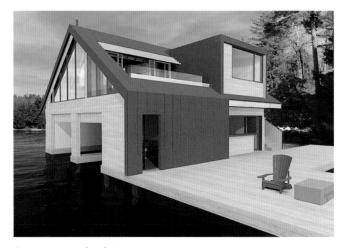

Computer generated rendering

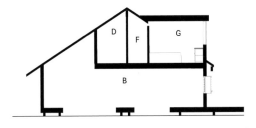

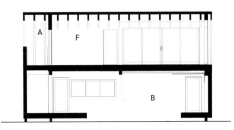

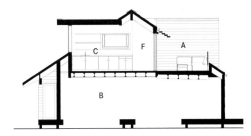

Sections

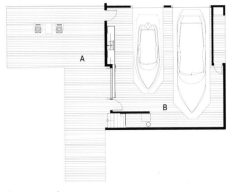

Boat garage plan

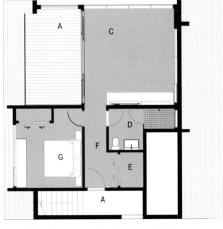

House floor plan

A. Deck	E. Utility
B. Boat garage	F. Hall
C. Living room	G. Bedroom
D. Bathroom	

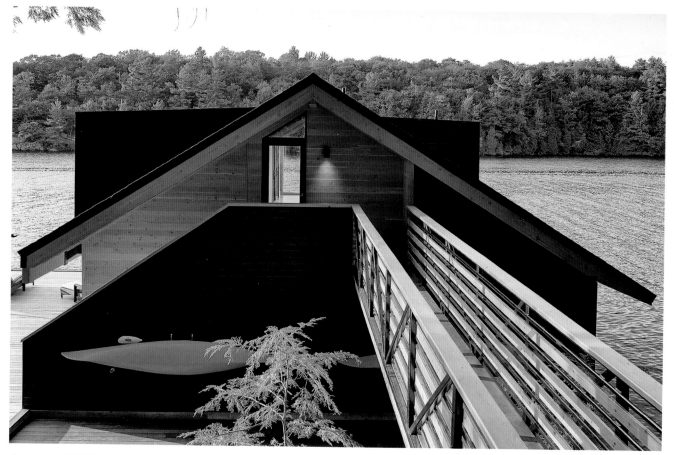

The elevations highlight how
contrasting materials play off
of each other. Openings like
the window here add texture
and enhance the dialogue
between building elements.

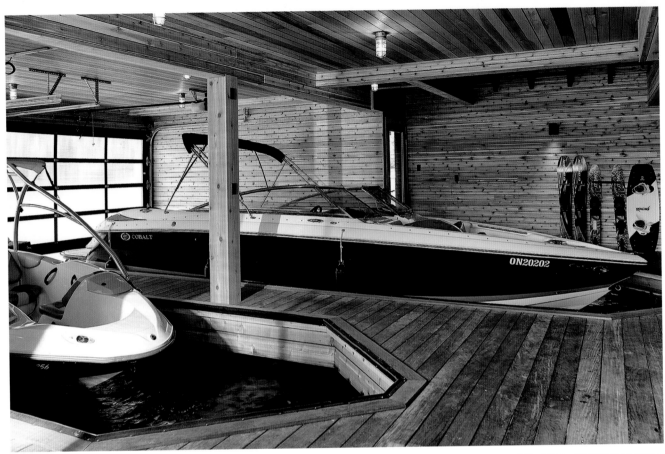

The detailing and the choice of wood as predominant material in the construction of boathouses make reference to the traditional language of marine architecture.

Exposed roof rafters play
a major role in creating bold
architectural accents.

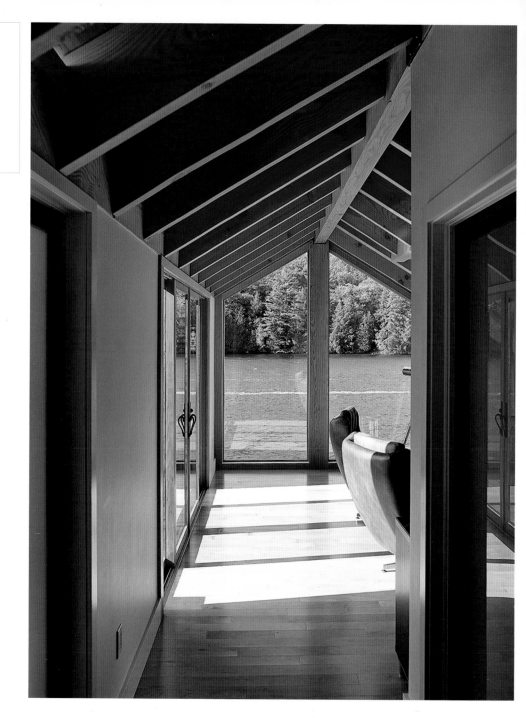

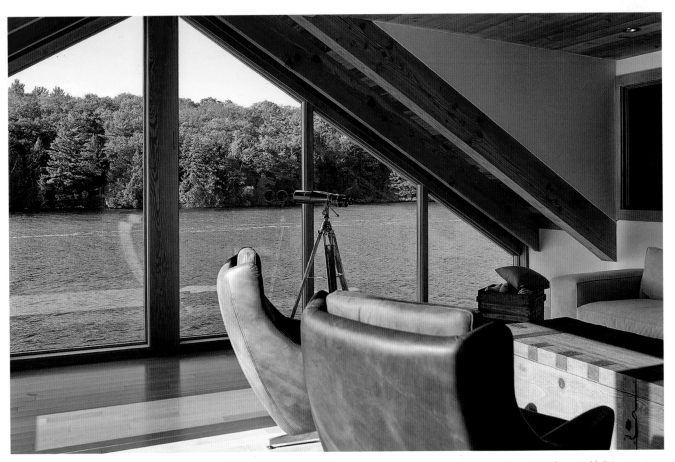

A spacious dormer adds living space on the second floor while creating visual balance with the deck on the same level.

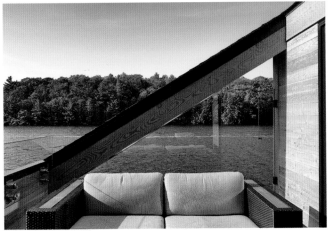

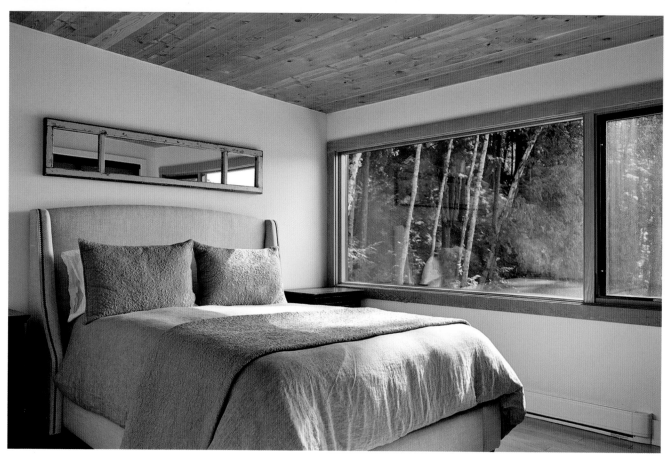

036

Large windows offer expansive views and bring in abundant light, countering the potentially cramped feeling caused by low ceilings.

037

Boathouses, like any seasonal homes, can be unoccupied for long periods of time. A simple design and robust construction will facilitate maintenance, especially in areas more vulnerable to leaks such as the kitchen and the bathroom.

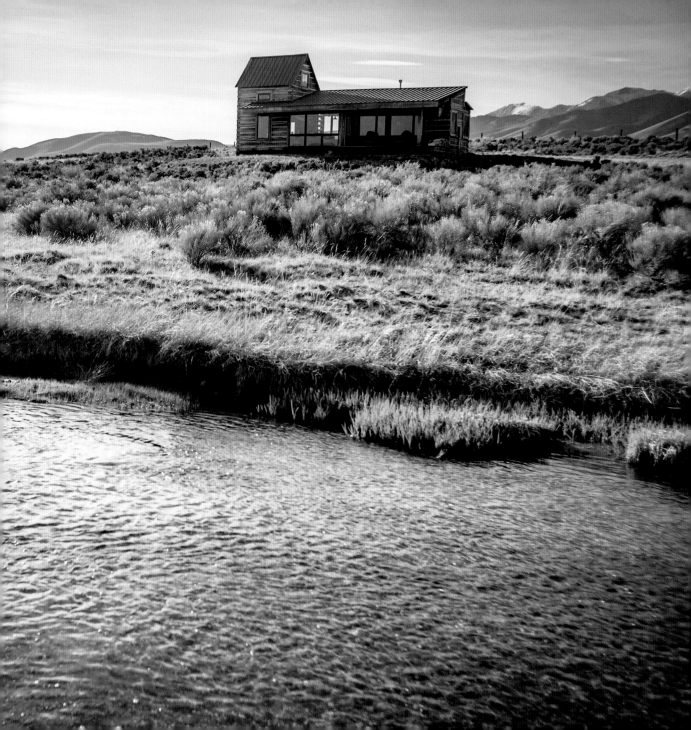

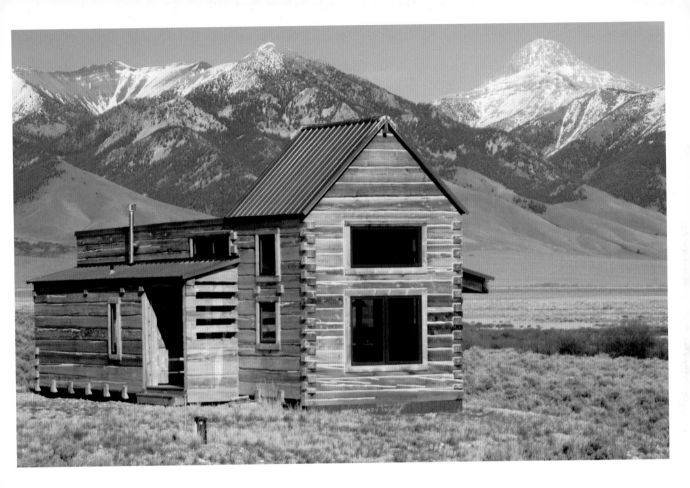

Little Lost Cabin is part of a much larger and important story about conservation and sustainable living in the landscapes of the American West. The cabin's construction was championed by Beartooth Capital, a for-profit conservation real estate fund committed to the restoration and preservation of important ranch properties. To address the lack of usable structures, the cabin was designed to make the ranch immediately functional. The oldest prefab design in the West, log construction, provided that approach.

Little Lost Cabin

690 sq ft

Clark Stevens, Architect / New West land Company

Clyde, Idaho, United States

© Michael Chilcoat, Brett Ziegler, Turner + Fitch

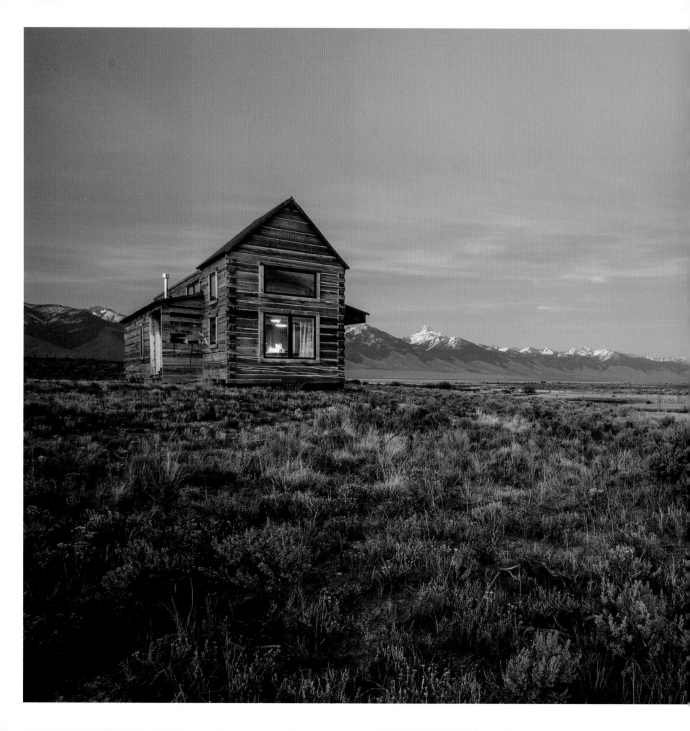

SketchUp models and Google Earth provided the 3D tools necessary to design a cabin that captures unique views from all angles.

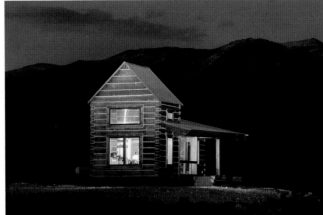

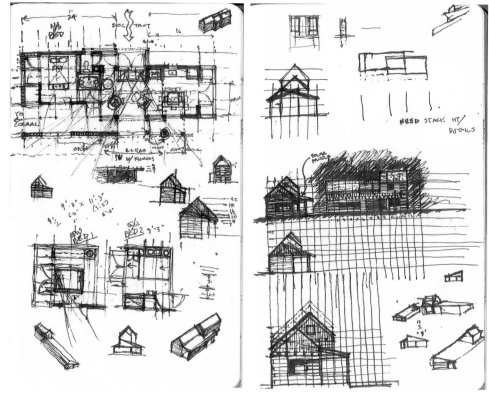

Preliminary sketches

038

Modern cabin design often takes after vernacular construction, whose principles are based on a building philosophy that adapts to local climate and culture as well as readily available materials.

Roof plan

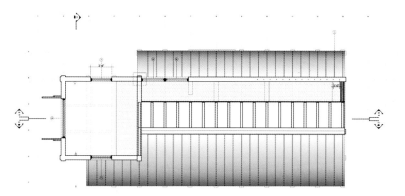

Loft floor plan

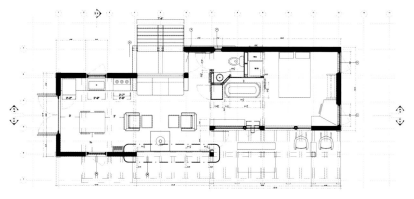

Ground floor plan

Northwest view

Northeast view

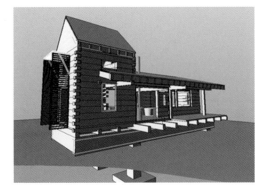

Southwest view

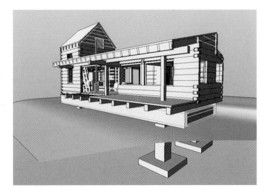

Southeast view

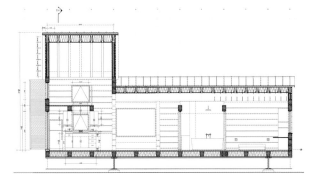

Section BB

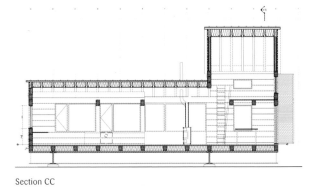

Section CC

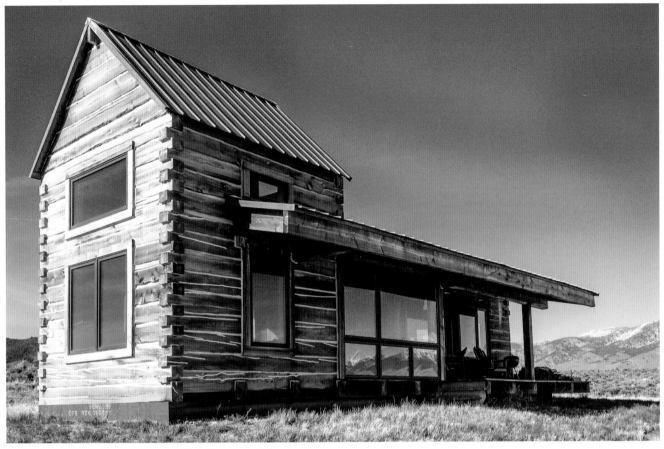

039

The base onto which a structure can be built—whether on piers or on a full foundation—is an important consideration. The type of soil and local regulations will determine which solution is suitable for the site.

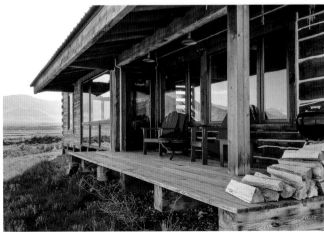

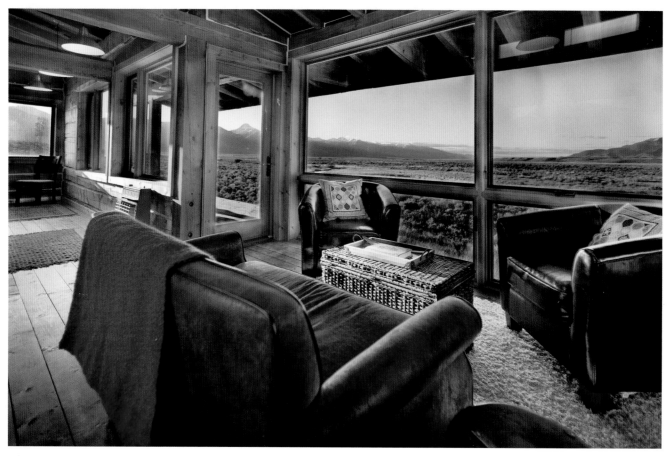

040

As part of a land conservation strategy, the design of the cabin called for local materials and skills, limited use of resources, and flexibility.

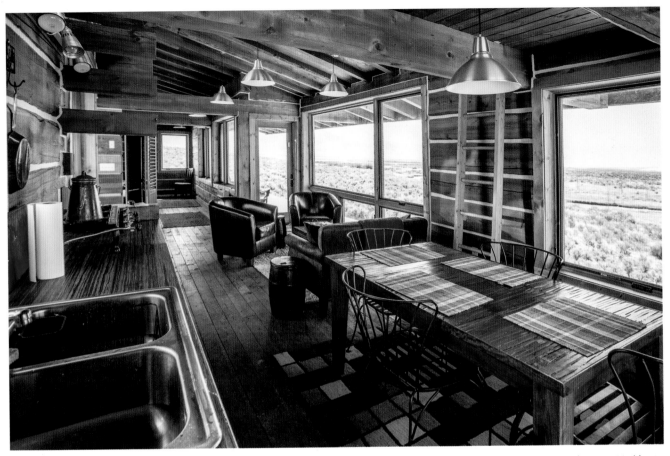

Spaces that can adapt are critical for rooms of reduced dimensions or no partitions. Different activities can take place in the same room with functional furniture that can multitask.

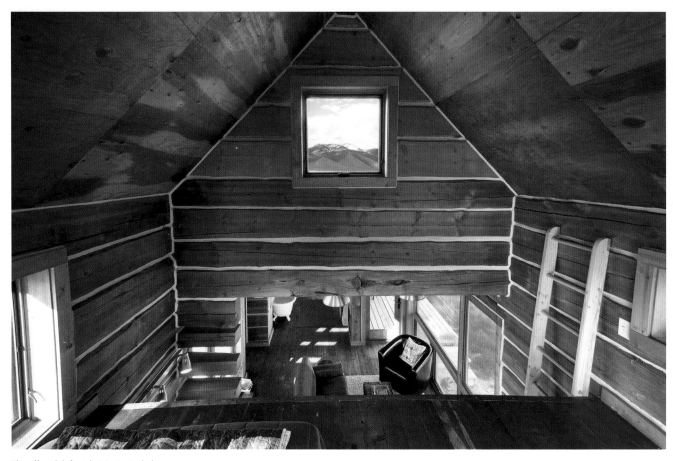

The off-grid, loft-style interior includes a
small kitchen with camp stove, a master
suite and central bathing location, and a
guest loft with unique views of its own.

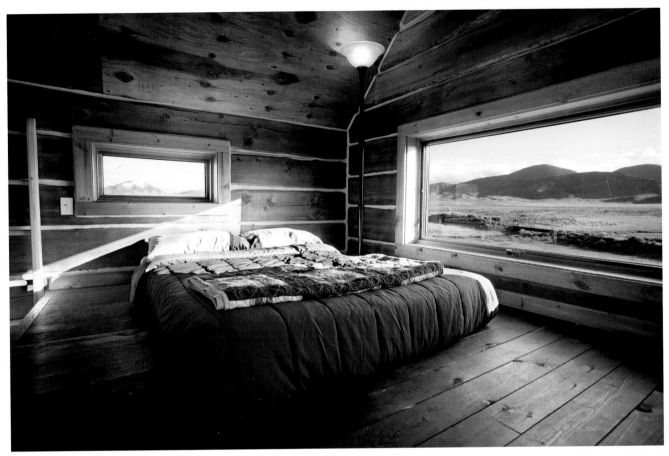

041

Square log cabins are a sophisticated version of the traditional log cabin. Their construction is labor intensive because the logs need to be hewn. But this technique minimizes gaps between logs, improving insulation.

Section 1

Section 2

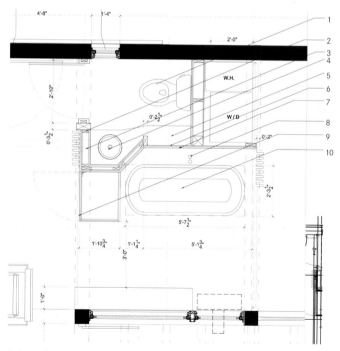

Bathroom floor plan

Bath elevation

1. Kohler-3432-U toilet Wellworth elongated
2. 2 x 4 framing
3. J-box location
4. Kohler-2610-MU Bolero round lavatory
5. ¾" Neopolitan plyboo shelving
6. ½" Homasote

7. ⅝" ply strips (each 11" high)
8. Bath plumbing through floor
9. Steel curtain rods
10. Rolled rim tub (skirted Piedmont, 67½" x 27½" x 27")

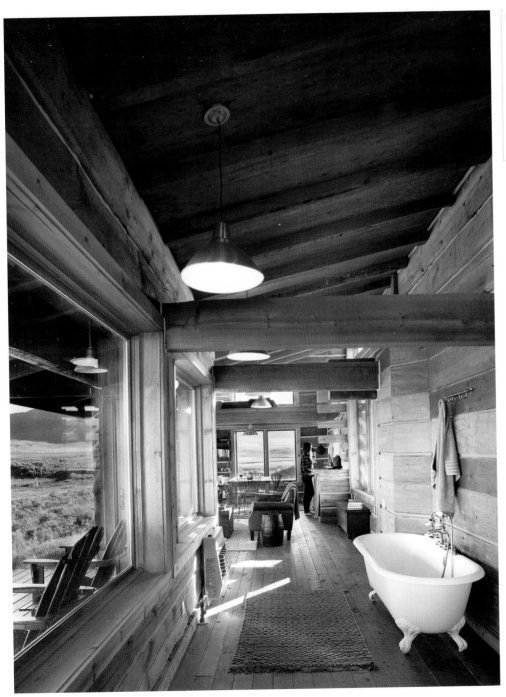

A thin interior partition system of Homasote and plywood "log" strips saves critical space, optimizing the cabin's built space, while helping to limit the structure's footprint.

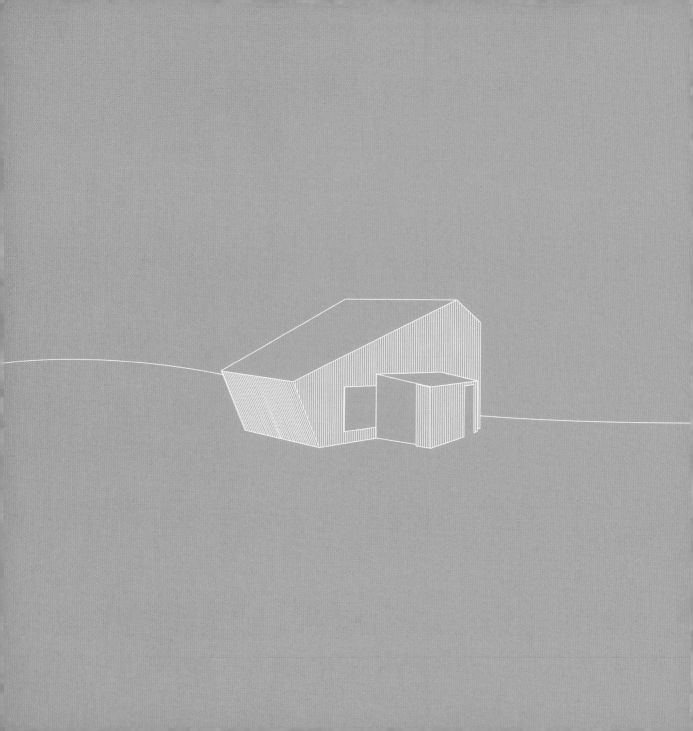

Shed and Saltbox Roofs

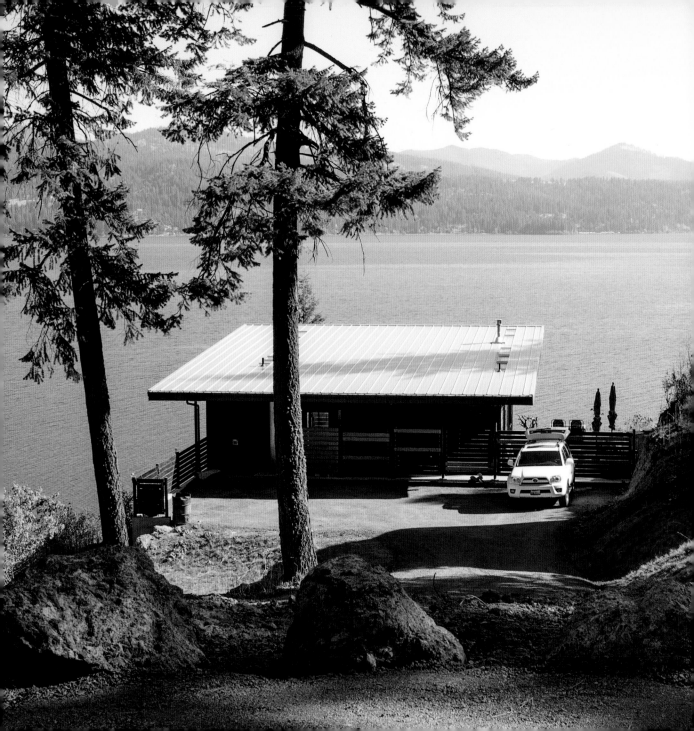

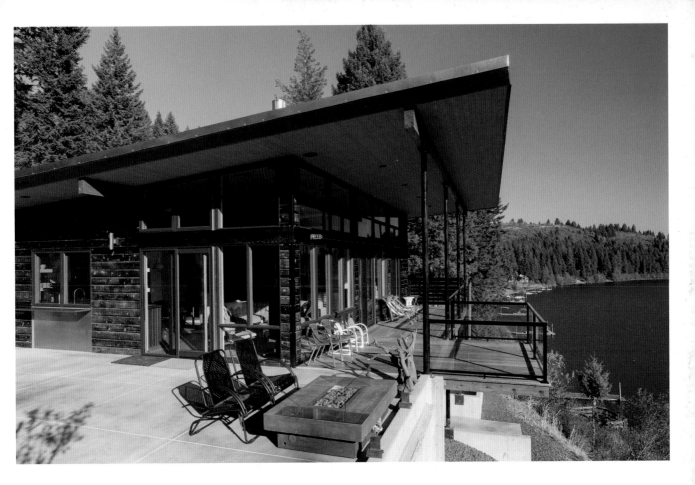

Camp Hammer is located on a scenic hillside overlooking Lake Coeur d'Alene, part of the Idaho Panhandle. The building's site starts at the edge of the forest and ends with a 125-foot drop to the lake. While the lot offers stunning views, it's long and narrow, with more than half of the land unsuitable for construction. These restrictions, in conjunction with the owner's desire for a minimal footprint, required a design that would maximize efficiency of the site and the interior spaces.

Hammer Cabin

1,500 sq ft

Uptic Studios

Lake Coeur d'Alene, Idaho, United States

© Larry Conboy Photography

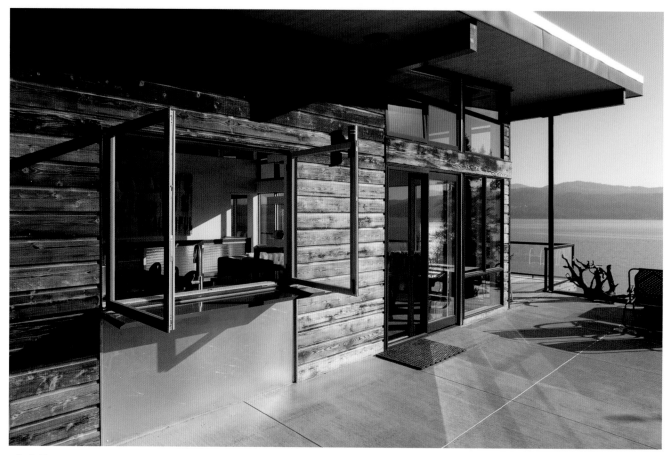

043

Spaces outside generally need protection from the wind and the sun. Sheltering devices such as a fence and a lean-to roof can extend the space's outdoor season.

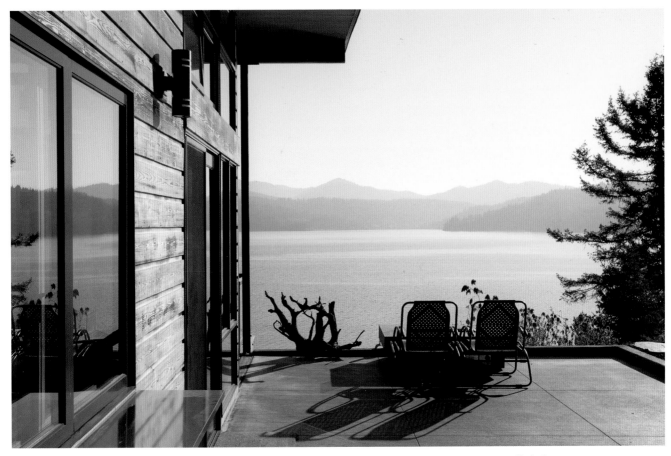

044

Higher elevations may benefit from long, unobstructed views, but they are also more exposed to the elements. When planning where to build, consider the region's climate as well as the sun exposure and the wind patterns.

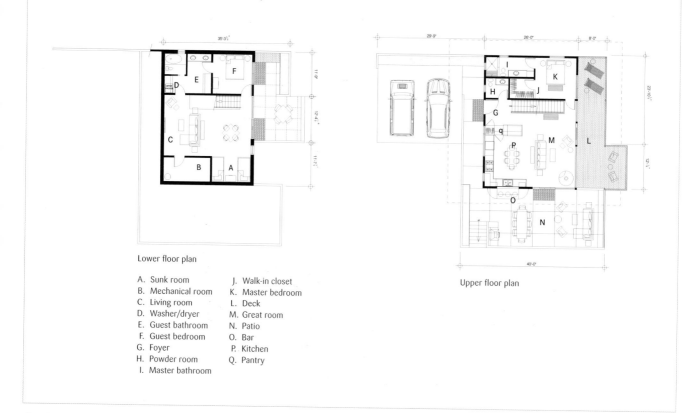

Lower floor plan

A. Sunk room
B. Mechanical room
C. Living room
D. Washer/dryer
E. Guest bathroom
F. Guest bedroom
G. Foyer
H. Powder room
I. Master bathroom
J. Walk-in closet
K. Master bedroom
L. Deck
M. Great room
N. Patio
O. Bar
P. Kitchen
Q. Pantry

Upper floor plan

The cabin's design approach is translated
into a language that reflects the harsh
environmental conditions of the region
and the topography of the site.

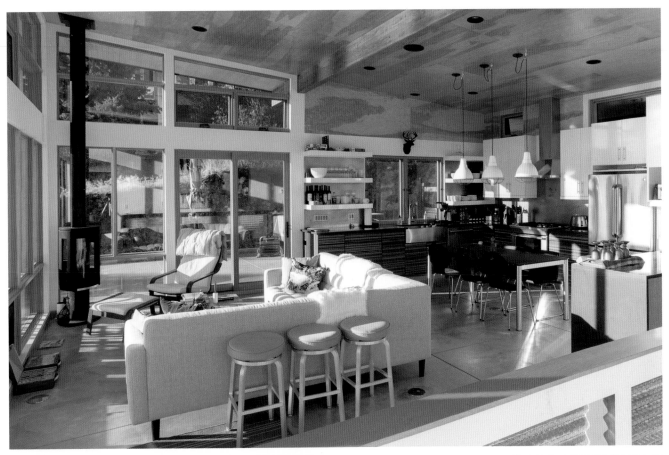

045

Industrial finishes such as concrete floors, plywood paneling, and steel details can be left unfinished, letting them age naturally over time to acquire a patina that harmonizes with a natural setting.

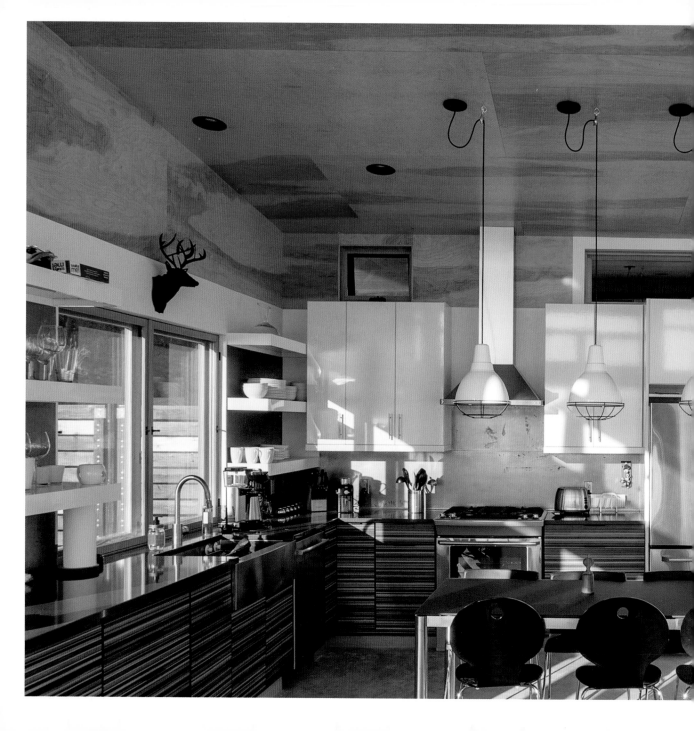

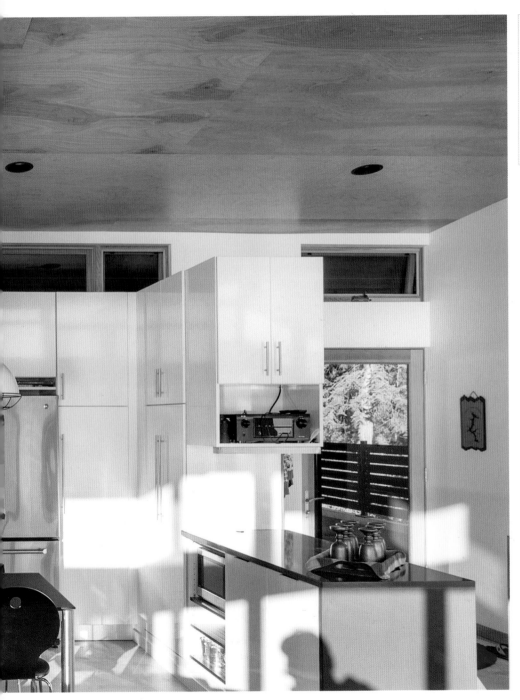

An efficient kitchen is just as desirable in a cabin as it is in a regular residence. The key is to facilitate tasks so that leisure can be a priority. But don't disregard styling! It's likely that your cabin's kitchen will be visible from the main room.

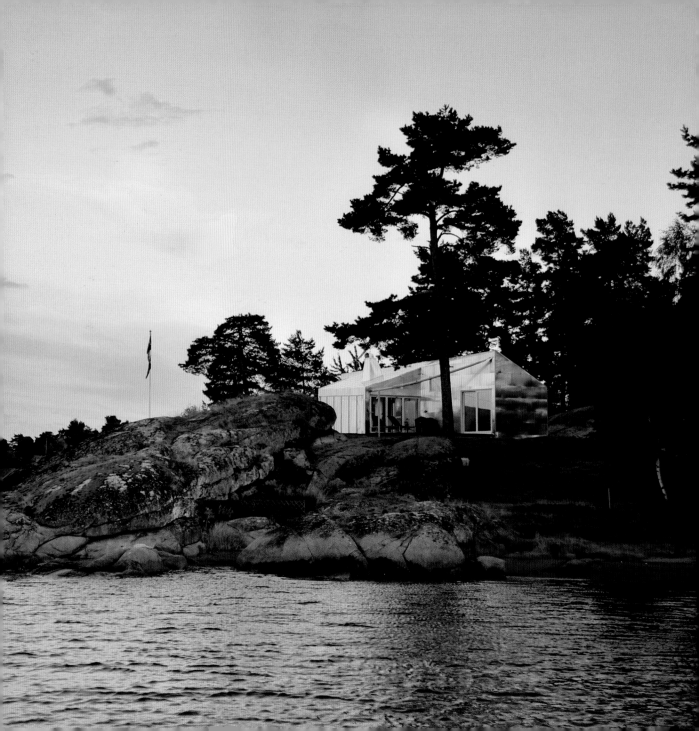

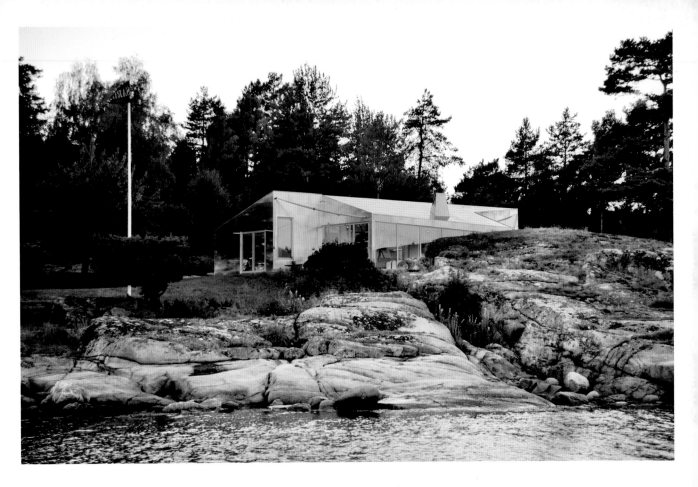

Situated in a beautiful archipelago, this eye-catching waterside cabin replaces a dilapidated and impractical structure. The restrictive planning and zoning regulations of the area dictated the scale and size of the new building. The design adapts to the specifics of the site and the climate conditions. Its irregular shape and varied elevations almost seem to echo the surrounding rocky outcrops. The distinctive exterior aluminum cladding catches light and reflects the changing weather conditions, helping to erase the boundaries between a built structure and its setting.

Aluminum Cabin
969 sq ft

Jarmund/Vigsnæs AS Arkitekter
Vestfold, Norway
© Nils, Petter Dale

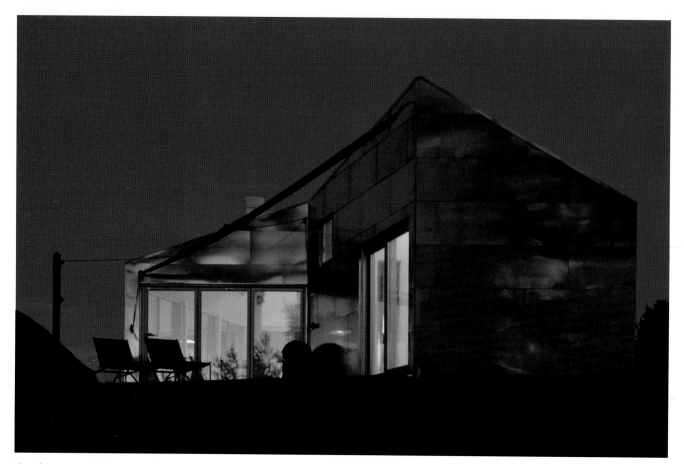

The cabin merges with the surroundings thanks to its metallic cladding, which reflects the colors and the light through the day and seasons.

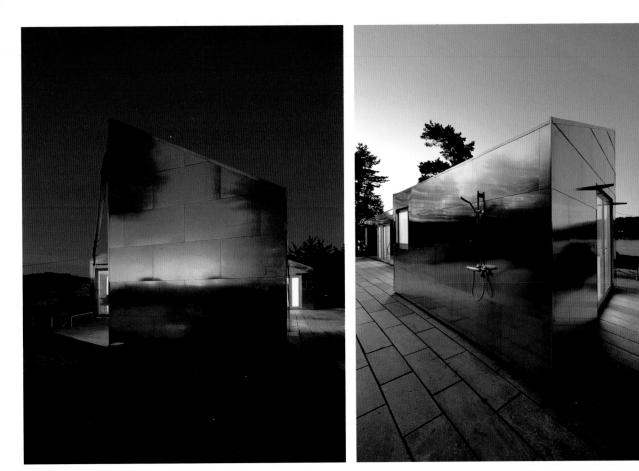

047

Coastal environments require great attention to moisture-management strategies. Corrosion-resistant materials and finishes—especially those applied to the outside of a building—are critical to minimize moisture damage.

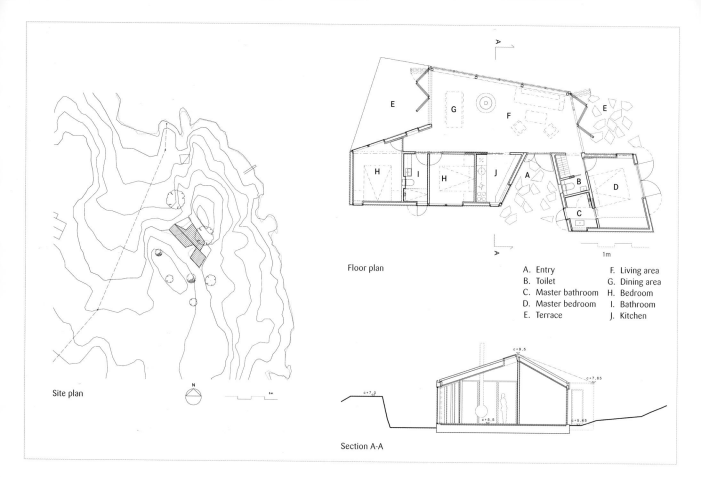

Site plan

Floor plan

N

1m

A. Entry
B. Toilet
C. Master bathroom
D. Master bedroom
E. Terrace

F. Living area
G. Dining area
H. Bedroom
I. Bathroom
J. Kitchen

Section A-A

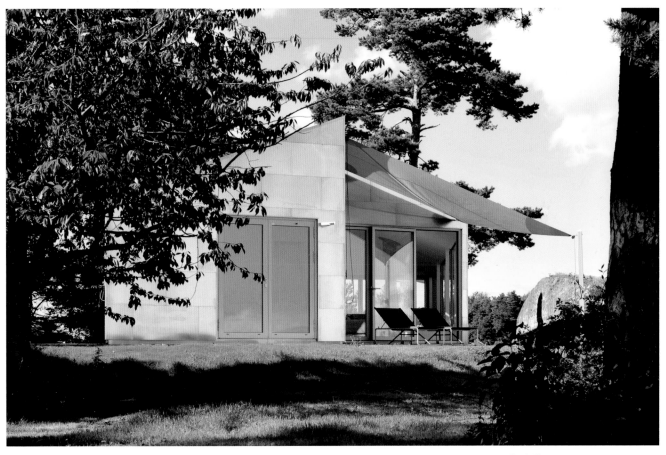

048

If you don't want a permanent overhang in your outdoor space, a simple shade sail is an effective solution. Don't forget to consider the angle of the sun and where the shadow will be.

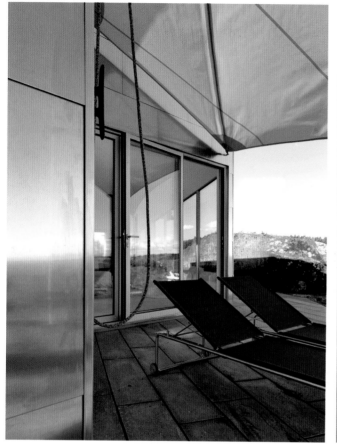

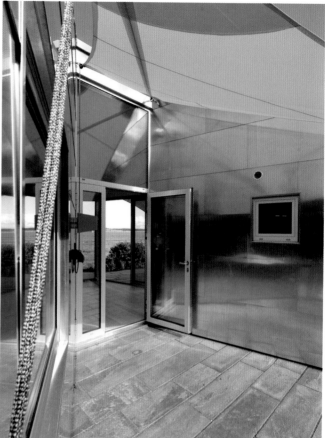

The layout of the Aluminum Cabin features three separate modules: the living area, the master suite, and the bedrooms and kitchen module. They are articulated by the entry and two terraces fitted with temporary shading devices.

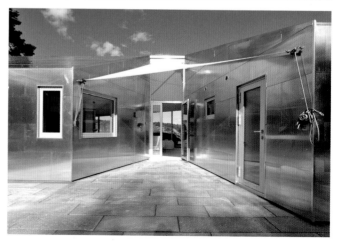

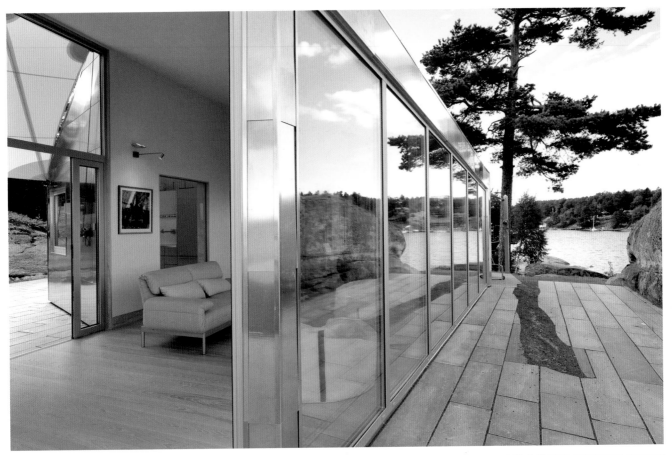

In the living area, opposite walls fold open to create a semiopen space that facilitates cross ventilation.

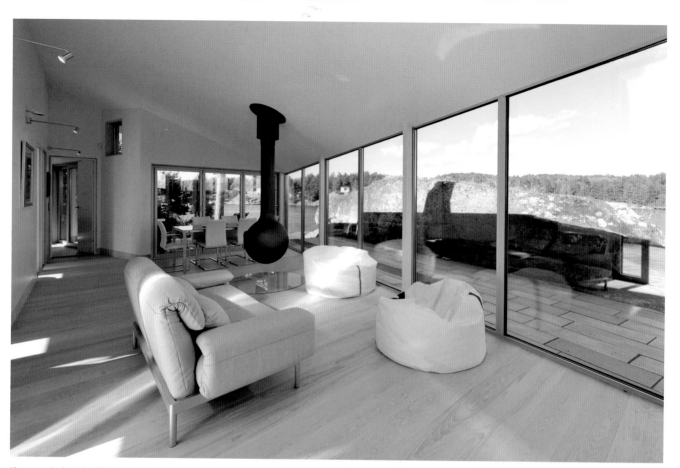

The sparsely furnished living area and the selection of natural colors pair with the large spans of glass. This minimalistic design allows the natural setting to be the focus of anybody in the room.

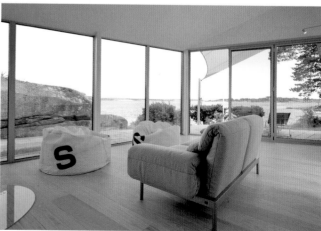

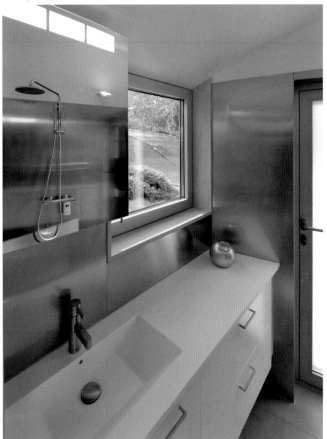

050

The soothing effect of white surfaces and airy feel that openings provide make a living space serene and cool.

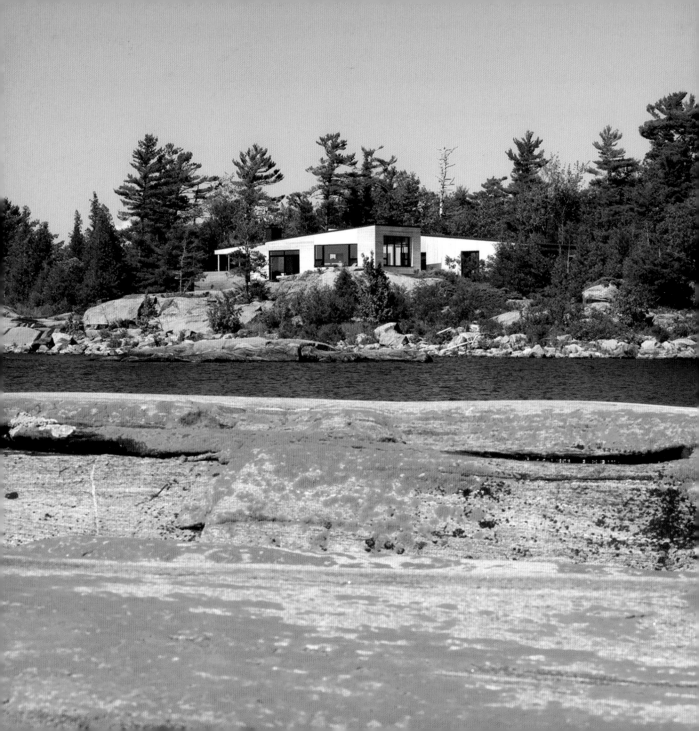

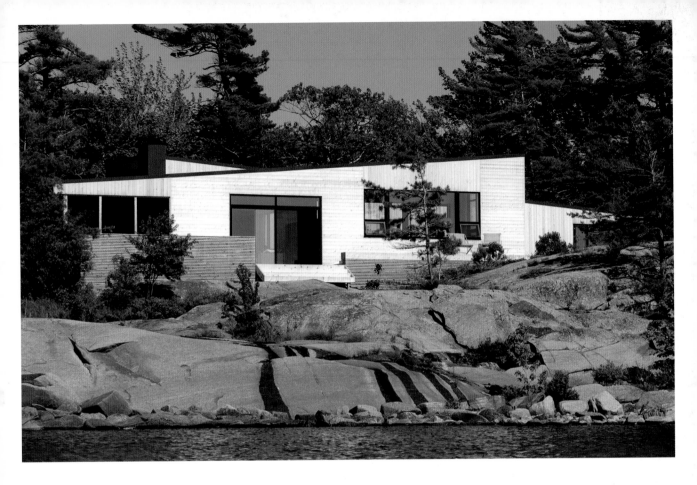

The site for SHIFT Cottage was chosen for its topography and orientation. Its location between a forested area and a rocky outcropping protects the cabin from the winds off a nearby lake. The low profile of the construction and its shape were designed so as not to compete with the surrounding landscape, but rather to highlight its unique beauty. A series of stepped decks gird the structure, easing its integration into the natural setting while facilitating access.

SHIFT Cottage

2,000 sq ft

superkül

Georgian Bay, Ontario, Canada

© Tom Arban

Site diagram

Massing diagram

Emplacement diagram

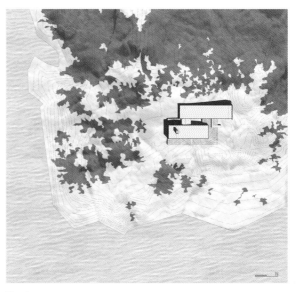

Site plan

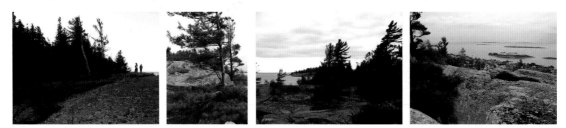

Site images

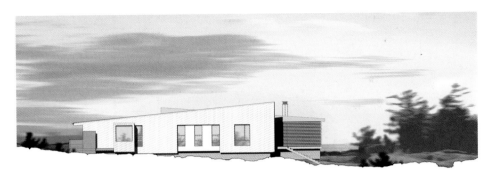

East elevation

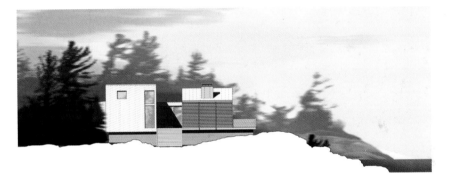

North elevation

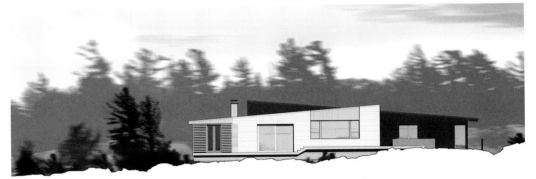

West elevation

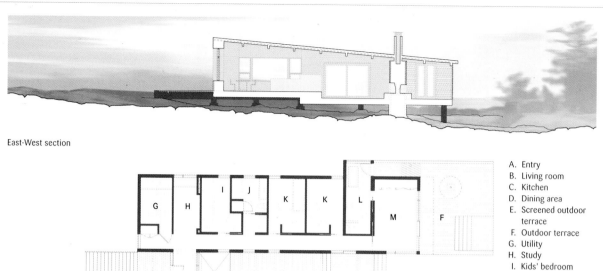

East-West section

A. Entry
B. Living room
C. Kitchen
D. Dining area
E. Screened outdoor
 terrace
F. Outdoor terrace
G. Utility
H. Study
I. Kids' bedroom
J. Bathroom
K. Bedroom
L. Master bathroom
M. Master bedroom

0 1 2 5 m

Floor plan

051

Let natural features guide
your design to create a
building that is respectful to
the environment. Also take into
consideration sun exposure,
prevailing winds, and other
meteorological variables that
could affect the design.

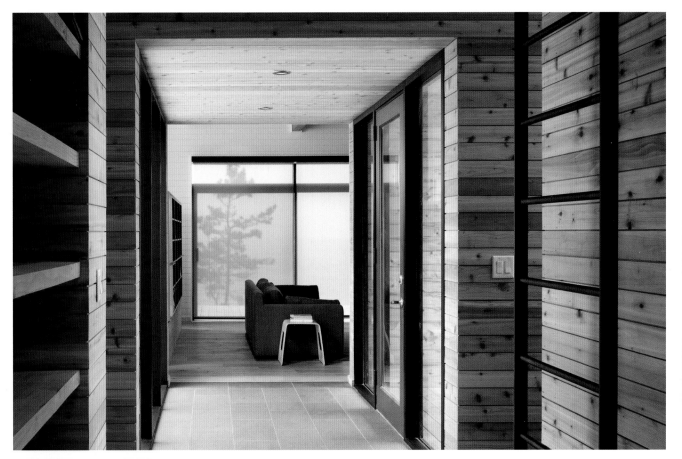

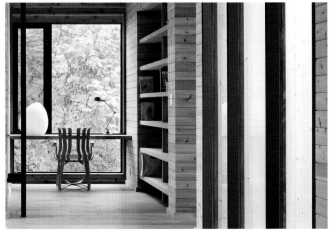

The limited selection of materials, which include cedar cladding, metal roofing, and stone, reinforces the simplicity of the building, while the horizontal cedar siding, both on the exterior and the interior, emphasizes the low proportions.

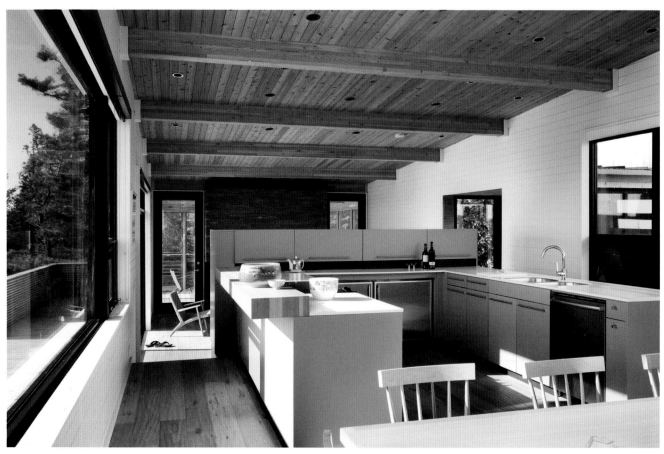

052

Position buildings and orient rooms strategically in order to frame views and take full advantage of sun exposure.

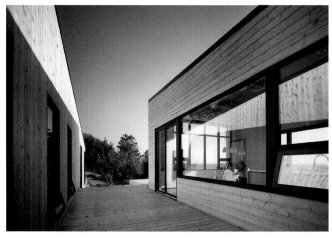

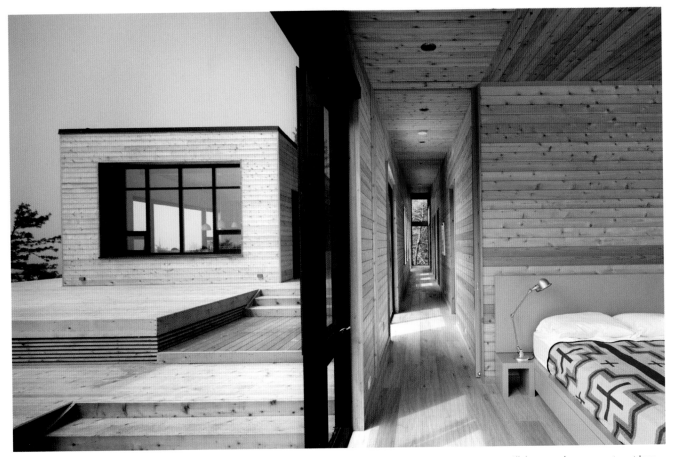

All the rooms have access to outdoor terraces facing different directions, allowing comfortable daytime activities in an area that is otherwise characterized by a rough terrain.

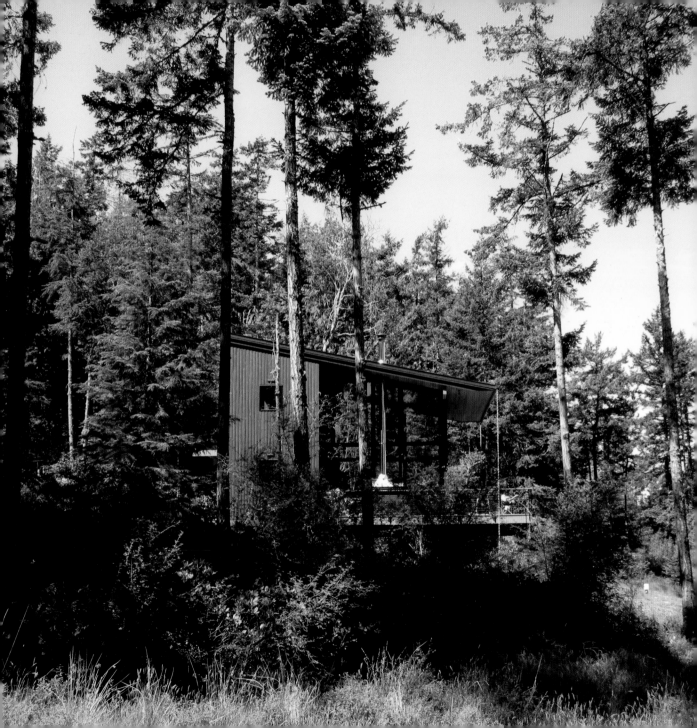

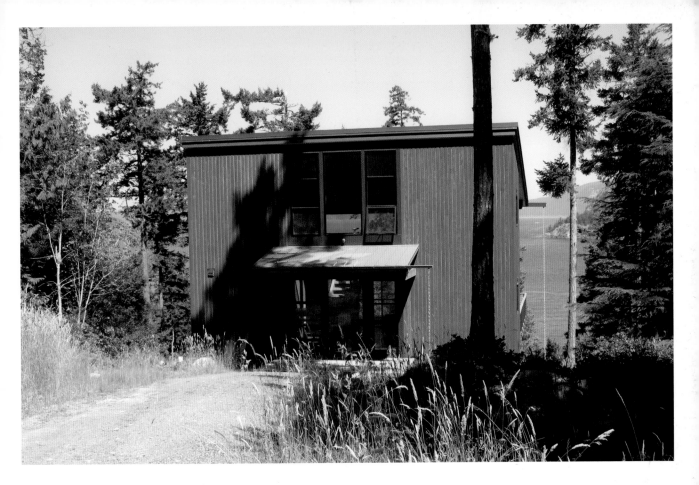

This cabin is designed as two contrasting forms, one transparent, and the other solid. One form is a cantilevering glass box containing the living area, which is conceived as a sheltered porch that opens to a large deck wrapping around three sides. The solid two-story rectangular form contains the bedrooms and service areas. A large shed roof ties the two forms together and extends over the deck for protection from the elements.

Decatur Cabin

1,200 sq ft

Balance Associates Architects

Decatur Island, Washington, United States

© Steve Keating

North elevation

East elevation

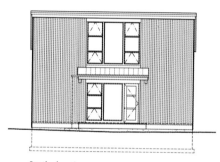

South elevation

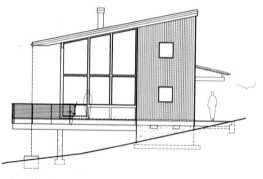

West elevation

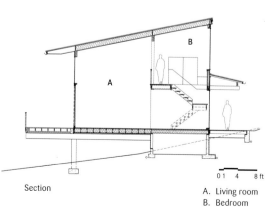

Section

0 1 4 8 ft

A. Living room
B. Bedroom

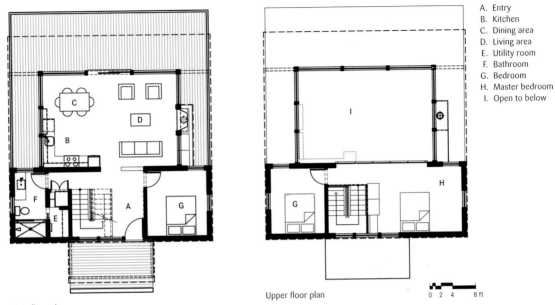

A. Entry
B. Kitchen
C. Dining area
D. Living area
E. Utility room
F. Bathroom
G. Bedroom
H. Master bedroom
I. Open to below

Main floor plan

Upper floor plan

0 2 4 8 ft

The living area is encased by glass walls on three sides. The fourth side is one wall of the wood-clad two-story rectangular form. This physical connection emphasizes the different spatial qualities of the two forms.

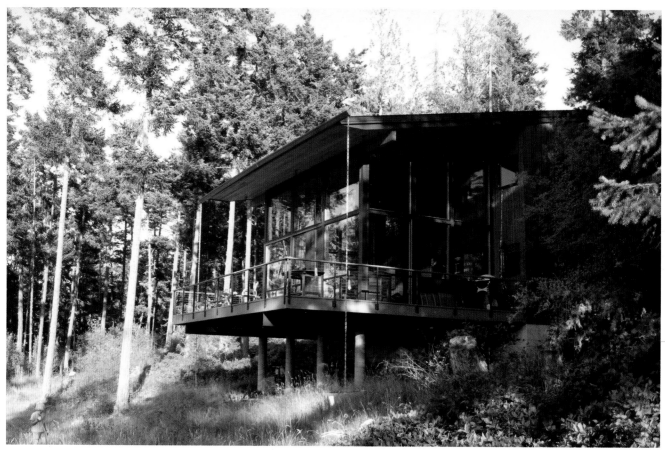

053

Deep overhangs can increase the lifespan of any cladding, protecting walls from severe rain and snow, as well as from UV rays.

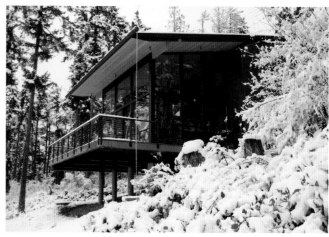

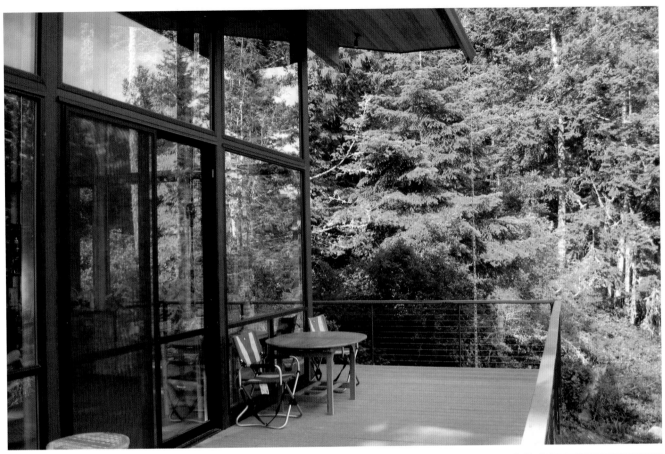

054

High-efficiency windows can help you reduce energy use and costs. Low-E glass is one of the most widely used building material because of its insulating properties, which offer thermal control during hot and cold weather.

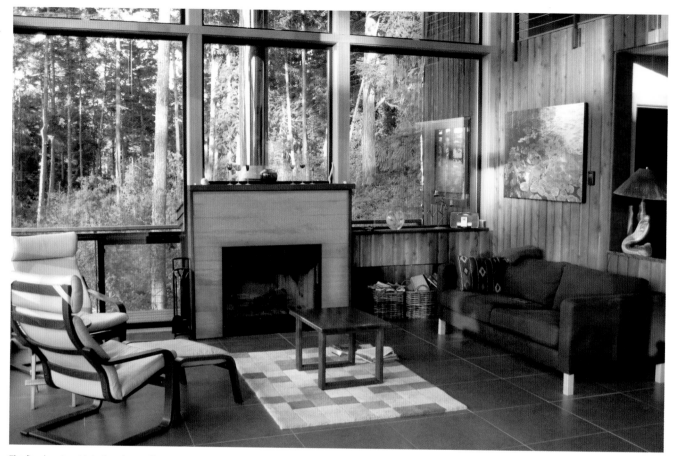

The fireplace is set into the glass wall. Far from being obtrusive, it allows those sitting in the room to enjoy the outdoor view.

Design sketch

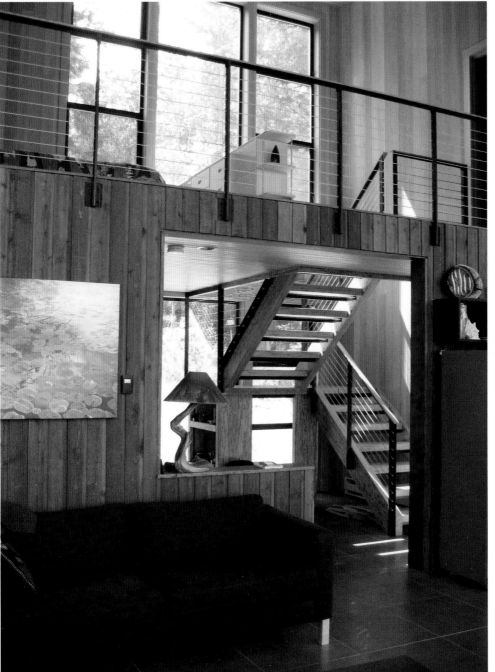

The master bedroom on the upper floor overlooks the living area on the main level. Floor-to-ceiling windows bring the landscape right into the bedroom.

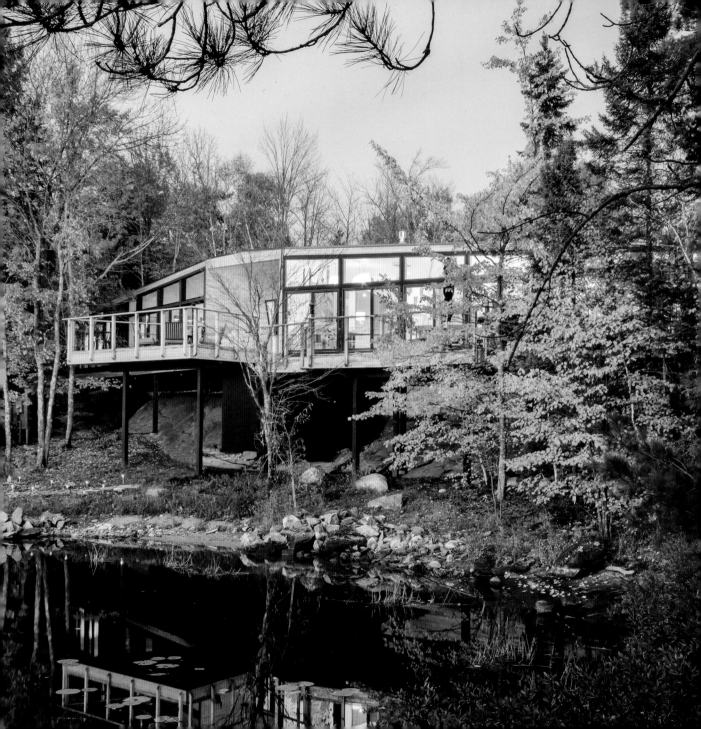

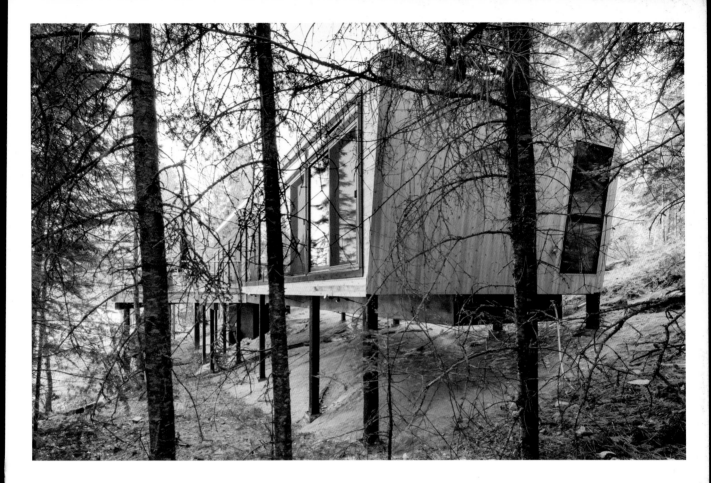

Kiss House is a custom-built modular, with the structure's two sections fabricated in a workshop to be ninety-five percent complete. Once transported to the site, the modules were placed so they delicately touch—or "kiss"—at one corner to form a V. A series of decks articulate the modules while establishing a dialog with the irregular site features. The structure's V shape forms an open-arm gesture, inviting all who visit to take in the landscape, including a nearby lake.

Kiss House
3,533 sq ft

LAZOR OFFICE | FlatPak
Ontario, Canada
© Peter VonDeLinde

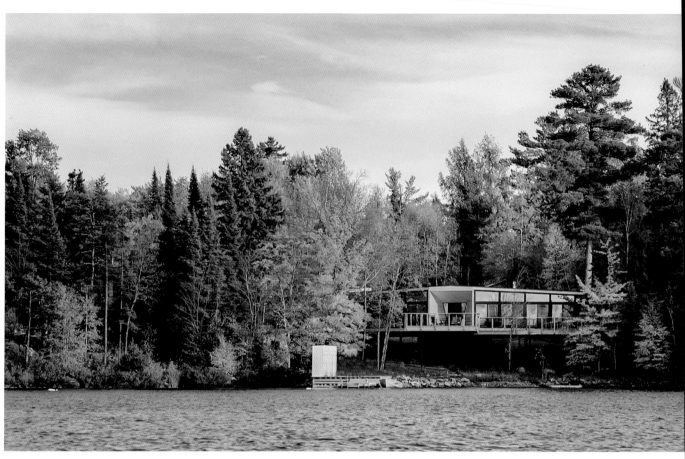

055

Regulations and restrictions that protect wetlands, lakes, and rivers can limit the construction of a new getaway or the modification of an existing one.

056

Rules and standards regarding development at water's edge can limit tree removal as well as the type of vegetation that can be planted.

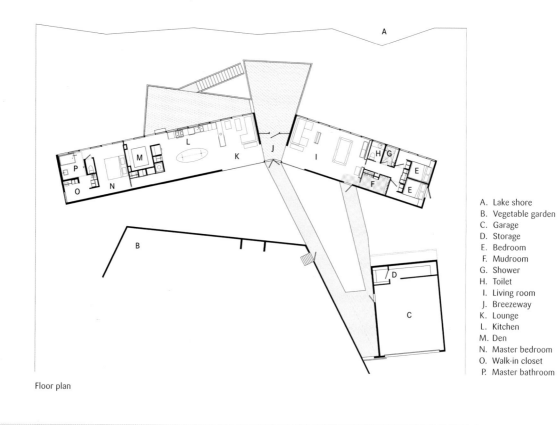

Floor plan

A. Lake shore
B. Vegetable garden
C. Garage
D. Storage
E. Bedroom
F. Mudroom
G. Shower
H. Toilet
I. Living room
J. Breezeway
K. Lounge
L. Kitchen
M. Den
N. Master bedroom
O. Walk-in closet
P. Master bathroom

The construction method that was
used in the construction of the Kiss
House differs from the usual stacking
and sealing of module joints that one
typically sees in prefabs.

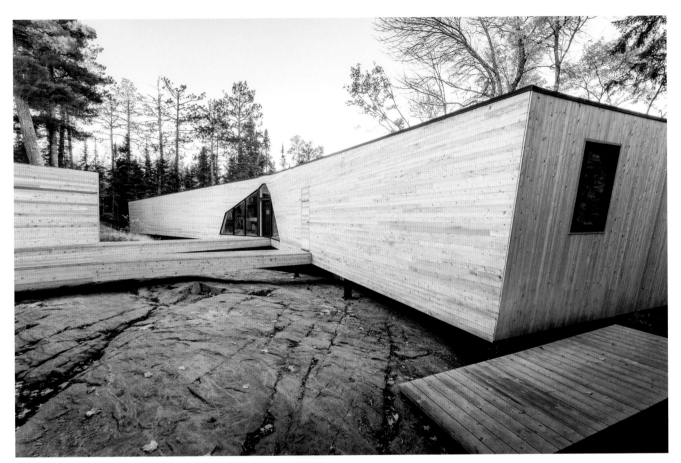

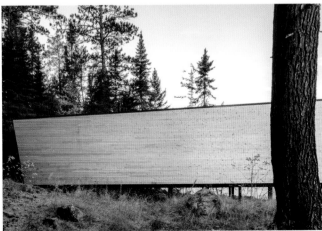

Decks are transitional spaces that link the built environment of a home and the rough natural elements. They allow the expansion of an interior space, creating a safer outdoor environment.

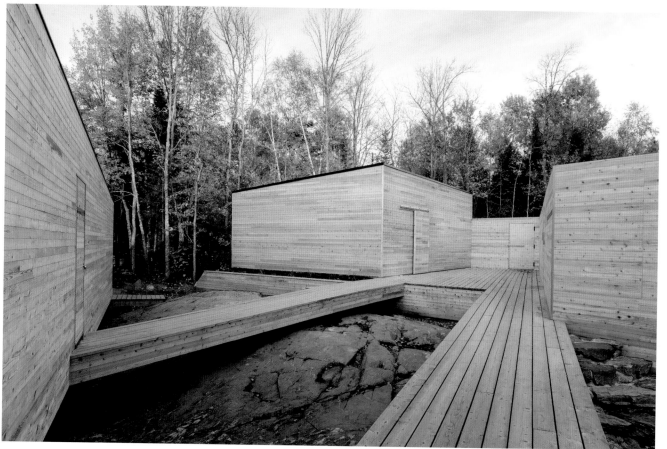

058

Rough, sloping terrains may determine the shape of your deck. It can be a single flat platform or various segments at different heights to accommodate the ground's unevenness.

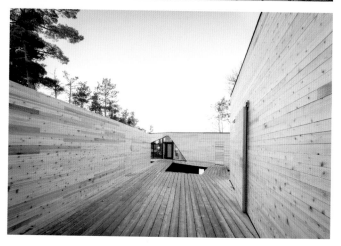

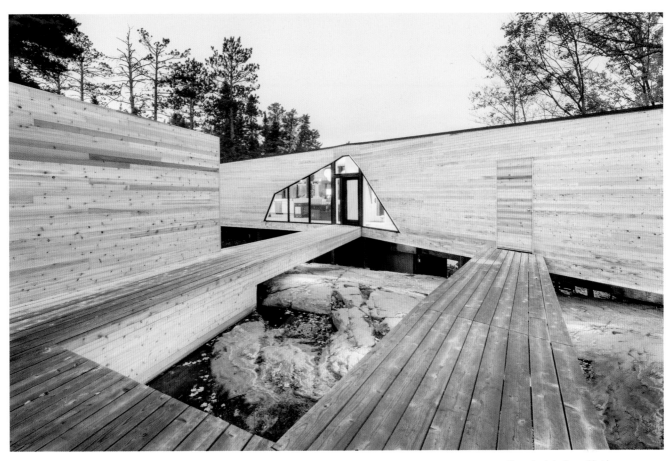

The raised decks and bridges connecting the different modules work their way around rock outcroppings to better integrate the construction into the natural context, while emphasizing its beauty.

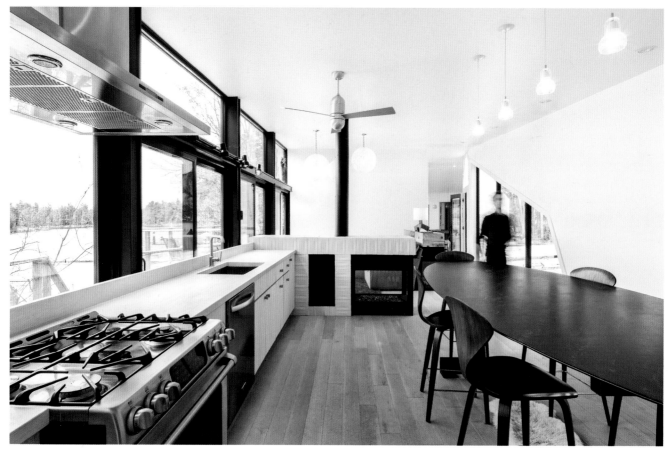

059

Getaways in remote locations call for durable and easy-to-maintain furnishings. Remember that a vacation home is for socializing and relaxing, not continual cleaning.

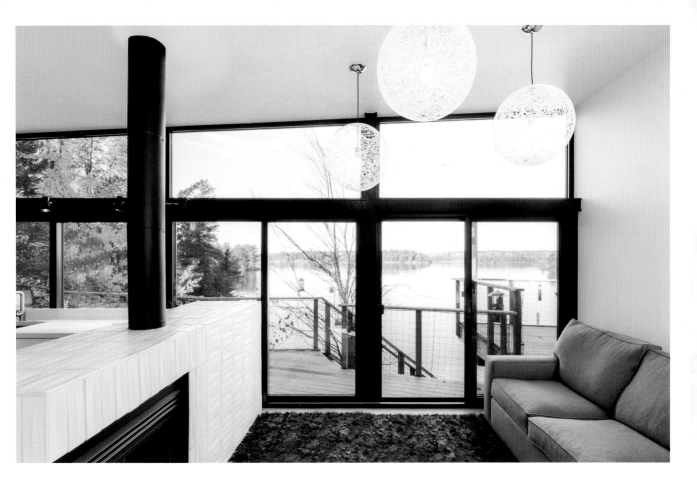

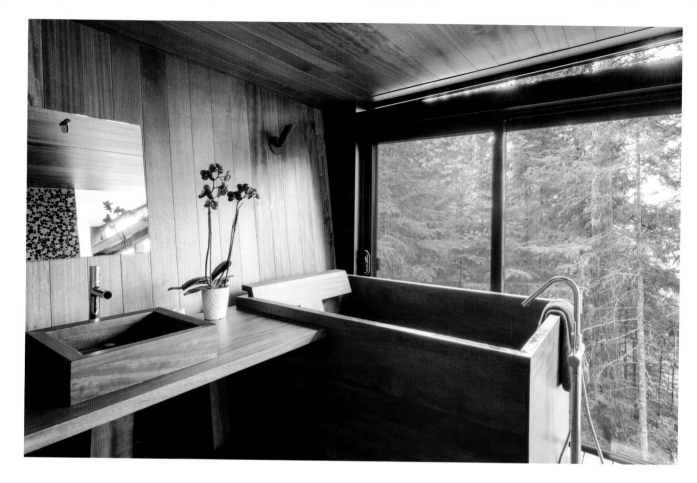

Since privacy might not be an issue in a remote place, every room can have a window to strengthen the nature experience.

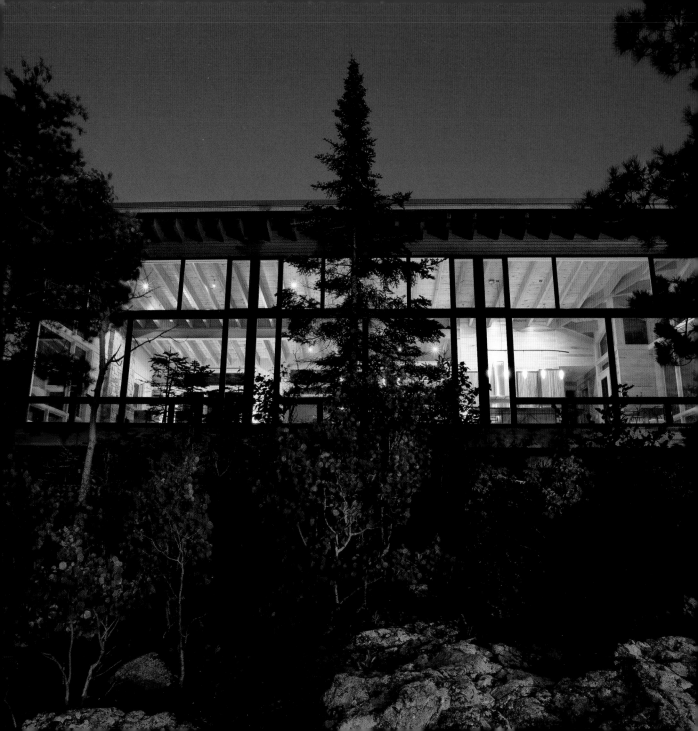

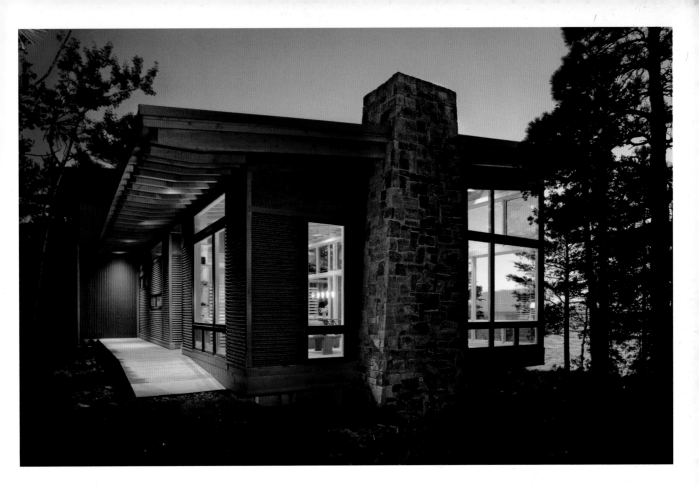

The cabin is located in a wooded area near a lake, and the structure cantilevers out toward the water with a 40-foot-long glass wall facing spectacular views. The construction is composed of two simple sections: a large open living/dining/kitchen space with an exposed timber ceiling structure and a two-story "bedroom tower." The exterior's corrugated metal cladding is complemented by a chimney made of Montana ledgestone.

Eagle Harbor Cabin

2,000 sq ft

FINNE Architects

Minneapolis, Minnesota, United States

© Eric Hausman

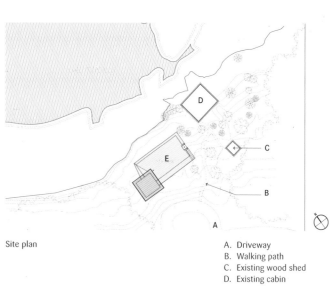

Site plan

A. Driveway
B. Walking path
C. Existing wood shed
D. Existing cabin
E. New cabin

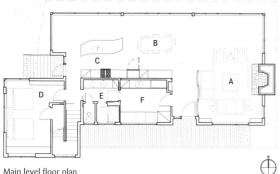

Main level floor plan

A. Living area
B. Dining area
C. Kitchen
D. Bedroom
E. Bathroom
F. Laundry room
G. Master bedroom
H. Cabin roof below

Master bedroom floor plan

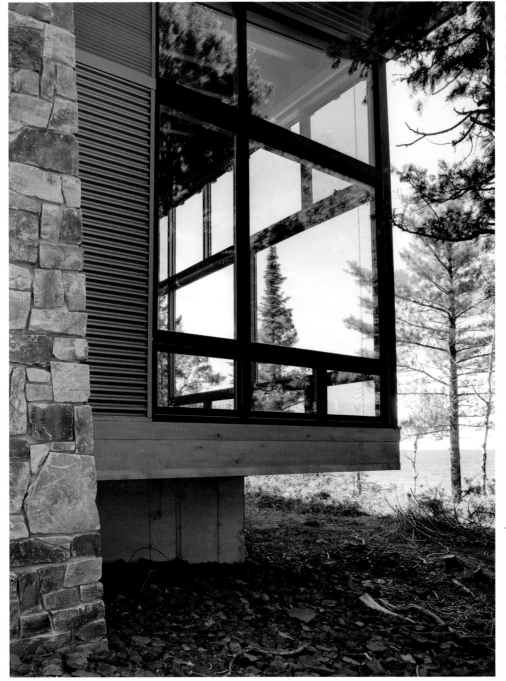

The cabin is built on a concrete foundation, which protects the floor from ground shifts caused by freezes and thaws. Large windows provide solar heat gain during the winter, and deep overhangs offer protection from snow and sun.

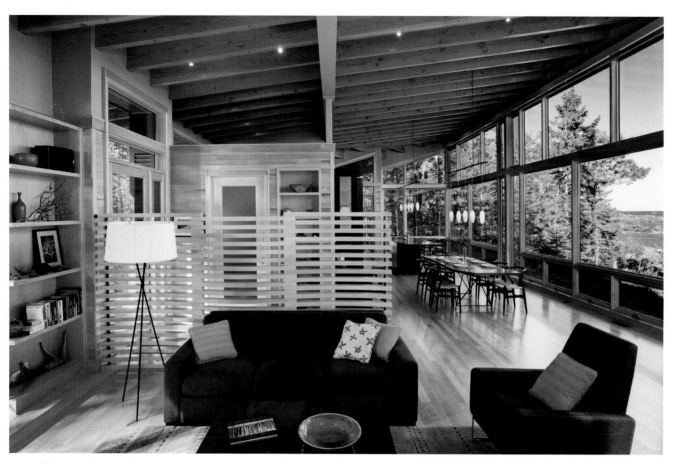

Sustainable interior finishes include
maple and linoleum flooring, birch
paneling, and low-VOC paints. The
cabinets are made from mahogany
and Plyboo—a Forest Stewardship
Council-certified bamboo product.

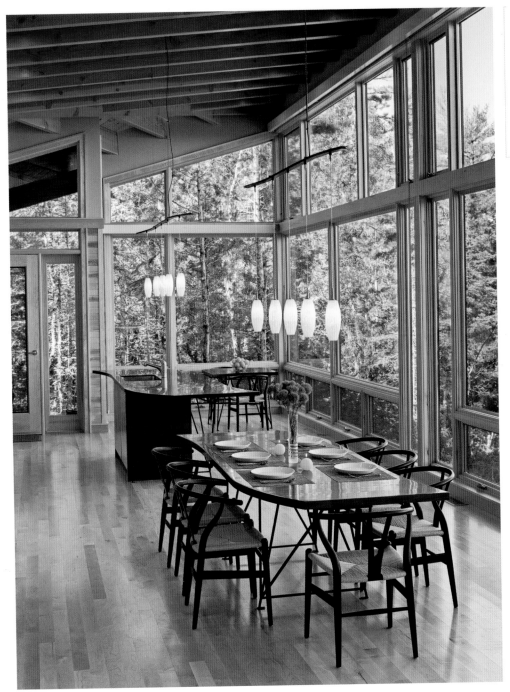

Building orientation as well as sizing and placement of openings are critical for effective cross ventilation to help air circulate through the entire space.

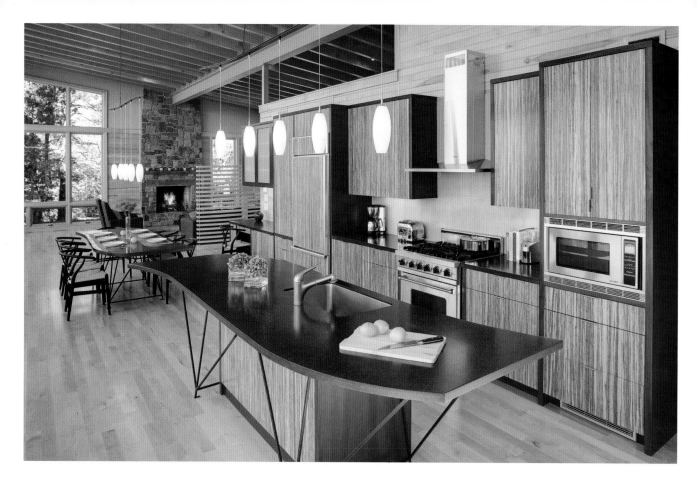

In addition to their decorative potential, transom windows add light to an interior space and give it a bright, airy feel. They also bring large walls and tall ceilings back into balance.

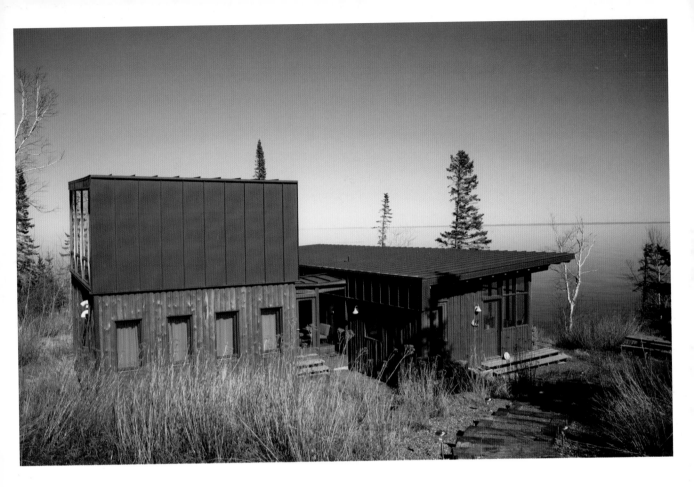

The owners of this cabin had been taking trips to Lake Superior well before they decided to build there. Their love for the local casual, simple architecture and its strong connection to the natural environment was enough of a motivating factor to make their ties to the area more permanent. The cabin is composed of two structures—the main building and a bunkhouse—connected by a glassed-in link that gives an impression of being outside, while being sheltered.

Fairwind Cabin

2,150 sq ft

CityDeskStudio

Knife River, Minnesota, USA

© Don Wong

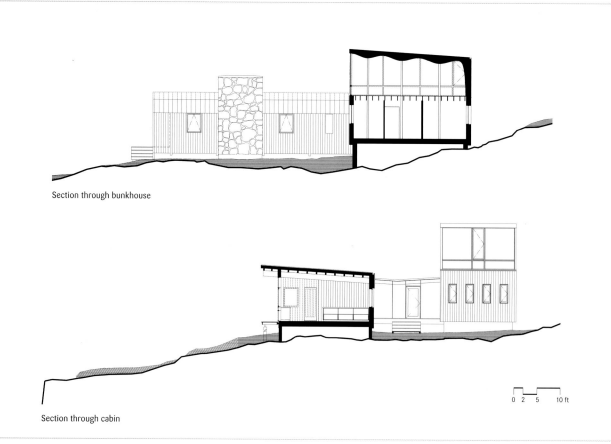

Section through bunkhouse

Section through cabin

0 2 5 10 ft

063

If you are building a new
cabin, consider a layout
that offers a protective
and enclosing section, and
another—perhaps, stacked
on the first—that offers a
different experience through
panoramic views.

Upper floor plan

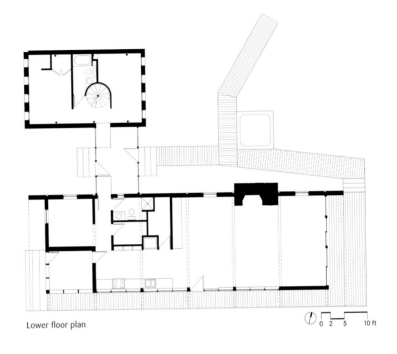

Lower floor plan

0 2 5 10 ft

064

The bunkhouse ground floor is protective and enclosing. The upstairs floor offers a totally new experience for the occupants, with a panoramic view of the tree canopy.

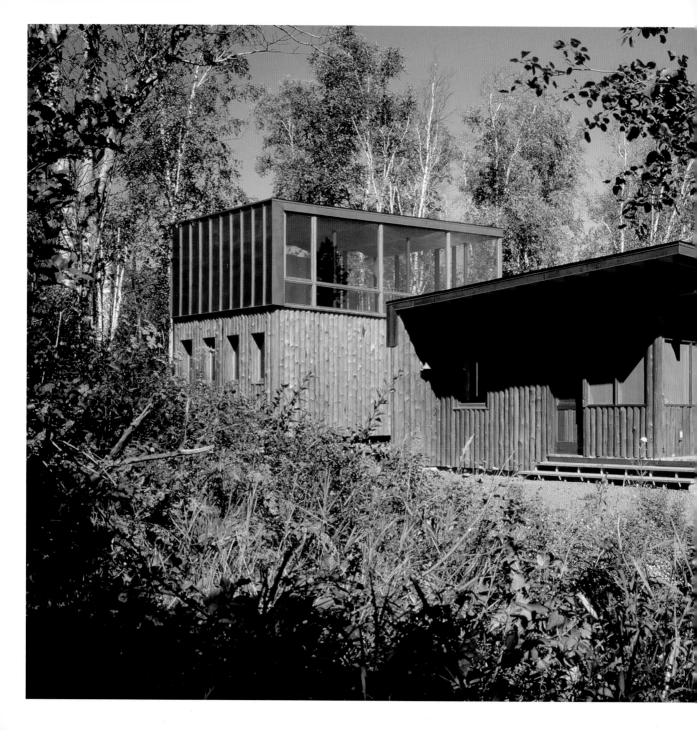

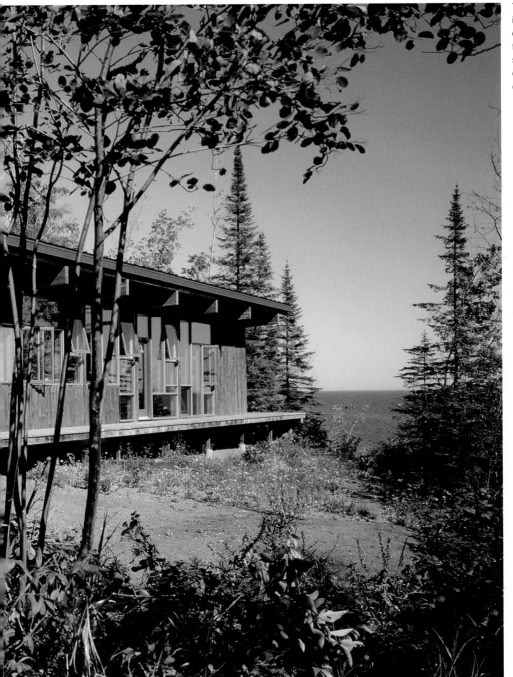

The main building celebrates the immediate landscape through a wall of stainless steel-framed windows facing south. To the east the ground slopes away and the deck extends out, providing a place for a direct connection to the lake and horizon.

Both buildings have copper-clad roofs to shelter and shape the interior spaces. The undulating ceiling of the bunkhouse's second floor stiffens the building, while echoing the subtle movement of the water's surface.

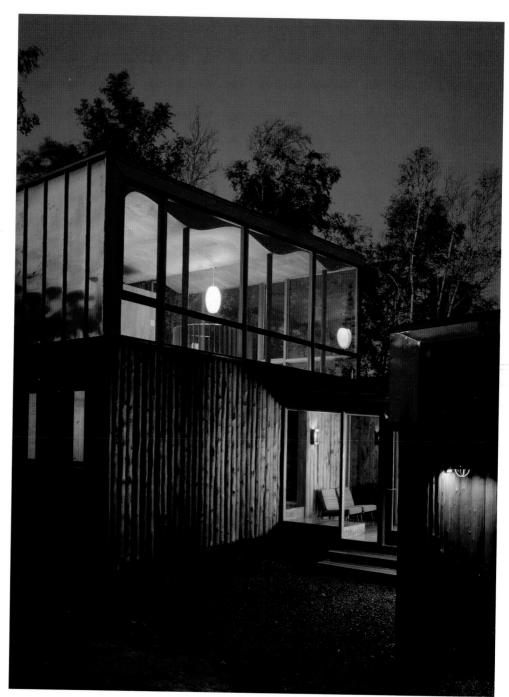

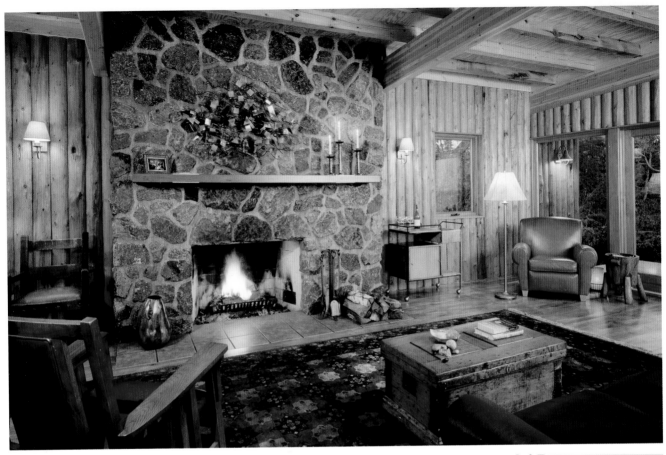

065

Extending a stone hearth
from the floor to the rafters
creates a great focal point,
breaking up bland walls. Also,
verticality tends to visually
raise the ceiling height.

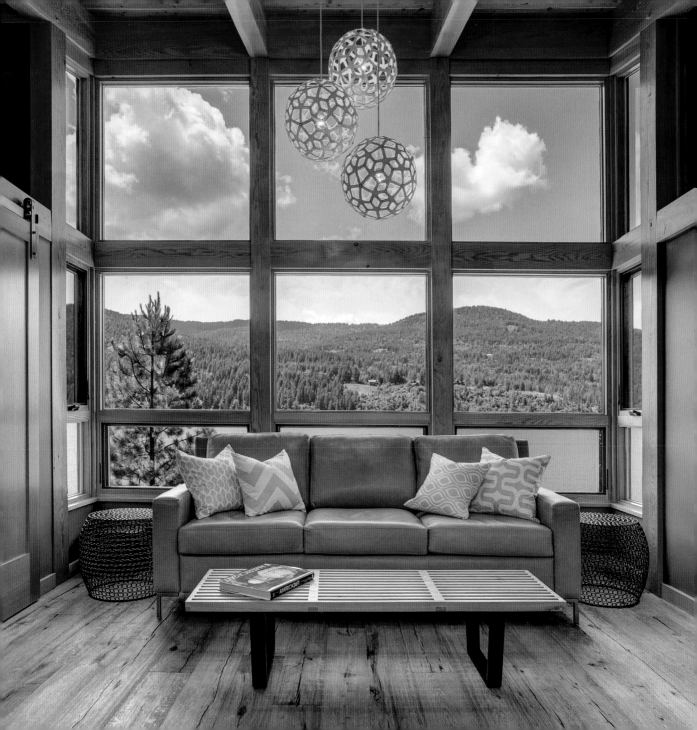

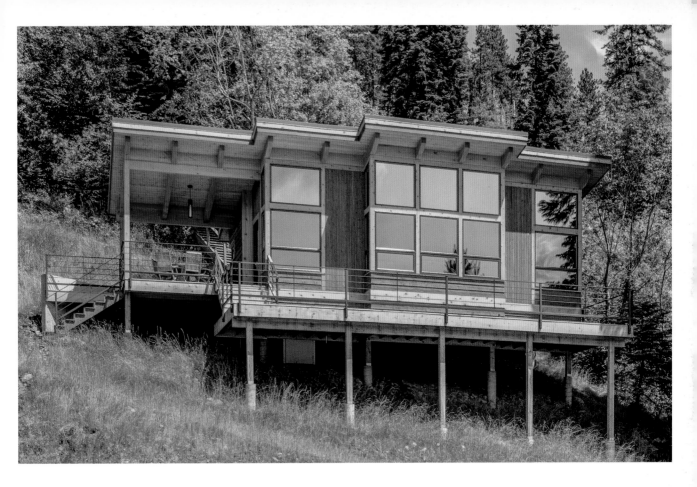

Situated on a sloping site with breathtaking lake views, this vacation retreat takes full advantage of its natural setting. A covered porch adds seasonal living space, and a wall of windows opens the cabin to the views and imbues it with natural light. The cabin is designed to make the most out of the available space, but this doesn't get in the way of creating comfortable, airy, and stylish spaces.

Idaho Cabin

550 sq ft

FabCab

Sandpoint, Idaho, United States

© Marie-Dominique Verdier

South elevation

North elevation

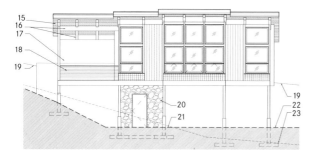

East elevation

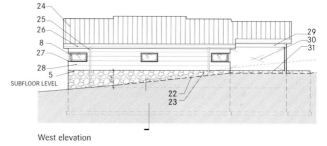

West elevation

SUBFLOOR LEVEL

1. Vertical cedar siding
2. Aluminum clad wood doors
3. Beams at porch roof in foreground
4. Cedar trim at end of SIPS wall
5. Concrete foundation and retaining wall
6. Cedar fascia
7. Exposed Douglas fir rafter tails, sealed
8. Aluminum-clad wood windows
9. Cedar trim over rain screen system over timber frame
10. Guardrail in foreground (omitted for clarity)
11. Cedar sill

12. Slate tiles
13. Rim joists and support beams
14. PT posts on concrete Sonotube piers
15. Tongue-and-groove DF soffit, continuous inside and outside
16. DF beams and rafters
17. Retaining wall beyond
18. 36" high guardrail with < 4" openings, where deck > 30" above finished grade
19. Approx. finished grade beyond
20. Concrete foundation wall below bathroom
21. Final grade to be determined on-site by contractor

22. Final grade
23. Approx. existing grade
24. Standing seam metal roof
25. Round metal downspout: connect to rainwater management system
26. Half-round metal gutter
27. Cedar "shadow box" window trim
28. Horizontal beveled cedar siding, stained, over rain screen system
29. Douglas fir exterior beam
30. Open to beyond
31. Concrete retaining wall

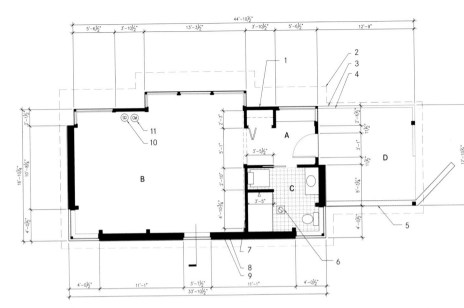

Floor plan

1. High-efficiency SIPS panels at infill locations
2. Edge of roof above
3. Edge of wood deck
4. 36" high guardrail < 4" openings, where deck >30" above finished grade
5. Concrete retaining wall
6. Whole house ventilation fan with timer
7. Sound insulation at bathrooms
8. SIP wall system
9. 2 x 4 furring
10. All smoke detectors to be hard wired to building power with battery backup
11. Carbon monoxide detector

A. Entry
B. Common area
C. Bathroom
D. Bedroom

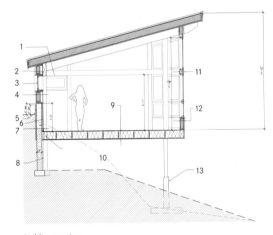

Building section

1. Roof construction:
 Standing seam metal roof
 Breathable roofing membrane
 R-40 structurally insulated panel (SIP)
 Vapor barrier (poly sheeting or FelTex®)
 1" tong-and-groove cedar soffit
 6 x 12 timber frame joists
2. Timber frame beam
3. Inset aluminum-clad wood window with cedar trim at exterior, fir trim at interior
4. Exterior wall SIPS construction:
 Cedar siding
 3/8" rain screen furring strips
 (2) layers building paper
 R-24 structurally insulated panel (SIP)
 SIP tape (+ OSB skin from SIP = Vapor retarder)
 2 x 4 furring at 24" O.C.
 ½" Gypsum wallboard
5. Cover exposed insulation with tile, HardiePanel or other approved siding
6. 6 x 6 timber frame post
7. Raised foundation wall construction:
 Tile, HardiePanel, or other approved siding,
 Where exposed, 2" rigid insulation (R-10)
 8" concrete wall
 2 x furring at 24" O.C.
 2" rigid insulation (R-10)
 1/2" Gypsum wallboard
8. 6 x 6 PT post directly below timber frame post
9. Floor construction:
 Plywood substrate
 Floor joists
 Min. R-30 Batt insulation
 Tongue-and-groove cedar soffit
10. Solid wood blocking between posts
11. Exterior wall timber frame construction:
 Douglass fir timber frame
 (2) layers building paper
 3/8" rain screen furring strips
 Cedar trim
12. Exterior wall high-efficiency SIPS construction:
 R-21 high-efficiency structurally insulated panel (SIP):
 ¼" MagBoard
 4" high-efficiency foam insulation
 7/16" OSB
 (2) layers building paper
 3/8" rain screen furring strips
 Cedar siding or tile, per location
13. PT post over concrete Sonotube® piers on spread footings

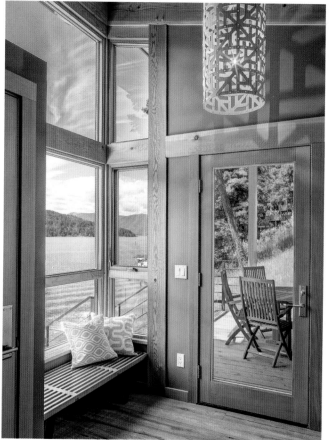
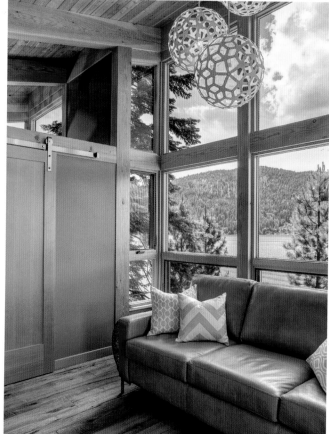

The 12'6" ceilings make the home seem much larger that its actual size, and the interior finishes—rustic oak-plank flooring, custom barn doors and hardware, designer pendants, and premium appliances and cabinets—are both upscale and simple.

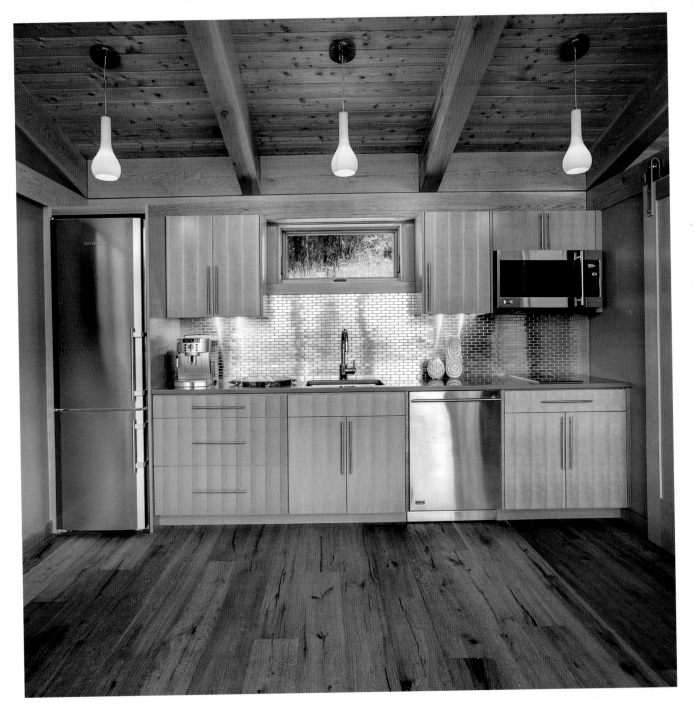

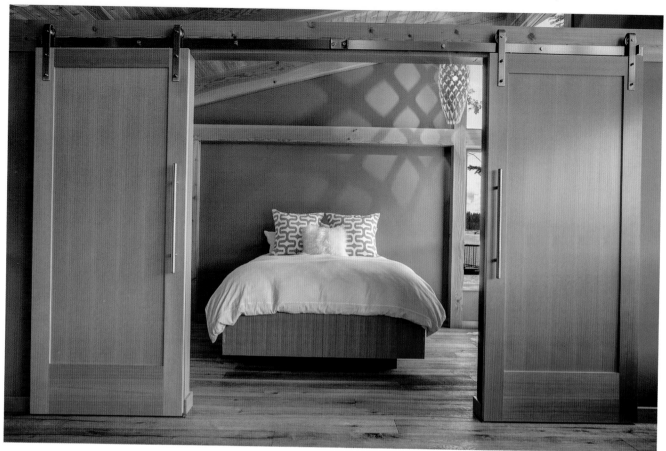

066

Another good thing about barn doors is that they can be used in oddly sized doorways, sometimes as a result of opening up floor plans during a remodel. One area where these beautiful doors fall short is their price tag.

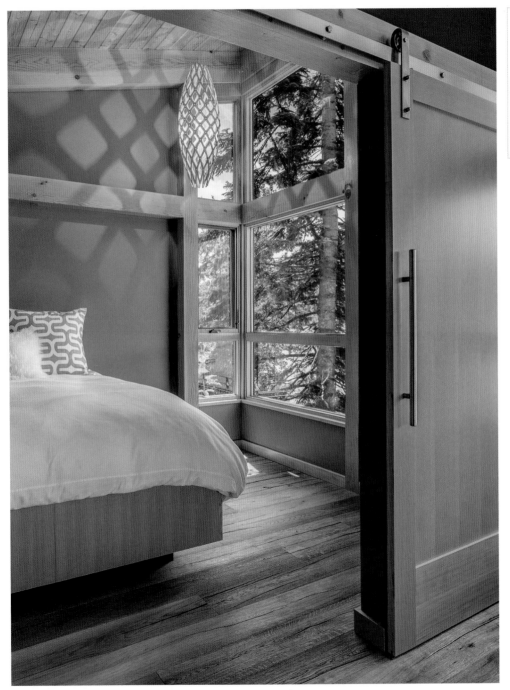

Barn doors work well in small spaces, because unlike hinged doors, they don't take up swinging space. They are available in many styles. Reclaimed wood can also make a great barn door, adding rustic charm to a room.

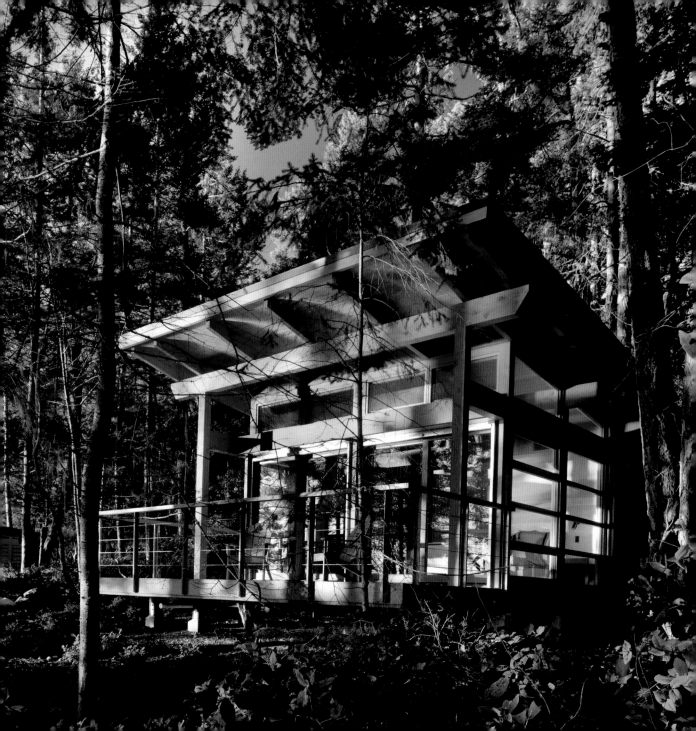

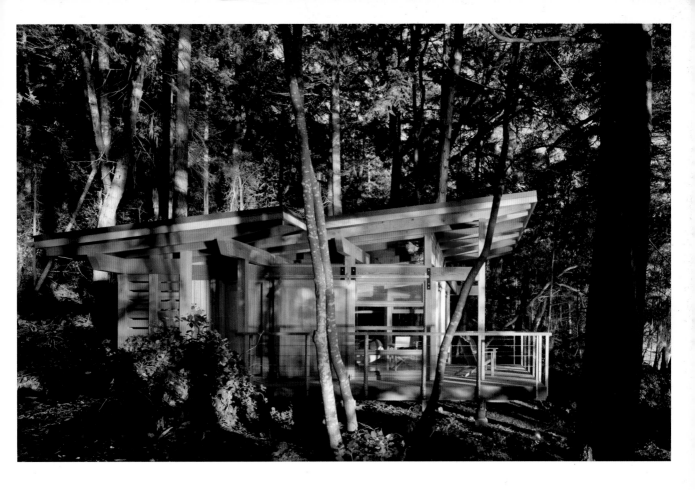

This project consists of four cabins with the same footprint, but in different configurations. Simple in plan, and intimately connected with their surrounding forest environment, these minimal structures are guest cabins designed for summer use. The buildings are off-grid and self-sufficient. During the rental season, a battery system is charged from solar panels and powers a low-voltage LED lighting system, and water is collected from the roof. Off season, the buildings are shut down with an exterior sliding-shutter system.

Gulf Cabins
550 sq ft

Osburn/Clarke

Gulf Islands, British Columbia, Canada

© Nick Lehoux

Ample window glazing and large openings maximize natural light in these little buildings, and allow the interior spaces to extend into their spectacular natural surroundings.

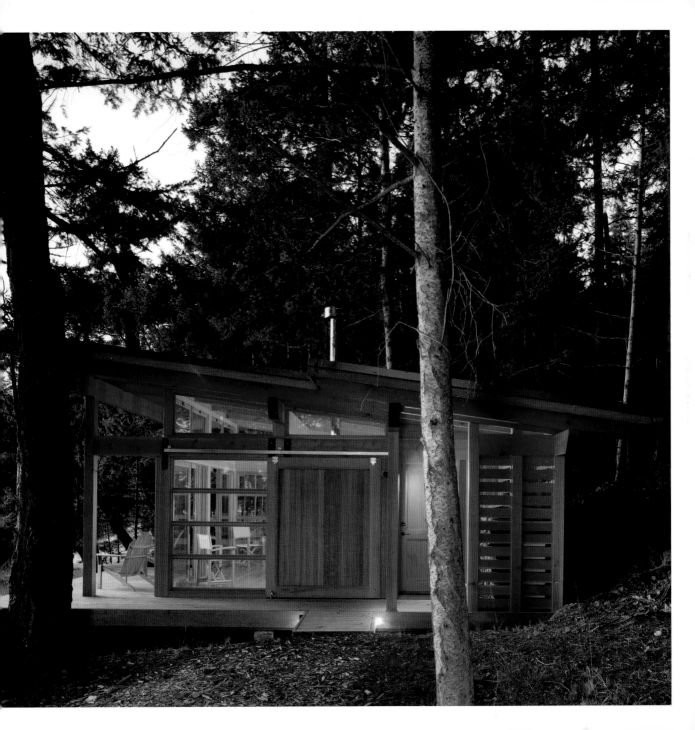

Cabin sketches

The design of the four cabins is grounded in the traditional, but boasts a contemporary feel. The cabins have different configurations, but the same footprint. In all, the cabins are a reminder that nature always offers the best backdrop.

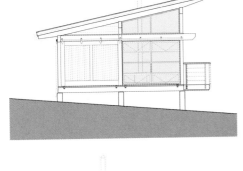
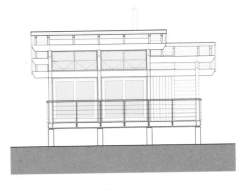

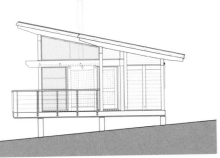
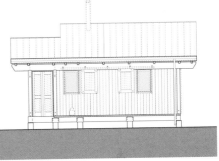

Cabin 3 and 4 elevations

Site plan

1. Studio 1 3. Studio 3
2. Studio 2 4. Studio 4

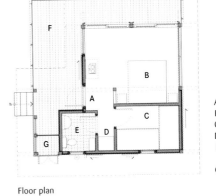

Floor plan

A. Entry
B. Bedroom
C. Bunk room
D. Closet
E. Washroom
F. Deck
G. Battery room

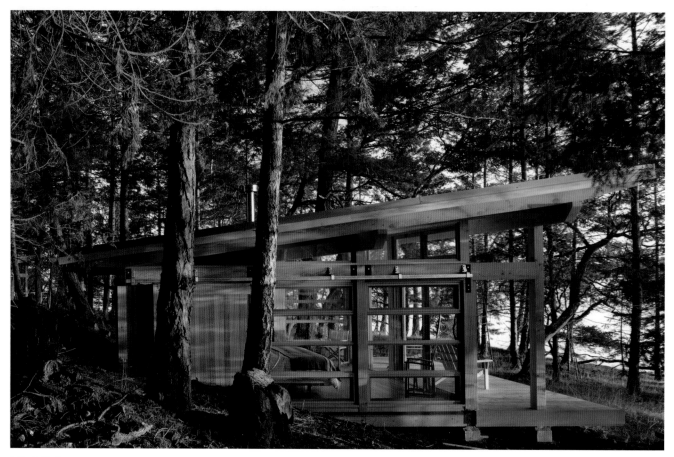

068

Simplicity can be appealing without being dull. The wood echoes the trees, and glass draws in and reflects the beautiful landscape as if one was part of the other.

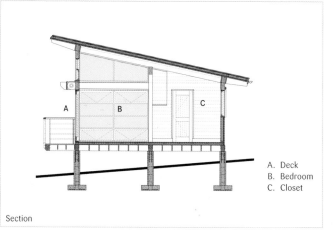

A. Deck
B. Bedroom
C. Closet

Section

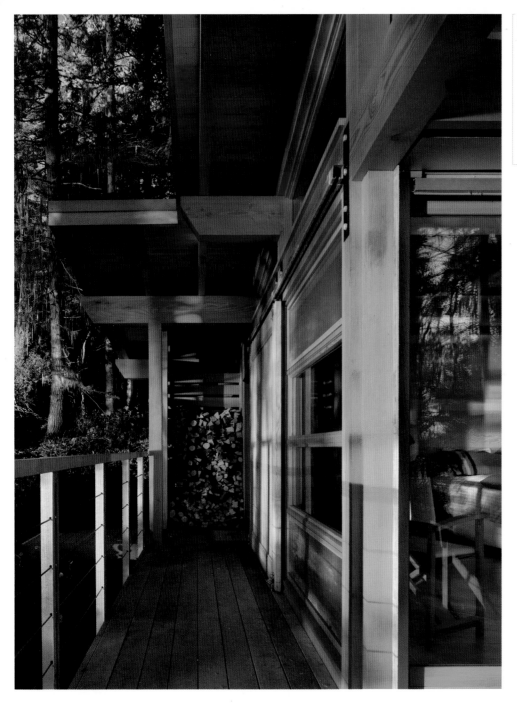

Sliding panels are a clean and efficient solution to enclose a cabin and protect it from the elements and from unwanted visitors. Vents, even if screened, should be covered, since they provide easy access for insects and small critters.

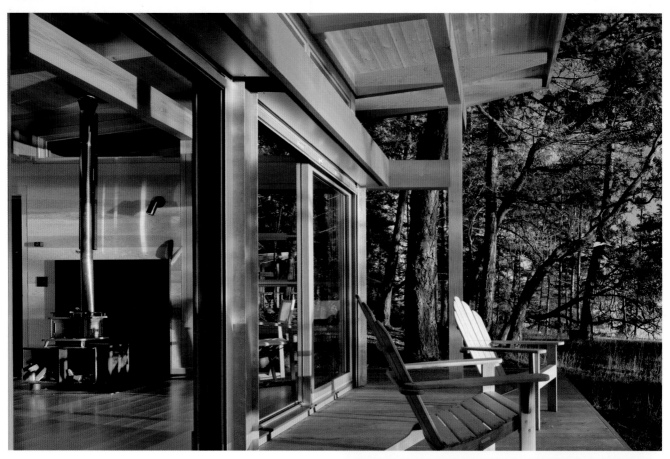

070

Small stoves are capable of heating spaces up to one thousand square feet and are efficient enough to handle cold spikes. In large spaces, they can provide backup in case of a power outage.

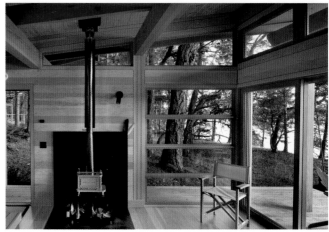

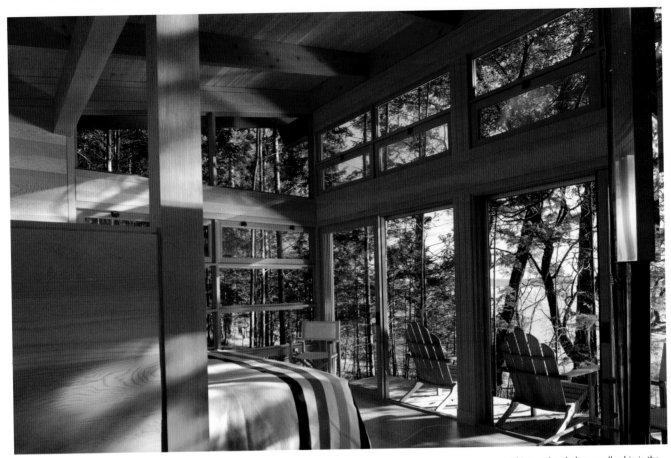

This wood-and-glass small cabin is the ultimate getaway experience, if you are looking to reconnect with nature. Little gets in the way of the enjoyment of simple pleasures: gathering around a fire or gazing at the stars.

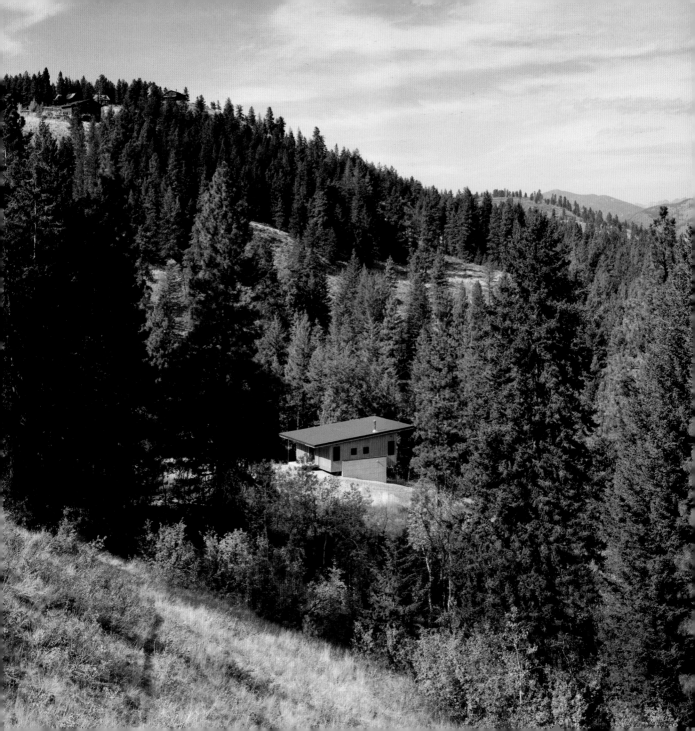

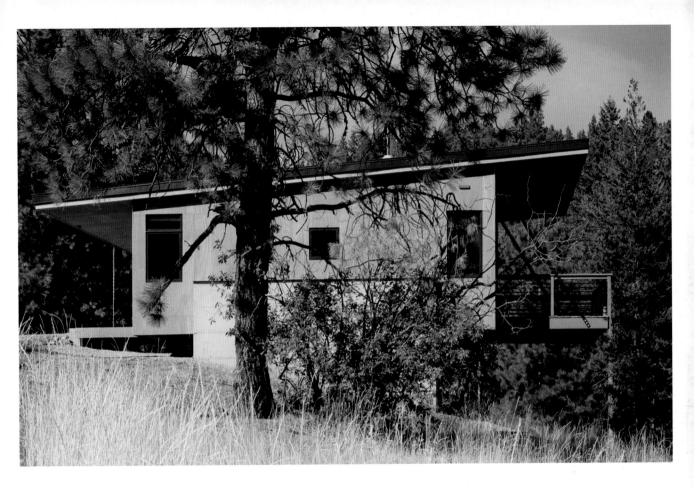

In the architects' words, "This project demonstrates our belief that architecturally interesting solutions can be achieved for budgets of all sizes without sacrificing quality or aesthetics." Pine Forest Cabin responds to this philosophy with an efficient plan and a cost-effective selection of building materials. A concrete base cradles the main structure and allows it to cantilever over the hillside, minimizing environmental impact and taking full advantage of the surrounding views.

Pine Forest Cabin
850 sq ft

Balance Associates Architects

Methow Valley, Washington, United States

© Steve Keating

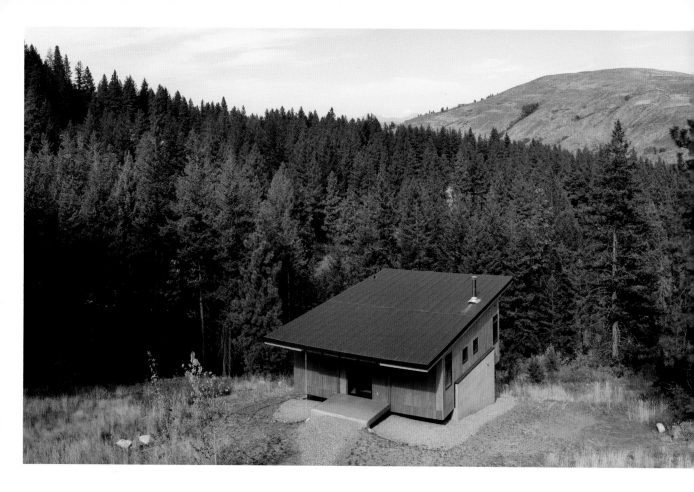

Using panel materials for the exterior and the interior helped keep a simple, low-cost design balanced and tied together.

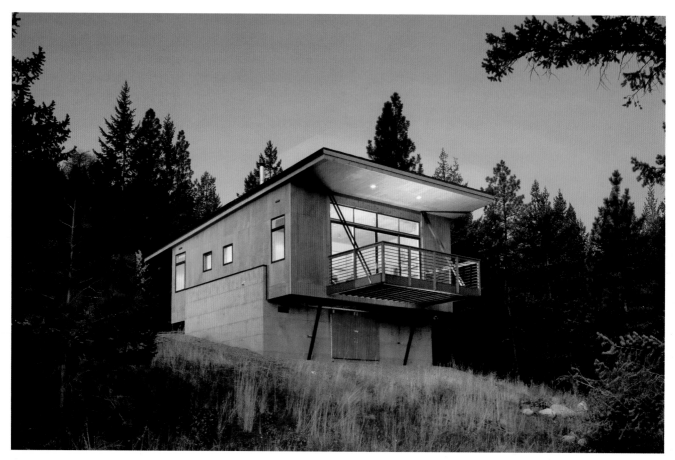

The structural concrete base anchors the cabin to the sloping site, providing the necessary support.

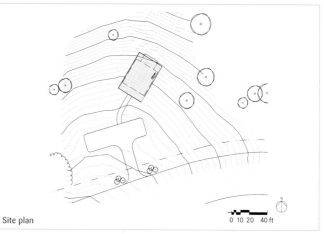

Site plan

0 10 20 40 ft

East view

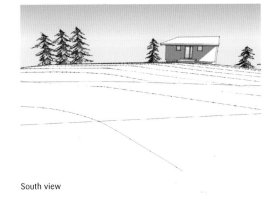

South view

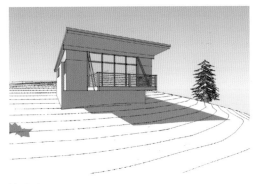

North view

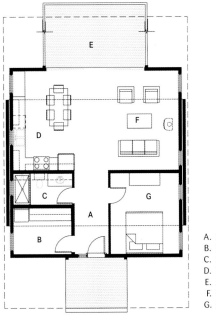

Floor plan

A. Entry
B. Mudroom
C. Bathroom
D. Kitchen
E. Deck
F. Living room
G. Bedroom

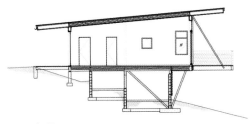

Section looking west

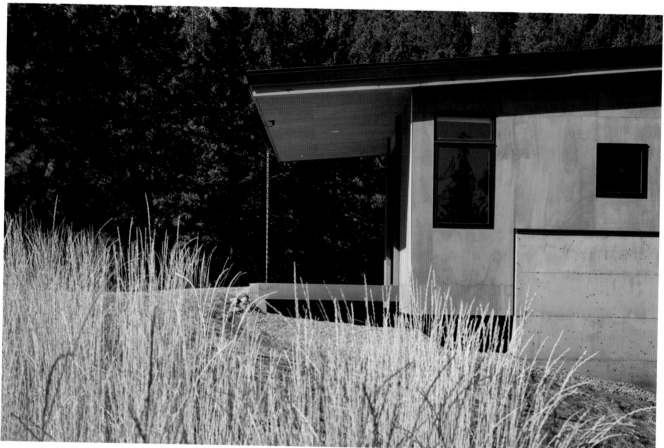

071

Building components were prefabricated in a workshop and transported to the construction site for assembly. This building method kept down construction costs and sped up the building schedule.

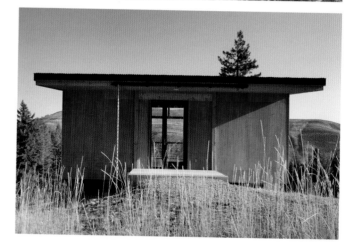

The cabin has large openings on the sides paralleling the terrain's incline. One is an entrance, directly opposite the balcony overlooking the valley.

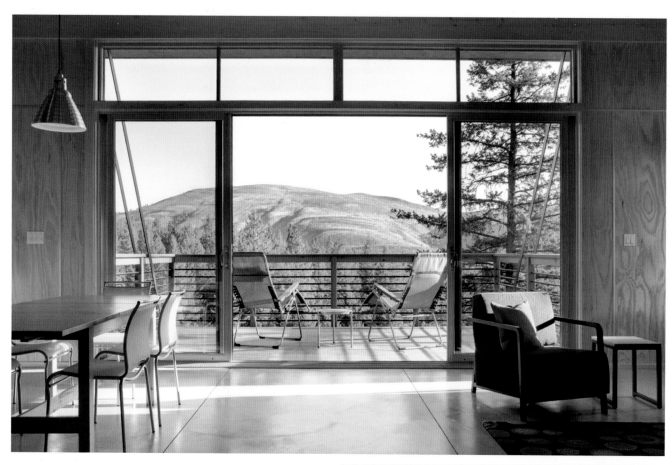

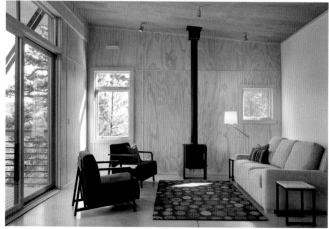

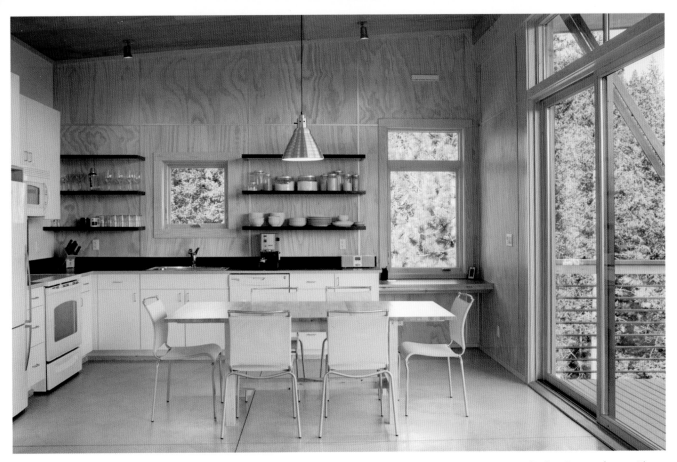

Wood is the primary surface outside
and in, and one dominant material helps
keep the design simple.

072

Pre-engineered panel
systems are a cost-effective
and time-efficient alternative
to traditional construction,
and they don't necessarily
require any finish.

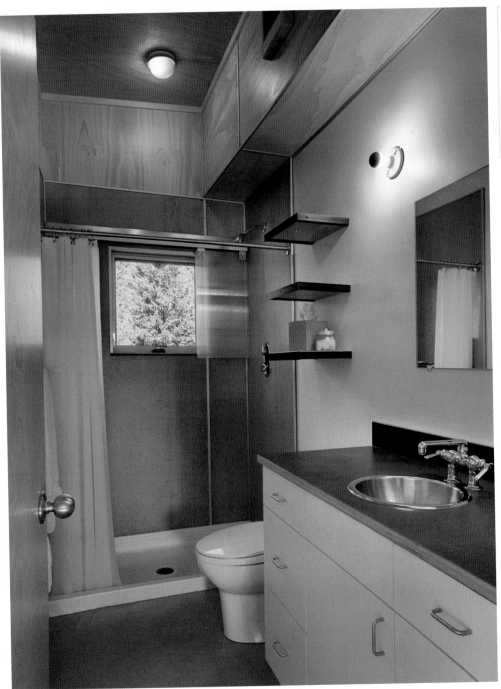

Panels can be pre-drilled in a workshop to accommodate all utility pipes and connections. All that is left to do on-site is installing the plumbing, mechanicals, and electrical fixtures.

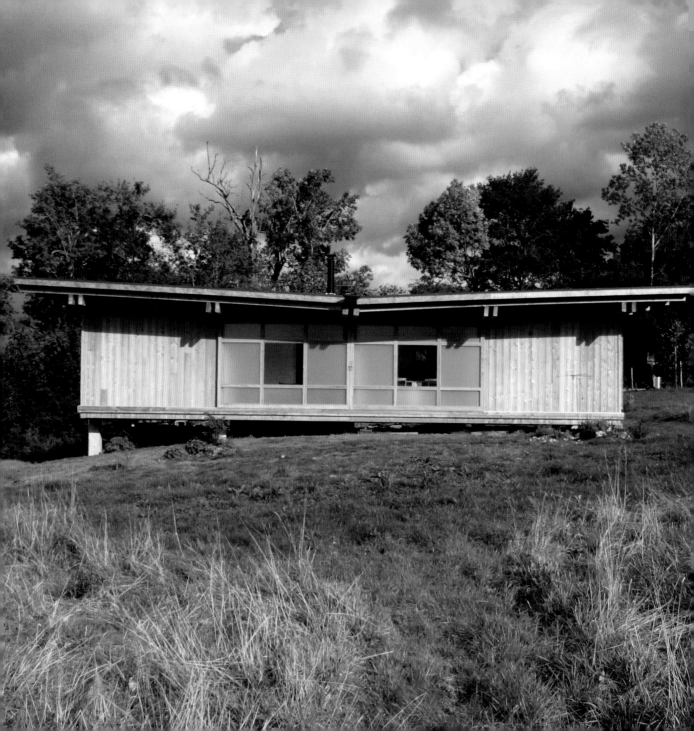

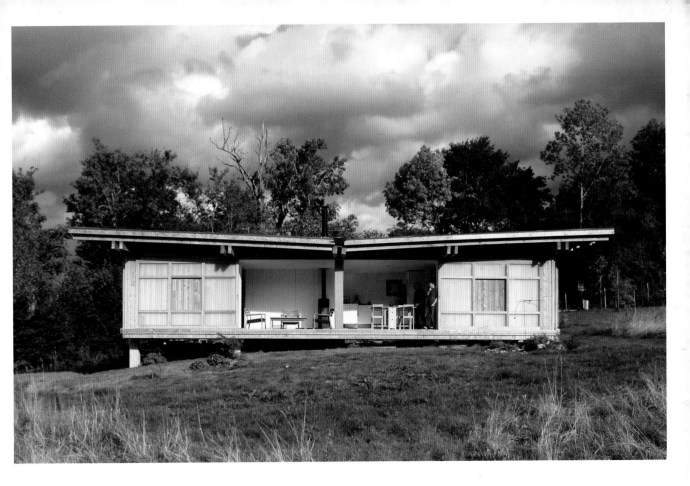

Small homes offer the advantage of efficient living, minimizing construction and maintenance costs. But this doesn't have to affect quality. The overall simple design of this house finds a beautiful balance through the unique, artistic detailing of the openings. Four modules of massive translucent glass doors with clear glass insets slide along the walls, opening up the house to the meadow and inviting in the landscape.

House in a Meadow
840 sq ft

arba
Montreuil, France
© arba, PoLa

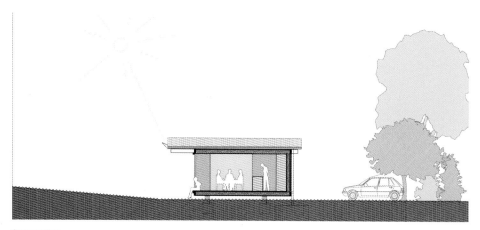

Cross section

Longitudinal section

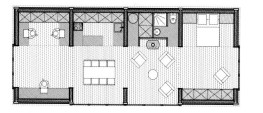

Floor plan

Assembly diagram

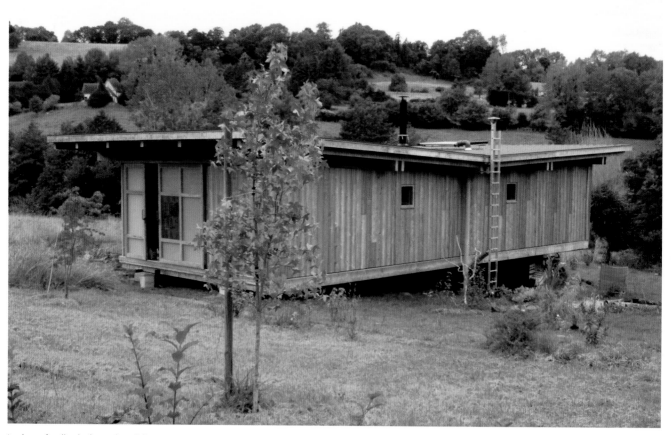

In place of walls, the house has sliding panels that enclose the interior spaces or open them to the exterior. These panels also organize the layout of the house to create a continuous room or a succession of smaller, individual spaces.

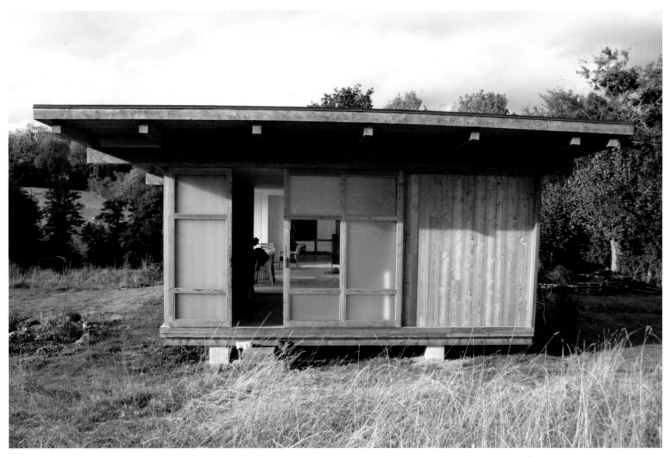

074

The design of this construction recalls traditional Japanese domestic architecture. Contemporary interpretations of the traditional shoji screen are often used to divide spaces and to diffuse light, partitioning spaces while letting in the light.

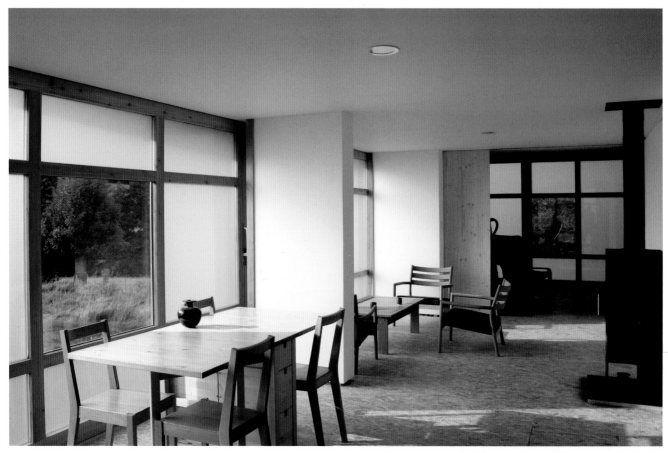

Sliding panels are a dominant feature of this cabin: They encourage interior activities to spill out into the exterior and allow the configuration of the cabin's interior to change depending on the needs, promoting a flexible use of the space.

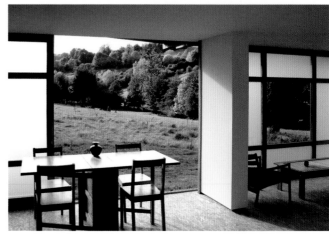

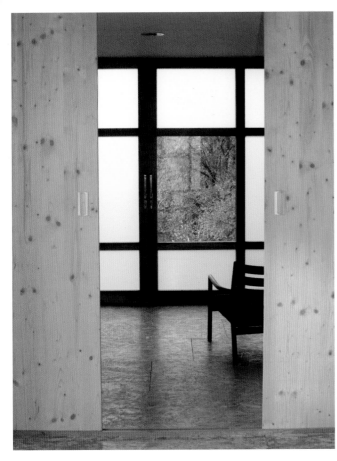

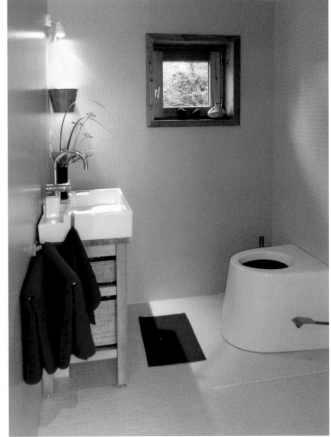

075

Different levels of transparency can be achieved choosing opaque, translucent, or transparent surfaces. They can be used to control the level of privacy between different spaces.

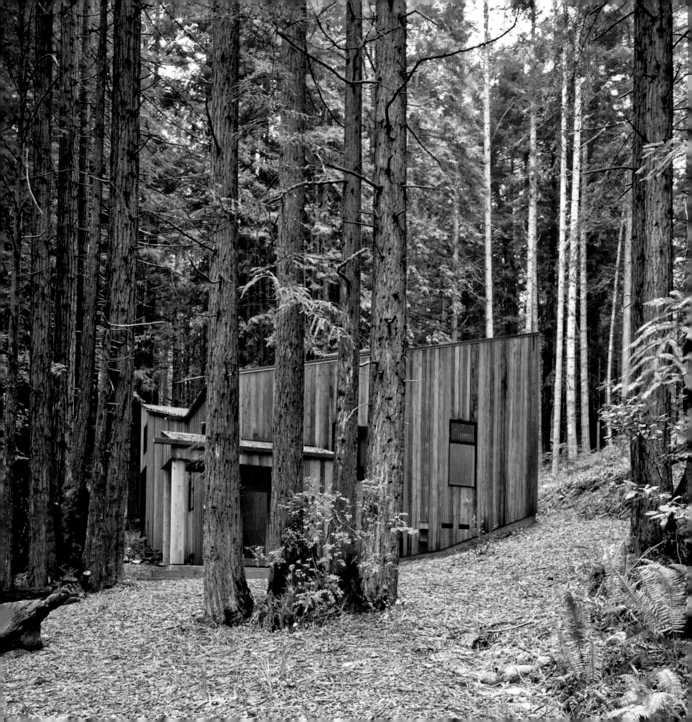

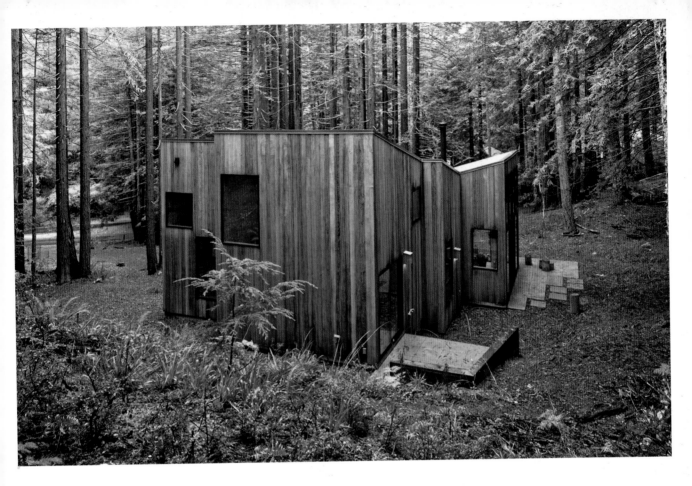

The Spudich Cabin is modest in size but spacious in feeling. Built with materials common to the site, it continues the building tradition of Sea Ranch, and its shape is uniquely tailored to a forested setting. The cabin is approached along a path winding up through trees to a porch. Inside, a flight of stairs continues the ascent toward a view of massive redwoods.

Spudich Cabin

1,115 sq ft

Frank / Architects

Sea Ranch, California, United States

© Domin Photography

Vertical siding outside and inside the cabin echoes the tall trees of the surrounding landscape, blurring the barrier between interior and exterior.

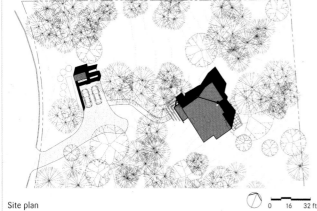

Site plan

0 16 32 ft

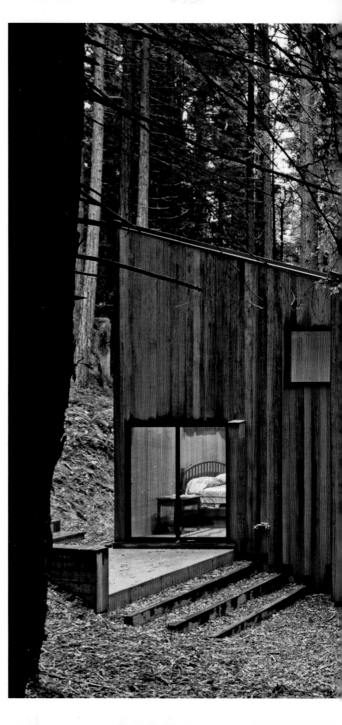

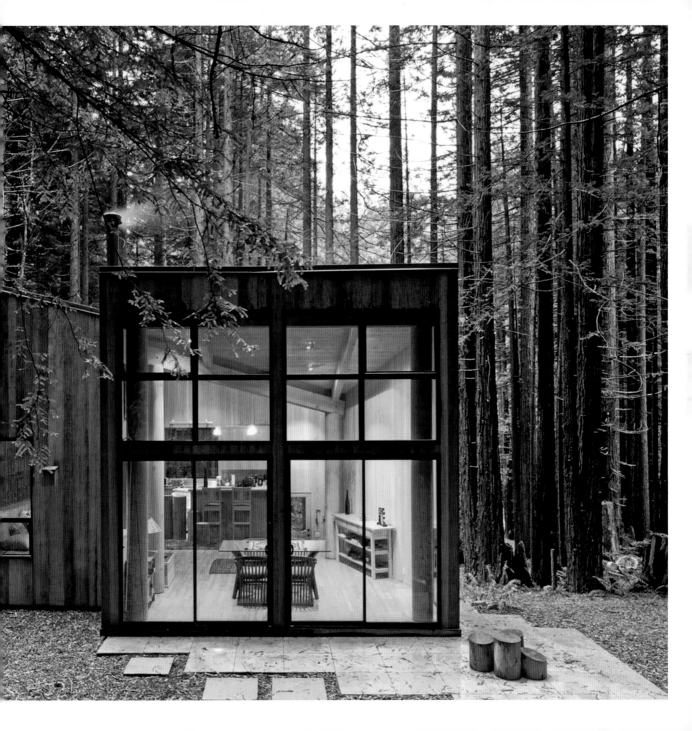

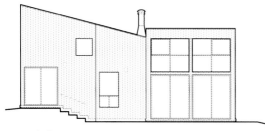

North elevation

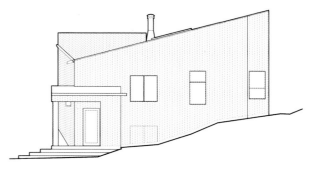

South elevation

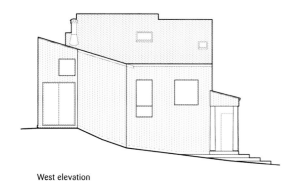

West elevation

0 8 m

East elevation

076

A mono-pitched roof, a skillion roof, slants at one angle, and snow and rain easily slide off. With its relatively flat proportions, a skillion roofline pairs well with solar panels to maximize solar collection.

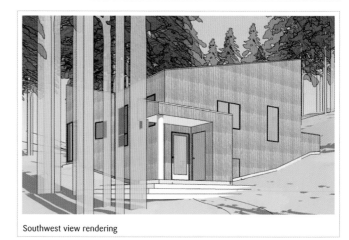

Southwest view rendering

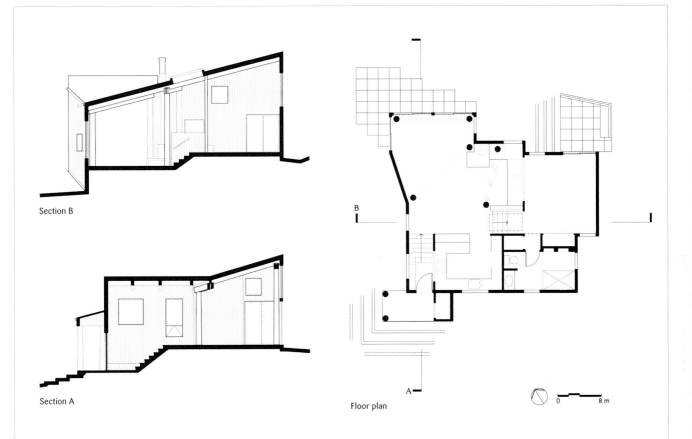

Section B

Section A

Floor plan

B

A

0 8 m

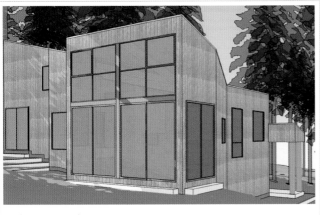

Northwest view rendering

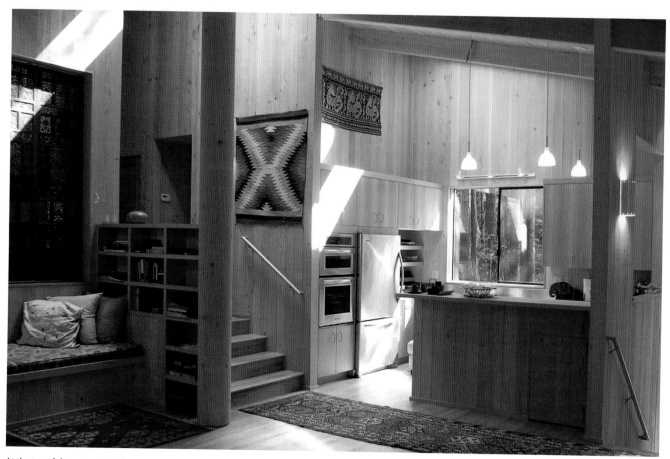

At the top of the main stairs, the space widens, creating a large living area with tall glass sliding doors. The round wood columns echo the verticality of the trees surrounding the cabin.

Wall section details

0 8 m

077

Glued laminated timber can be used wherever the sturdiness of steel or concrete is needed and is often chosen over the other two structural materials for its visual appeal and natural feel.

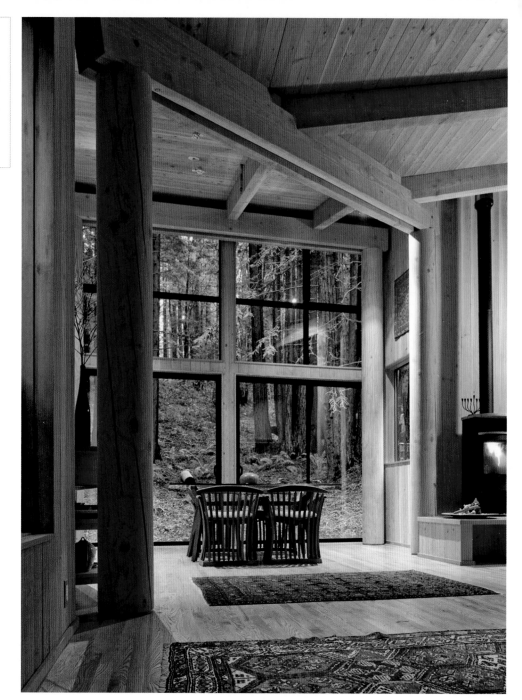

Strategically placed high windows and skylights can make a dramatic contribution to the aesthetic and light level of your mountain refuge, enlivening it with treetop views and constantly shifting light patterns.

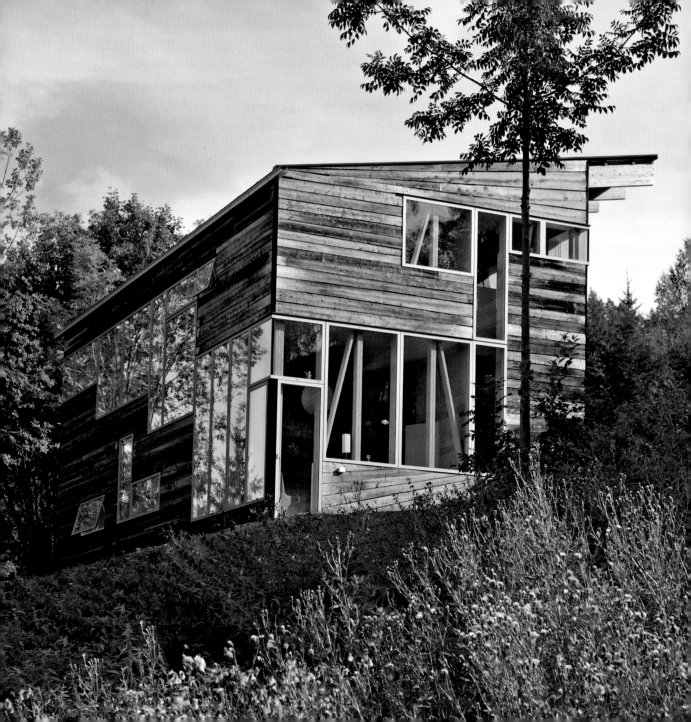

Farmhouse replaced an existing building in disrepair and no longer habitable. The old house was taken down, but the cladding, which was still in good conditions, was salvaged and reused in the new construction. The exterior walls of the new building form a mosaic of wood planks and glass, making the house ethereal and partially transparent. Despite the reduced size—only 1,780 square feet—Farmhouse feels spacious thanks to large expanses of glass that invite the gaze to go beyond the windows, into the surrounding landscape.

Farmhouse
1,780 sq ft

Jarmund/Vigsnæs
Toten, Norway
© Nils Petter Dale

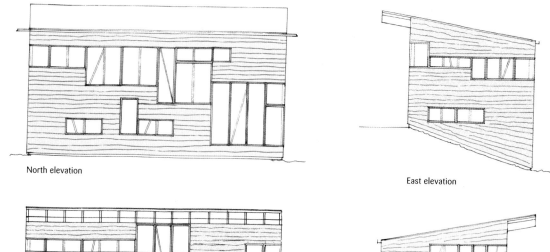

North elevation

East elevation

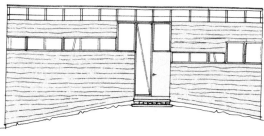

South elevation

West elevation

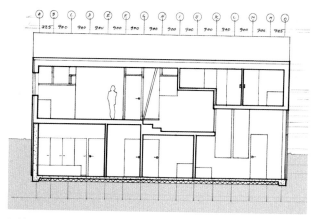

Building section

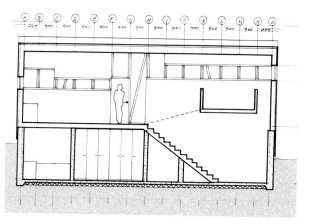

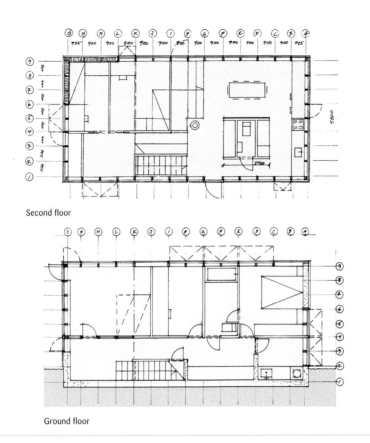

Second floor

Ground floor

The house was designed with the site's steep pitch specifically in mind. Because of the slope, the primary living spaces are located at the entry level, with the benefit of opening up to the sweeping valley views.

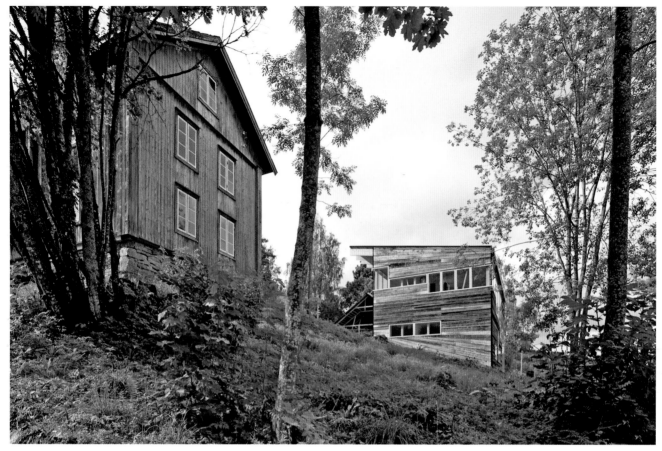

079

Reclaimed wood from old structures such as barns, factories, or even fences can be potential siding for a new building. Not only does the use of recycled wood add character to a new construction, it also promotes sustainable design.

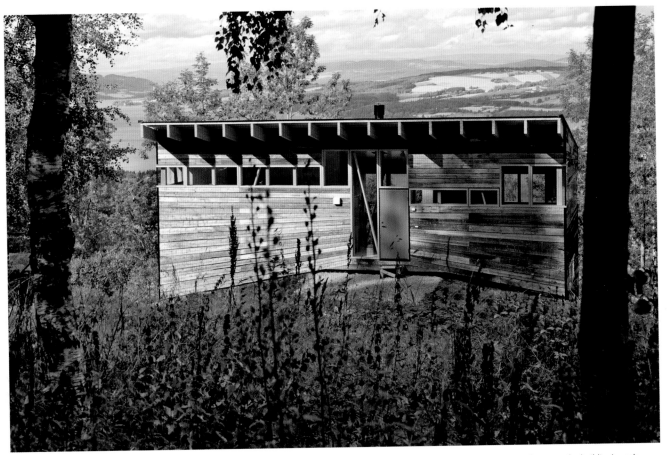

From the entry, the building's scale is modest and appropriate for the site. As the structure unfolds down the hill, though, surprisingly large spaces are revealed.

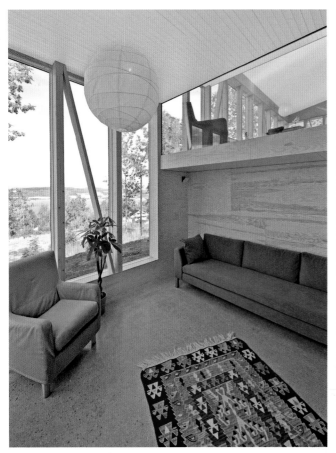

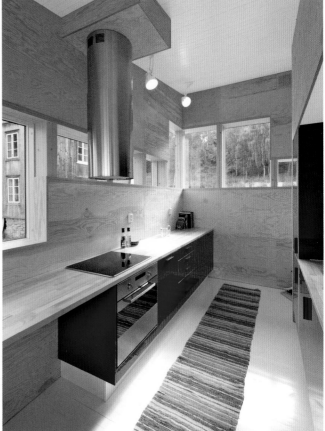

080

Built-in furniture creates a tailored finish, while helping to fill every last inch of available space, and maximizing its use. Built-ins also meet the users' specific needs, and maximize the house's unique design.

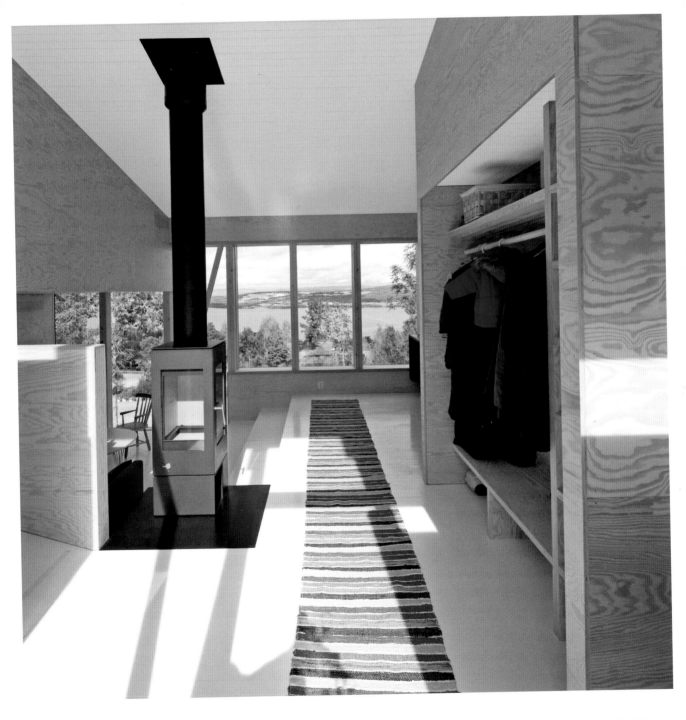

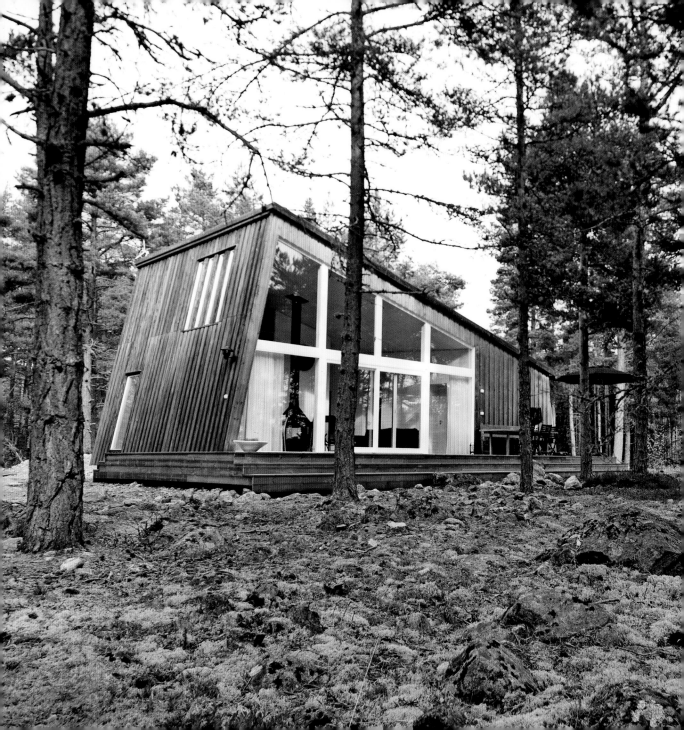

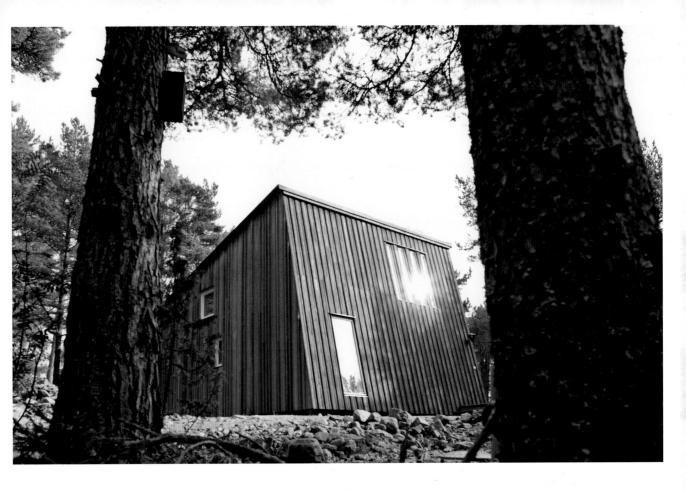

This is one of the twenty-two cabins of two different sizes—860 or 970 square feet—that have been built as part of a sea resort in an area that traditionally has been used as a camping site. Pine trees and sandy beaches serve as a backdrop to modern structures that boasts timber, glass, and white window frames accents. The natural stain of the wood cladding helps camouflage the cabins in their forested site. In all, the design focuses on enhancing the nature experience.

Hölick Sea Resort

861 sq ft

Mats Edlund, Henrietta Palmer, Matts Ingman | Form Arkitectur Mats Edlund

Hudiksvall, Sweden

© Jacob Nordström

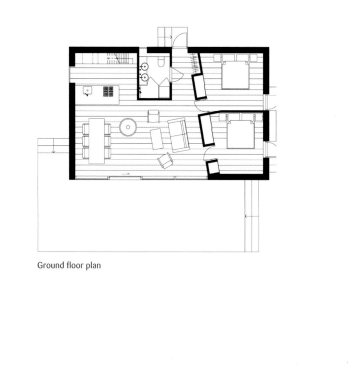

Ground floor plan

Loft floor plan

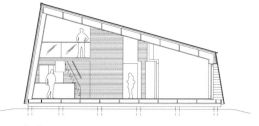

Section

The interior wall separating the
bedrooms from the living area is
at an angle to give the main room
more space and more light.

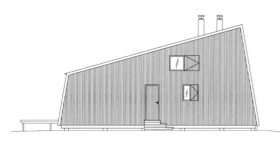

North elevation

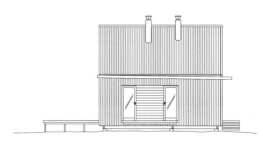

East elevation

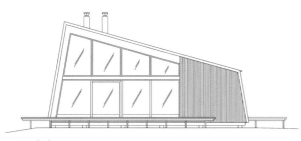

South elevation

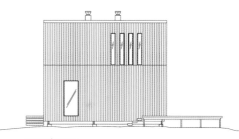

West elevation

Using Swedish traditional construction methods, the design of the cabins is inspired by the form of a camping tent. At the same time, the asymmetric shape reminds one of the distinctive features of a saltbox.

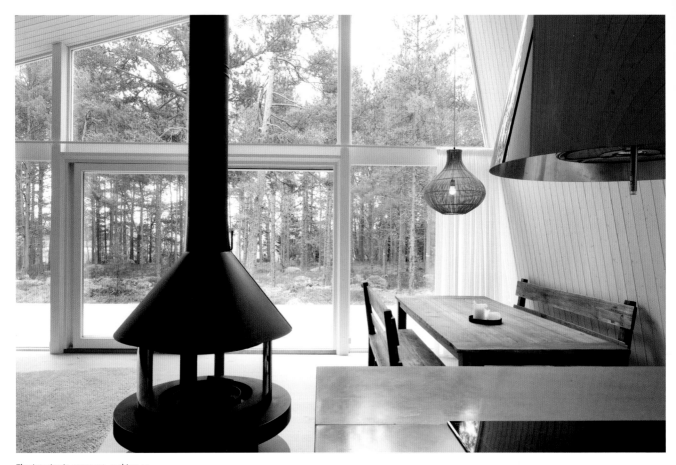

The interior is compact, making an
efficient use of the available space.
The full glass wall, tall ceiling, and white
paneling and flooring keep the space
bright and airy, while a wood-burning
stove creates a focal point, adding
warmth to the monochromatic interior.

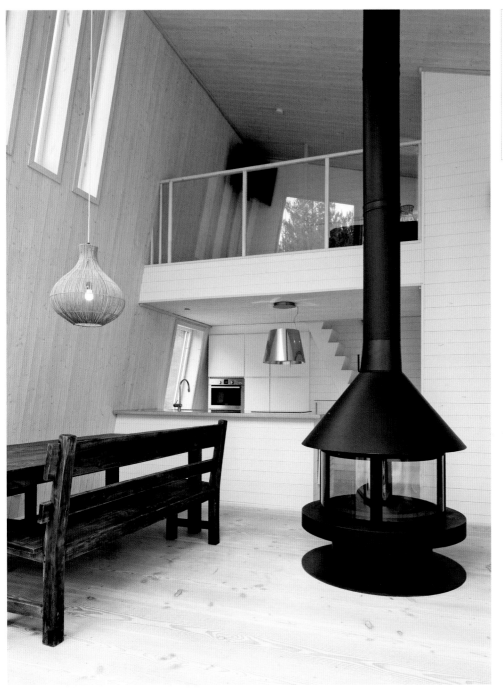

A black steel wood-burning stove can contribute to a relaxed atmosphere in modern and rustic-style cabins. In a Nordic-like minimal interior, the stove creates a cozy core, one that provides light from its crackling flames.

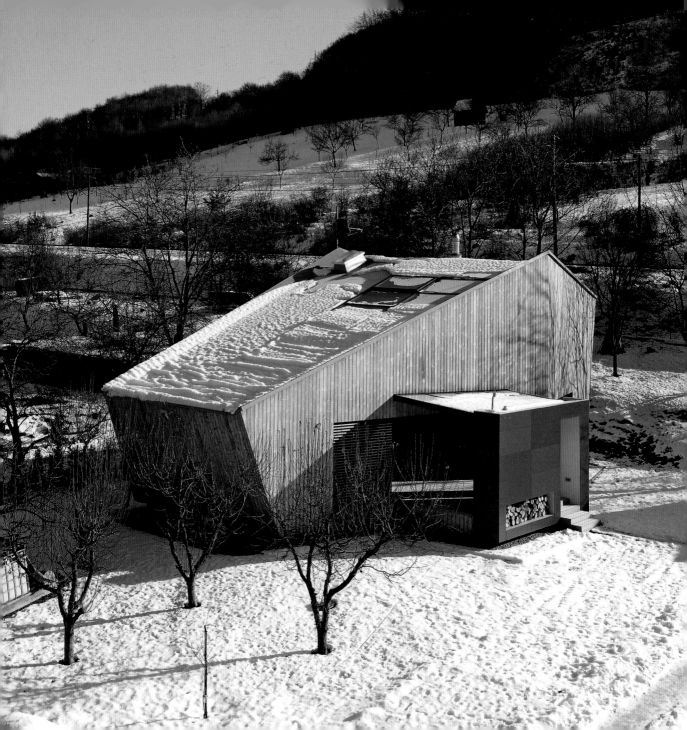

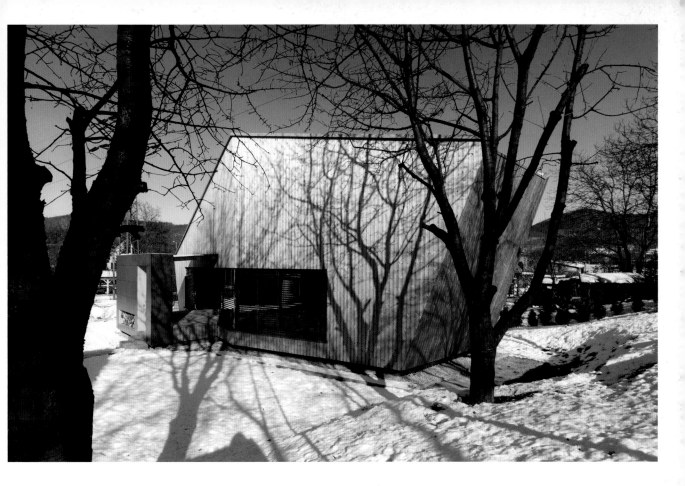

The client wanted a weekend retreat, but traveling long distances to a remote place didn't have the appeal that one would expect, considering that he commutes daily for work. After some considerations, the retreat was built just a stone's throw from the client's main residence, in the back of the same property. By creating a very close-by getaway, the client and his family have more time to relax and entertain.

Weekend House
1,400 sq ft

Pokorny Architekti
Nosice, Slovakia
© Dano Veselsky

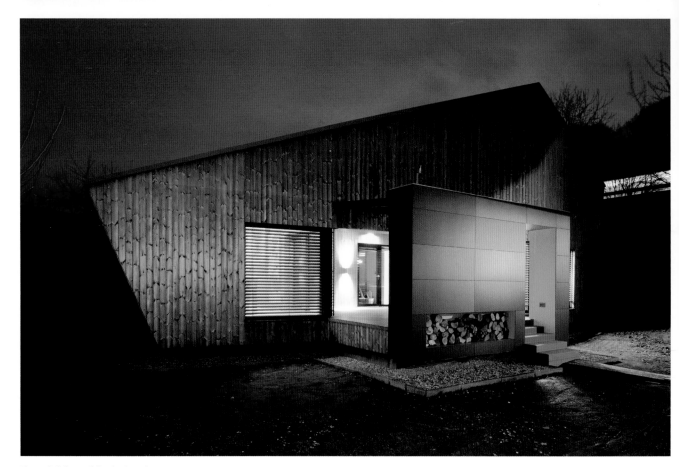

The stylish form of this backyard
getaway draws on the traditional
mountain cabins in central Slovakia
and on the archetypal saltbox house.

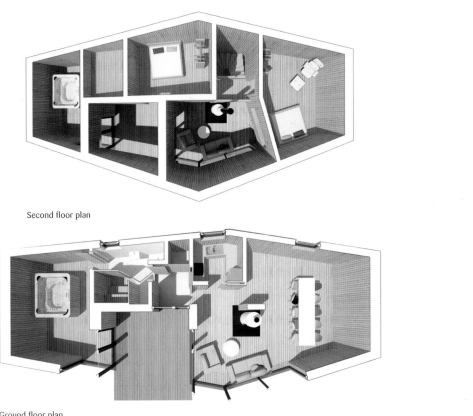

Second floor plan

Ground floor plan

The distinctive shape of the house dictates the interior. It has a two-story tall living space, two lofts for sleeping, and a sheltered outdoor area.

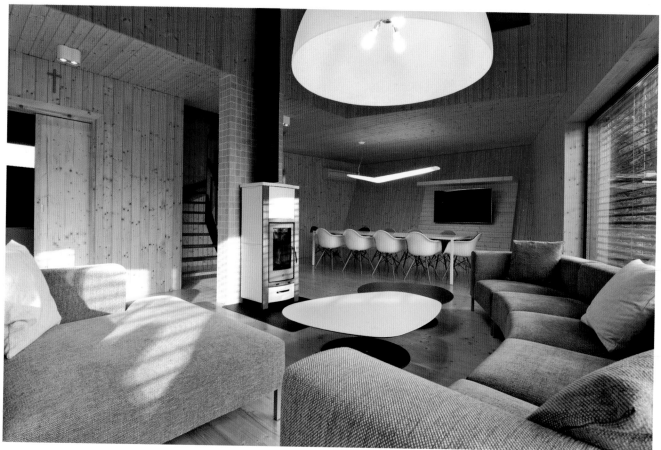

082

Furnish your getaway with
a welcoming, generous
seating area, one that will
help you enjoy family time
or gatherings with friends.

083

Sloped ceilings bring design challenges, but you can use potentially awkward angles to your advantage to create intimate spaces with activities and purposes in mind.

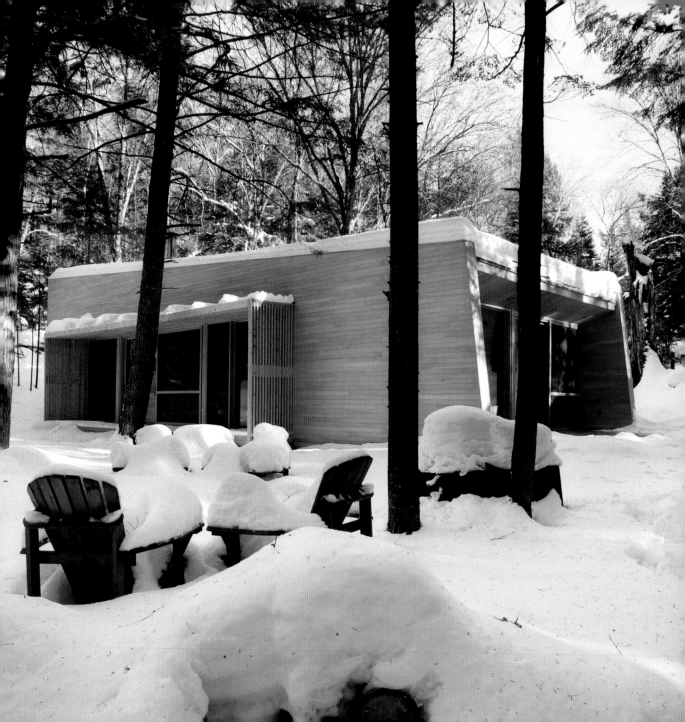

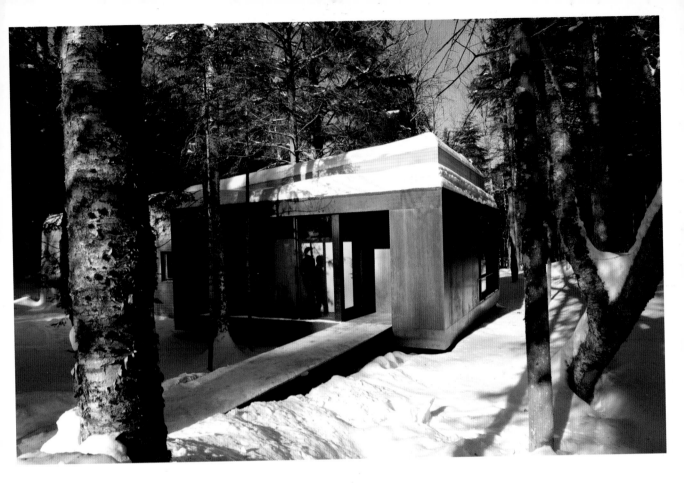

La Luge is a second home in the middle of a forest close to a ski resort. Its proximity to a ski slope might have inspired the cabin's shape, which can remind one of a *luge*, French for the small sled used in the winter Olympic sport of the same name. Surrounded by dense vegetation that preserves the house's seclusion, the building integrates a private spa occupying a third of the usable area. The spa's prominence supports the idea of the countryside cabin as a peaceful place to escape and relax.

La Luge
1,292 sq ft

YH2

Montreal, Quebec, Canada

© Francis Pelletier

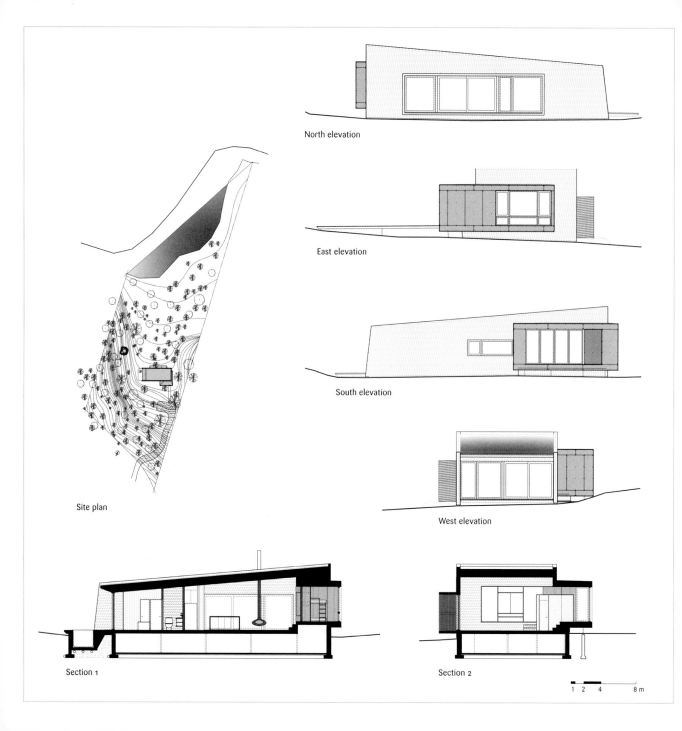

North elevation

East elevation

South elevation

West elevation

Site plan

Section 1

Section 2

1 2 4 8 m

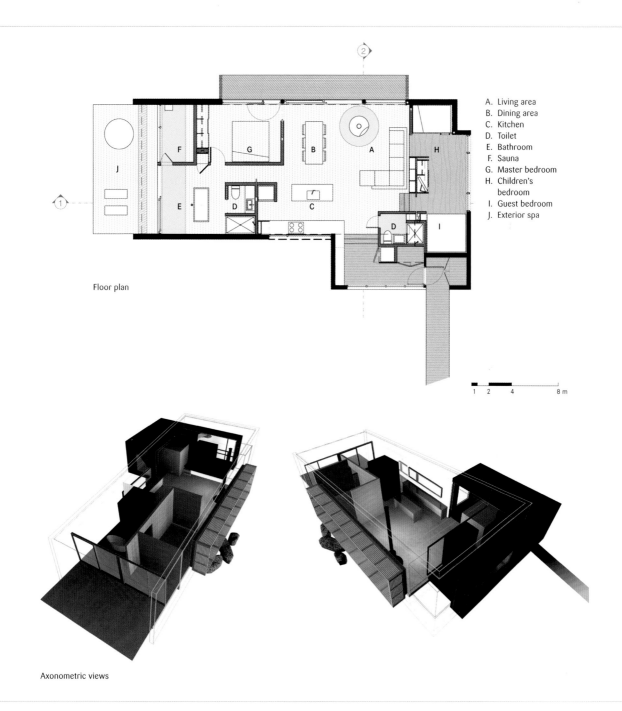

A. Living area
B. Dining area
C. Kitchen
D. Toilet
E. Bathroom
F. Sauna
G. Master bedroom
H. Children's
 bedroom
I. Guest bedroom
J. Exterior spa

Floor plan

1 2 4 8 m

Axonometric views

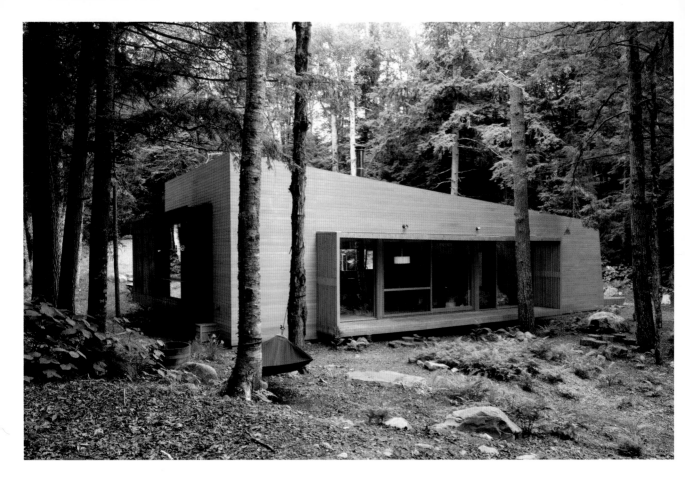

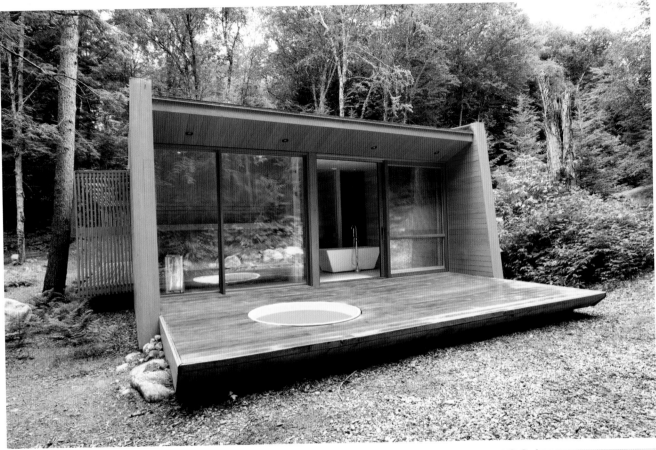

084

Outdoor patios and terraces
are extensions of a home,
adding to livable spaces.
They can be enhanced with a
fireplace, an outdoor kitchen,
or a Jacuzzi.

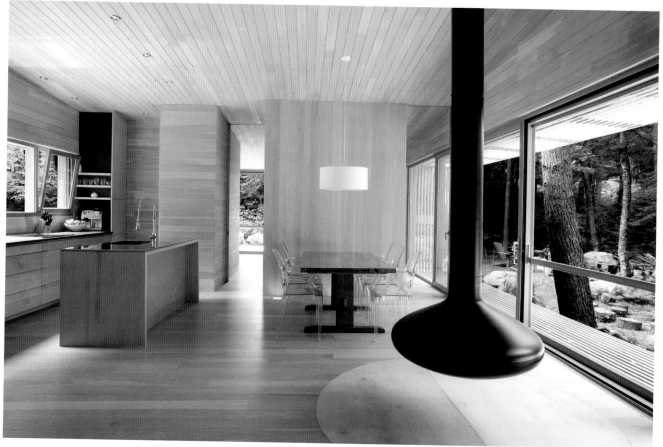

085

Similar finishes and colors chosen throughout a home create a unified décor. In the context of this mountain cabin, the extensive use of wood facilitates the integration of the kitchen island into the main level's open plan.

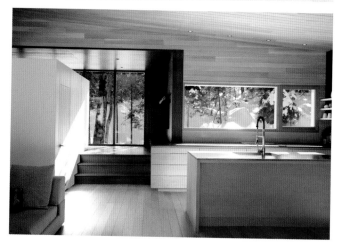

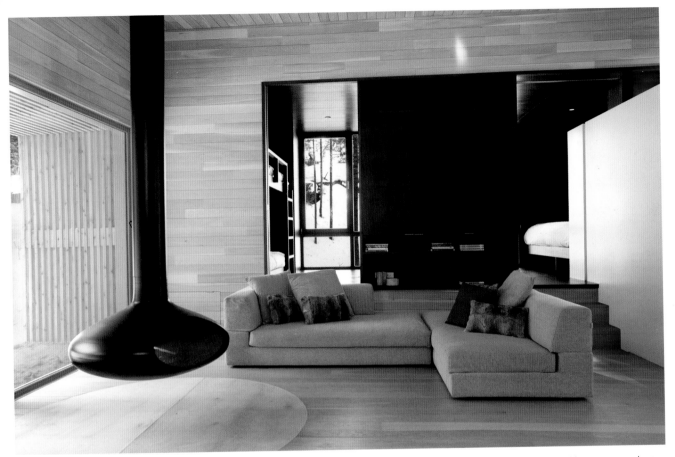

A hanging wood-burning stove takes center stage in the living area. It doesn't take up floor or wall space, and it also adds a stunning accent to this contemporary cabin.

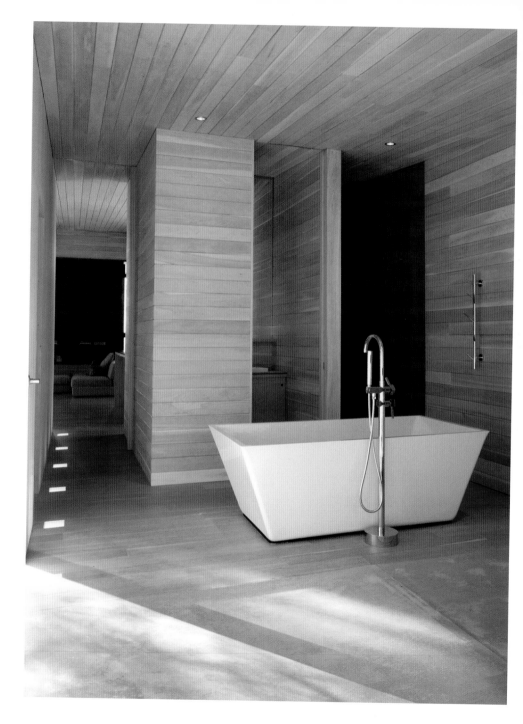

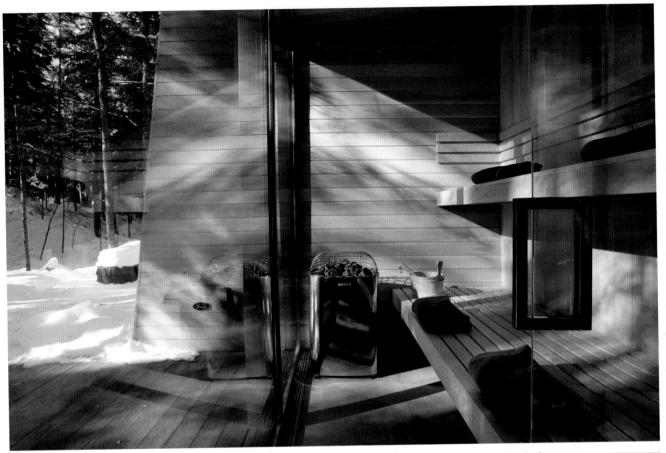

086

A sauna facing a beautiful natural setting is the epitome of body and mind rejuvenation. It imparts a feeling of Nordic genuineness and comfort, blending unique design and ecological values.

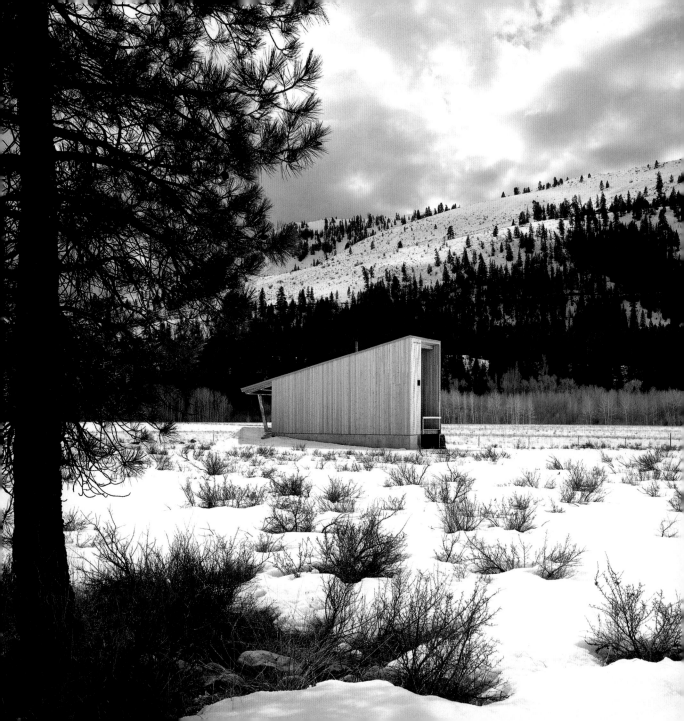

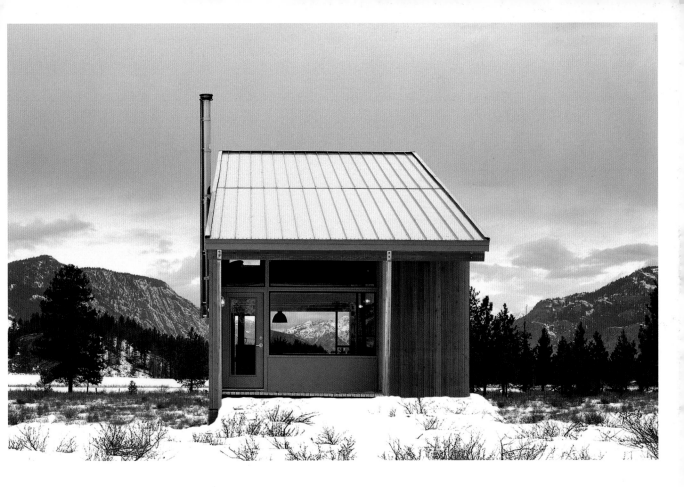

Methow Cabin, which can accommodate up to eight people, serves as a base for cross-country skiing and mountain biking. This small retreat sits in the meadow of a valley floor, and there are expansive openings at each end of the structure to capture the views. The roof echoes the slope of the hills beyond and creates both a protected entry porch that shields the living spaces from the road at the low end and a sleeping loft at the high end. There are no breaks in the roof, and the simple form eliminates ridges and dips that would be susceptible to leaks.

Methow Cabin
1,175 sq ft

Eggleston|Farkas Architects

Winthrop, Washington, United States

© Jim Van Gundy

Preliminary Design Sketch

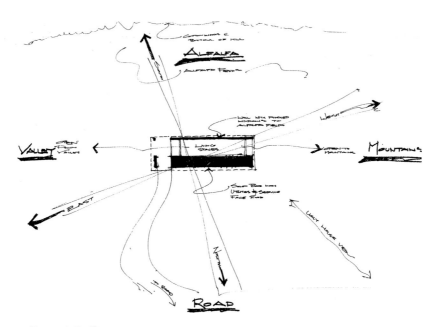

Diagramatic Site Plan

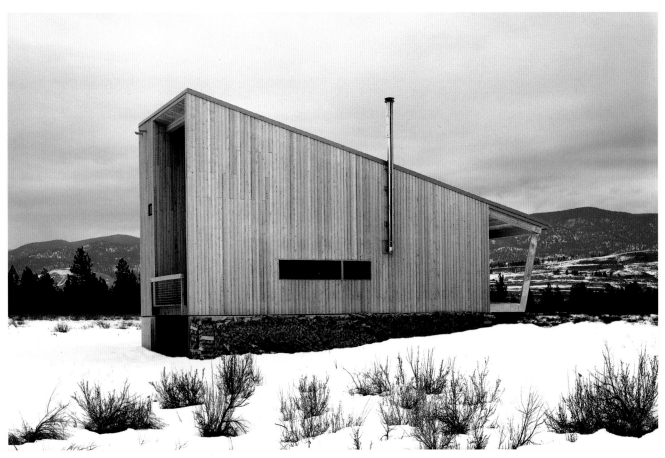

087

The shed roof allows snow to slide off easily. Simplifying the roof form, which eliminates ridges and valleys, as well as limiting roof breaks, reduces the risk of leaks.

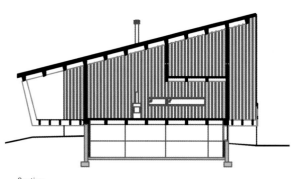

Section

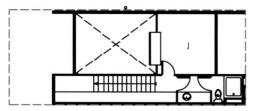

Upper level floor plan

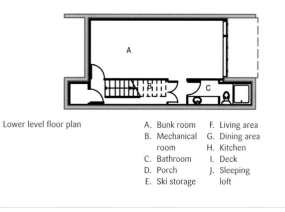

Lower level floor plan

A. Bunk room
B. Mechanical
 room
C. Bathroom
D. Porch
E. Ski storage

F. Living area
G. Dining area
H. Kitchen
I. Deck
J. Sleeping
 loft

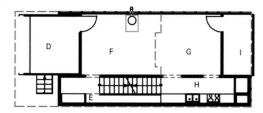

Main level floor plan

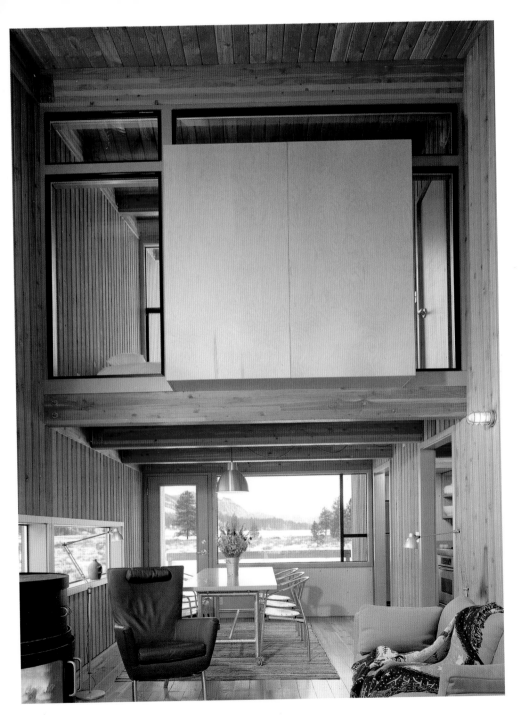

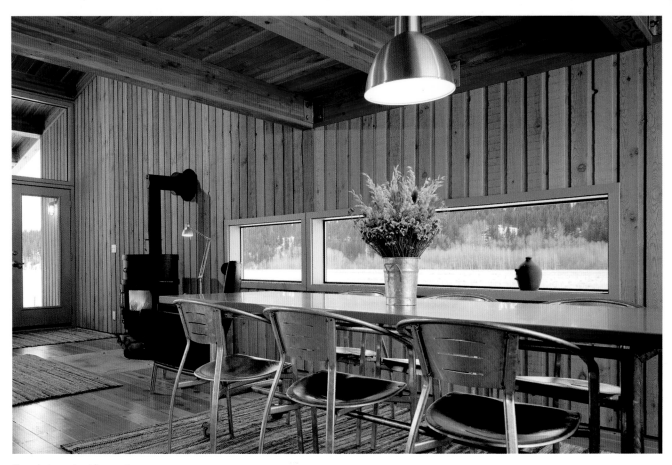

The exterior cedar siding continues
through the living spaces to create
a continuum of interior and exterior
space. Steel details were designed
for ease of fabrication by local
agricultural welders.

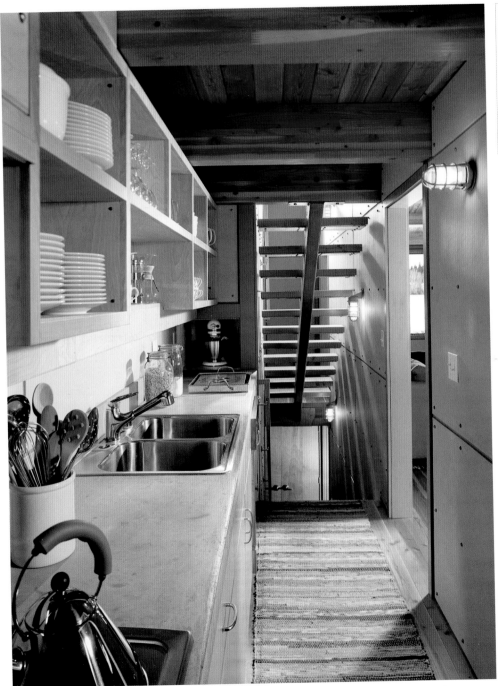

Glued laminated timber, known as glulam, combines engineered strength and the beauty of a natural material. Thanks to its structural qualities, glulam can span long distances.

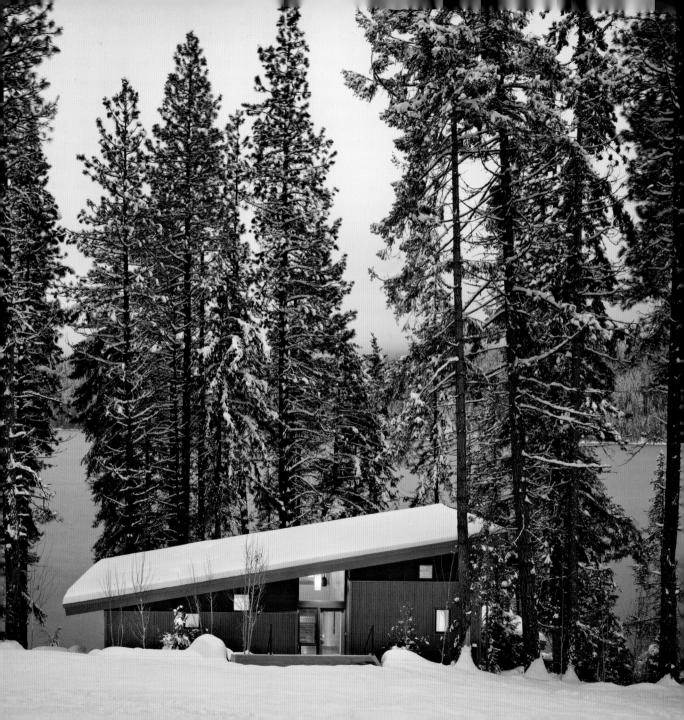

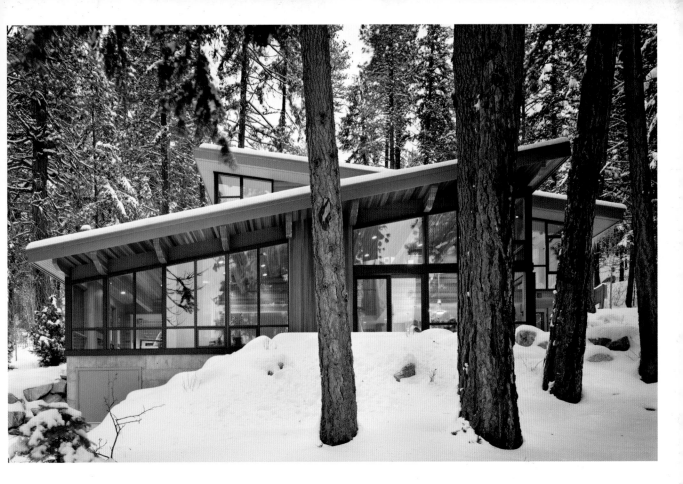

A thorough site analysis was the initial step that allowed key views and natural features to influence this modern cabin's design. The site, as the architect saw it, "is a series of landscape layers and the house is a collection of simple volumes emerging from them—almost like geological rock formations." Client input was critical for the development of the project. The result is a simple, yet unique retreat that focuses on the enjoyment of the surrounding landscape and family time.

Lake Wenatchee residence
2,890 sq ft

DeForest Architects

Winton, Washington, United States

© Ben Benschneider

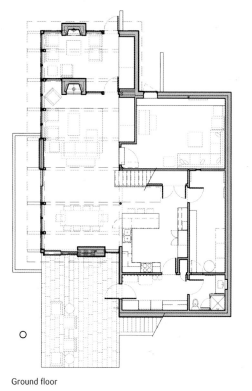

Ground floor

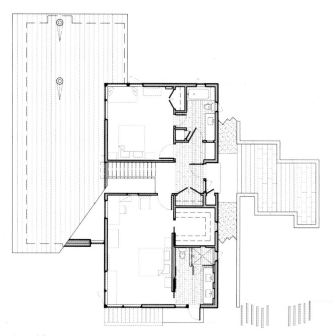

Second floor

089

Based on the client's idea that the house should be conceived as a "series of stops along a trail," the house is composed of two parallel sections, stepping down the hill, and opening toward different views.

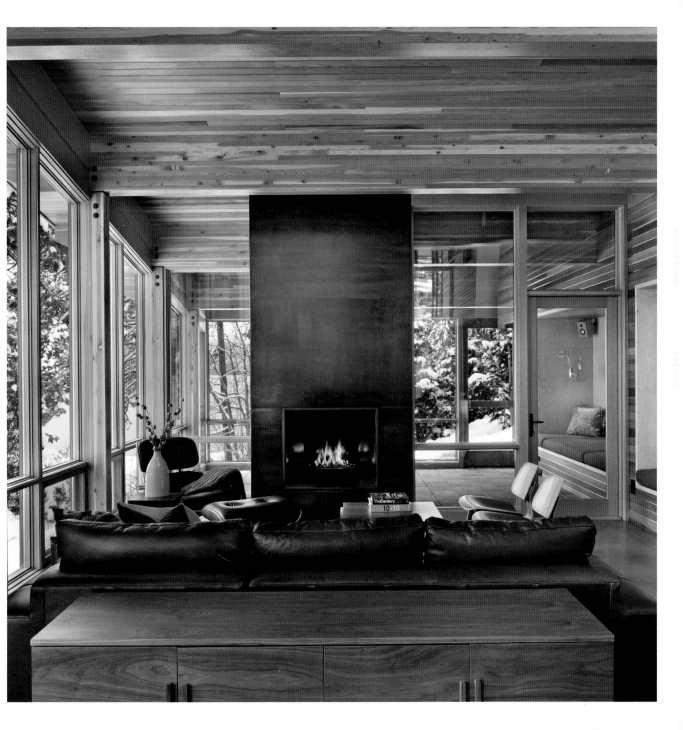

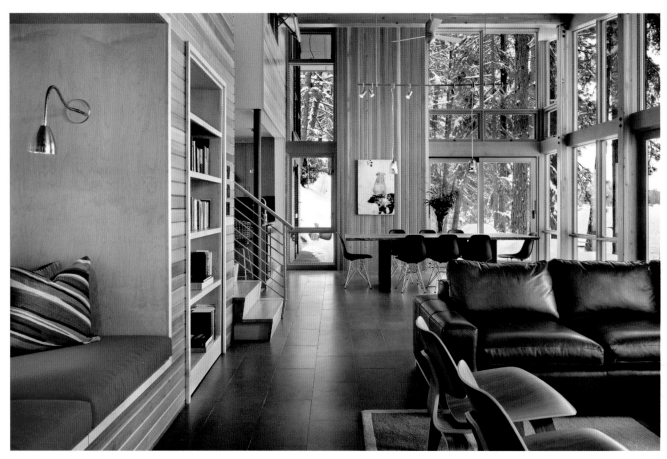

090

Banquette benches can boost
seating capacity and add
storage space below the seat.
A banquette can also double
as a cozy reading alcove or
as an occasional guest bed.

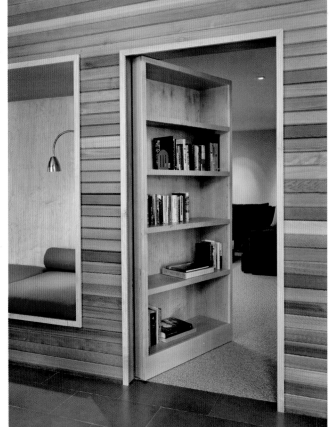

091

Bookshelves nestled in doors are a playful yet functional design idea. They expand your storage space while they also camouflage a door leading to a guest bedroom or a secret retreat.

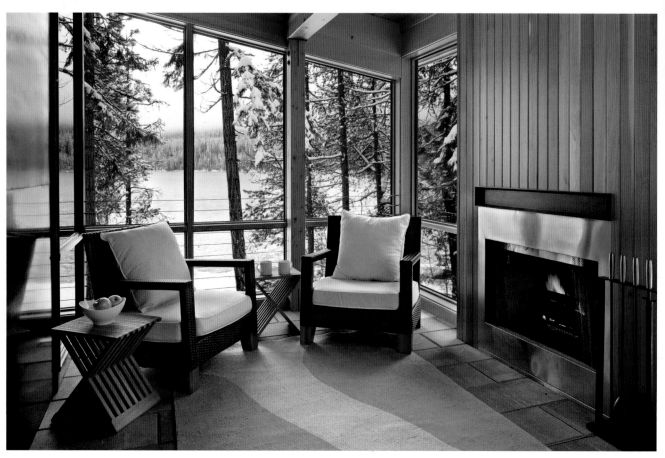

092

Consider how your color and
material selection will blend
with the colors and textures
of the surrounding landscape.

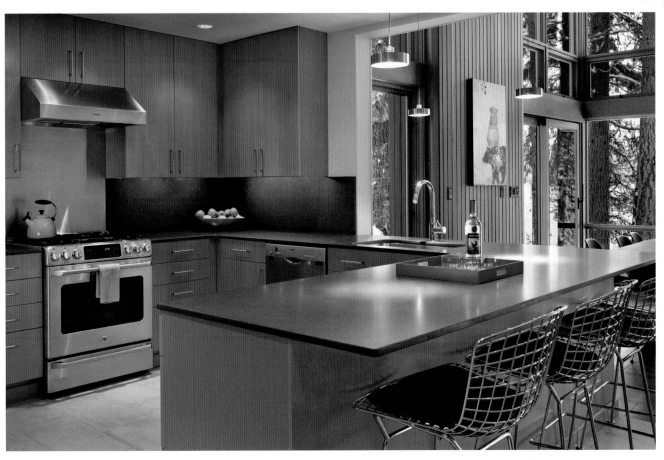

The kitchen is equipped with all the props necessary for an extended stay at the cabin. It boasts wood cabinets that blend with the rest of the space. Other kitchen components include durable, low-maintenance tile, stone, and composites.

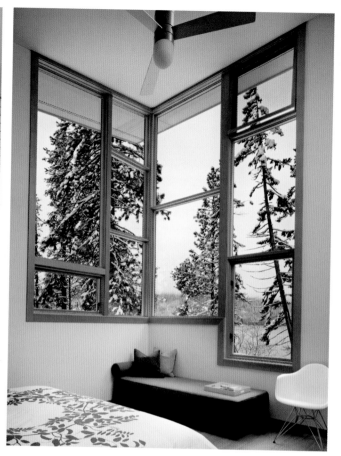

093

Sleeping lofts are as much great space savers—taking full advantage of a room with a tall ceiling—as they are playful spaces, ones where kids will want to spend time.

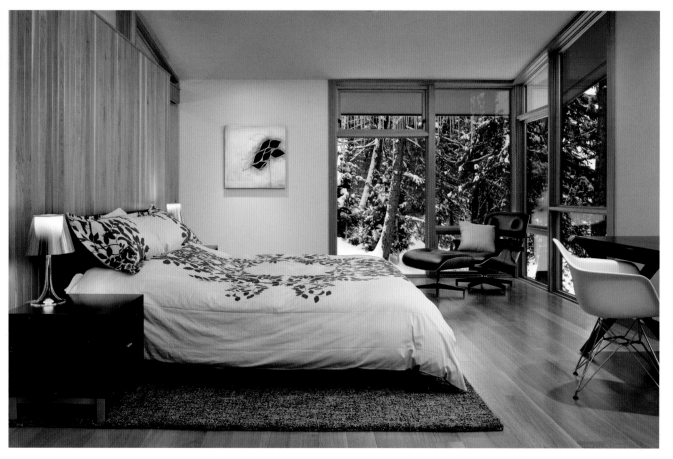

The floor-to-ceiling windows framing views of the trees canopy, transom windows, and wood paneling combine with the smooth hardwood floor and tall ceiling to give the master bedroom a modern but rustic feel.

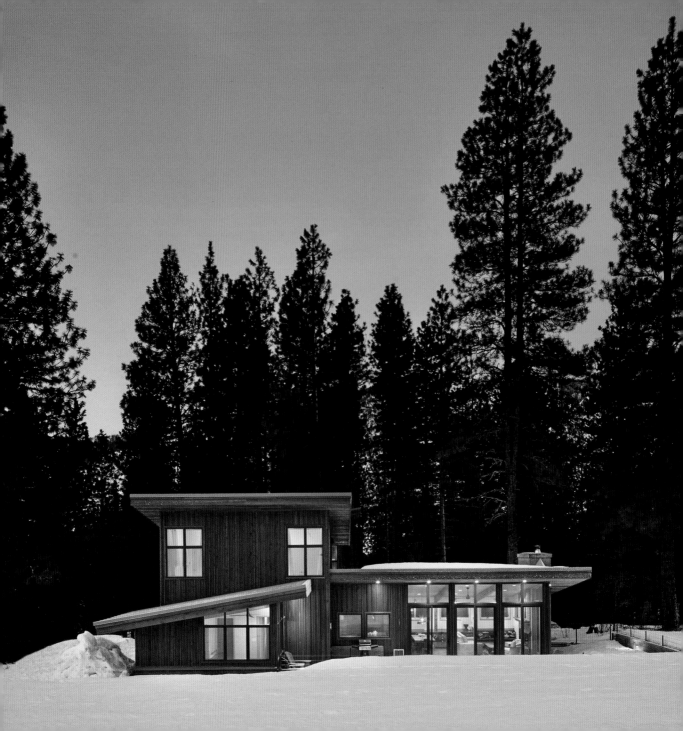

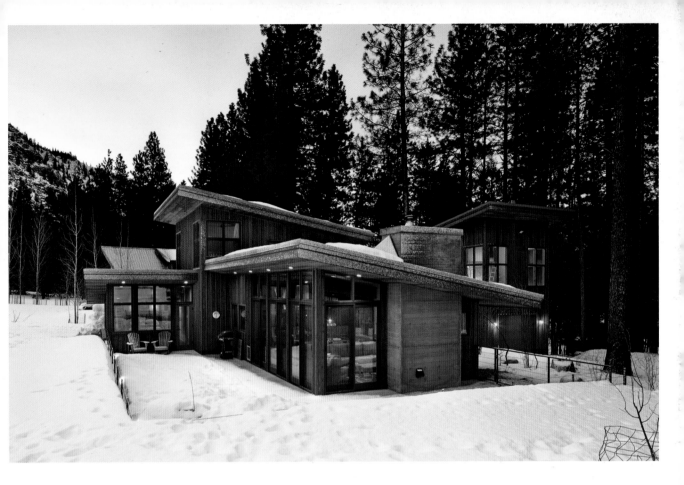

A splendid landscape stretches in all directions from this cabin located at the edge of a meadow. It has views to the north across the grassland and to the west to the nearby mountains. The structure is sunk into the ground to keep the profile from the meadow low and to provide a sheltered courtyard. In all, Homestead Cabin fits into the setting as if it was meant to be there and nowhere else.

Homestead Cabin

1,713 sq ft

Lawrence Architecture

Cascade Mountains, Washington, United States

© Benjamin Benschneider

North elevation

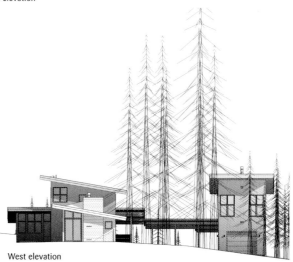

East elevation

South elevation

West elevation

0 4 8 ft

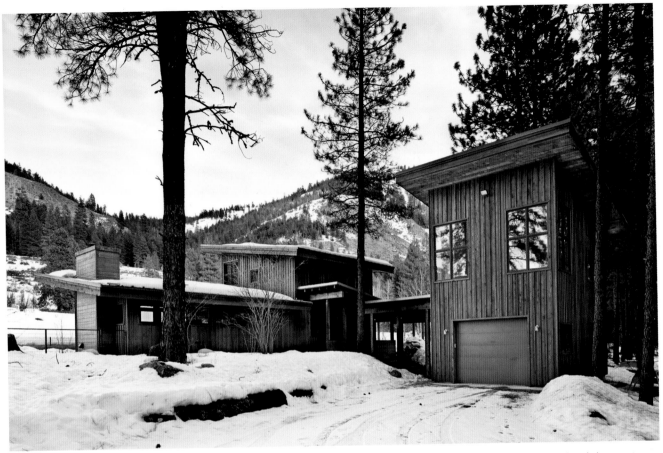

Building materials include concrete
retaining walls and chimney; stained,
insulated, concrete slab-on-grade floors;
engineered wood framing; recycled
exposed framing and wood finishes;
metal-clad wood windows and doors;
and metal roofing.

Shed roofs open the building to views and direct snow away from doors and windows during the winter. The broad overhangs provide shade during the summer.

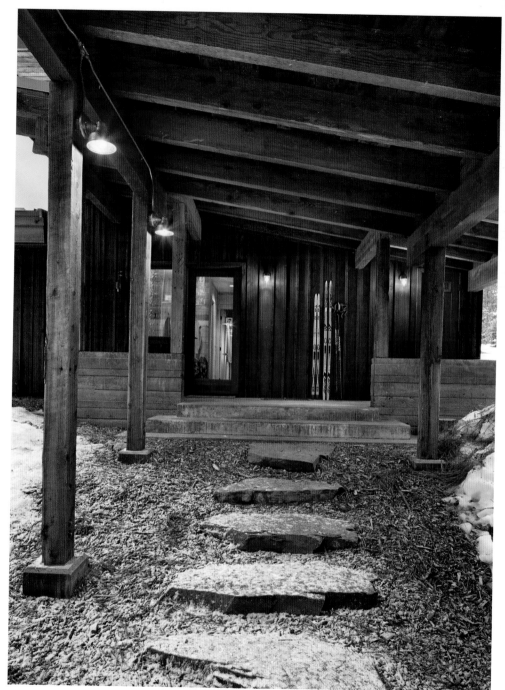

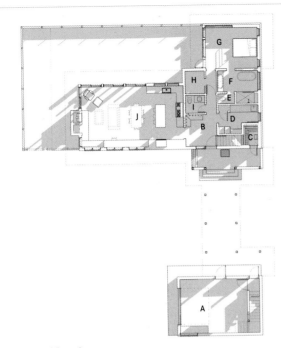

Ground floor plan

A. Garage
B. Entry
C. Sauna
D. Laundry room
E. Toilet

F. Master bathroom
G. Master bedroom
H. Walk-in closet
I. Powder room
J. Main room

K. Apartment
L. Bathroom
M. Hall
N. Bedroom

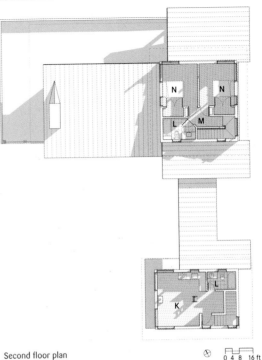

Second floor plan

0 4 8 16 ft

The garage is an independent building, connected to the cabin by a breezeway. Above the garage, there is a living unit with a separate entrance. It provides a measure of privacy and independence for occasional visitors.

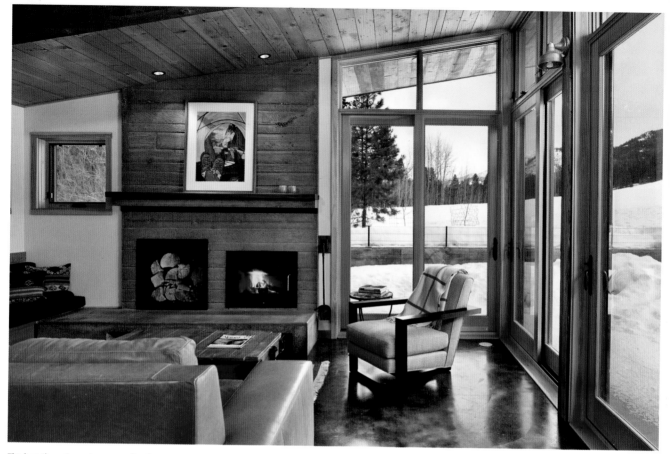

The heavily patterned concrete fireplace ties in with the concrete flooring, and, at the same time, harmonizes with the wood-clad ceiling and wood windows.

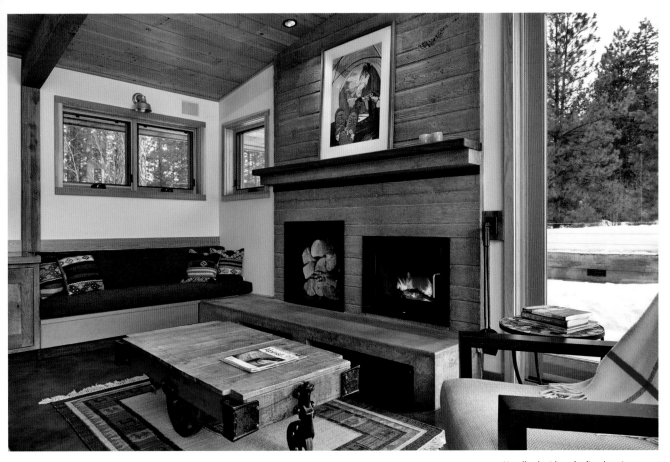

Usually, the idea of a fireplace in a cabin conjures images of rustic wood or stone constructions. A fireplace in a modern retreat doesn't mean that coziness is sacrificed.

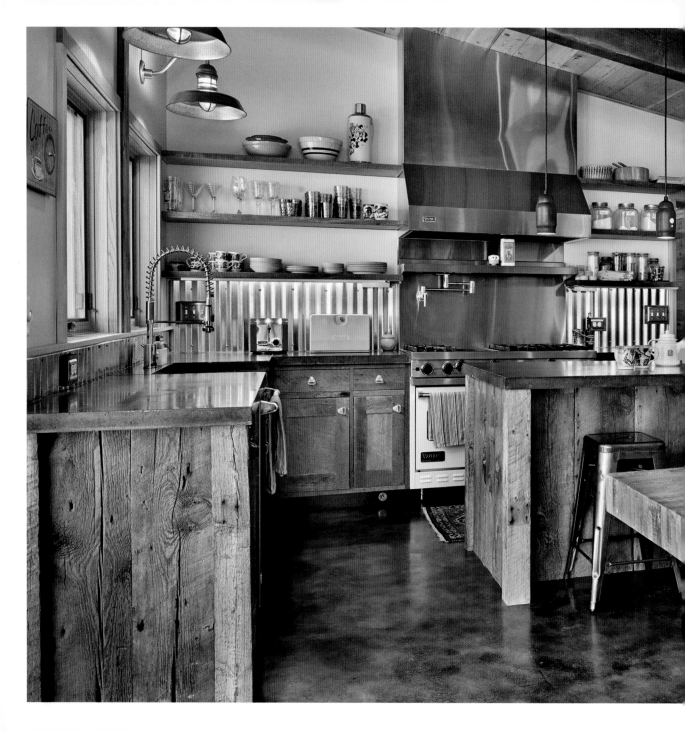

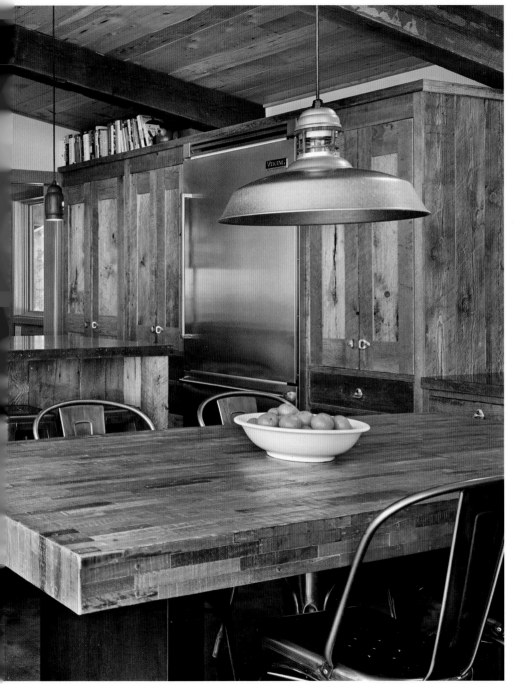

The combination kitchen and dining area is warm and inviting. The space boasts the rustic charm of recycled wood as well as the modern appeal of contemporary finishes such as stainless steel and polished concrete.

094

Reclaimed wood adds a layer of history to a home. It is suitable for cladding or building furniture, but you might want to talk with a structural engineer before you use reclaimed wood to build anything structural.

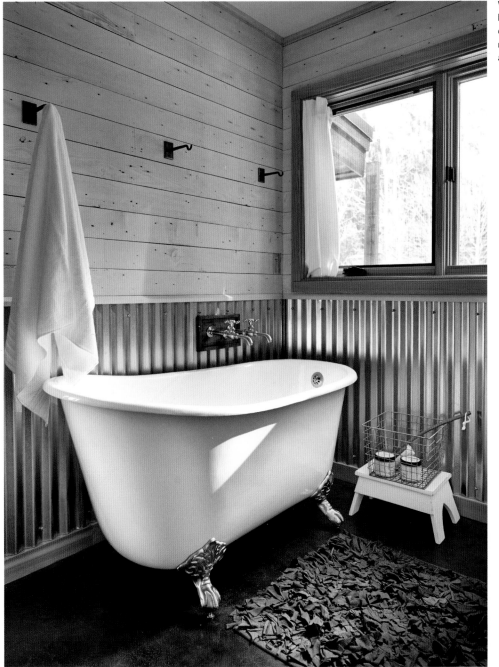

With an interesting combination of horizontal siding above a wainscot of corrugated metal, the bathroom maintains the same level of detail as the other rooms of the cabin.

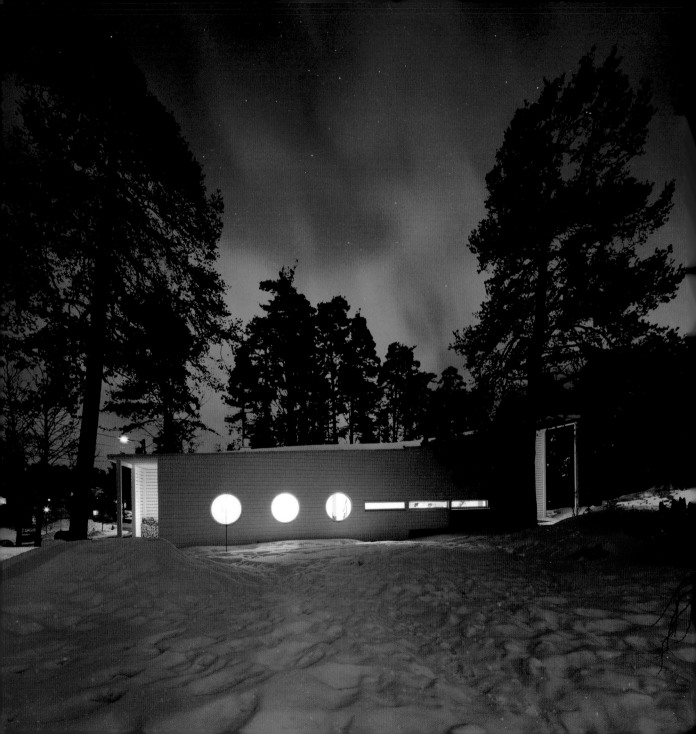

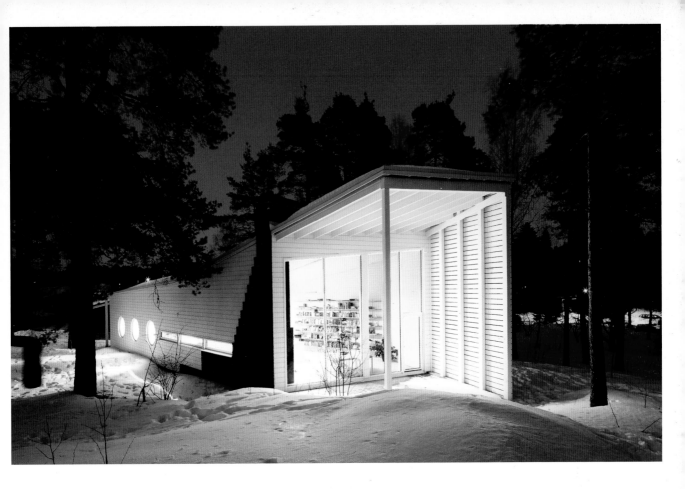

A maritime theme infuses the design and building method of this cabin. Two carpenters specializing in the construction of wooden boats were hired to assemble the wooden structure, implementing traditional Finnish carpentry and craftsmanship. This vessel-like retreat is "anchored" in a sheltered, rocky harbor surrounded by trees. A large glass entry and portal windows invite in the outdoors.

Wood Boat House Apelle
1,506 sq ft

Casagrande Laboratory

Karjaa, Finland

© AdDa Zei

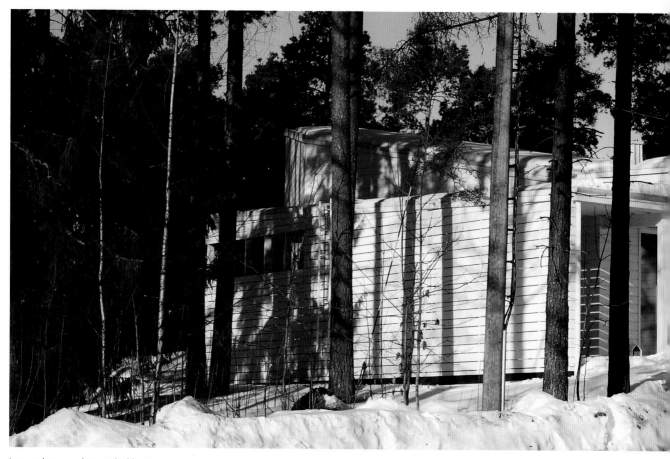

Long and narrow, the main building is structurally supported by a smaller side section—almost like an outrigger, which enhances the maritime design.

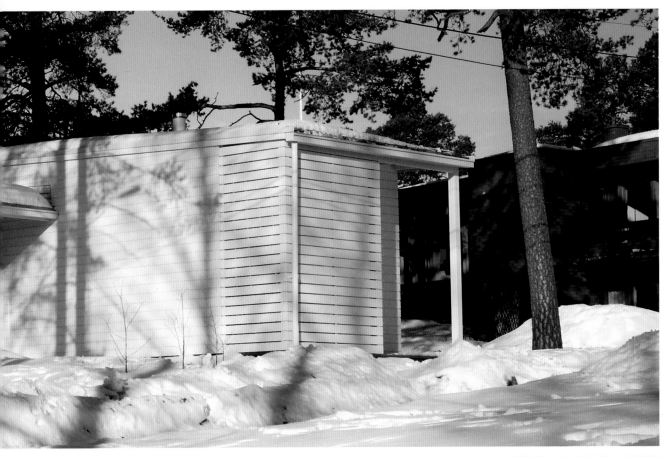

095

Wood can be used in a tongue-and-groove construction for a solid building exterior. It can also be used in slats to let in light and air.

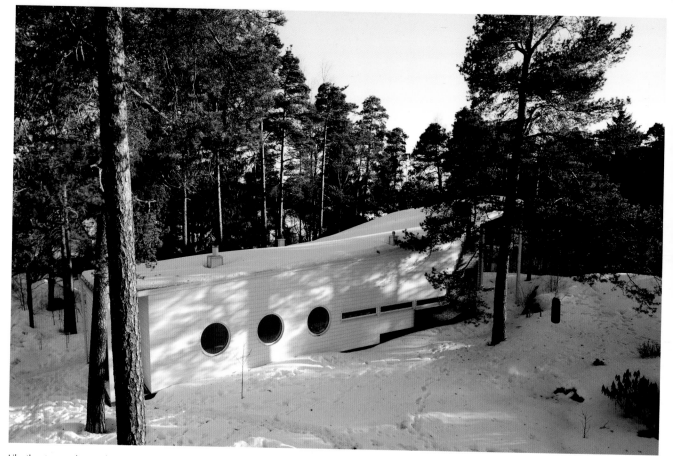

Like the structural masts between ship decks, a metal stove pokes through the roof of the cabin. Three circular windows support the ship motif.

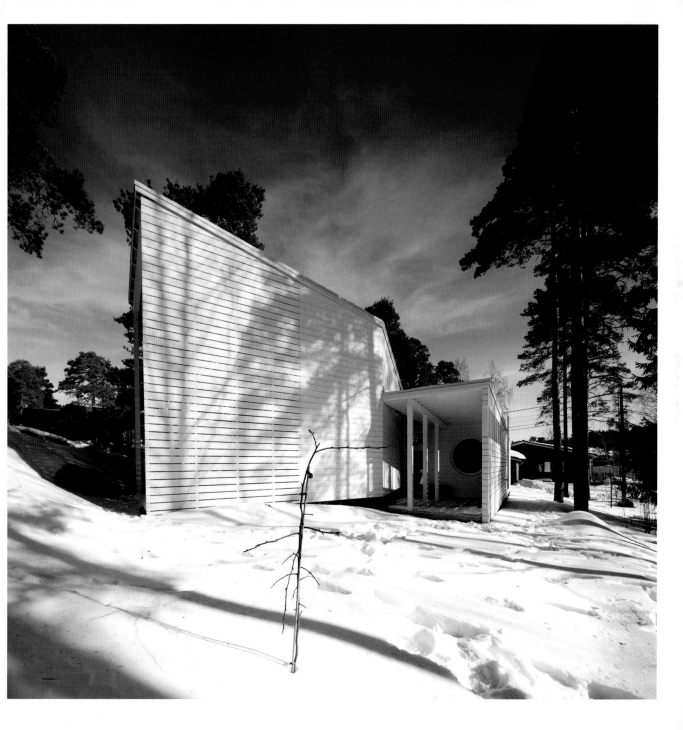

Section

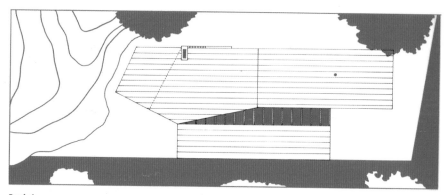

Roof plan

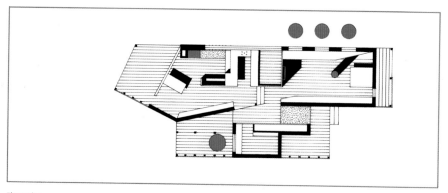

Floor plan

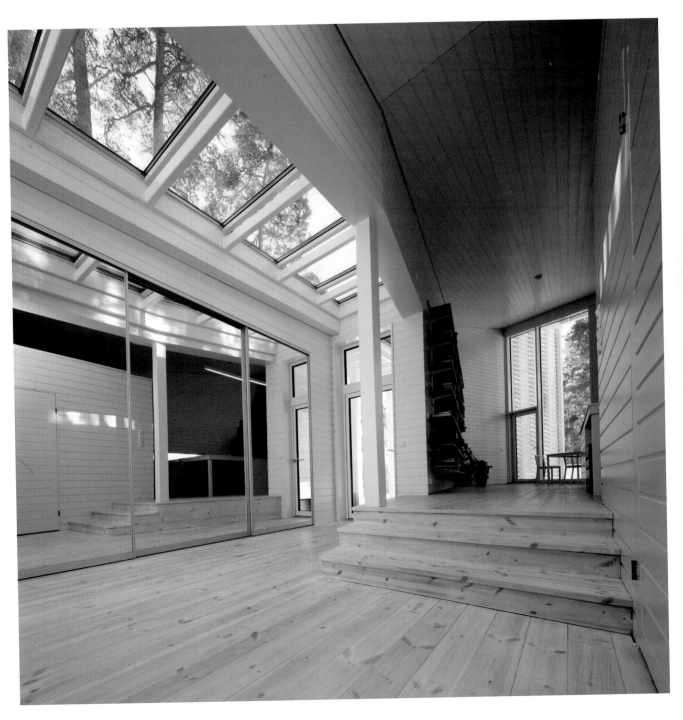

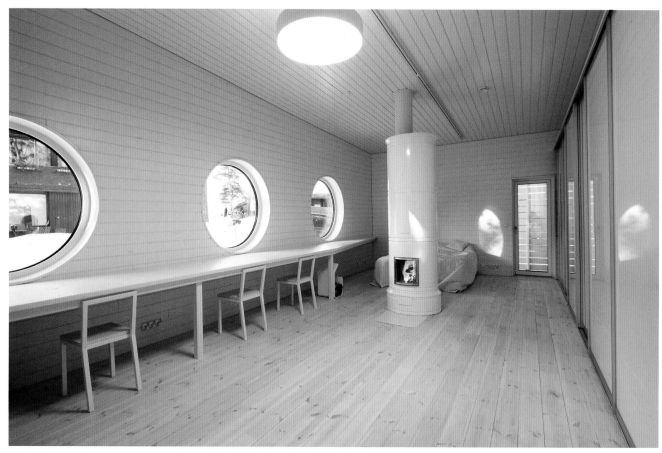

096

Fireplaces are often focal points around which traditional living functions are organized. In this mountain cabin, a wood-burning stove separates the sleeping area from a long desk lining the wall with the portal windows.

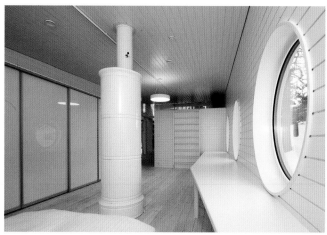

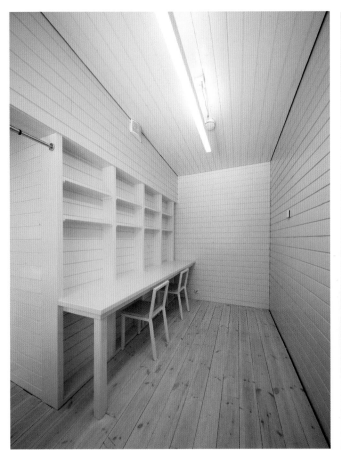

A small spa can be a good addition to a mountain or waterside cabin, adding comfort to your stay—especially after a long day hike.

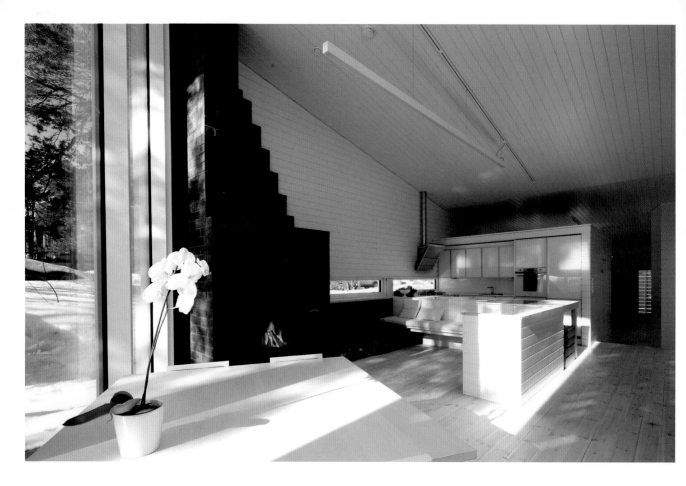

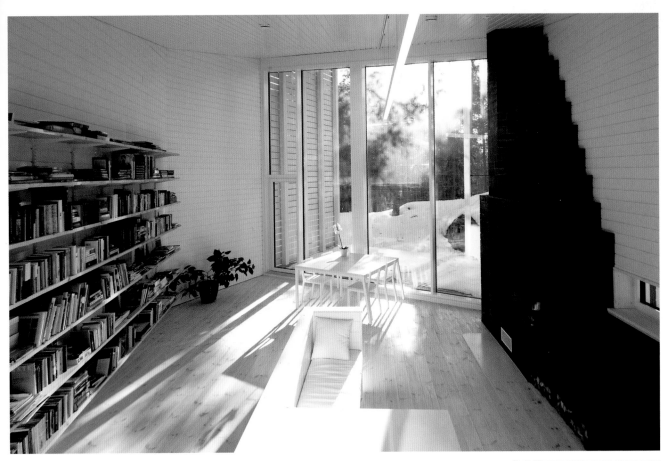

097

Solar orientation is critical
to make the most of natural
daylight, which can be used
for passive heating and
cooling. Living areas should
be north-facing to benefit from
as much sunlight as possible.

Flat and Custom Roofs

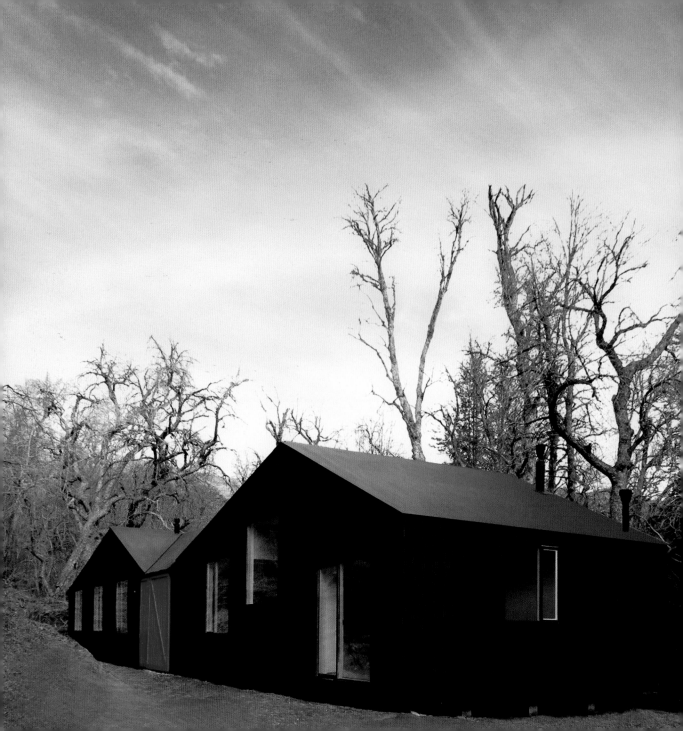

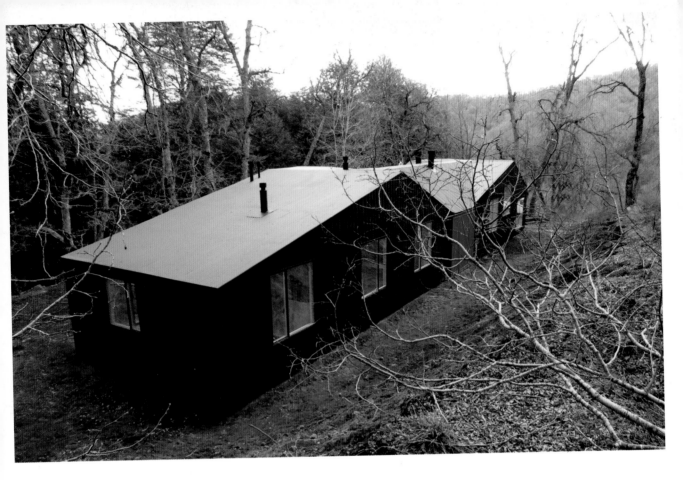

A clearing in a forested area in the Andes was the site chosen for the construction of an all-year-round shelter for a family. The site is an ancient woodland with difficult access. This context and the study of existing sheds found in the area determined the proportions and shape of the construction. As a result, MR House is a simple building where the roof acts as a shell protecting three habitable sections.

MR House
1,927 sq ft

MAPA

El Buchén, Maule, Chile
© MAPA

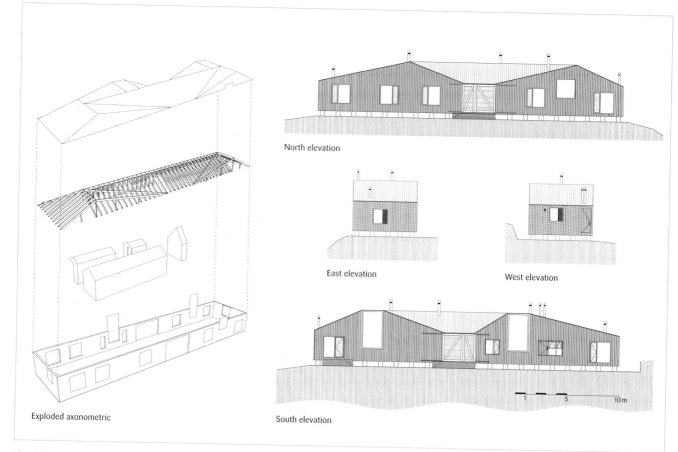

North elevation

East elevation

West elevation

South elevation

1 5 10 m

Exploded axonometric

The shelter contains a series of spaces
that progressively make the transition
between exterior and interior.

Section E-E'

Section F-F'

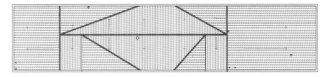

Section G-G'

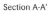

Section A-A'

Section B-B'

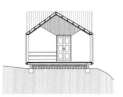

Roof plan

Section C-C'

Section D-D'

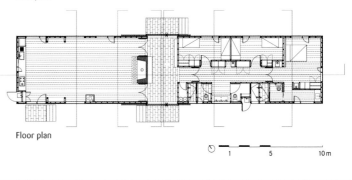

Floor plan

1 5 10 m

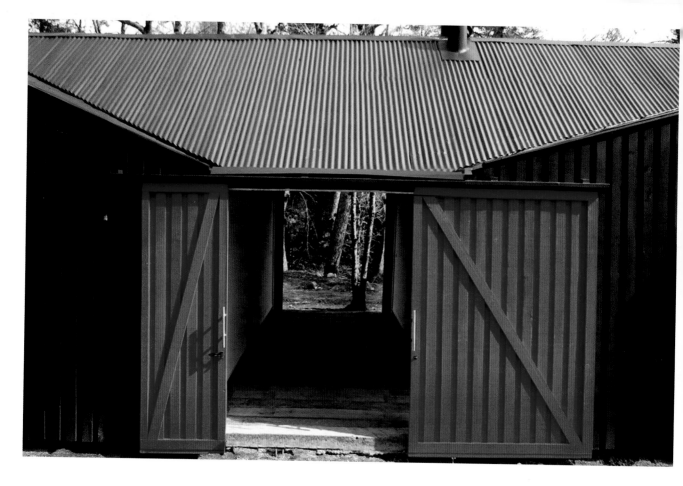

Porches and sheltered terraces are climate-control barriers allowing cross ventilation during warm weather and acting as an additional layer of thermal insulation during cold weather.

A large interior space under a pitched roof contains the living/dining area and kitchen and a playroom with a fireplace.

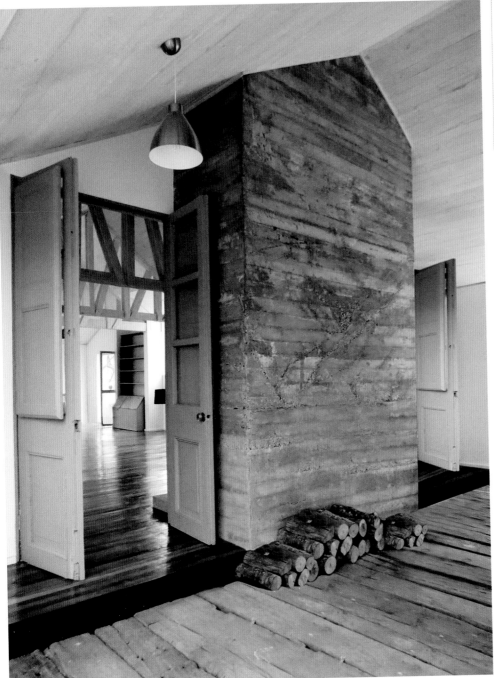

Board-formed concrete offers a fine-grained wood texture, which is very decorative. This concrete form imbues the space with an industrial look, while providing the warm tone of wood.

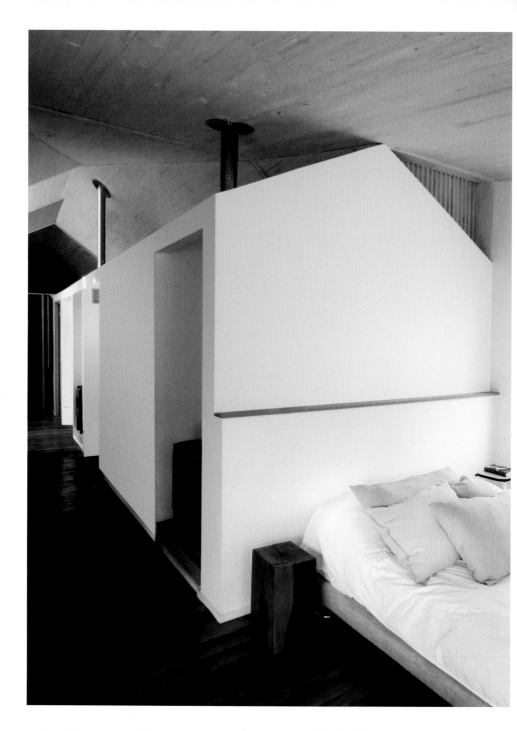

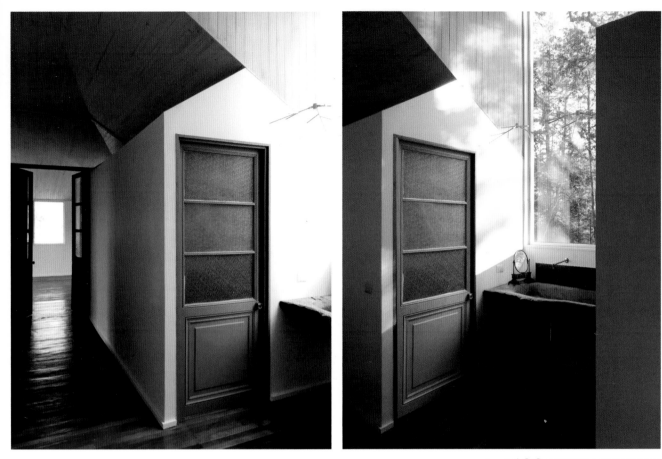

100

For a seasonal home, choose low-maintenance materials and finishes that are durable and age well. Decoration should be simple, but comfortable. Use sturdy, no-fuss materials to help maximize enjoyment of your vacation time.

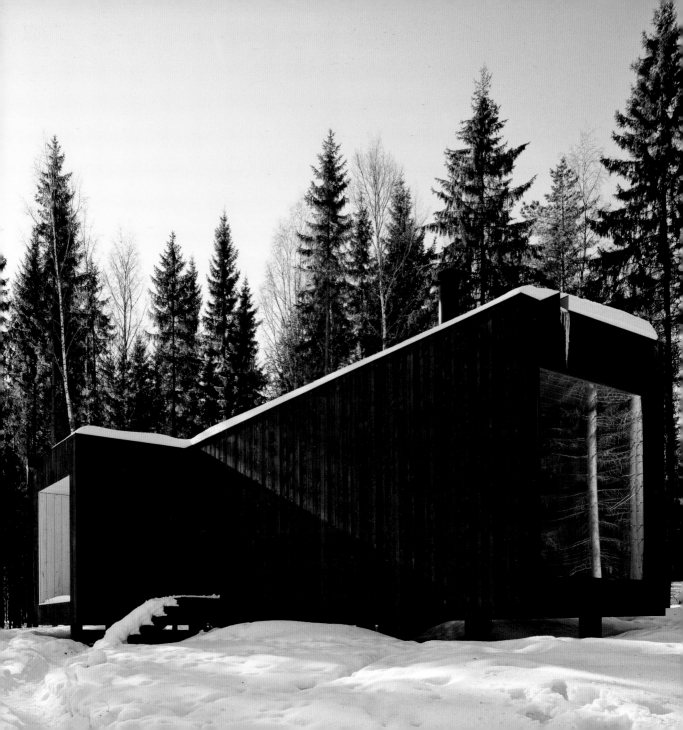

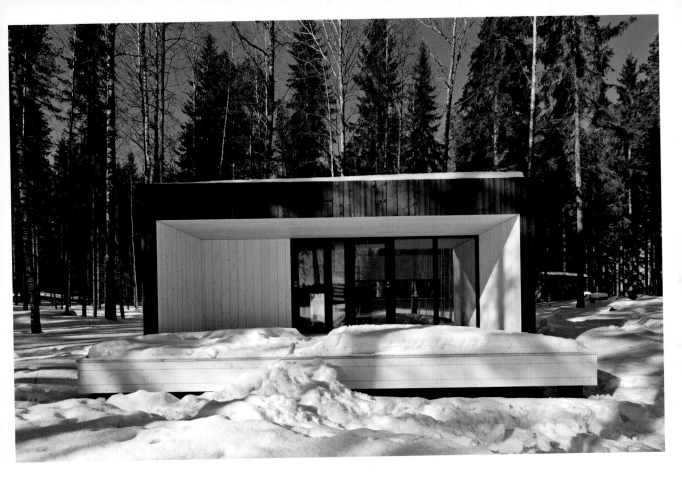

This modern cabin is situated on a horseshoe-shaped island in a lake. Its walls are stained dark to merge with the trees of the surrounding landscape, making it almost invisible from a distance. This feature responds to a design intent on respecting the site's ecological character. The cabin's cruciform shape reaches toward four very different views, which can be seen from the living area in the center of the cabin. A sauna stands a few yards from the cabin, as a place for relaxation and contemplation.

Four-cornered Villa

1,098 sq ft

Avanto Architects

Virrat, Finland

© Anders Portman and
Martin Sommerschield/kuvio.com

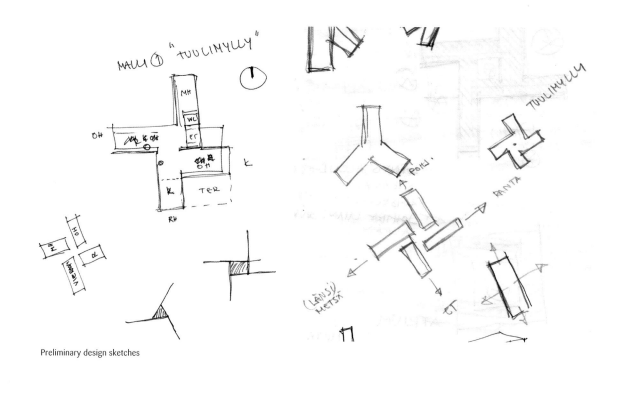

Preliminary design sketches

The cruciform shape creates a structure with four wings, all with a different view—thanks to a picture window capping each wing.

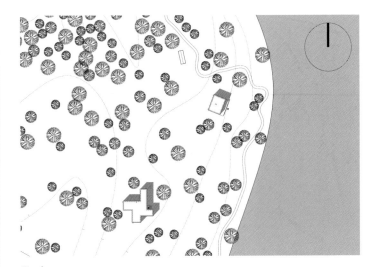

Site plan

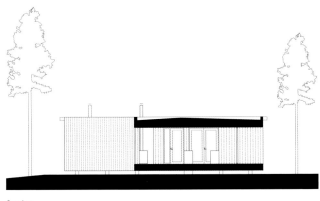

Section

North elevation

East elevation

West elevation

South elevation

0 3 m

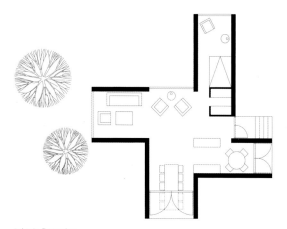

Cabin's floor plan

Top view of the cabin's scale model

B A

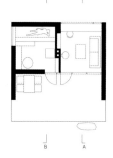

B A

Sauna's floor plan

Sauna's east elevation

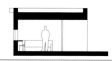

Section A-A through sauna

Sauna's north elevation

Sauna's west elevation

Section B-B through sauna

Sauna's south elevation

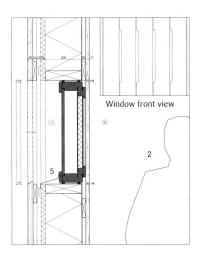

Window front view

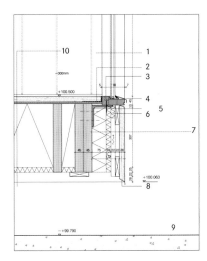

1. Wall paneling
2. Floor surface flush with window sill
3. Wood block glued to window frame
 to hide screw
4. Aluminum flashing
5. Steel angle window support
6. Additional thermal insulation at window sill
7. Wall assembly at window sill:
 Exterior cladding panel 28 x 195 mm
 Horizontal furring strips 22 x 100
 Vertical furring strip
 Fiberboard insulation panel 25 mm
 Wood frame +insulation 100 mm
8. Beveled bottom drip edge
9. Land infill
10. Floor assembly:
 Flooring finish
 Plywood boards with taped seams
 Glulam + wood fiber insulation 350 mm
 Fiberboard insulation panel 25 mm
 22 x 100 board
 Crawl space

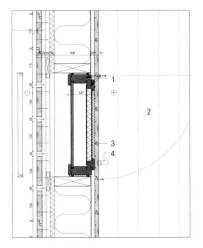

Ventilation hatch details

1. Hinge welded to 3. Wood paneling
 35 mm-long over 22 mm layer
 extensions of insulation
2. Ventilation hatch 4. Handle on panel
 with hinged panel 5. Flashing

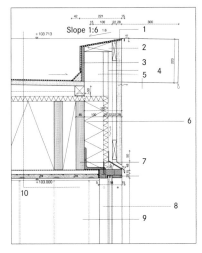

Slope 1:6

Clerestory details

1. Metal sheet
2. 50 x 150 blocking
3. Waterproof plywood
4. Screen
5. Metal gutter 50 x 100
6. Wall assembly:
 Exterior cladding panel 28 x 195
 Horizontal furring strips 22 x 100
 Vertical furring strips 22 x 100
 Fiberboard insulation panel 25 mm
 Wood frame plus insulation 100 mm
 Laminated wood joists
7. Window frame according to designer
8. Double glazed windows 6 plus 15 plus 6
9. Wall paneling
10. Roof assembly:
 Bituminous waterproof membrane
 Plywood sheathing 23 x 95 mm
 Furring 50 x 50 at 600 mm o.c.
 Air chamber (between 20 and 50 mm)
 Fiberboard insulation panel 25 mm
 Glulam plus wood fiber insulation 350 mm
 Thermal insulation
 Metal channel to allow for electrical conduits
 Tongue-and-grove paneling 21 x 195 mm

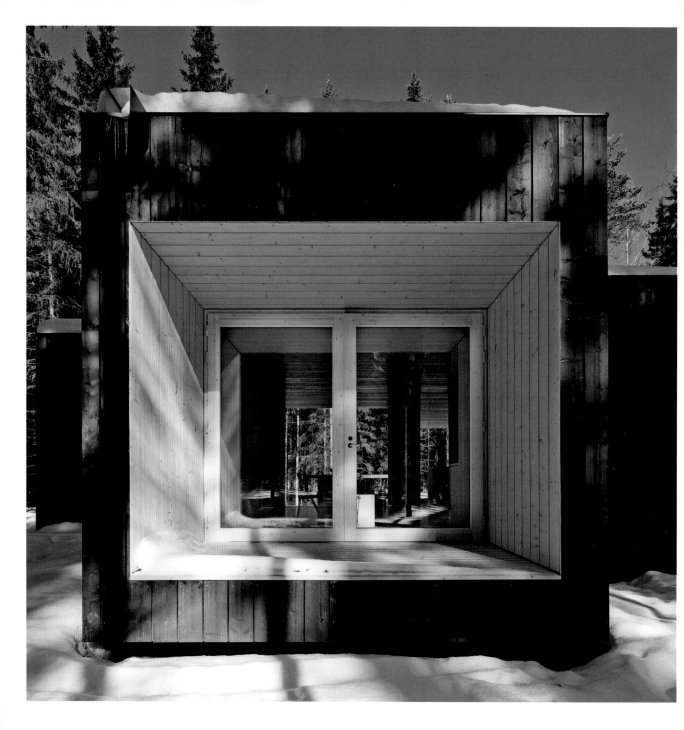

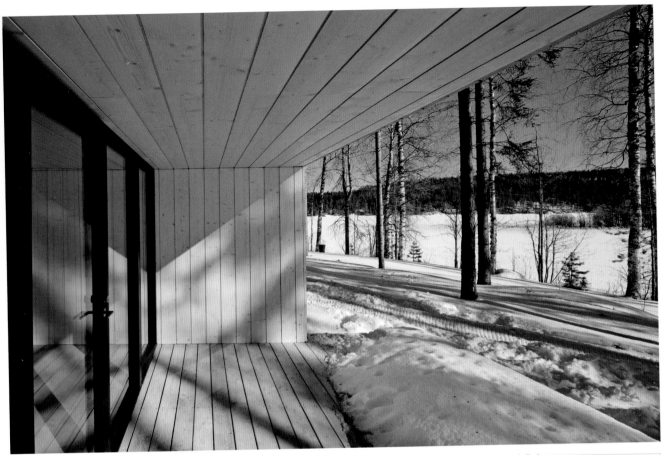

101

Deep eaves protect the exterior of a building from the elements and contribute to the creation of an outdoor space as an extension of the interior.

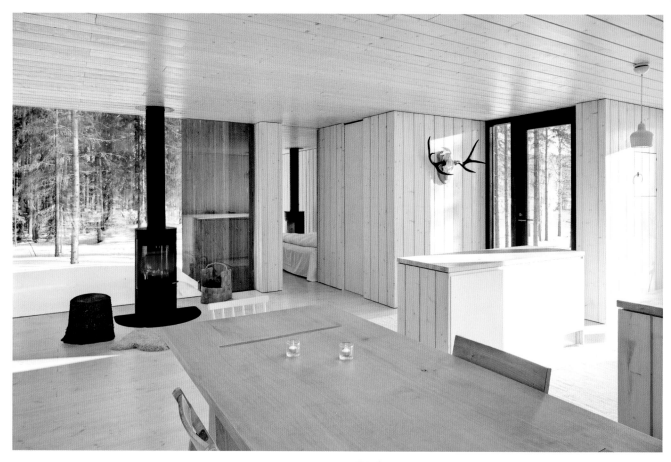

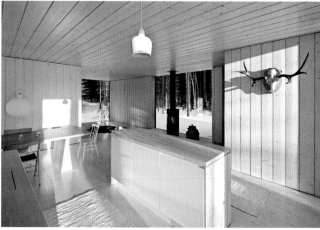

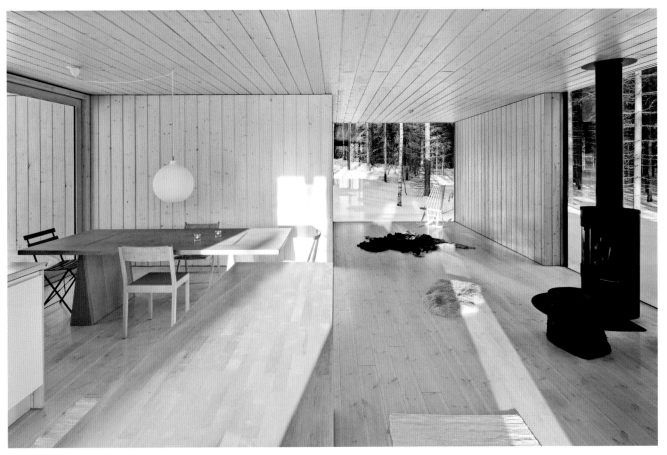

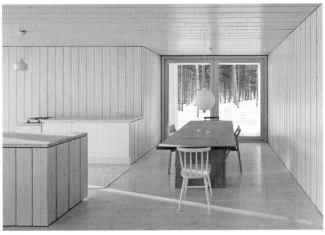

102

The color white is part of the compositional forces that highlight form. Use various shades of white to create a space full of nuances and play with different textures to add depth, visual interest, and warmth.

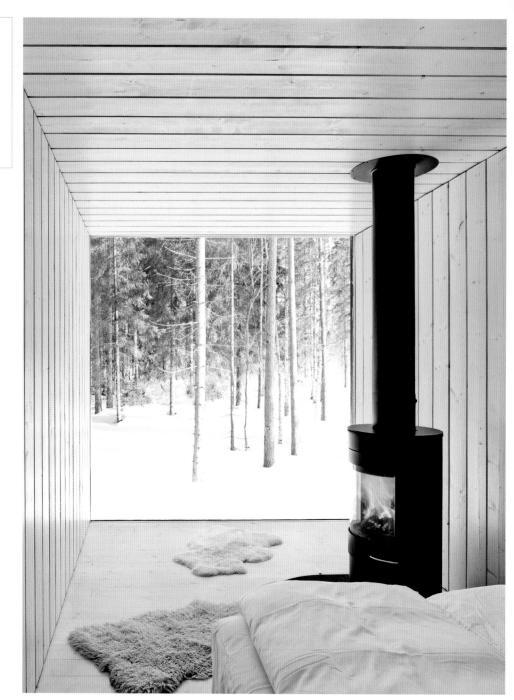

103

Frameless windows are much in line with modern styles. Their minimal framework can be fully integrated into the ceiling, walls, and floor. This feature helps minimize the barrier between the interior and the exterior.

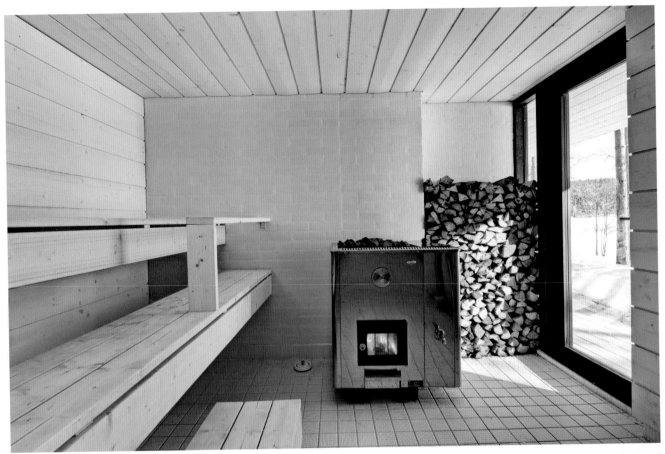

The design of the sauna is a reflection of the same design philosophy applied to the cabin. The large window and glass door leading to an outdoor deck include the landscape as part of the experience.

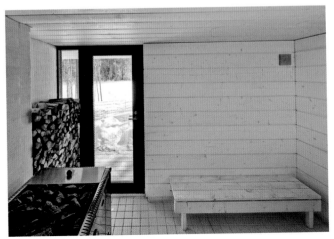

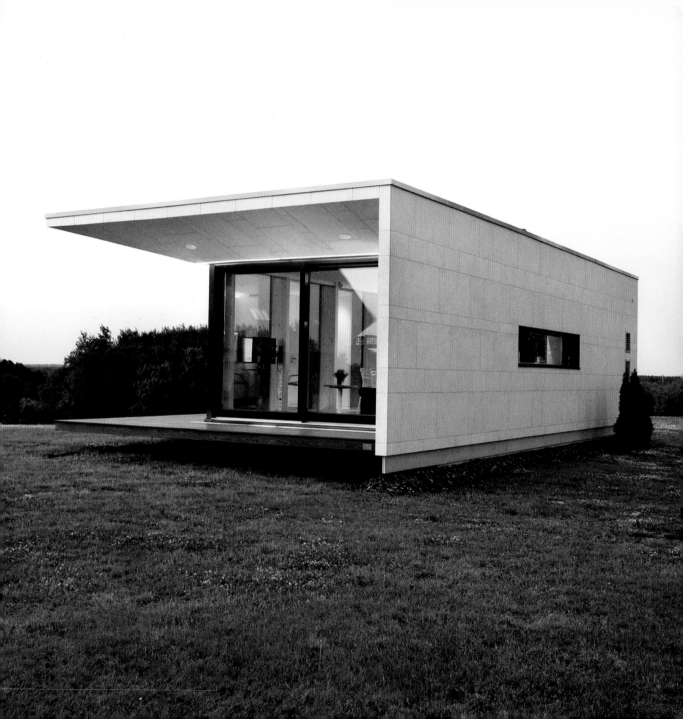

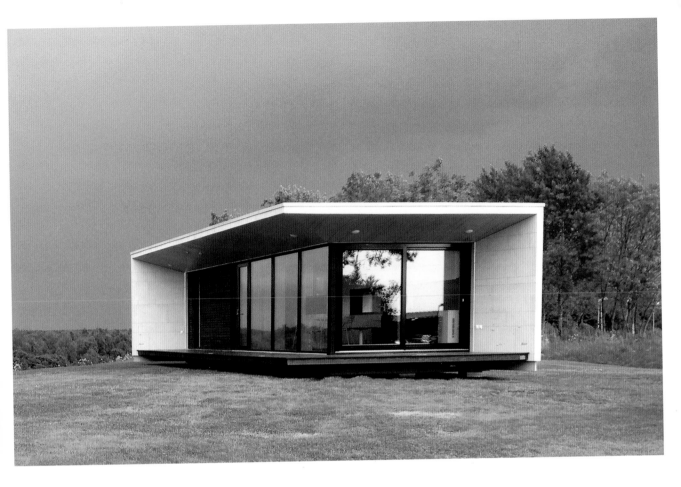

The design of the M series cabins is inspired by the passion fruit. A hard shell protects a stylish and comfortable interior. The structure is prebuilt in a workshop to achieve high-quality standards and assembled quickly on-site, often within two weeks. This process minimizes environmental impact. The roofline uses sunlight efficiently, absorbing warmth in winter and blocking it in summer. Low horizontal lines and large panoramic windows emphasize simplicity and an open-minded approach toward living.

M1 House

550 sq ft

Passion Smart Design Houses

Anywhere

© Passion Smart Design Houses

Back elevation

Side elevations

Front elevation

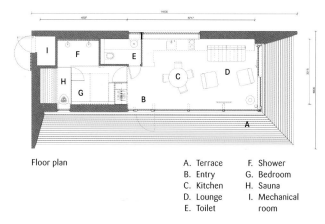

Floor plan

A. Terrace F. Shower
B. Entry G. Bedroom
C. Kitchen H. Sauna
D. Lounge I. Mechanical
E. Toilet room

Basic features diagram

1. ENERGY EFFICIENT
 Heating and ventilation
 Highly efficient heat
 ventilation (HRV)
 Heat pump for heating
 and cooling
 Solar water heating system
 Panel connectivity
2. GROOVY
 Multimedia appliances
 Preinstalled inside and outside
 speakers, receiver, TV, Internet
 ports
3. COOL
 LED lights
 All interior and exterior
 lights installed
4. NO WORRIES
 Rainwater system
 Piping from roof to rain-
 water drainage
5. NORDIC STANDARDS

Roof structure
2 layers SBS
Ventilated cavity
Vapor-permeable wind barrier
Min. 300 mm mineral
wool insulation
Nail plate trusses withstanding
snow loads up to 3 kN
Finish: cross-laminated timber

6. DURABLE
 Wall structure
 Exterior cladding
 Ventilated cavity
 Vapor permeable wind barrier
 250 mm mineral wool insulation
 Timber frame structure
7. STRONG FOUNDATION
 Floor structure
 Interior finish: Concrete slab
 with under-floor heating
 Insulation up to 300 mm – EPS
8. LONGLASTING

Terrace
Oiled thermo-treated wood
9. LOW MAINTENANCE
 Windows
 Aluminum-clad wooden
 windows with UV protection
 triple-glazing units
10. RELAX
 Fully furnished
 Custom-made design furniture
11. EASY
 Sanitary ware and piping
 All sanitary ware and piping
 preinstalled
12. INTELLIGENT
 Smart home system
 Automated controlling
 security, heating/cooling,
 lights, blinds, audio, CO_2,
 humidity

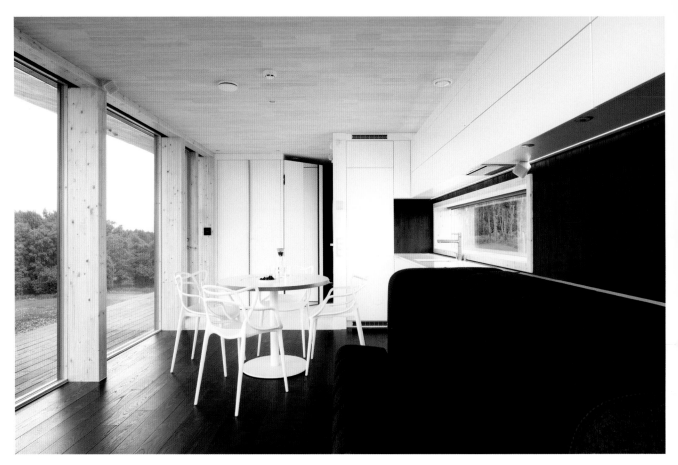

Fully equipped with the necessary appliances, planned to optimize the use of space, fitted with clever storage solutions, and completed with smart details and lighting ideas, the M1 cabin offers the utmost comfort with style.

104

Multifunctional furnishings offer flexibility, which is a valuable feature in compact construction. They help minimize the number of freestanding items that could interfere with moving comfortably around the space.

105

Built-in cabinets are designed to meet the storage needs of their users. They make the most of the available space, while simplifying lifestyle and adding comfort.

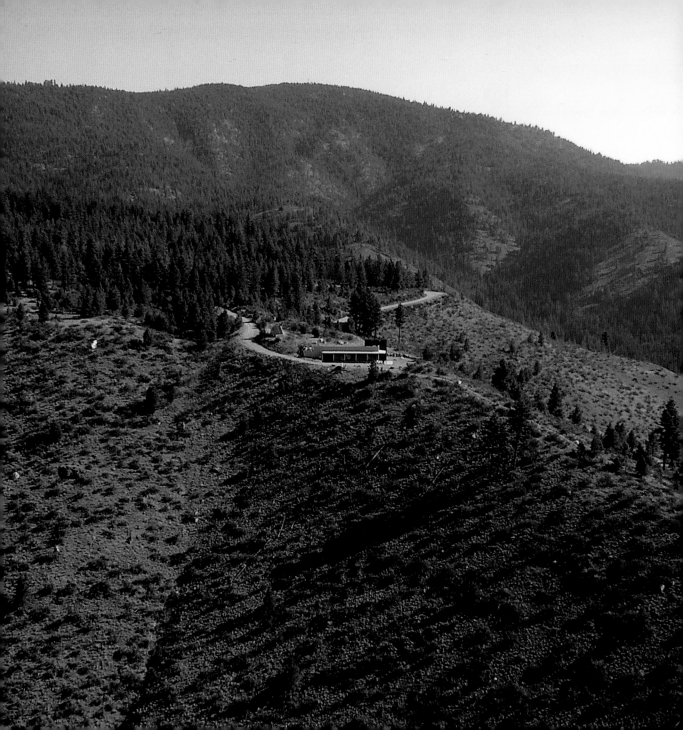

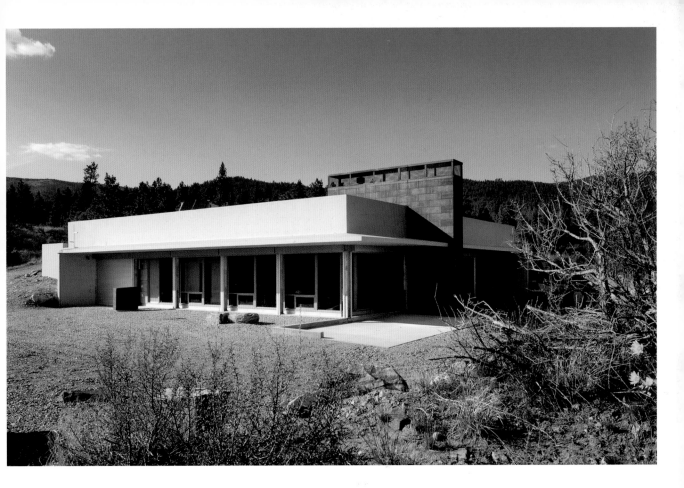

Windy, snowy winters and extremely hot, arid summers with occasional brush fires characterize the severe climate of the site where this concrete construction was built. Its remote location made public utility hookups impossible. But despite these inconveniences, the users of this vacation retreat find that the soothing seclusion and pleasurable connection with the natural environment are well worth any extra efforts.

Nighthawk Retreat
1,686 sq ft

Eggleston|Farkas Architects

Eastern Cascades Foothills, Washington, United States

© Jim Van Gundy and owner

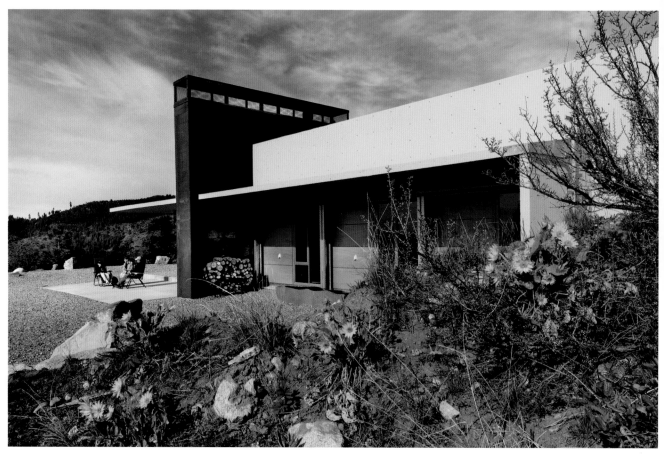

106

Deep overhangs provide
shade to walls, doors, and
windows. Net result: reducing
summer temperatures inside,
which improves comfort and
saves energy.

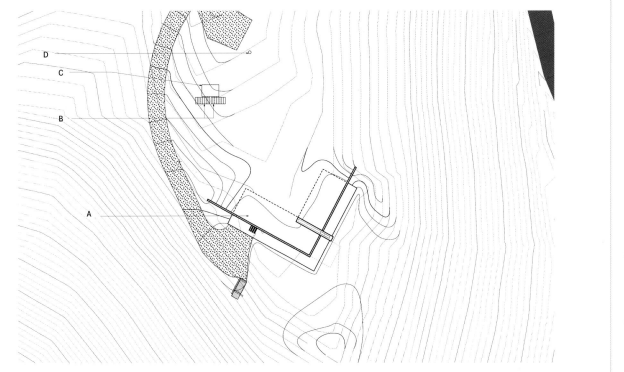

Site plan

A. Earth sheltered house
B. Solar array
C. Power shed
D. Well

The site is off-grid, so solar electrical generation and energy conservation were critical to the success of the project.

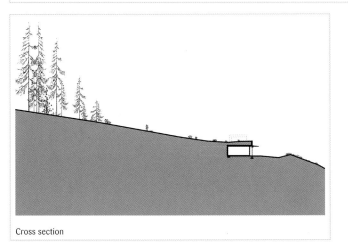

Cross section

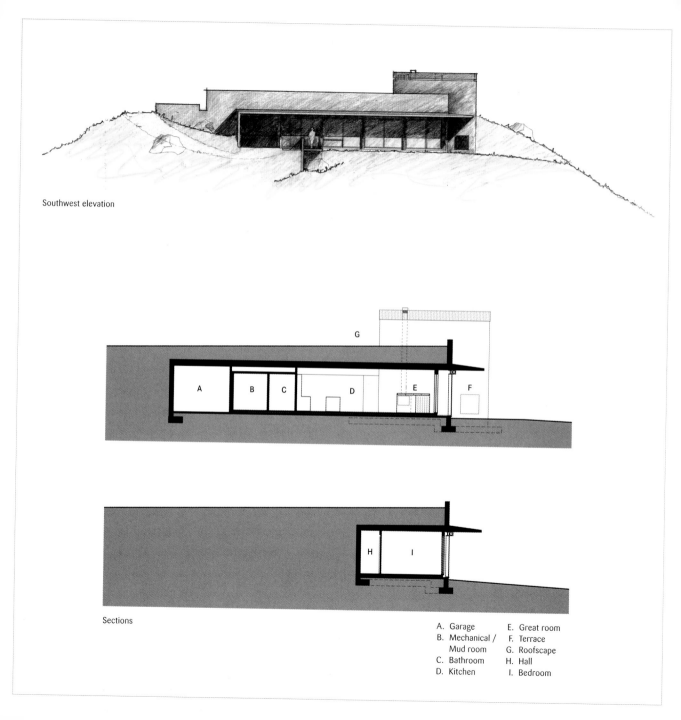

Southwest elevation

G

A B C D E F

Sections

H I

A. Garage
B. Mechanical /
 Mud room
C. Bathroom
D. Kitchen

E. Great room
F. Terrace
G. Roofscape
H. Hall
I. Bedroom

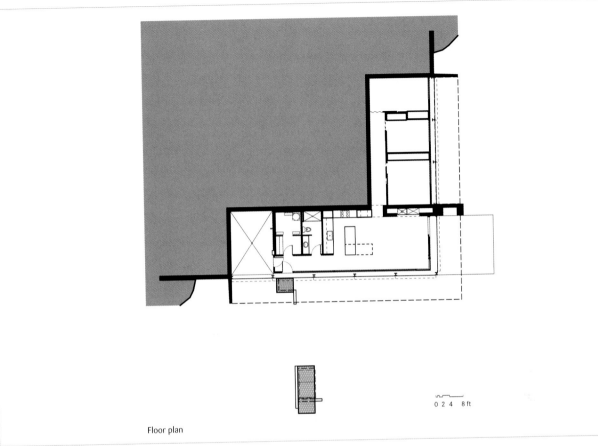

Floor plan

0 2 4 8 ft

Earth-sheltered constructions
have a considerable heat
capacity, storing solar energy.
Popular among supporters
of sustainable architecture,
earth sheltering reduces heat
loss and maintains a constant
indoor temperature.

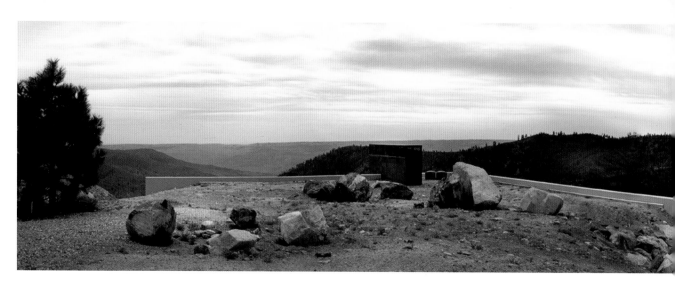

The concrete roof and retaining walls allowed the house to be buried under four feet of earth, offering insulation in the winter and cave-like cooling in the summer.

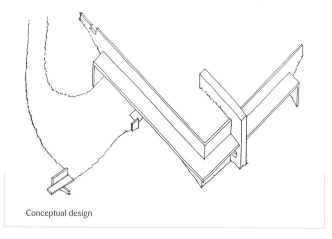

Conceptual design

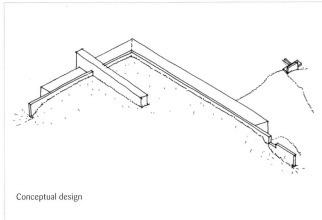

Conceptual design

108

Earth-sheltered houses use the ground as an insulating material, protecting the interior from extreme weather conditions. This makes the house energy efficient and low maintenance.

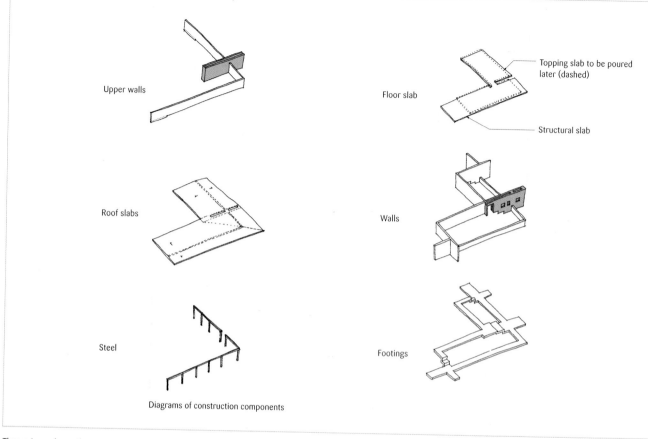

Upper walls

Floor slab

Topping slab to be poured later (dashed)

Structural slab

Roof slabs

Walls

Steel

Footings

Diagrams of construction components

The various planes that compose the house interlock to form a powerful geometric composition expressed both in the exterior and in the interior.

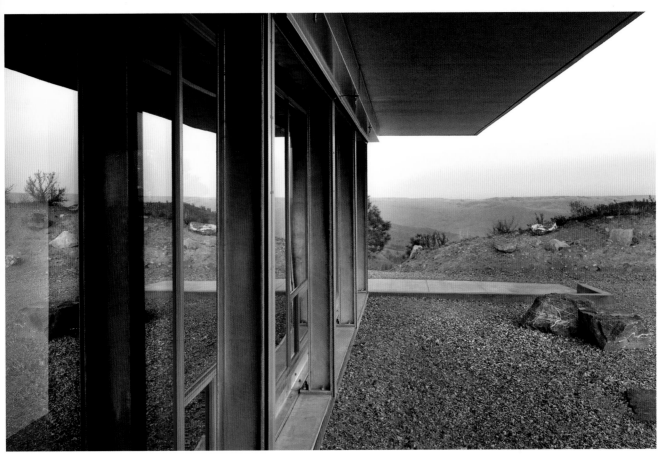

109

Rolling metal shutters serve the dual purposes of forming a second skin offering additional thermal control as well as fire protection and security when the retreat is not in use.

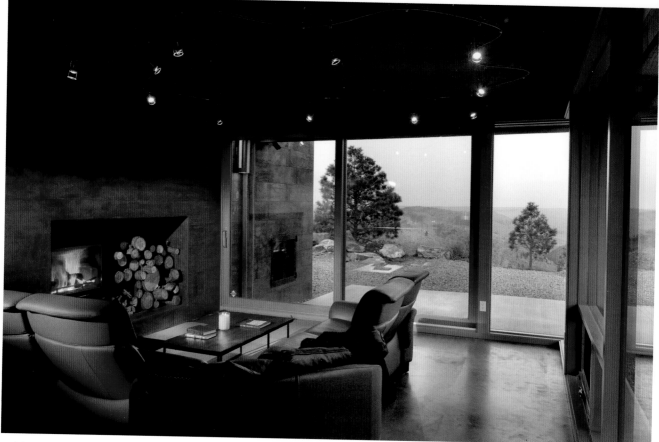

110

The terrace is an extension of an interior living space. Create a comfortable area that can be suitable for relaxing and entertaining.

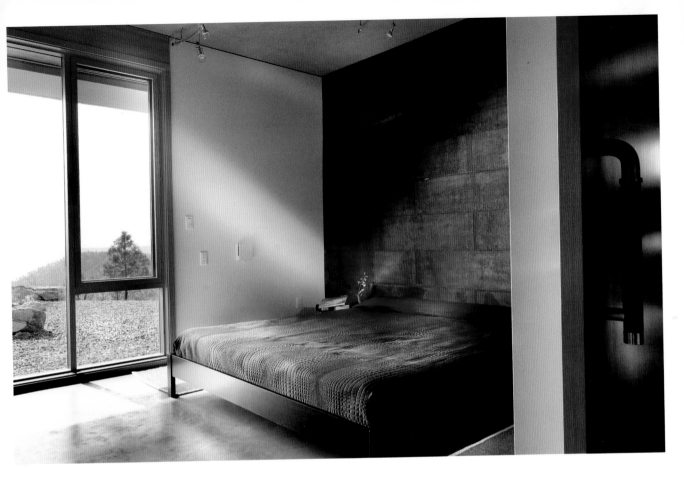

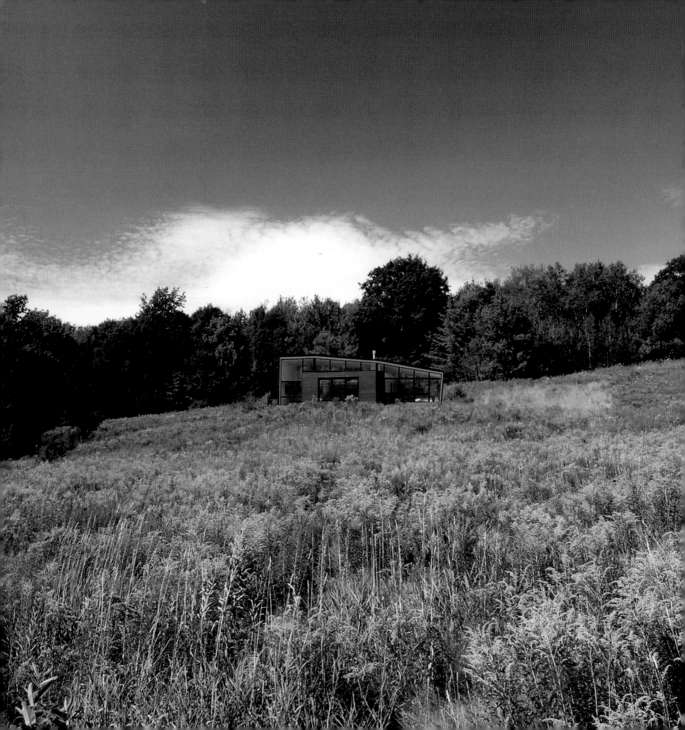

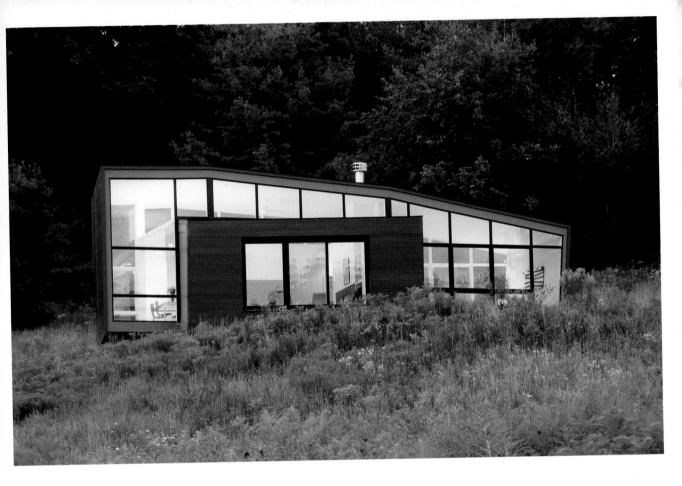

The house is conceived as a single sweeping volumetric "sheet," evoking the folds of a Japanese kimono. The wrapping enclosure defines two major interior spaces: a living area extending to an enclosed porch, analogous to an *engawa* or "in-between space" found in traditional Japanese architecture, and a master bedroom suite with floor-to-ceiling windows. A concrete plinth elevates the house slightly above the ground, increasing the sense of lightness often found in Asian design.

Weekend House

1,200 sq ft

David Jay Weiner, Architect

Rensselaer County, New York, United States

© Tony Morgan

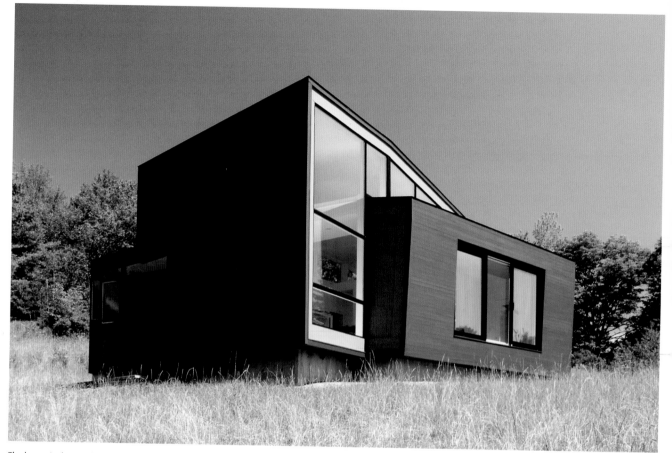

The house is designed to be relatively inexpensive, both in construction and maintenance, and to have the compactness and interior sparseness akin to traditional Japanese architecture for relaxing and entertaining.

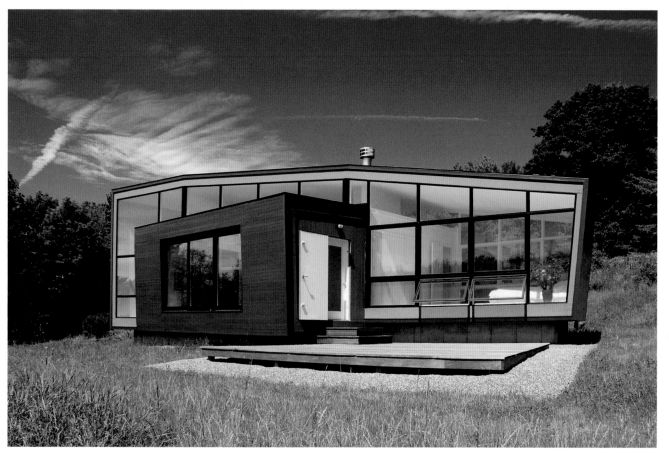

Materials include standard wood-frame
construction with tongue-and-groove
exterior cedar siding, poured-in-place
concrete foundation, EPDM roofing
membrane roof, aluminum-clad windows,
painted gypsum-board interior partitions,
and gravel driveway and a parking area.

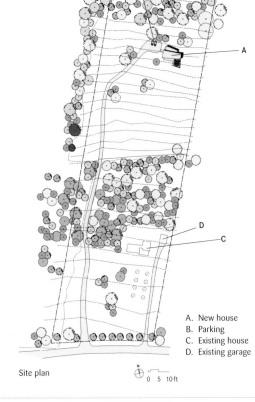

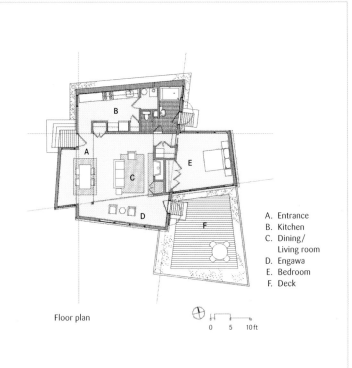

B

A ─── A

D
C

A. New house
B. Parking
C. Existing house
D. Existing garage

Site plan

N
0 5 10 ft

A. Entrance
B. Kitchen
C. Dining/
 Living room
D. Engawa
E. Bedroom
F. Deck

Floor plan

N
0 5 10 ft

As much of the site as possible
has been left untouched. During
the summer, native wildflowers
fill the landscape.

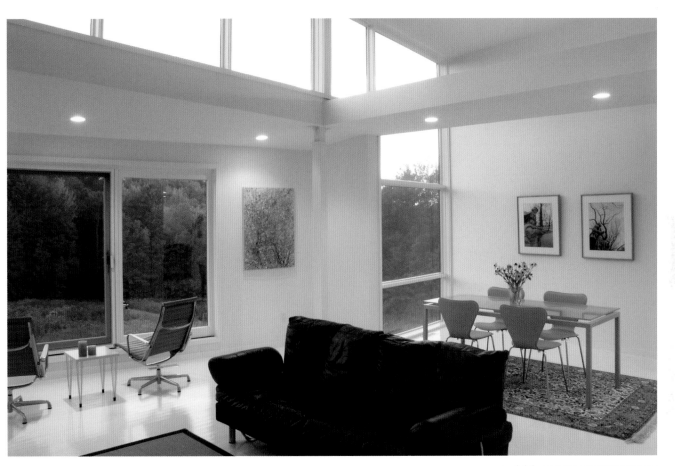

111

From an energy-efficient standpoint, high clerestory windows can be used as part of a passive solar strategy. The windows should be sized and placed to optimize solar heat gain.

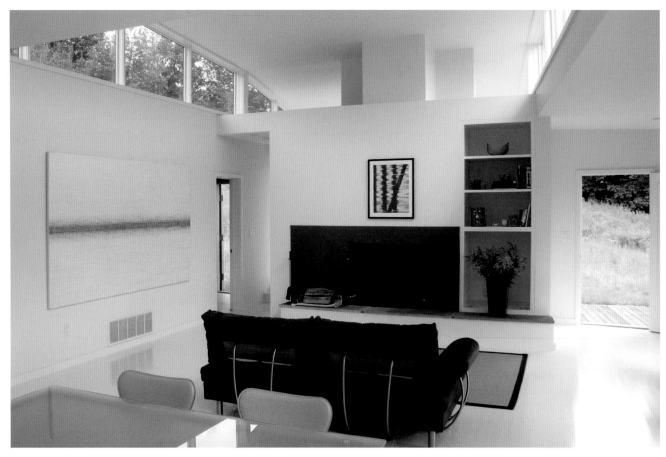

112

An alternative to the popular freestanding stove is an inset wood stove. Both offer efficient fuel use and a minimum of heat loss.

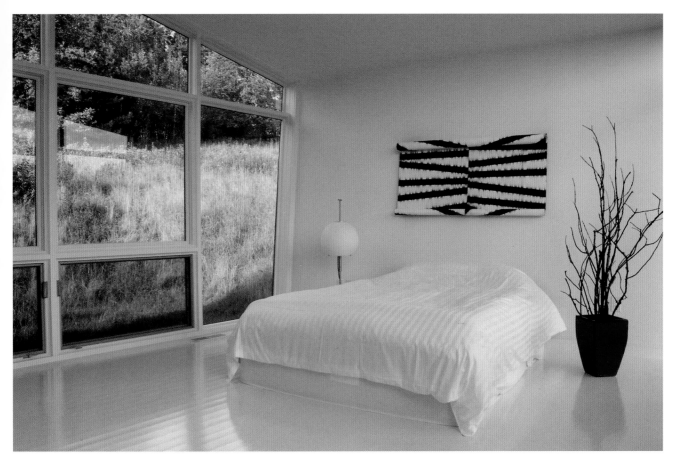

113

A successful wall system depends on the adequate integration of wall components with window design, which may include parts that are fixed, operable, or a combination of both.

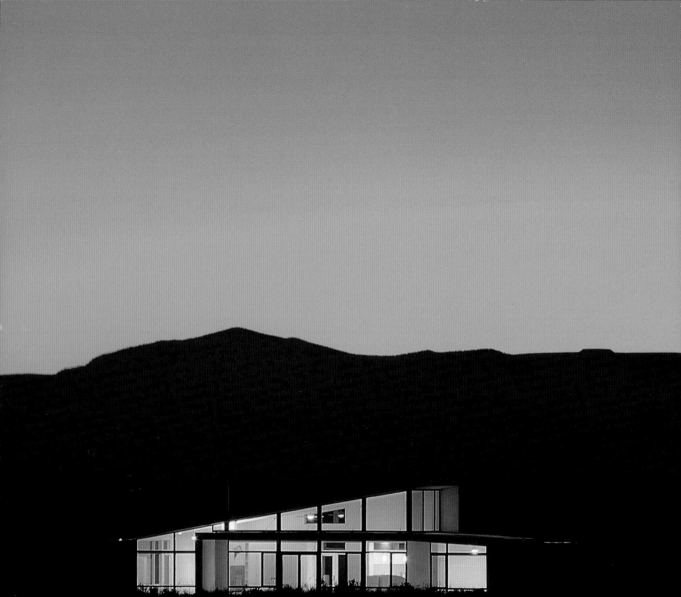

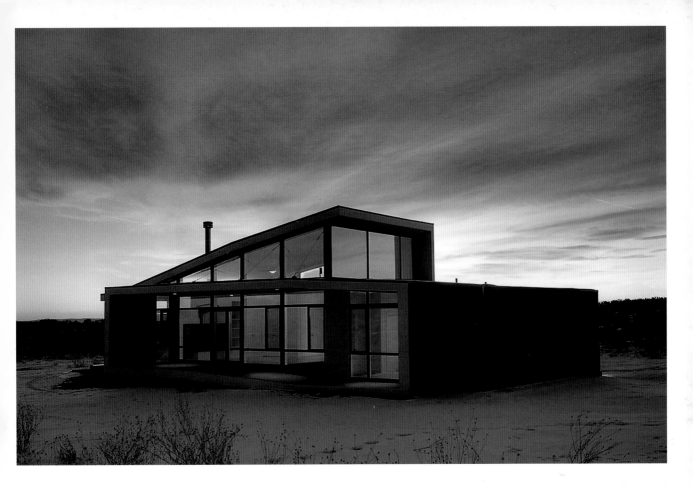

This small retreat in the high desert was designed to respond to the unparalleled beauty of the area, and take advantage of its unique spirituality as well. The retreat is conceived as a singular enclosure that wraps and folds around itself to form three major interior spaces and tie the building to the landscape. The primary interior space is used as a living area with kitchen. The two other spaces correspond to the master bedroom suite and to a meditation space adjacent to a Zen rock garden.

Zen Garden House
1,600 sq ft

David Jay Weiner, Architect
Crestone, Colorado, United States
© Bill Ellzey

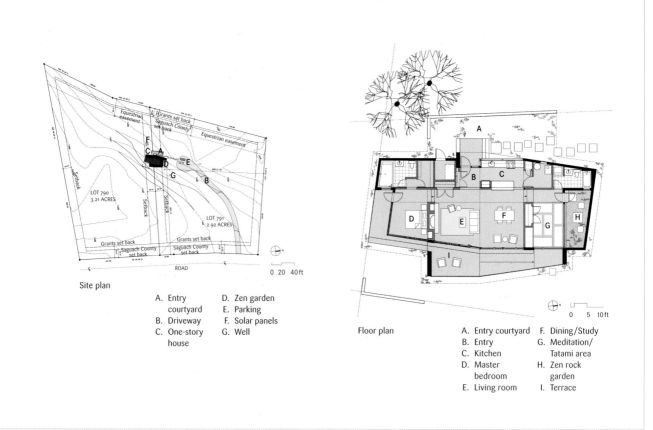

Site plan

A. Entry
 courtyard
B. Driveway
C. One-story
 house
D. Zen garden
E. Parking
F. Solar panels
G. Well

Floor plan

A. Entry courtyard
B. Entry
C. Kitchen
D. Master
 bedroom
E. Living room
F. Dining/Study
G. Meditation/
 Tatami area
H. Zen rock
 garden
I. Terrace

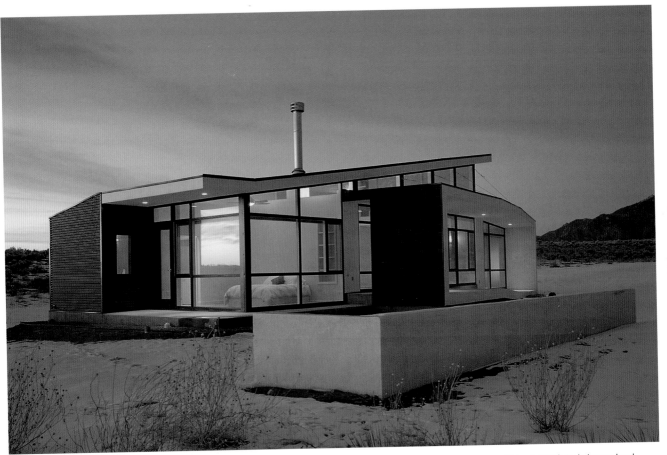

Major materials include wood and lightweight metal-frame construction, metal exterior corrugated siding, concrete slab on grade with radiant heating, EPDM membrane roof, aluminum-clad windows, painted gypsum-board interior partitions, and tatami mats.

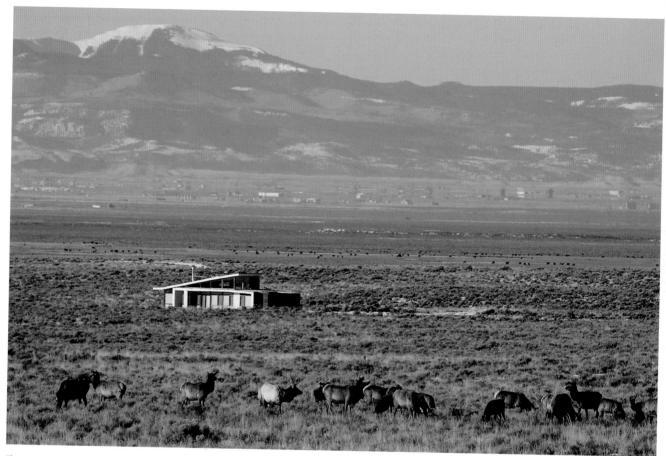

The seven-acre site has been left
undisturbed to the fullest extent
possible. A solar energy photovoltaic
system solves the problem posed by
the cabin's remote location.

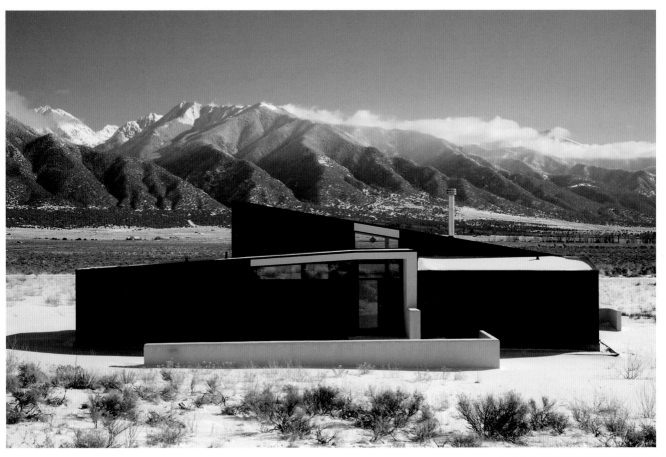

114

Large areas of glass are used to capture views, but also allow for passive solar heating during the winter. In order to maximize solar gain, windows should be south-facing in the northern hemisphere, and north-facing in the southern hemisphere.

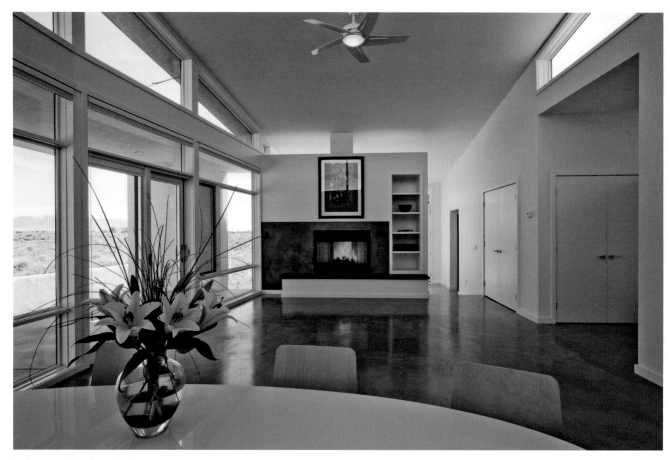

Set into a partial wall, the fireplace separates the living room from the master bedroom, satisfying privacy needs, while creating an open feel.

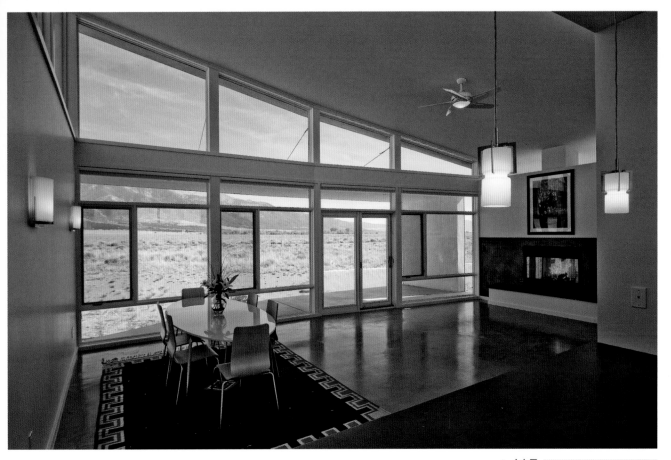

115

Window walls soar in modern rooms and impart an airy sunroom-like feel. Play with wide or thin mullions to give the wall some form, and mix fixed and operable windows to direct breezes through the house.

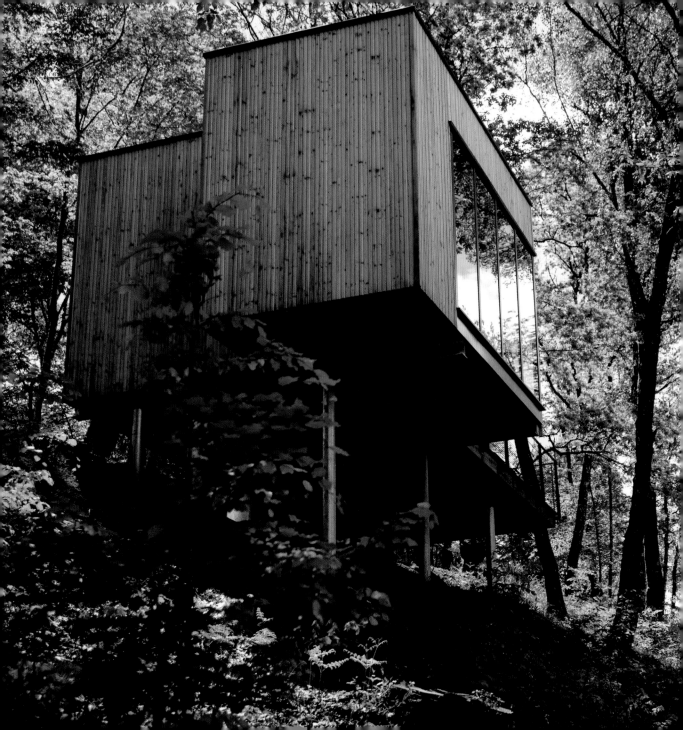

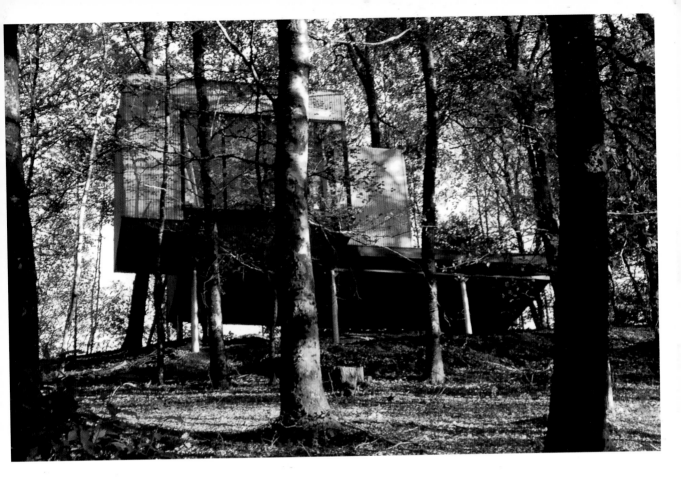

Resolutely contemporary, the cabins in Salagnac are nested in a natural area of ecological, floral, and faunal interest, where the rough granite terrain is complemented by the lush vegetation, mainly hardwood trees—chestnuts, elms, walnuts, and wild cherries—but also conifers—sequoias, pines, firs, and cedars. Six cabins and a visitors' center are designed as lookouts in a steep valley, where the only other structures are manors from the seventeenth and nineteenth centuries and annex constructions at the bottom of the valley.

Salagnac Cabins
6 cabins, 602 sq ft each

Agence Apolline Terrier
Meyrignac-l'Eglise, France
© Alain Smilo, Apolline Terrier

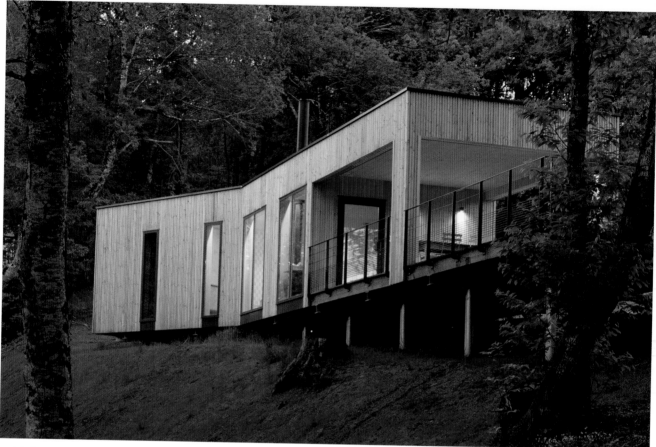

116

Zigzagging among trees, the cabins overlook the valley through big windows and large terraces, independent from one another and each maintaining its privacy.

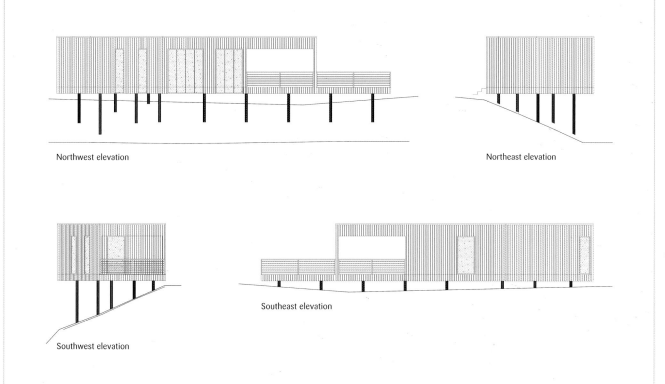

Northwest elevation

Northeast elevation

Southwest elevation

Southeast elevation

Reception building

The architect wanted to stay away from the stereotypical log construction and tree house design. The reception building and cabins stand out as simple geometric forms, blending with the natural surroundings, yet maintaining a strong identity.

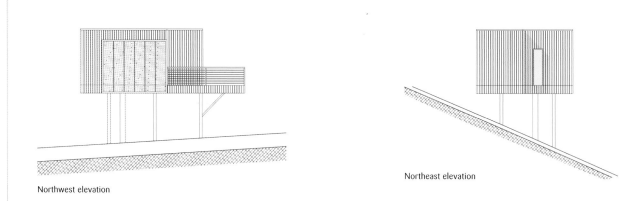

Northwest elevation

Northeast elevation

Southwest elevation

Southeast elevation

Typical cabin

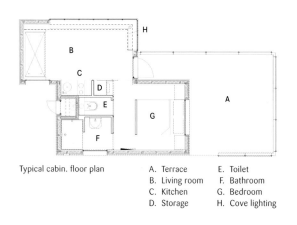

Typical cabin. floor plan

A. Terrace
B. Living room
C. Kitchen
D. Storage

E. Toilet
F. Bathroom
G. Bedroom
H. Cove lighting

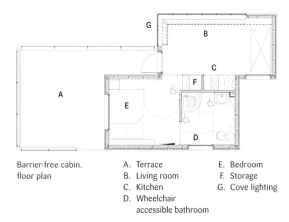

Barrier-free cabin.
floor plan

A. Terrace
B. Living room
C. Kitchen
D. Wheelchair
 accessible bathroom

E. Bedroom
F. Storage
G. Cove lighting

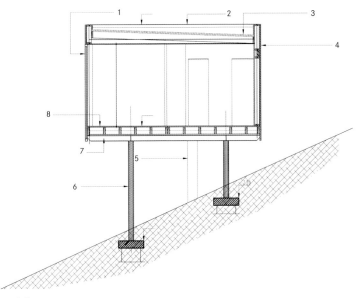

1. Aluminum window frame, black color finish
2. Zinc flashing
3. Waterproof membrane
4. Wood framing with Douglas fir cladding, natural finish
5. Utility shaft
6. Steel column, painted black (68.3 mm dia. 6.3 mm thick)
7. Wide flange H steel beam (HEA 180)
8. Wood flooring

Detailed section

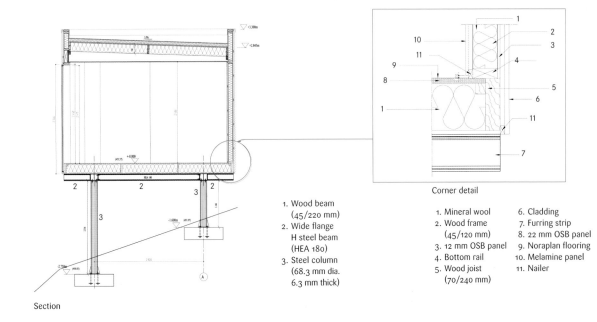

Section

1. Wood beam (45/220 mm)
2. Wide flange H steel beam (HEA 180)
3. Steel column (68.3 mm dia. 6.3 mm thick)

Corner detail

1. Mineral wool
2. Wood frame (45/120 mm)
3. 12 mm OSB panel
4. Bottom rail
5. Wood joist (70/240 mm)
6. Cladding
7. Furring strip
8. 22 mm OSB panel
9. Noraplan flooring
10. Melamine panel
11. Nailer

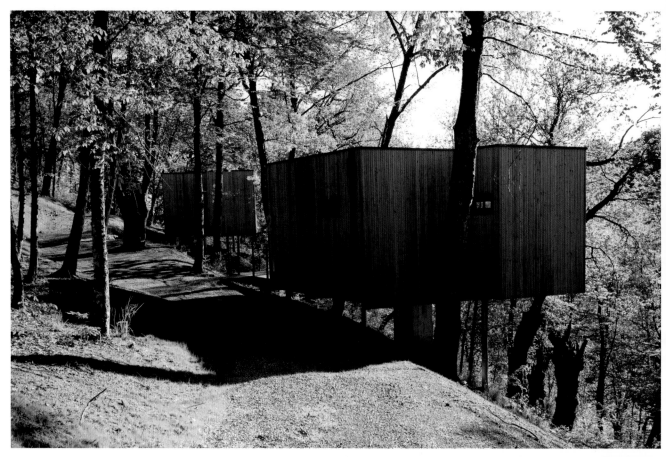

117

The design of these cabins follows the principle of environmental footprint minimization. In time, as the buildings age and the vegetation grows back, the cabins should become nearly invisible.

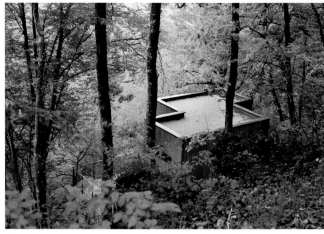

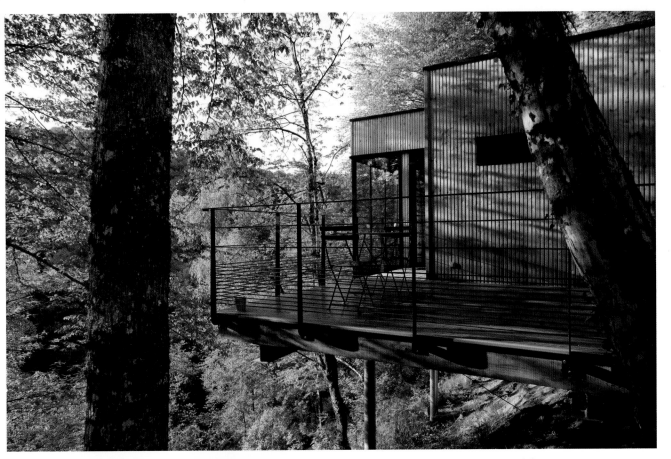

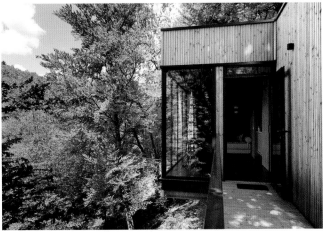

118

Glass, metal, and wood constitute an appropriate material combination for cabin construction. Wood will need to be pressure treated if it's meant to be in contact with the ground.

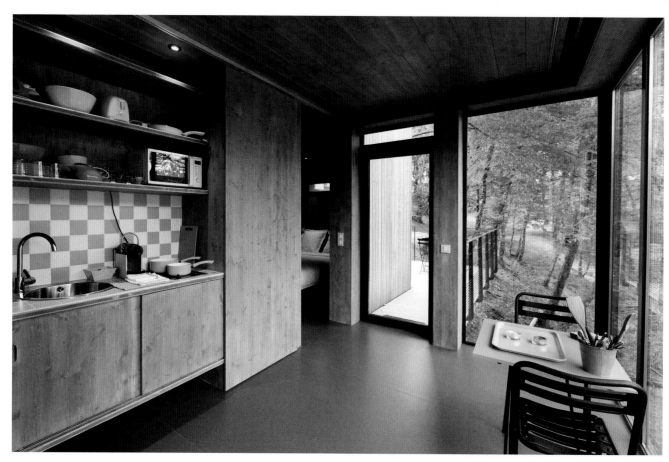

119

Sliding panels are space savers and promote a flexible use of the space. The Salagnac cabins have sliding panels separating the bedroom from the living area, and hiding the kitchen.

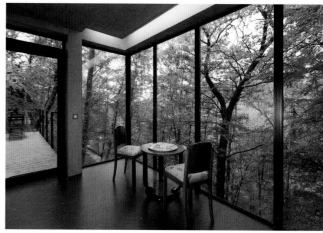

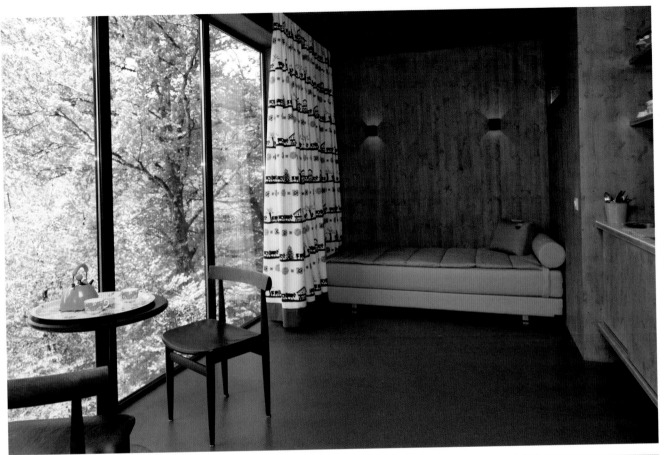

120

Make things practical
and take any opportunity
to expand your cabin's
accommodation possibilities
by choosing furniture that is
multifunctional. For instance,
banquettes that can double
as beds.

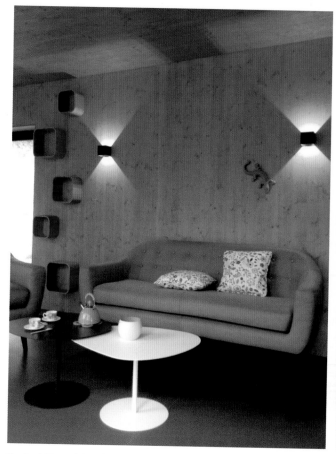

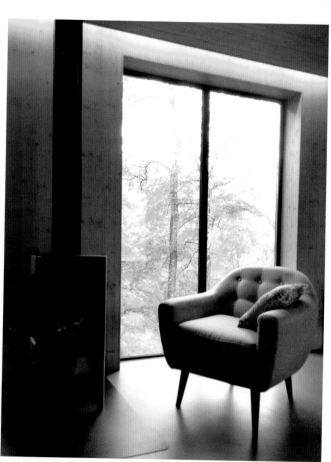

The furnishings of the cabins follow three different trends: contemporary design, retro-vintage, and traditional. Regardless of the style, the cabins offer a compact layout optimizing space usage.

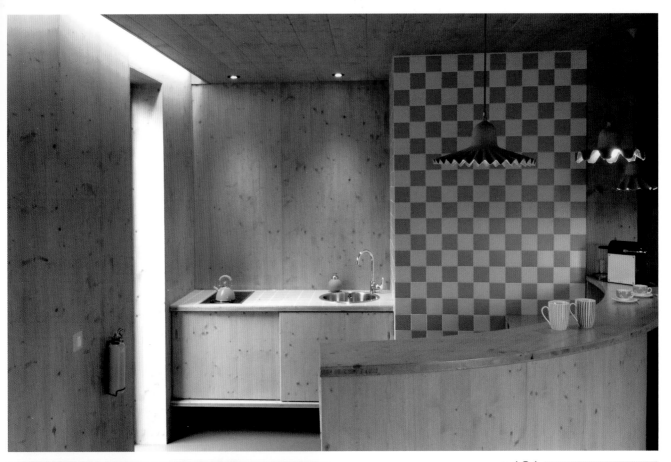

121

Built-in furniture and integrated equipment and appliances such as TV, Wi-Fi, and stereo systems free up space, improving circulation and optimizing the space available.

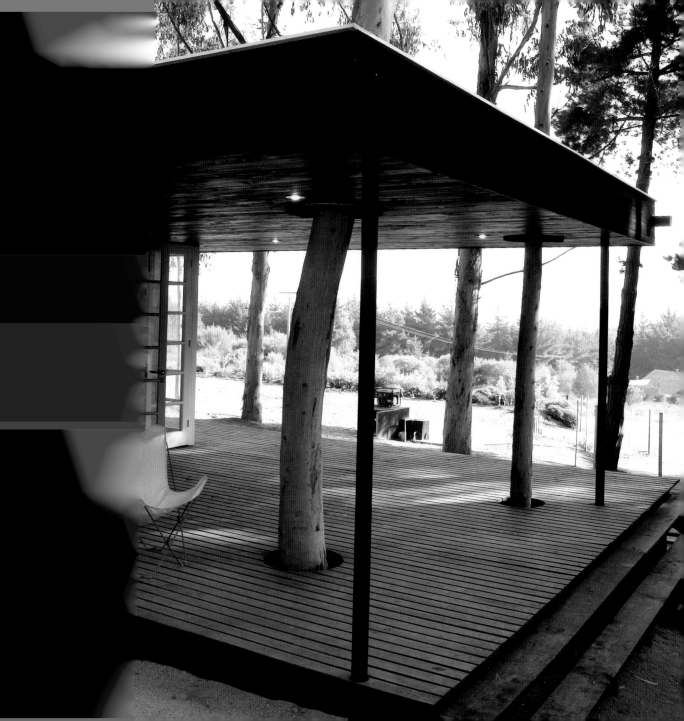

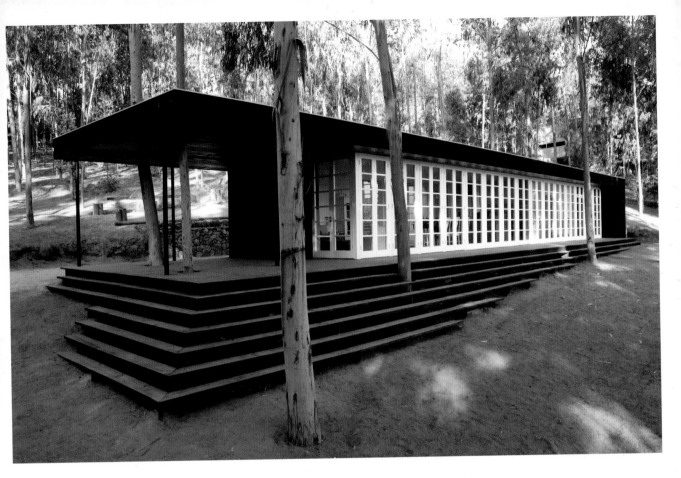

Located in a eucalyptus and pine forest, this long and low cabin boasts a strong relationship with its surroundings, emphasized by the use of local materials in its construction. An effort was made to avoid the removal of any tree. The terraces offer various views, different levels of privacy, and sunlight exposure, while allowing multiple and simultaneous activities. The layout of the single-floor retreat is a study of flexibility and the optimization of space.

House in the Woods

1,902 sq ft

Gonzalez Vergara Arquitectos (formerly F3 Arquitectos)

Cachagua, Chile

© Ignacio Infante

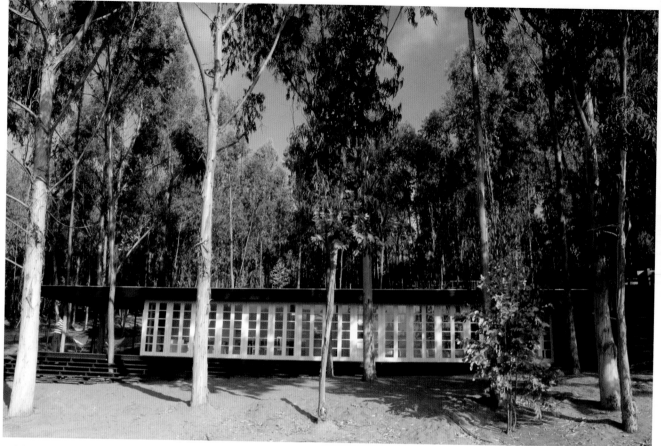

122

It is critical that a structure is a good fit for its surroundings. Even a well-designed building can fail if it's not sensitive to the specifics of the landscape.

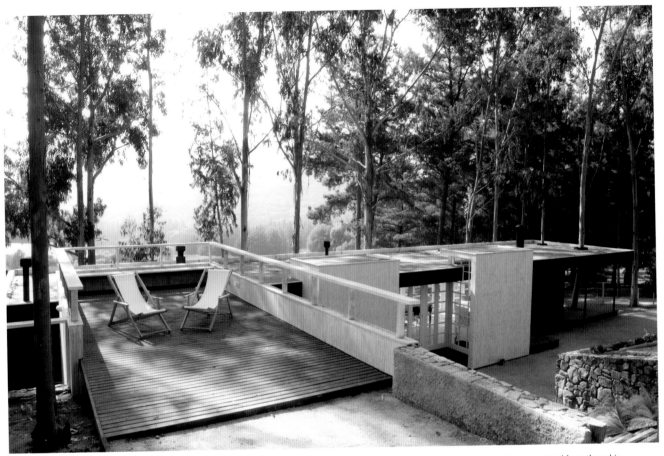

Terraces extend from the cabin and integrate the house into the topography. The construction responds to the landscape, reinforcing its distinctiveness.

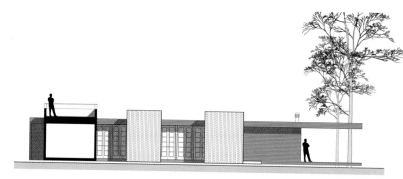

South elevation

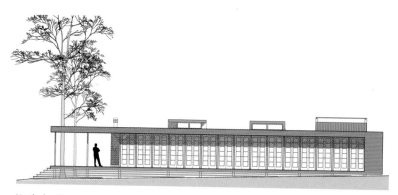

North elevation

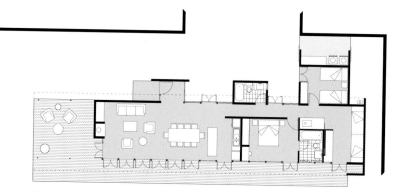

Floor plan

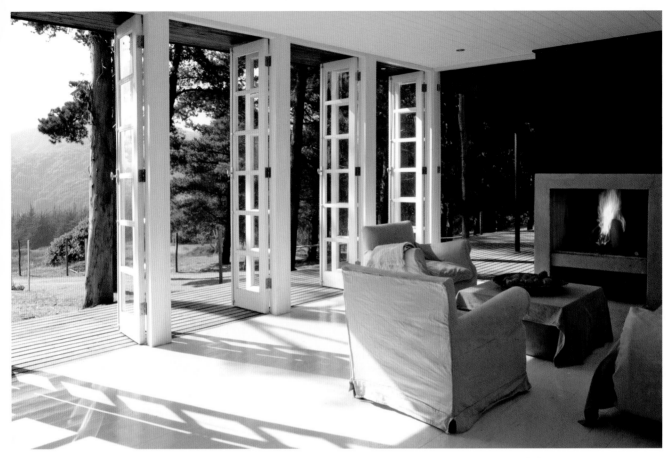

123

Make the landscape an integral part of your retreat to enhance the natural experience. Limit furnishings to a few basic items to keep the sight lines open. This way, you'll be able to tap into the best decorative touch of all, an ever-changing landscape.

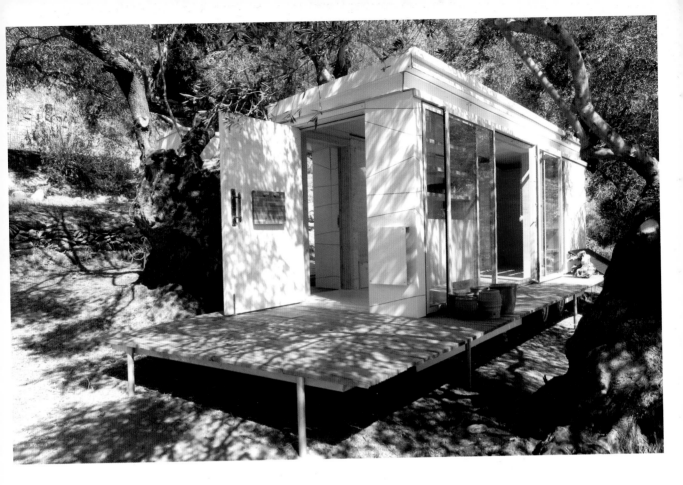

This small off-grid hideaway was built in a workshop in Scotland, and its fabrication took into account that the structure had to be shipped to a remote site on the Greek island of Crete. It now sits between three ancient olive trees, which provide dappled shade on even the hottest days. Clad in white aluminum composite panels, this quiet home echoes the village buildings on the hills above and opens up to reveal a comfortable living space with stunning sea views.

House on Crete

452 sq ft

echoLIVING

Kerames, Crete, Greece

© echoLIVING

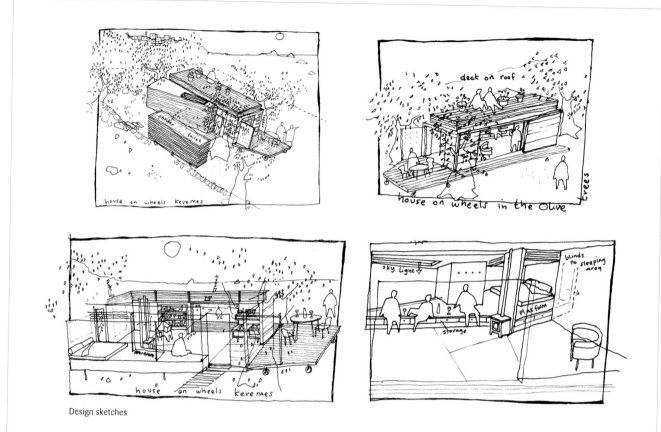

Inside the sketches:
house on wheels keremes

deck on roof

house on wheels in the olive

trees

house on wheels keremes

sky light

blinds to sleeping area

storage

PLAY form

Design sketches

124

Make the most of a compact vacation home by planning spaces that promote flexible use and a variety of activities happening at the same time.

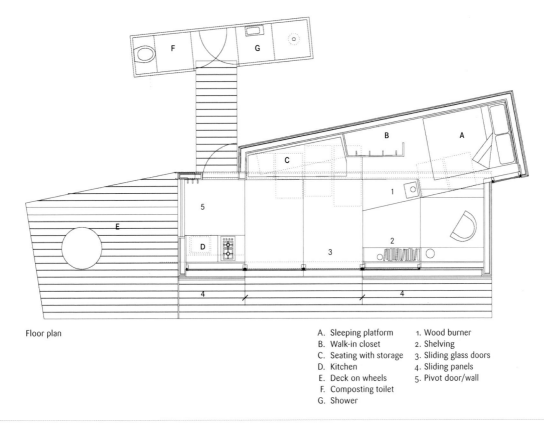

Floor plan

A. Sleeping platform	1. Wood burner
B. Walk-in closet	2. Shelving
C. Seating with storage	3. Sliding glass doors
D. Kitchen	4. Sliding panels
E. Deck on wheels	5. Pivot door/wall
F. Composting toilet	
G. Shower	

This small construction boasts many space-savings features: a compact kitchen extends out onto an outdoor patio sheltered by a large pivoting door, the seating area has pullout storage drawers, and the secluded sleeping space has its own wardrobe.

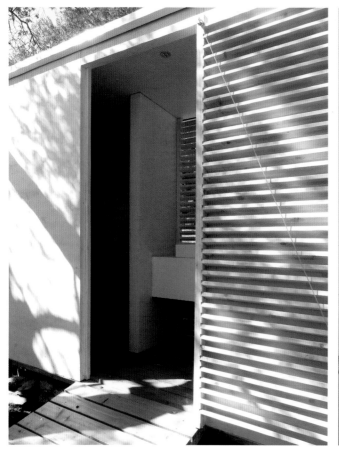
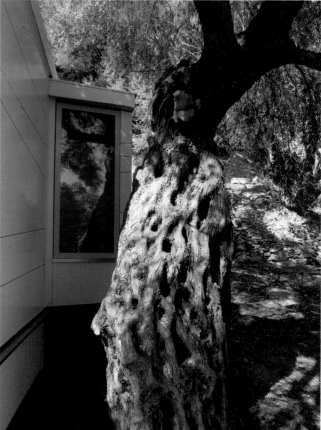

The house is clad in white aluminum
composite panels and finished internally
in spruce laminated timber.

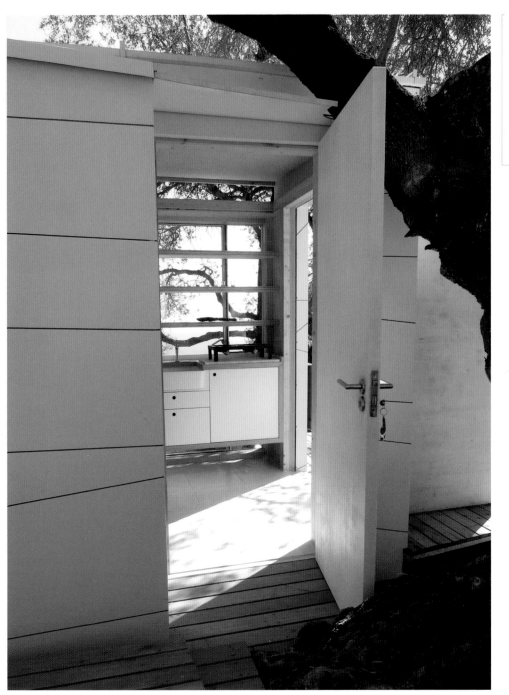

Consider the positive effects of natural features in the design of a new cabin. Trees can provide wind protection, shade, and lower temperatures, reducing the need for air conditioning.

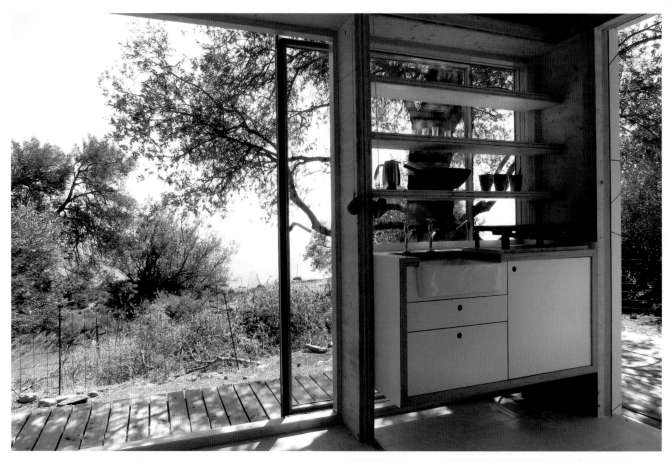

A compact kitchen and shelving float in front of the glazed façade. The interior space extends onto an outdoor eating space on decking sheltered by a solid timber, pivot door.

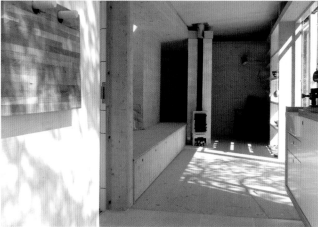

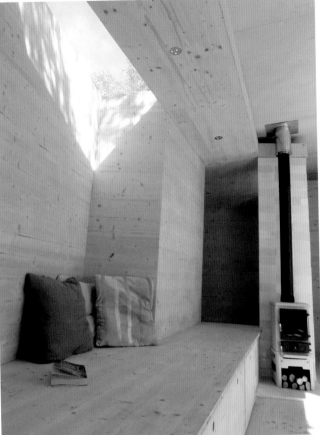

126

Climate conditions and orientation can influence your choice of glazing materials and day-lighting control strategies. They can also determine how much light can illuminate an interior space through a skylight.

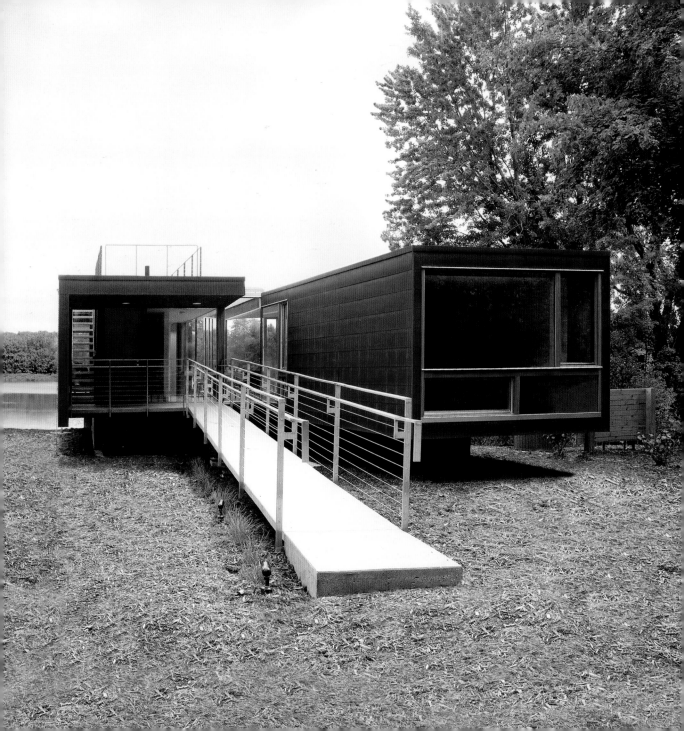

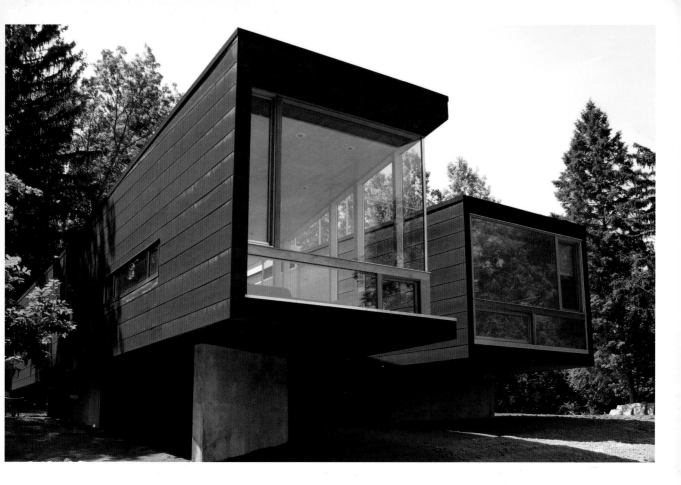

Koby Cottage was designed to accommodate families visiting their children attending a boarding school for troubled teens. The structure is raised above the ground and the space between the modules is sheathed with glass to show the landscape as continuous. Surrounded by nature, here is a peaceful and domestic setting for reuniting families.

Koby Cottage
1,100 sq ft

Garrison — Architects

Albion, Michigan, United States
© Garrison Architects

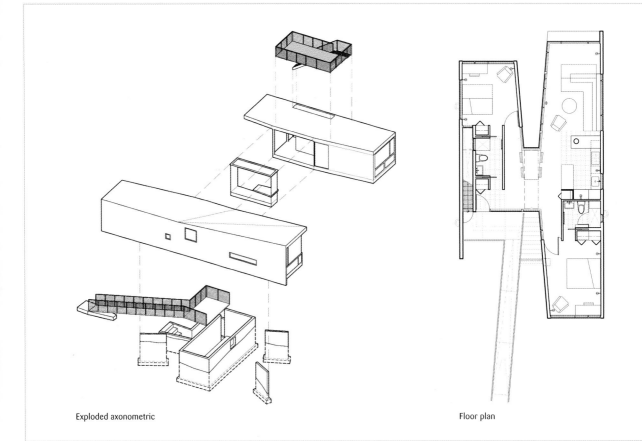

Exploded axonometric

Floor plan

Koby is a prototype constructed using an extremely strong and efficient modular space frame. The eleven-hundred-square-foot cottage has an X-shaped plan. One wing is for parents, the other for their child.

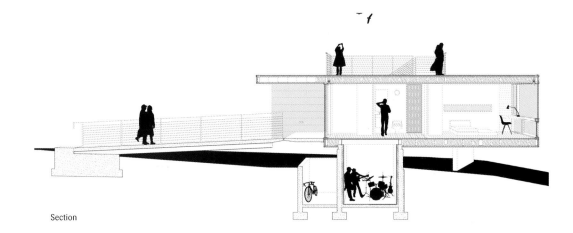

Section

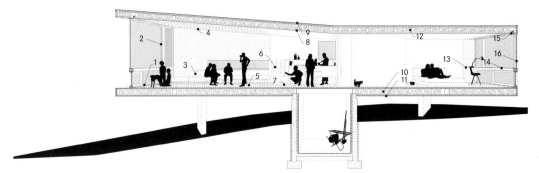

Perspective section

1. Heating and cooling
 High-velocity ducted heating/
 AC system with heat exchange
 ventilator
2. Rain screen cladding
 Corten steel rain screen
 cladding allows walls to
 breathe, while resisting to
 water
3. Banquette/Daybed
 Banquette with removable
 bolsters, seats 8, sleeping for
 3, upholstered with Climatex
 Lifecycle fabric
4. Ceiling and wall finish
 Tongue-and-groove FSC-
 certified prefinished maple
5. Floor
 Tongue-and-groove FSC-

certified pre-finished maple
floor with 50-year warranty
6. Fireplace
 EcoSmart non-polluting
 alcohol-burning fireplace
7. Floor tile
 Floor Gres recycled porcelain
8. Roof integrated photovoltaics
 Optimal thin film photovoltaics
9. Moisture retardant
 Smart moisture retardant taped
 at all seams and openings,
 breathes in warm weather
10. Foamed-in-place insulation
 Foamed-in-place insulation
 R6.8/inch polyisocyanurate
11. Continuous insulation
 Continuous R40/inch
 Nanopore vacuum

insulated panel
12. Steel frame
 Welded tubular steel frame
 with high-recycled content
13. Desk
 Integrated writing desk
14. Window system
 Insulated maple, cedar, and
 stainless steel window system
 with adjustable neoprene
 weather stripping
15. Blinds
 Integrated roller blinds
16. High-performance glass
 Heat Mirror Plus R10/U0-10
 glazing with Low-E coating and
 argon-filled cavity

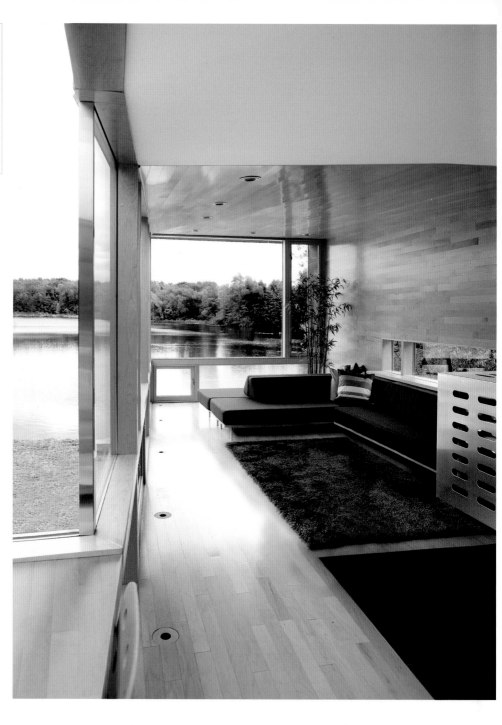

127

A narrow, long room can be softened and light let in by windows or doors making up as much of an exterior wall as possible.

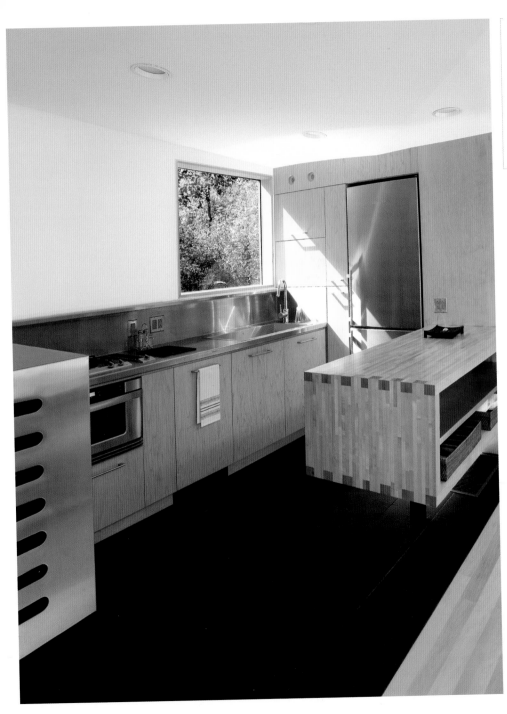

In homes where the kitchen and the living area share the same open space, choose integrated appliances for a simple, but clean and efficient look. This choice will help the kitchen blend with the rest of the space.

129

In addition to glass doors and large panorama windows, Koby has a skylight over where the two wings meet. This design detail enhances the shape of the building, while emphasizing where the two wings join.

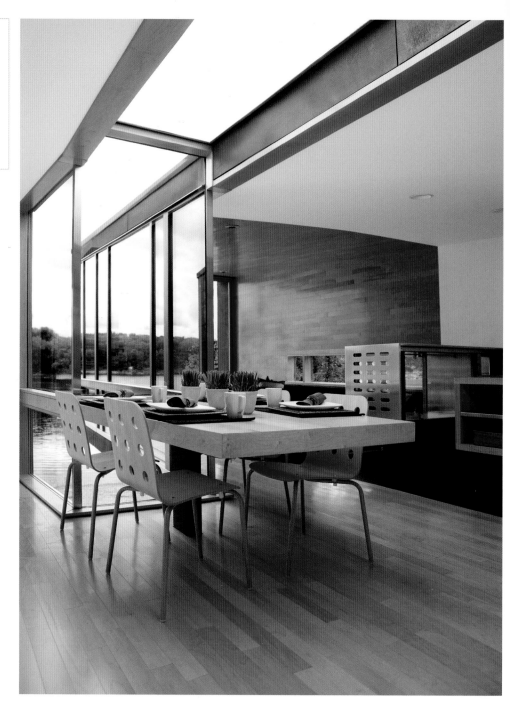

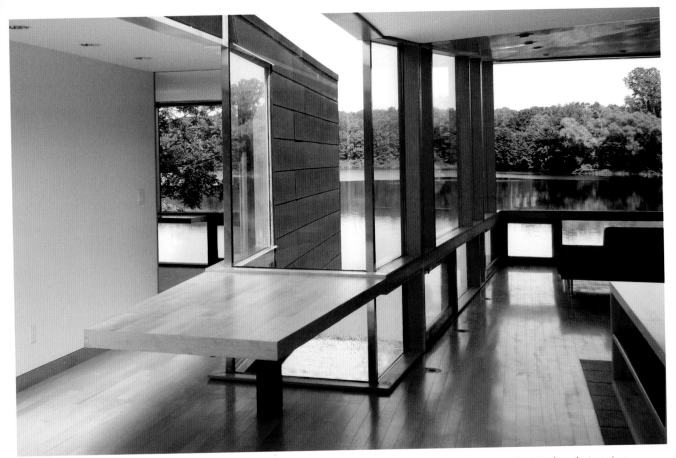

The area where the two wings cross has a table. It is the meeting point, an area for socializing, and strengthening family ties.

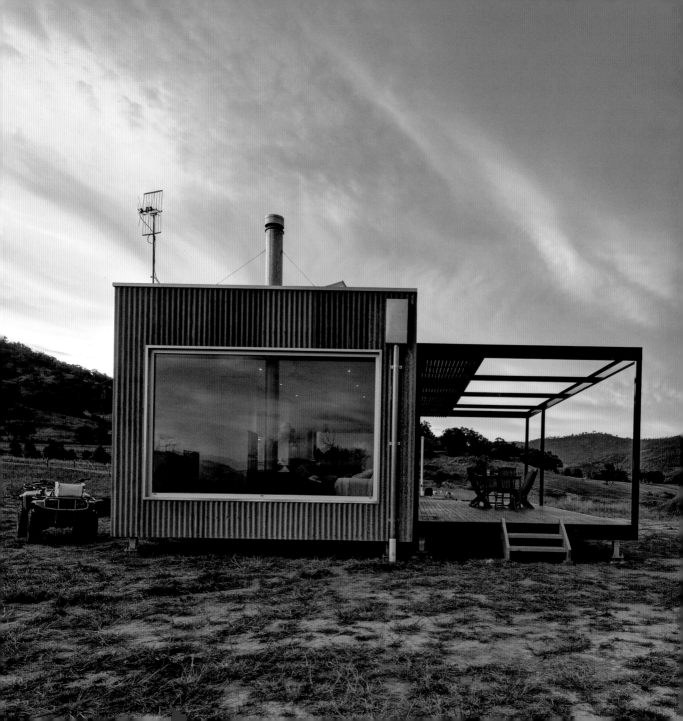

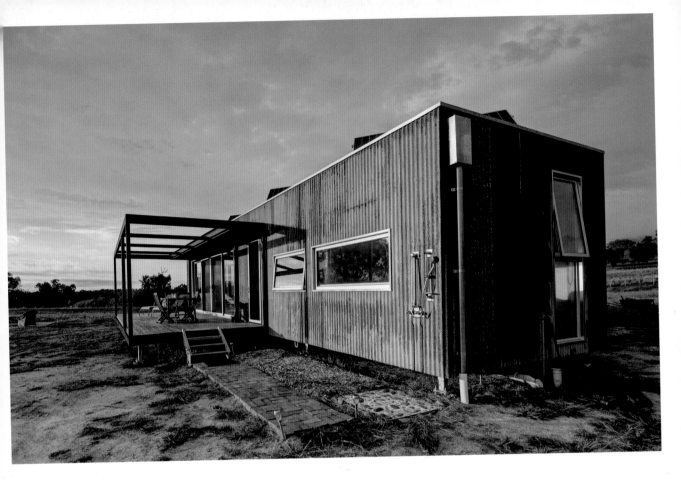

This unique home serves as an Australian base for a client living overseas and offers a secluded yet intimate base from which the surrounding environment can be observed. The design brief required a single-module cabin that was completely off-grid and easily maintained during long periods of vacancy throughout the year. When viewed from the road, the cabin recedes into the landscape by looking like any number of sheds in the area and appears as a small silhouette against the imposing mountain range on the horizon.

Tintaldra
1,033 sq ft

modscape

Tintaldra, Victoria, Australia

© Chris Daile

A cladding system was developed to create a shed-like exterior, consisting of a base layer of new Zincalume—a metallic-coated sheet steel—and a top layer of recycled Zincalume, which was applied for effect.

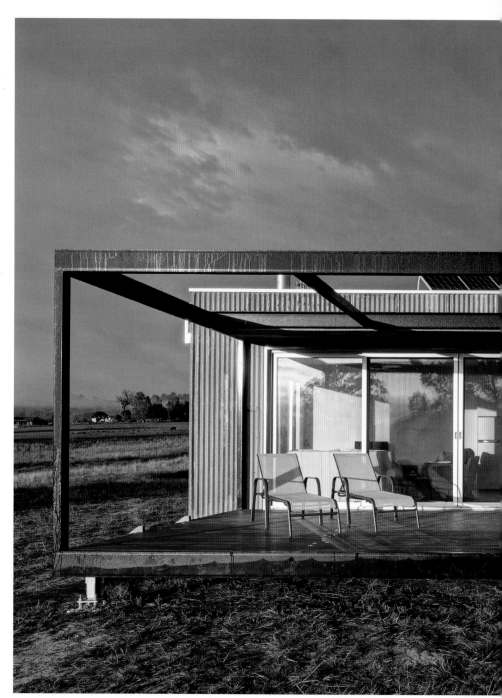

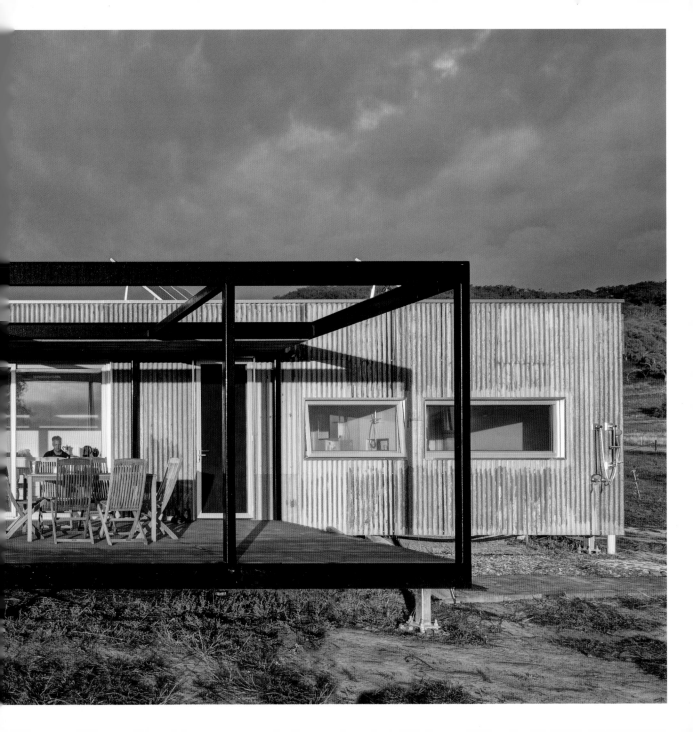

Front view

Front elevation

Side views

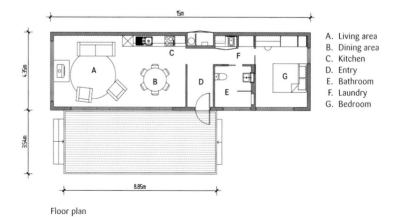

Floor plan

A. Living area
B. Dining area
C. Kitchen
D. Entry
E. Bathroom
F. Laundry
G. Bedroom

15m

4.35m

3.54m

8.85m

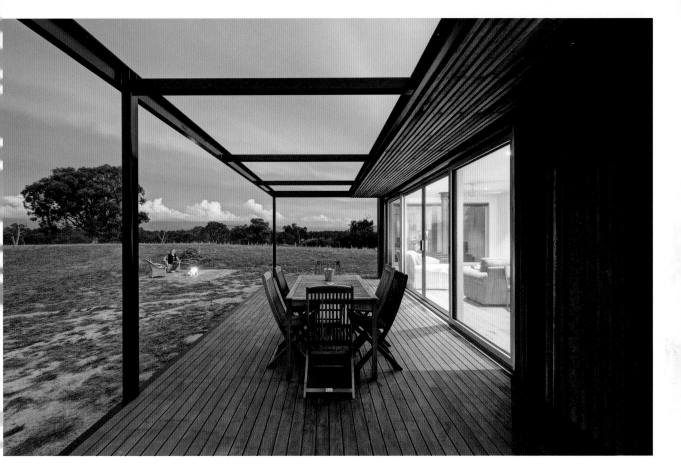

130

Modular construction can be stronger than on-site construction, because the different components are engineered independently in a workshop to withstand transportation and craning.

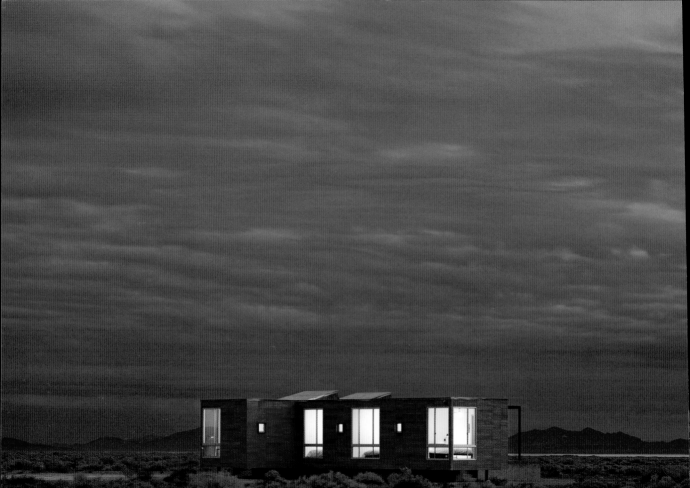

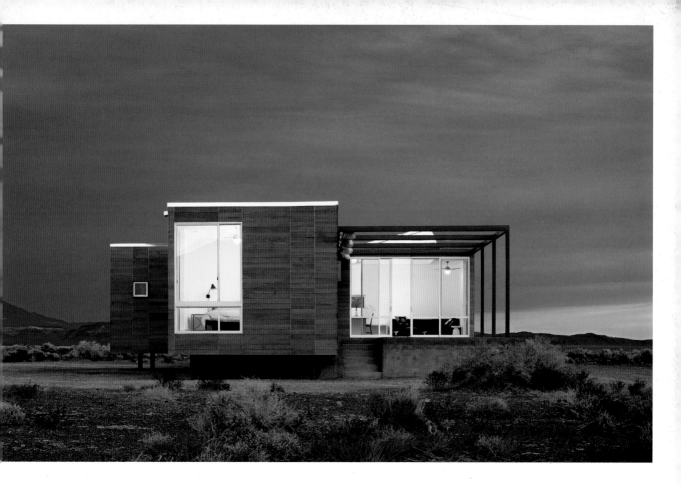

The Rondolino Residence stands on an isolated stretch of land far from any infrastructure or neighbor. The remoteness of the site required scraping a dirt path, digging a well, and constructing a leach field. Bringing electricity to the site was also required. With all these challenges met, the structure was positioned to take full advantage of the surrounding views, wind patterns, and trajectory of the sun.

Rondolino
1,200 sq ft

Peter Strzebniok / nottoscale

High Desert, Nevada, United States
© Joe Fletcher, photographer

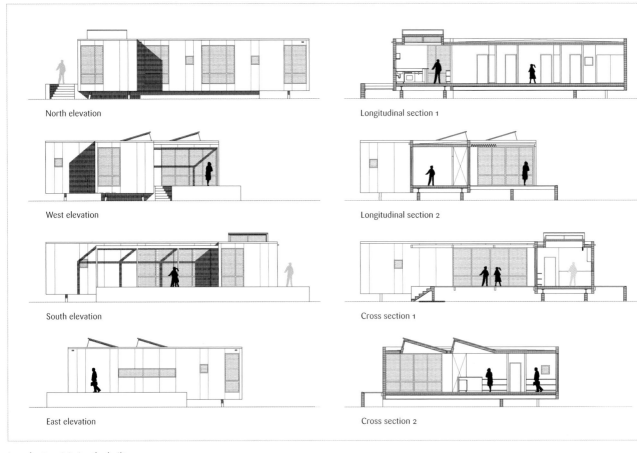

North elevation

West elevation

South elevation

East elevation

Longitudinal section 1

Longitudinal section 2

Cross section 1

Cross section 2

In order to minimize the built
environment, the rooms were kept
relatively small, but a 9' ceiling and
floor-to-ceiling windows made the
spaces seem spacious.

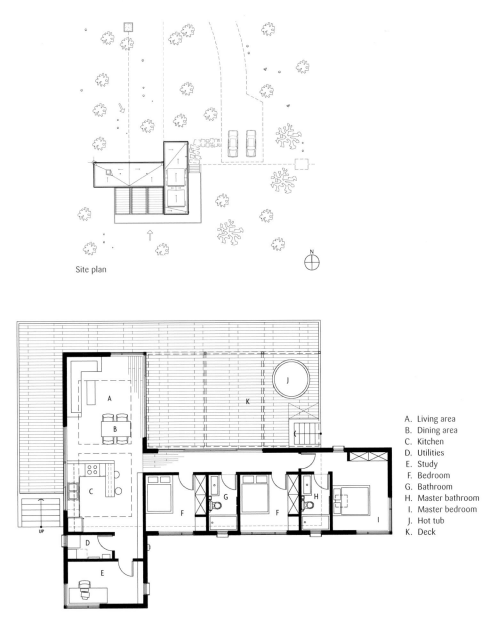

Site plan

Ground floor plan

A. Living area
B. Dining area
C. Kitchen
D. Utilities
E. Study
F. Bedroom
G. Bathroom
H. Master bathroom
I. Master bedroom
J. Hot tub
K. Deck

UP

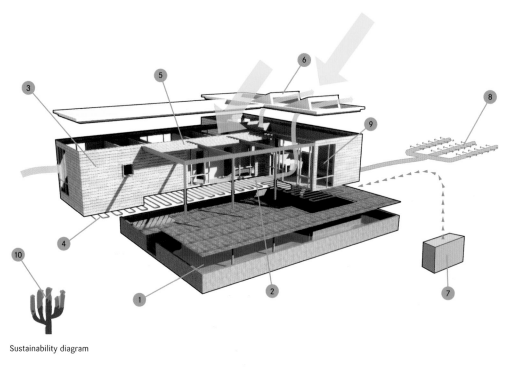

Sustainability diagram

1. Thermal mass temperature buffer—crawlspace filled with gravel maintains temperature year round to reduce heating and cooling needs.
2. Natural cross and stack ventilation.
3. Highly insulated Structural Insulated Panels (SIP).
4. Energy-efficient hydronic radiant heating system that can be upgraded to include radiant cooling.
5. Trellis shading system reduces solar heat gain.
6. Diffused day lighting through light monitors.
7. Off-the-grid local well.
8. Local septic leach field system.
9. High performance double-pane, low-E coated windows.
10. Landscaping with local species that do not require irrigation.
11. Compact floor plan to provide greater efficiency.
12. Sustainable materials such as low-VOC paints and bamboo eco-timber flooring.
13. Energy Star-rated appliances.
14. Reduction of construction waste through prefabrication.

131

The crawlspace under a building can double as storage space and as climate buffer, maintaining a low average temperature below the structure throughout the year.

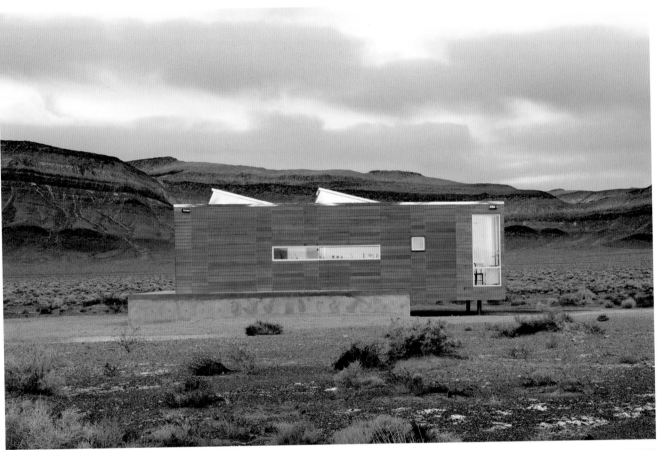

132

Various sustainable systems and approaches were used in order to minimize the physical as well as the carbon footprint of the building.

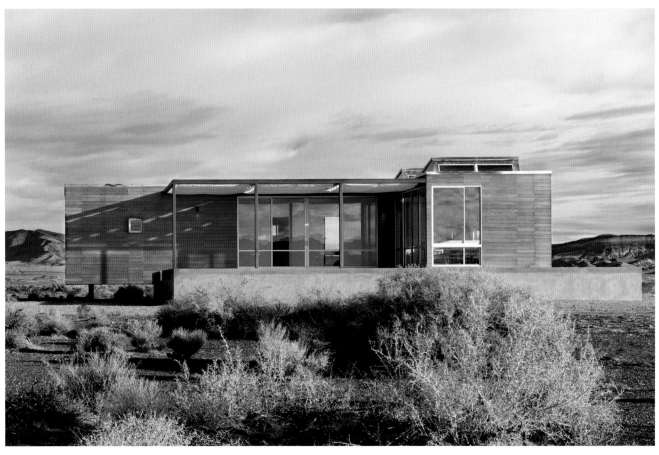

133

The size and placement
of windows are critical to
control temperature. A trellis
protecting windows facing
south can prevent heat gain.

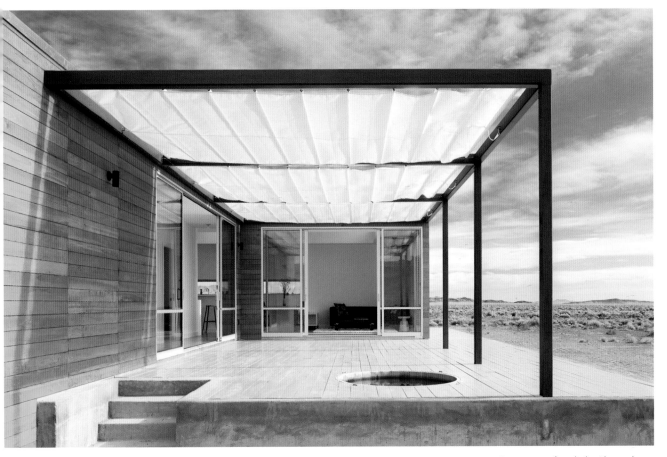

A 900-square-foot deck with a sunken-in hot tub connects the two building modules while creating a transition zone between the inside and outside.

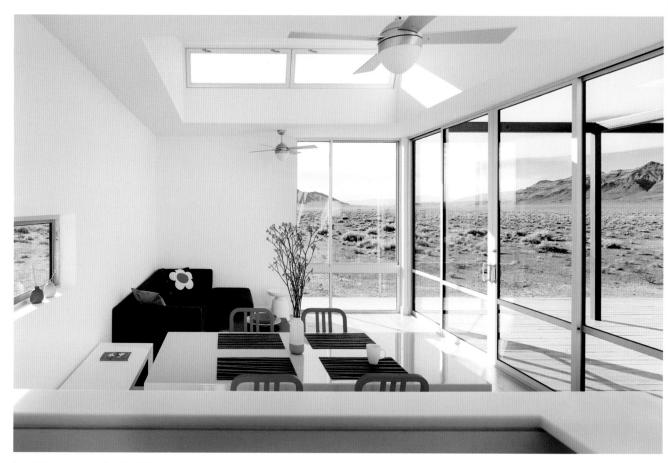

Despite its remote location, Rondolino is equipped with all the amenities required for a comfortable stay: a fully outfitted kitchen, stereo system, washing machine, alarm system and tools. Here's a desert retreat that's truly a turnkey vacation home.

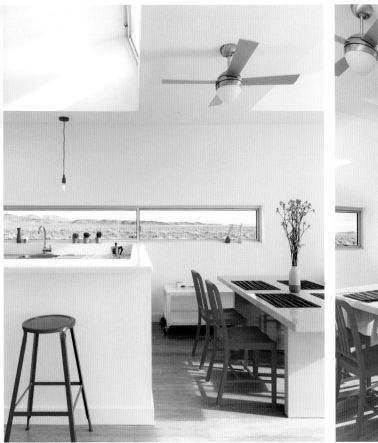

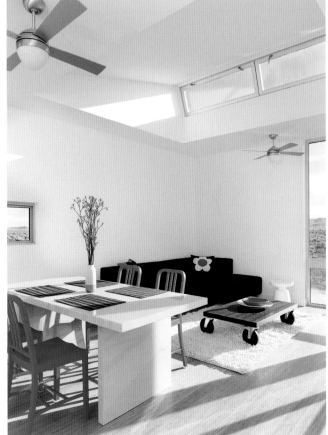

134

Place windows strategically to frame special aspects of the surrounding landscape. Here the long and low window in the kitchen frames a beautiful mountain range, which one can only see while sitting down at the dining table.

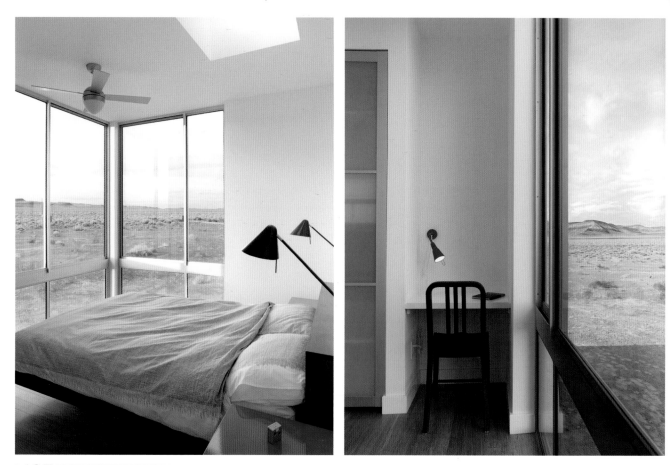

135

Raising the building off the
ground and using floor-to-
ceiling windows give the
impression of a home floating
in a beautiful setting.

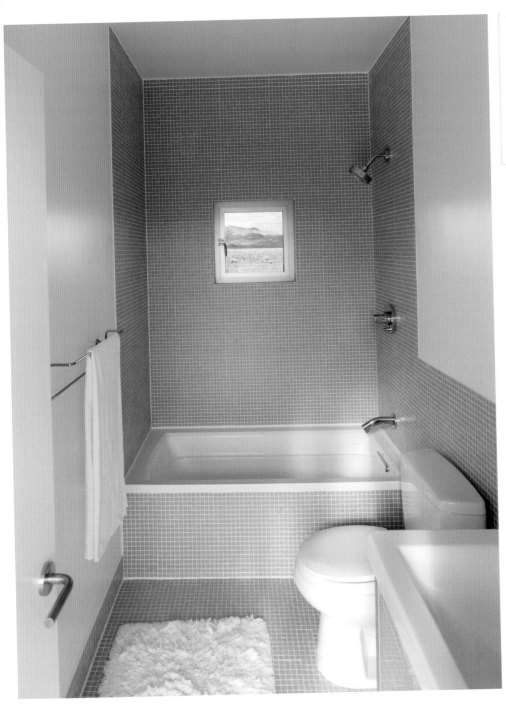

Leach fields are designed for the disposal of black water, produced by toilet and garbage-disposal waste. They are used in developments that are not connected to public sewage systems, mainly due to the remoteness of their location.

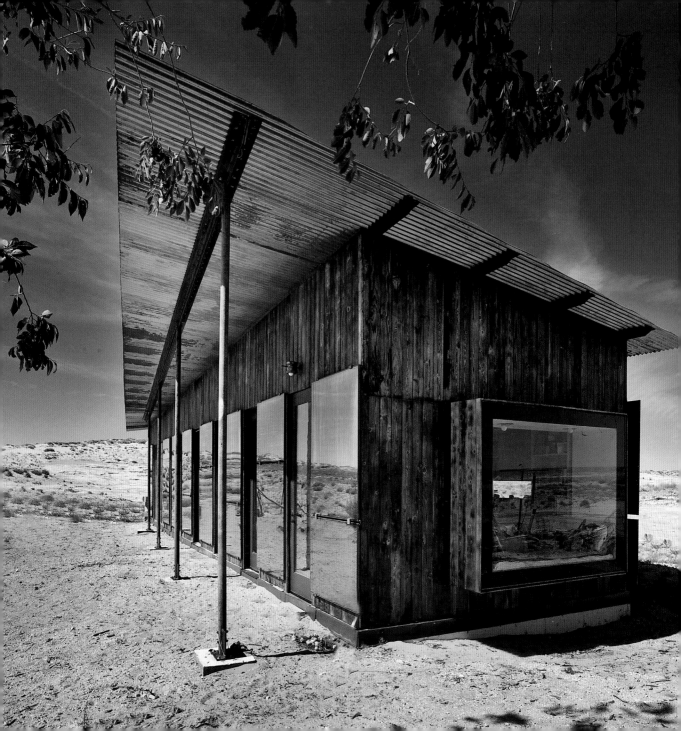

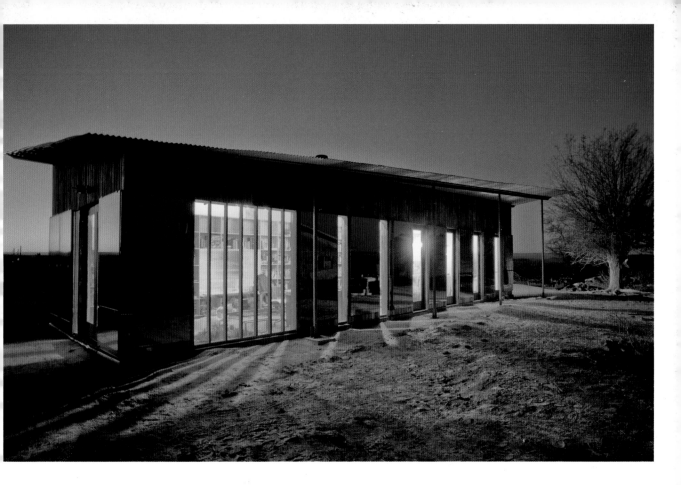

A group of architecture students from the University of Colorado took on the challenge of building a home for an avid collector of books, objects, and memorabilia. The limited budget and remote location in the Utah desert posed added challenges that the team was able to successfully overcome, surpassing all expectations. The result is a modern and space-efficient home, proof that good design can be achieved with limited resources.

Nakai House in Utah

1,100 sq ft

Students from the University of Colorado, DesignBuildBLUFF

Southwestern Utah Desert, Utah, United States

© Scot Zimmerman, James Anderson

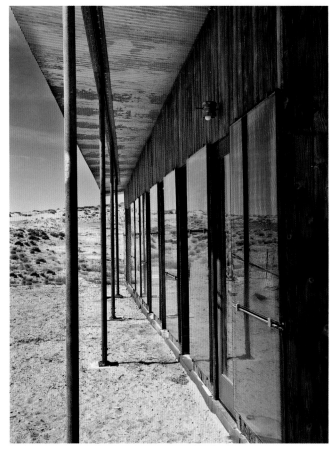
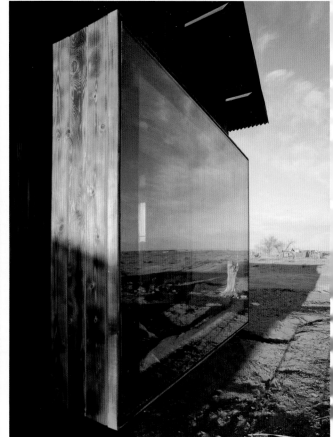

137

Deep eaves on the south side will shield a building from the summer sun, and also protect its weather side.

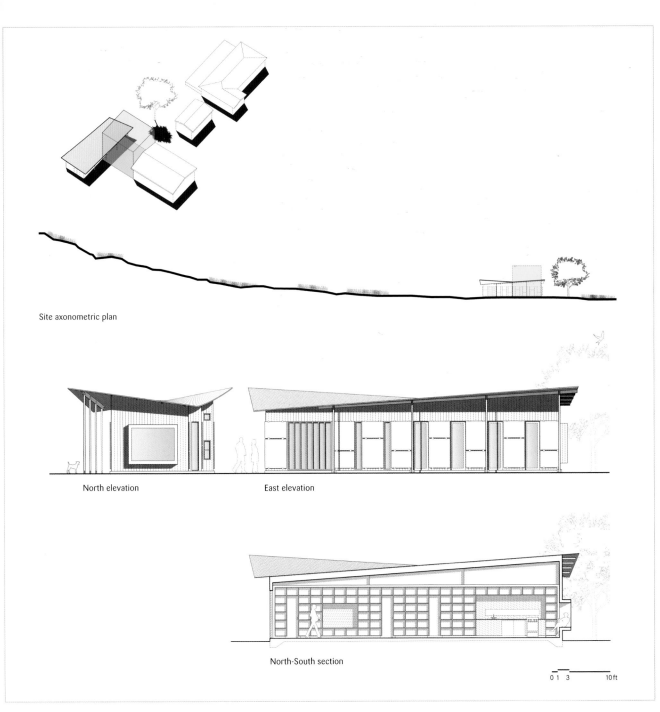

Site axonometric plan

North elevation

East elevation

North-South section

0 1 3 10 ft

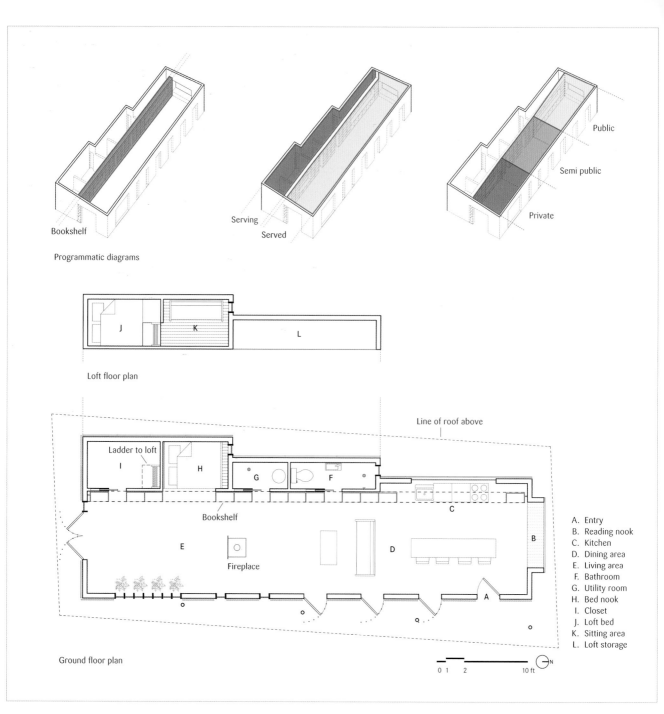

Programmatic diagrams

Bookshelf

Serving

Served

Public

Semi public

Private

Loft floor plan

J

K

L

Line of roof above

Ladder to loft

I

H

G

F

C

Bookshelf

E

Fireplace

D

B

A

Ground floor plan

A. Entry
B. Reading nook
C. Kitchen
D. Dining area
E. Living area
F. Bathroom
G. Utility room
H. Bed nook
I. Closet
J. Loft bed
K. Sitting area
L. Loft storage

0 1 2 10 ft

N

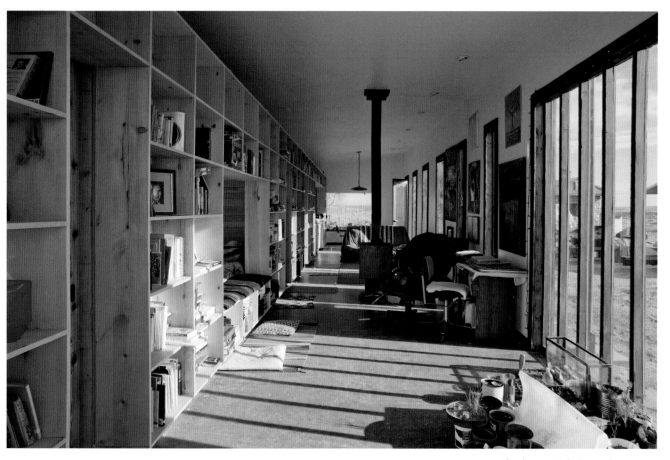

The client wanted a home where she could display her book, art, and plant collections. But the space had to be efficient and flexible enough to accommodate living functions comfortably.

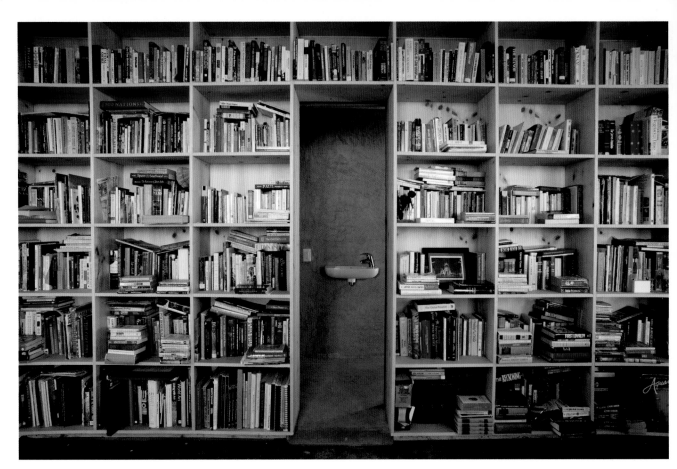

138

Optimize the use of a long wall
by lining it with shelves and
bookcases. The effect is further
enhanced if the bookcases
surround an opening.

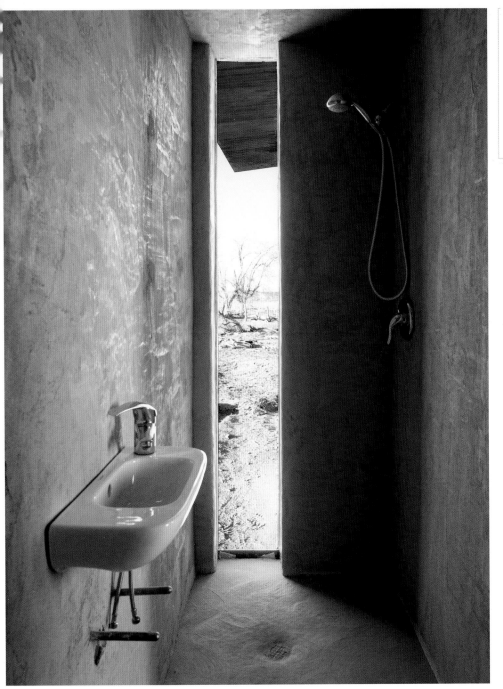

A tall and narrow frameless window emphasizes the sense of openness and minimizes the interior-exterior barrier, while it visually lifts up the ceiling.

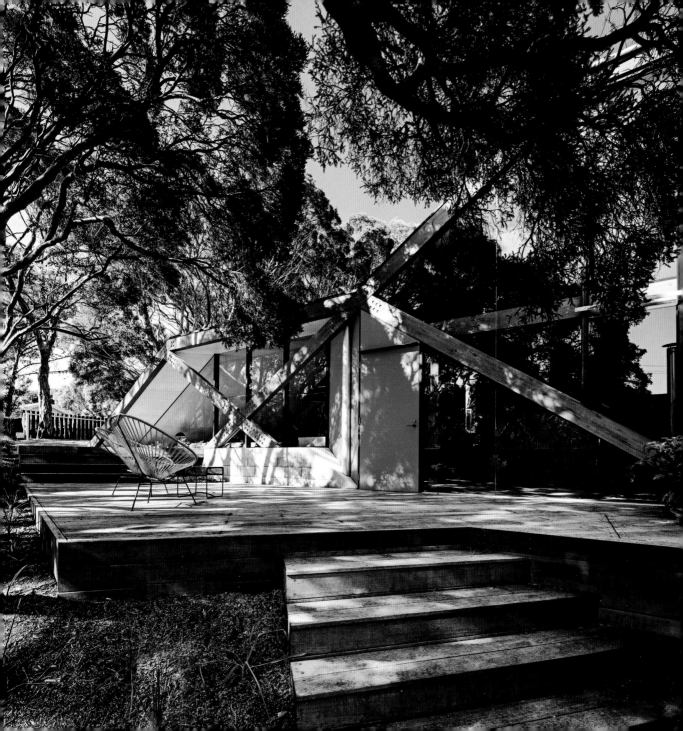

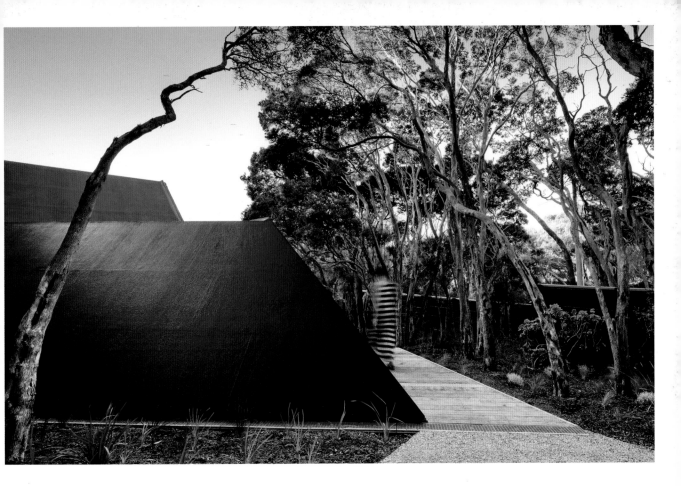

Cabin 2 is an addition to an existing 1960's log cabin. The surrounding coastal woodland camouflages a suburban-like density of holiday homes built along winding roads and footpaths with an accompanying high level of development activity. It's within this context that a self-contained retreat was developed to accommodate a good number of occupants. The design strategy involved separating the new addition from the existing cabin, allowing new and old to retain and express their unique identities.

Cabin 2
1,184 sq ft

Maddison Architects

Blairgowrie, Victoria, Australia
© Will Watt

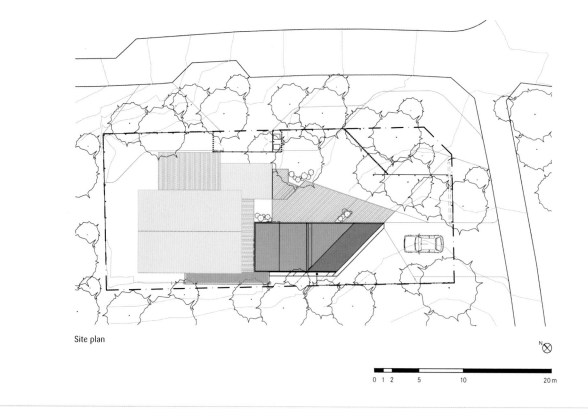

Site plan

0 1 2 5 10 20 m

The new architecture is informed by and embedded in the landscape. The folding roof grows out from the topography to act almost as a new type of landform.

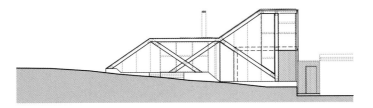

North elevation

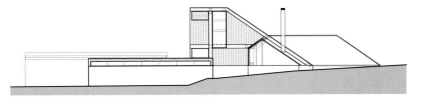

South elevation

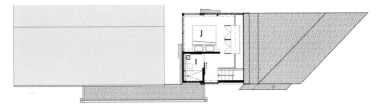

Mezzanine floor plan

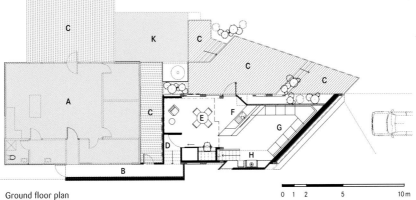

Ground floor plan

A. Existing dwelling
B. Link
C. Outdoor decking
D. Extension entry
E. Dining area
F. Kitchenette
G. Living area
H. Landing/Hearth
I. Bathroom
J. Bedroom
K. Existing carport/
 Shelter

0 1 2 5 10 m

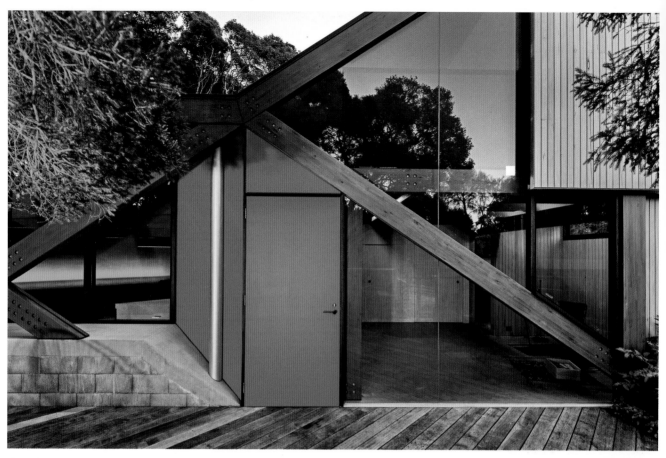

The roof form is unified so that roof is also a ceiling. The structural timber frame is fully exposed both inside and out to convey both a structural and architectural honesty.

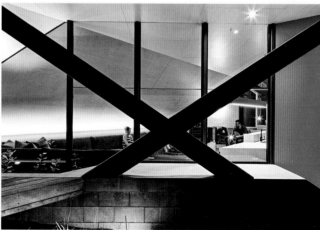

140

Trees can provide shade and improve comfort through evaporative cooling during the summer. They can also double as a privacy screen. When leaves fall, they let in the winter sun.

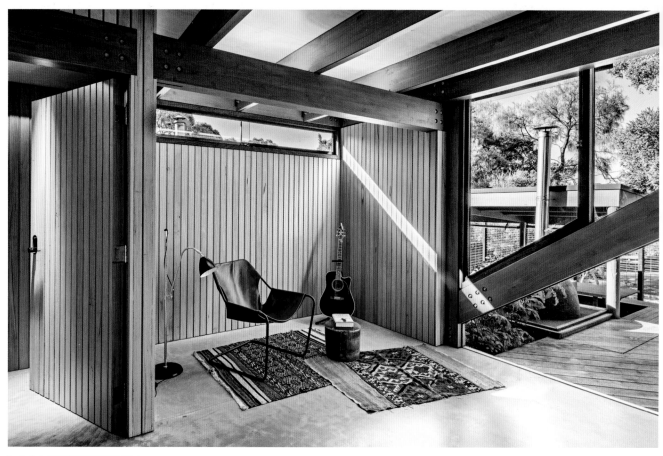

141

Clerestories can make a
difference in a space by
bringing in more light and
balancing out other light
sources without loosing
wall space.

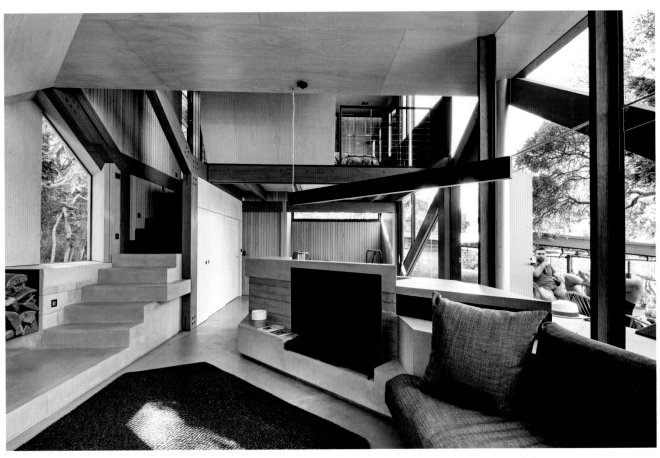

142

Roofs are prominent features in the design of houses and other types of buildings. From the outside, a roof sets the style of a home. From the inside, it enhances the living spaces.

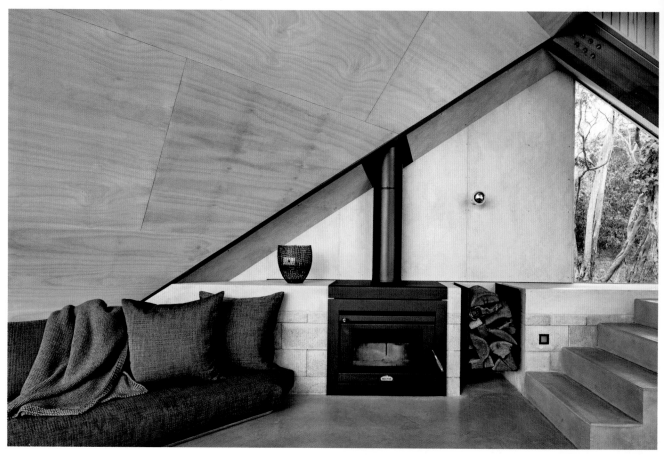

143

To complement and soften angular rooms, use organic shapes and avoid straight lines: throw in a few large floor pillows, pick soft chairs, and fill in with rounded items. Plants will also help soften a space and will add texture, too.

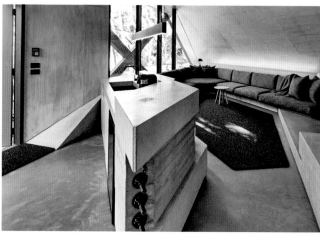

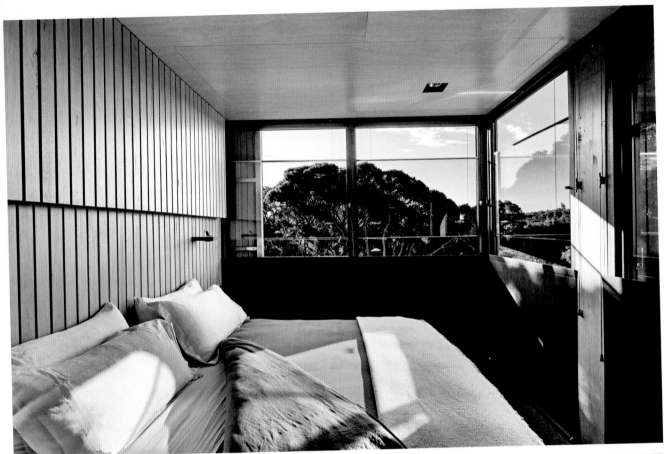

144

Nothing creates a cozy and snug setting like wood covering the surfaces of a cabin's interior. If you can't commit to the rustic theme, you can combine the warmth of wood with the coolness of other finishes to create a brighter ambiance.

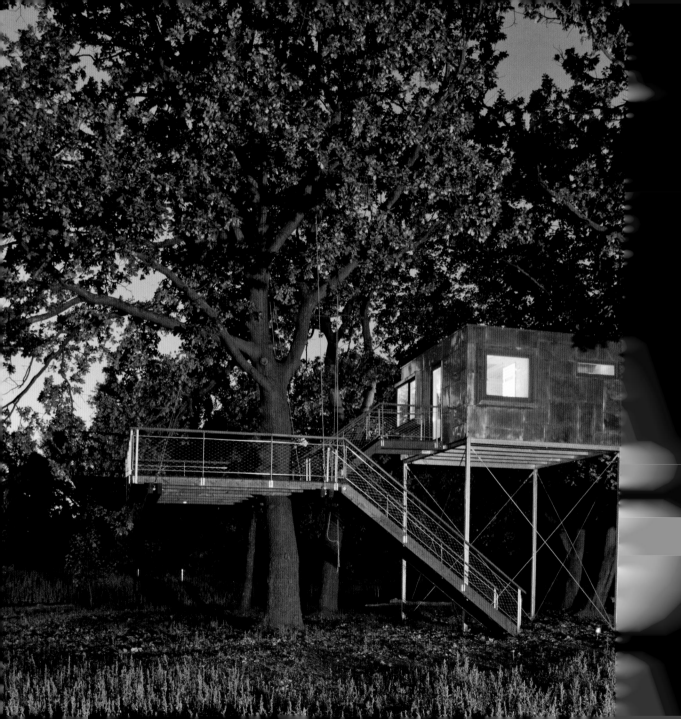

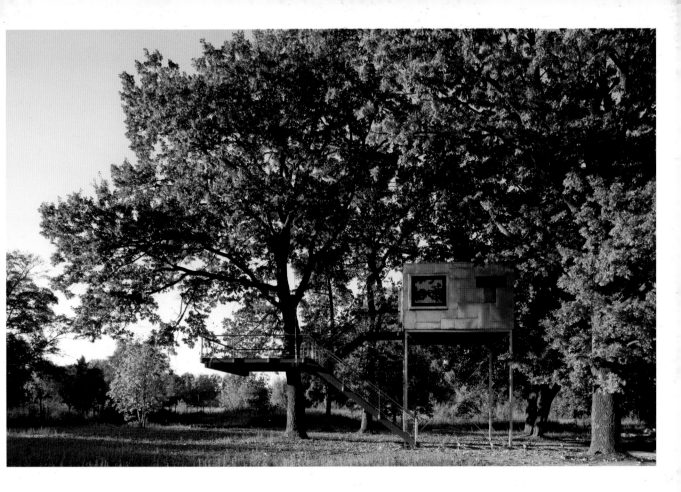

There is always something playful about tree houses no matter how sophisticated they are. For adults, tree houses are the ultimate accommodation that can help realize their childhood dream or can bring back memories of fun sleepovers with friends. These amazing retreats lure one away from everyday stress. This creative retreat perched in a tree canopy can be used as a guesthouse—one equipped with all the necessities required for a pleasant stay.

Copper Cube
630 sq ft

Andreas Wenning / Baumraum
Werder, Germany
© Markus Bollen

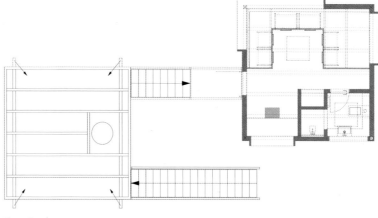

Floor plan

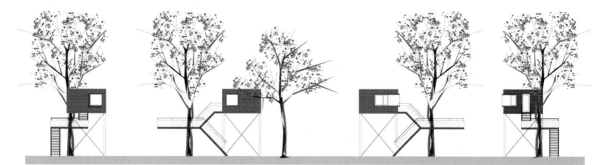

Elevations

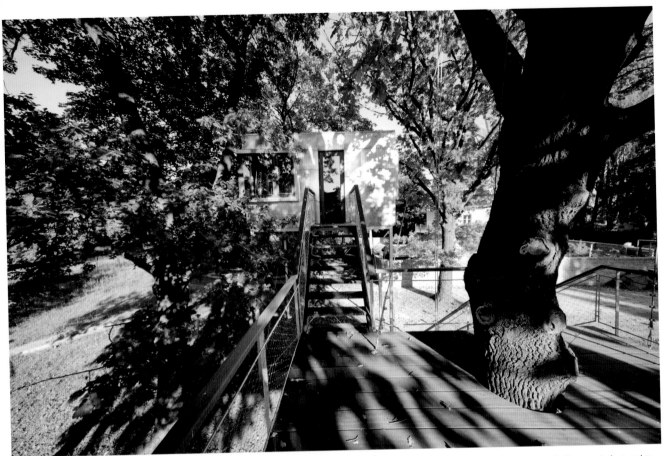

The terrace, halfway up, is fastened to an oak tree with ropes and textile belts.

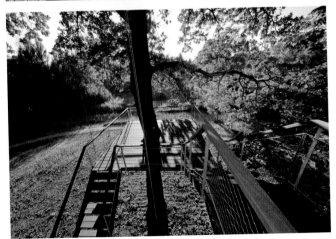

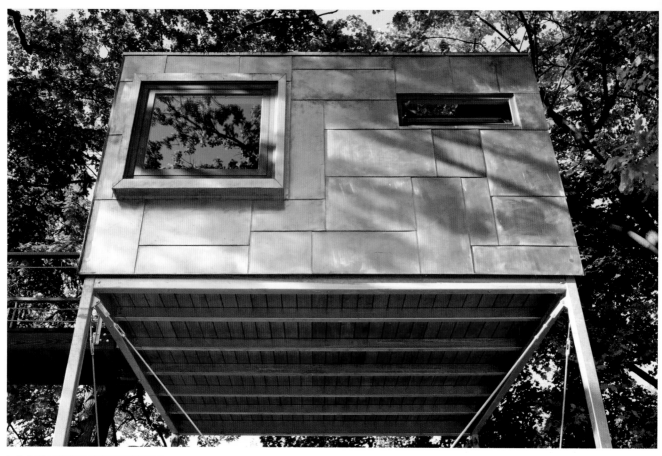

145

To take utility pipes and cables—water and electricity—up to a tree house, you can use steel poles that can also serve as support for the suspended construction.

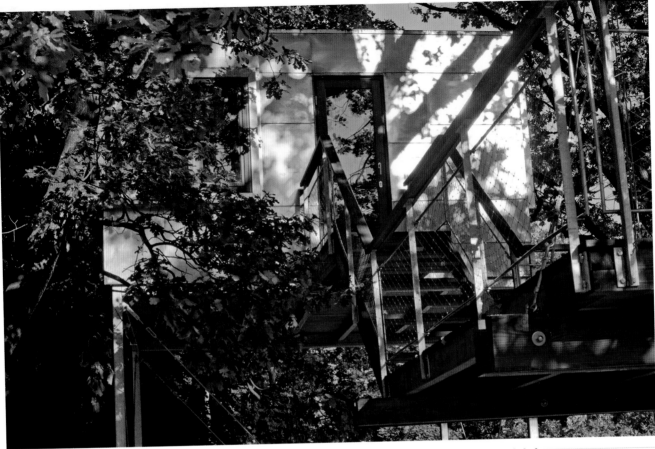

146

Copper is a material that tarnishes over time when exposed to the elements if it's not protected. But tarnishing's green patina will actually help the tree house achieve one of its primary design goals: blending in with the surrounding trees.

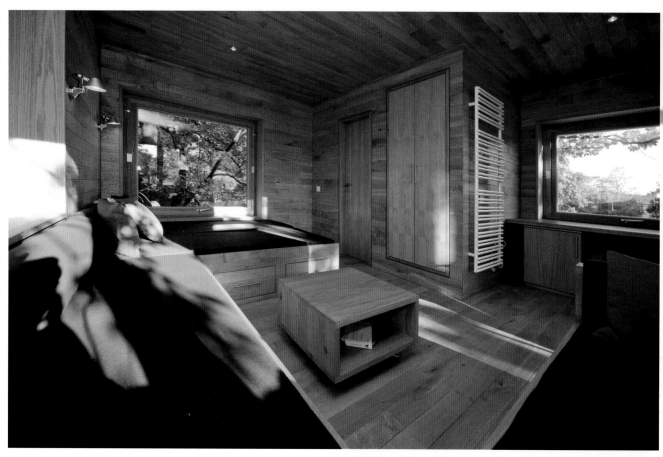

Copper Cube offers comfortable bedding and seating, a desk, a closet, and a minibar. It has windows facing all directions and two skylights enhancing the experience of being perched up in the trees canopy.

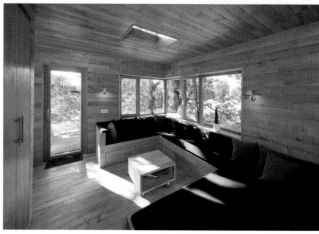

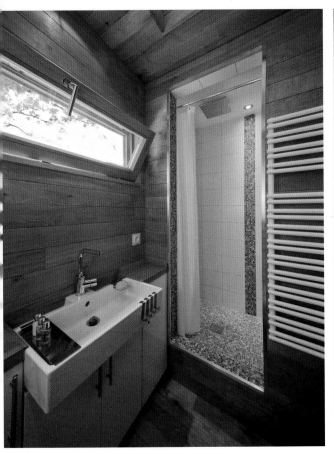
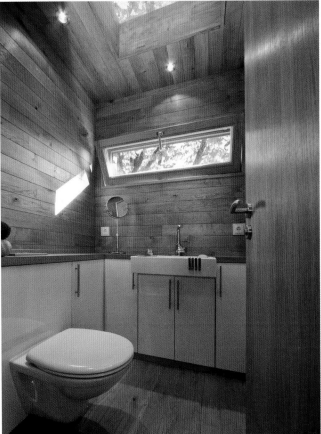

147

Consider high windows in your bathroom to let in natural light without compromising privacy.

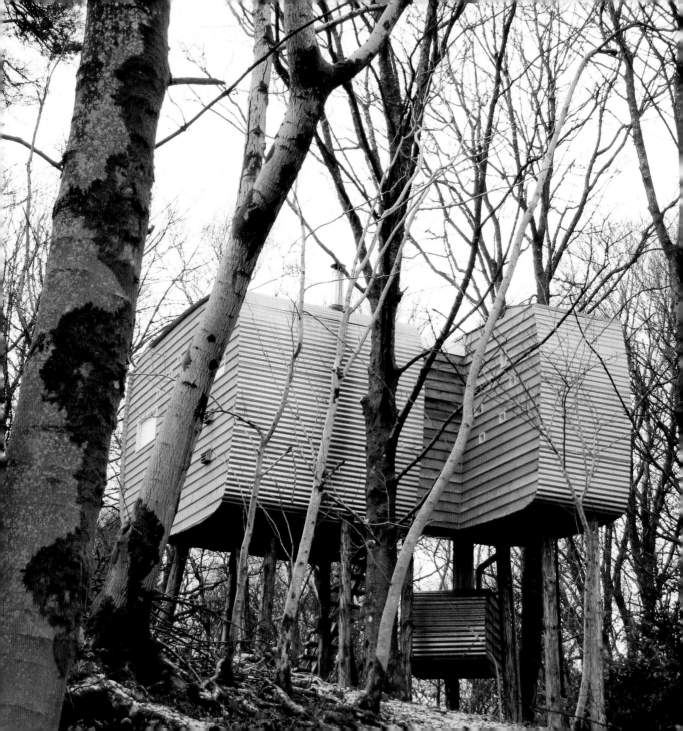

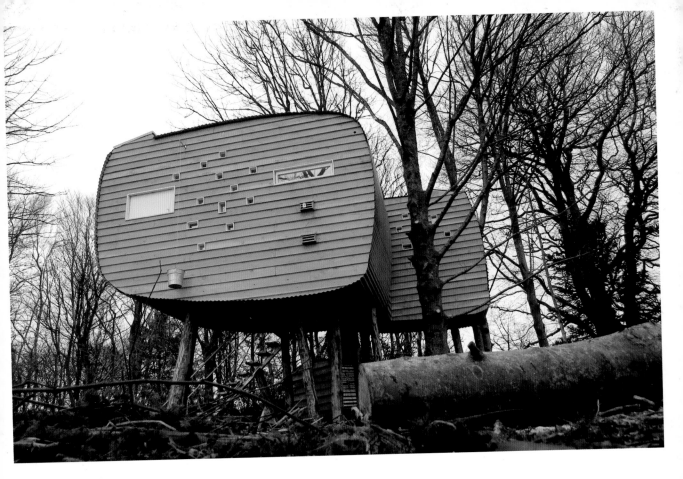

This original tree house was designed to be an intimate off-grid retreat for two, complementing an existing main house on a large wooded property. Two distinctive pods sit atop eleven larch stilts. Their larch-clad flat walls perforated with numerous tiny windows allow views into the trees and let in the dappled woodland light. The pods are wrapped in corrugated tin, and crowned by two skylights and a stainless steel chimney. A long staircase leads to the front door and to the intimate, cozy interior.

Brockloch Tree House
200 sq ft

echoLIVING

Dumfries & Galloway, Scotland, United Kingdom

© echoLiving

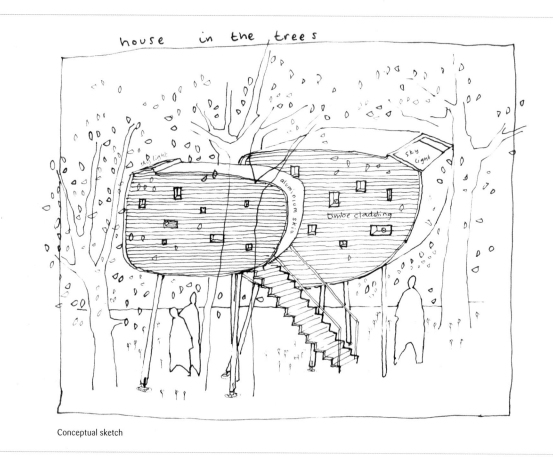

Conceptual sketch

The sides of the tree house are
punctuated with tiny box windows
that dapple the interior with light.

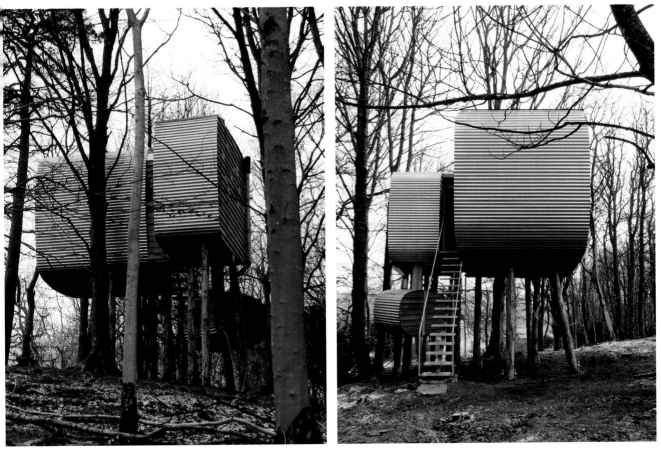

148

Exterior cladding plays an important role in setting the style of a home. The main factors to take into consideration when choosing cladding materials are climate, budget, and aesthetics.

Mainly used in industrial construction, corrugated metal has found its way into contemporary residential construction. The material offers visual appeal, affordability, availability, and durability.

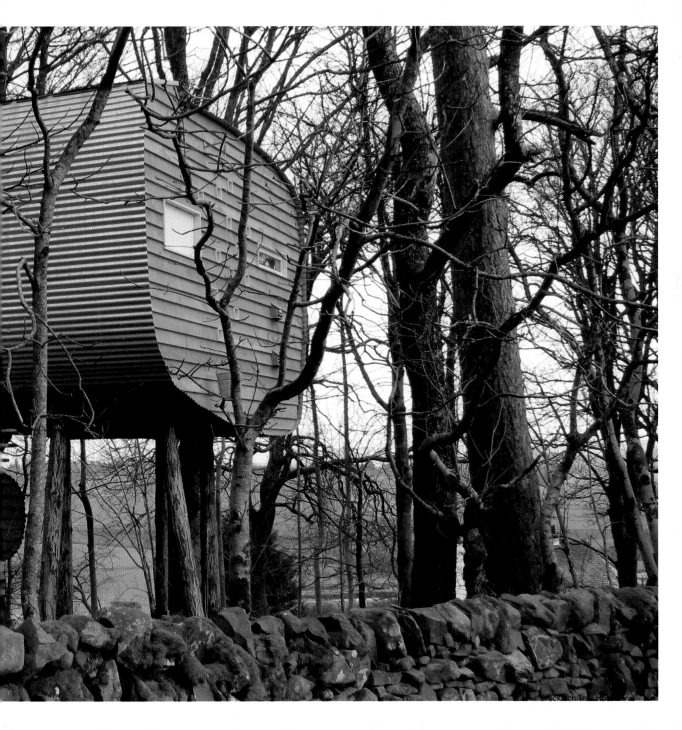

Brockloch Tree House

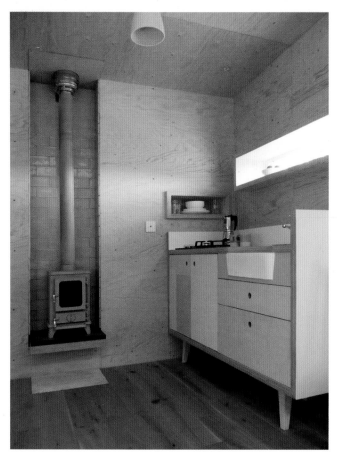

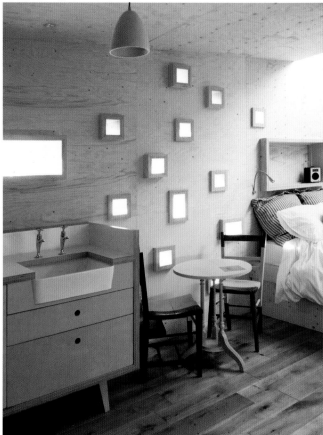

The living area has a hand-built freestanding kitchen cabinet with a built-in gas stove, fridge, butler sink and cupboard, and drawer space. At the opposite end, a built-in double bed nestles under a skylight for sleeping under the stars.

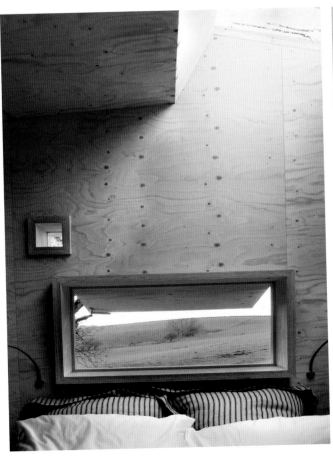

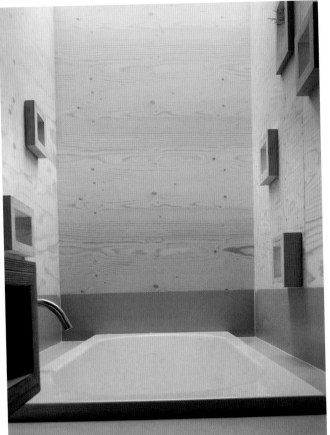

150

A separate bathroom has minuscule windows, whose purpose is framing views, more than letting light into the room. What these windows lack in size, they make up for in impact.

DIRECTORY

Agence Apolline Terrier
Paris, France
www.apolline-terrier.fr

Altius Architecture
Toronto, Ontario, Canada
http://altius.net

Amy A. Alper, Architect
Sonoma, California, United States
www.alperarchitect.com

Andreas Wenning / Baumraum
Bremen, Germany
www.baumraum.de

arba
Paris, France
http://arba.pro

avanto architects
www.avan.to
Helsinki, Finland

Balance Associates, Architects
Seattle, Washington, United States
www.balanceassociates.com

Casagrande Laboratory
Karjaa, Finland
www.clab.fi

CityDeskStudio
Saint Paul, Minnesota, United States
http://citydeskstudio.com

**Clark Stevens Architect /
New West Land Company**
Clyde, Idaho, United States
www.clarkstevens.com

CWB Architects
Brooklyn, New York, United States
http://cwbarchitects.com

David Jay Weiner, Architect
New York, New York, United States
www.dweiner.com

**DesignBuildBLUFF and students
from the University of Colorado**
Salt Lake City, Utah, United States
www.designbuildbluff.org

DeForest Architects
Seattle, Washington; Tahoe City,
California, United States
www.deforestarchitects.com

echoLIVING
Dumfries and Galloway, Scotland,
United Kingdom
www.echoliving.co.uk

Eggleston|Farkas Architects
Seattle, Washington, United States
http://eggfarkarch.com

FabCab
Seattle, Washington, United States
http://fabcab.com

FINNE Architects
Seattle, Washington, United States
www.finne.com

**Mats Edlund, Henrietta Palmer, Matts Ingman/
Form Arkitektur Mats Edlund**
Lund, Sweden
www.formarkitektur.com

Frank / Architects
Berkeley, California, United States
www.frankarch.com

Garrison — Architects
Brooklyn, New York, United States
www.garrisonarchitects.com

**Gonzalez Vergara Arquitectos
(formerly F3 Arquitectos)**
Santiago de Chile, Chile
http://f3arquitectos.cl

Graypants
Seattle, Washington, United States
Amsterdam, the Netherlands
www.graypants.com

Greg Hill
Turon Valley, New South Wales, Australia
www.turon-house.com

Heliotrope Architects
Seattle, Washington, United States
www.heliotropearchitects.com

Jarmund/Vigsnæs AS Arkitekte
Oslo, Norway
www.jva.no

Korteknie Stuhlmacher Architecten
Rotterdam, the Netherlands
www.kortekniestuhlmacher.nl

Lawrence Architecture
Seattle, Washington, United States
http://lawrencearchitecture.com

LAZOR OFFICE | FlatPak
Minneapolis, Minnesota
www.flatpakhouse.com

M Valdes Architects
Saint Paul, Minnesota, United States
www.mvaldesarc.com

maddison architects
South Melbourne, Victoria, Australia
www.maddisonarchitects.com.au

MAPA
Montevideo, Uruguay; Porto Alegre, Brazil
http://mapaarq.com.uy

Max Holst Arkitektkontor
Stockholm, Sweden, United States
http://maxholst.se

Modscape
Brooklyn, Victoria, Australia
http://modscape.com.au

nottoscale
San Francisco, California, United States
www.nottoscale.com

Osburn/Clarke
Vancouver, British Columbia, Canada
www.osburnclarke.com

Passion - Smart Design Houses
Tallinn, Estonia
www.passionhouses.com

Pokorny Architekti
Bratislava, Slovakia
www.pokornyarchitekti.sk

superkül
Toronto, Ontario, Canada
http://superkul.ca

Turnbull Griffin Haesloop Architects
San Francisco, California, United States
www.tgharchitects.com

2by4-architects
Rotterdam, the Netherlands
www.2by4.nl

Uptic Studios
Spokane, Washington, United States
http://upticstudios.com

YH2 - yiacouvakis hamelin, architectes
Montreal, Québec, Canada
www.yh2architecture.com

Zecc Architects
Utrecht, the Netherlands
www.zecc.nl